TONY SPINA

CHIEF PHOTOGRAPHER

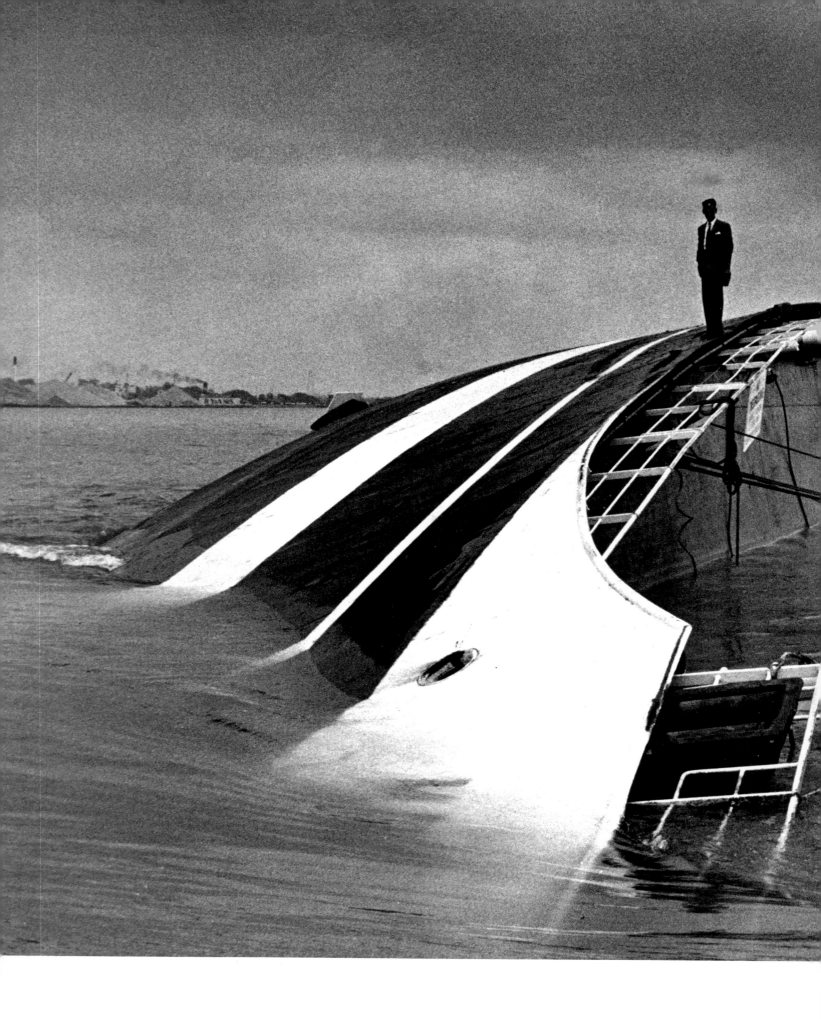

DETROIT RIVER, 1962
Capt. Ralph Eyre-Walker stood on top of his British freighter, the Montrose, for one last look after it collided with a cement barge and sank just downstream of the Ambassador Bridge. I rode out with him when he went to get some belongings. Life magazine ran this photo across two pages.

With admiration, I dedicate this book to

David Lawrence Jr.
Lee Hills
and the late John S. Knight

I'll always cherish their friendship and leadership.

TONY SPINA

CHIEF PHOTOGRAPHER

Edited by SANDRA J. WHITE

With an introduction by
NEAL SHINE

Detroit Free Press
1988

TONY SPINA
CHIEF PHOTOGRAPHER

Photography and text: Tony Spina
Editing and design: Sandra J. White
Project co-ordinators: Michele Kapecky, William R. Diem
Introduction: Neal Shine
Research: Detroit Free Press librarians
Copy editing: Helene Lorber
Cover: Kinetic Imagery photograph by Julia Spina-Kilar
Photographic prints: Kodak film and paper
Book printing: Gaylord Printing Co., Detroit

Published by the Detroit Free Press
Detroit, Michigan 48231

Copyright by the Detroit Free Press 1988

Manufactured in the United States of America

ISBN 0-937247-05-7

Cataloging in Publication Number: 88-070363

ACKNOWLEDGEMENTS

Heartfelt thanks to Sandy White, who devoted many hours and much thought to the editing of this book, along with Bill Diem and Michele Kapecky, who coordinated its publication.

In preparing this book, I'm also grateful for the interest and assistance of: Knight-Ridder and the Detroit Free Press, Dave Lawrence, Neal Shine, Heath Meriwether, Kent Bernhard, Scott Bosley, Ken Clover, Al Politi, Jeff Piety, Bob McKean, Paul LaBell, Walter Persegati, Arturo Mari, Guido Gusso, Marjorie Weeke, William Pekala, Richard LoPinto, Diane Edgecomb, Judge Damon Keith and Mayor Coleman Young.

I have been involved with many fine photojournalists, editors and technical people throughout my newspaper career. Among them are: Sandy White, David Turnley, Taro Yamasaki, Daymon J. Hartley, Manny Crisostomo, John Collier, Craig Porter, Patricia Beck, Hugh Grannum, Al Kamuda, William Archie, Mary Schroeder, Richard Lee, George Waldman, Pauline Lubens, Helen McQuerry, John Stano, William DeKay, Steve Nickerson, John Luke, Ed Haun, Ira Rosenberg, Diane Bond, Charles T. Haun, Jimmy Tafoya, Herman Allen, Toby Massey, Hal Buell, Jack Corn, Charles Cooper, Maurice Johnson, George Shivers, Del Borer, Bill Baker, Jim Batten, Derick Daniels, Joe Stroud, Kurt Luedtke, Frank Angelo, Al Neuharth, Gene Roberts, Clint Baller, John Goecke, Marcia Prouse, Mike Smith and Randy Miller.

My special thanks and love to Julia Spina-Kilar, who, with her "kinetic imagery" photography, is teaching her dad yet another thing or two.

I express my deep appreciation to my entire family, whose love and support has been a constant source of motivation throughout all my endeavors.

And, to my fans, friends and colleagues too numerous to mention — thank you.

Tony Spina

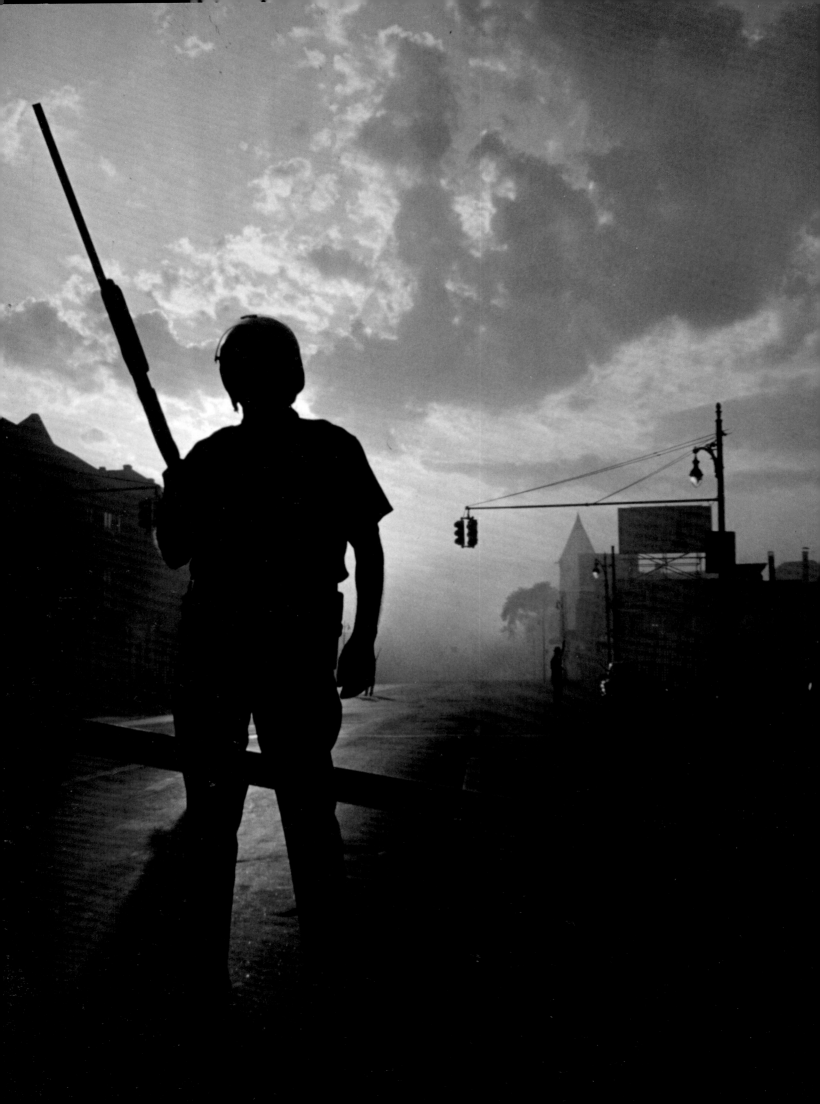

DETROIT, 1967
A Detroit policeman during the riots.

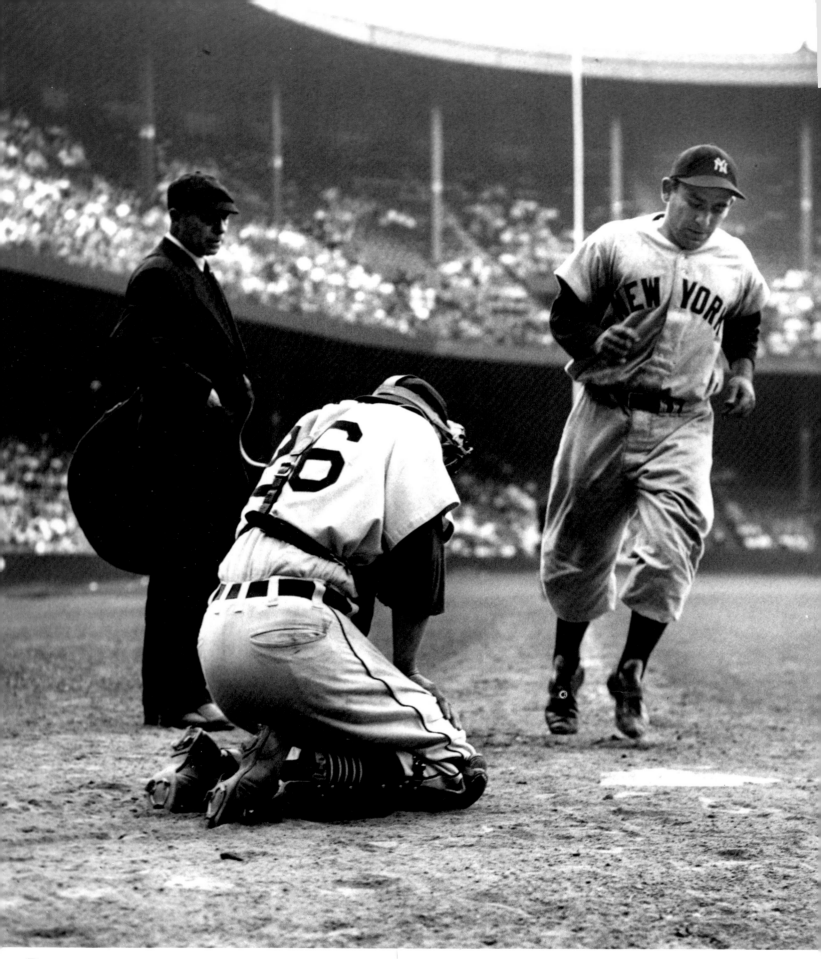

DETROIT, 1951

"In all the manliness of grief" I call this diamond drama. The
dejected figure of catcher Joe Ginsberg on his knees tells the
story of a Detroit Tiger defeat June 2 at the hands of the New
York Yankee catcher, Yogi Berra. Yogi is crossing home plate
at Briggs Stadium with the winning home run in the 12th
inning, making the score 8 to 7.

PREFACE

I was 14 years old when I first picked up a camera. The excitement of saving for and finally holding my camera is something I remember even today. Who would have thought that moment was going to be the very beginning of a fascinating journey: snagging life's intimate, historical moments in fractions of seconds. After all these years, that excitement is still there. It has deepened and transferred into more intricate areas of my work, but it's definitely there.

The years have brought many changes, not only in technology, but also in the very definition of my field. Technology has helped us advance from being intrusive shooters of news to being quiet recorders of intimacies on all levels. Picture the photographers of the 1940s lugging their bulky 4-by-5 Speed Graphics and awkward No. 22 flashbulbs. Intrusive, intimidating, yet invaluable compared to anything else that was then available in newspaper journalism.

During my career with the Detroit Free Press, I have probably taken several hundred thousand photographs. I've selected nearly 300 photographs that I think illustrate a cross section of my work during 42 years at the Freep. Most of my photographs from 1946 through 1954 were taken with a Speed Graphic. Others were shot with a Panon, Widelux, Rolleiflex, 5-by-7 Big Bertha, fish-eye lenses, and the reliable 35mm Nikon cameras with which the majority of photographs in this book were taken.

I am amazed by all of the transitions in photojournalism I have had the privilege to help shepherd and to incorporate in my career. Allow me to briefly share them with you.

I started at the Detroit Free Press in May 1946 after serving four years in the U.S. Navy as a chief photographer's mate.

The Forties were difficult for the press photographer. With very few photojournalism schools in existence, we waded through the basics of photography by ourselves. Trial and error were our instructors, unless one was a darkroom helper or tagged along on assignment as an apprentice.

On assignments we dealt with important technical unknowns, such as "guesstimating" lighting situations. Literally every shot counted. Film was packed in holders, one sheet on each side. The routine was: dark slide out, anticipate, shoot, dark slide in, flip holder, and begin to anticipate the next important moment. But moments happen in fractions of seconds. Unfortunately, our sheet film restrictions and film speed did not. Anticipation and determination were not just words, they were the determinants of our success. As inconvenient as this decade seems today, we captured dynamic images while learning the virtue of patience. The payoff came to us in the 1950s.

The 1950s was a great decade for press photographers. The 35mm camera was incorporated into our work. I became Chief Photographer for the Free Press in 1952, and in 1956 I provided my staff with 35mm cameras. Since one of my first cameras was a Leica model G, I was well aware of its capabilities. Now Speed Graphics were gone, and what a wonderful job they had done for us. Flashbulbs were replaced with the new electric strobe lights. Emotions ran high as photographers got used to something new.

The 35mm camera gave us a wonderful accessibility. We felt practically invisible on assignment and that brought a greater intimacy to our work. Emphasized in the print media as visual reporters, our new worldwide label was "photojournalist." Our images were strong and demanded good play. Often, they extended across double pages. Life magazine set the standards for impressive display imagery, followed by Look magazine. We were consumed with the excitement of the amazing possibilities open to us with our small-format camera.

The 35mm camera had allowed us to easily record the movement of people and events, candid encounters capturing the impact and drama of life. But the edge we gained was soon to be lost. Television, with its great advantage over the still photographer, began covering news. As photojournalists, we realized that we must improve our still pictures to retain the impact and drama of a moment that can be lost in a moving picture. Capturing that precise story-telling moment in time had never been so important. Sharpening the competitive edge helped form a new breed of photographers. Along with that came a period of frustration and confusion.

In the 1960s, many photojournalists favored an arty approach that at times led to clashes with their editors. The camera equipment of choice consisted of wide-angle and telephoto lenses with nothing in-between. Close-up portraits, often cutting off the tops of heads, and extreme wide-angle shots were in vogue. While these photographers may have been refining their art, their subjects did not always appreciate this distortion. Also, more silhouettes and sunrise-sunset pictures were taken than ever before. While such images are interesting and at times exciting, there is more to photojournalism than making a pretty picture. By the late '60s, photographers were getting back to what our craft is all about: visual communication.

The photojournalist of the 1970s incorporated all the styles and techniques of past decades without sacrificing the central mission. This was the calm after the storm. The field was expanding. Universities offered degrees in photojournalism, which gave us better-educated and -trained professionals. Photography gained recognition in the art world. This truly was the halcyon period in

developing and shaping the potential of our field.

One of the technological innovations I worked hardest for over the years is the use of color photography. People see in color, I reasoned, and so they ought to see color pictures in their newspapers.

In the 1950s, the Free Press made its first attempts to run multicolor color on news pages. At the beginning, we used the 4-by-5 Curtis "One Shot" camera. Loaded with black and white film, it used red, green and blue filters to produce three negatives of the picture. A black and white print was made from each, leading to a three-color printing process using red, yellow and blue inks.

Mid-decade, we started to use Kodacolor negative color film. Registration was a problem because of the imprecision of stereotype plates for the presses. Later, we tried a color process called "Spectacolor." For that, the color pictures had to be pre-printed on newsprint six weeks before publication. We discontinued using "Spectacolor" because the deadlines just weren't compatible with journalism.

During the Sixties, we tried again. In 1966 the Free Press became the first large metropolitan newspaper to use negative color film and make prints to size on type-C color paper. It was a slow process because we were using outside engravers to separate the color print. Eventually, we once again decided it was too slow to incorporate in our regular news coverage.

In the late 1970s, all the right technology came together. The Free Press replaced its old letterpresses with the latest offset presses and systems for more precise color registration. Electronic color separation equipment was available; it could speed up the production time and take some of the guesswork out of the process.

Executive Editor Dave Lawrence was eager to use daily color in the paper and was open to new ideas, so I outlined the advantages of using negative color, instead of transparency film, which was still the standard everywhere even though negative color technology had greatly improved.

We developed a system of making prints to the size they would be on the printed page and then scanning (color separating) an entire page at once. That allowed editors to use as many color photos on the page as they wanted. Furthermore, we could produce the color prints nearly as fast as black and white ones, so we could cover late-breaking news and sports in color.

With the help of Sandy White, graphics editor, and the cooperation of our talented production people, we pioneered this approach among large newspapers. Within a year, we were running multicolor on as many as two dozen news and feature fronts a week. This system brought the Free Press national attention, and subsequently I trained many newspapers in its use. The National Press Photographers Association also asked me to hold workshops on the advantages of this process.

The technology of our field has given us electronic cameras, electronic darkrooms and electronic picture desks. In the 1980s, we have cameras so computerized and motorized that photographers can now devote their skills to creativity, composition and imagination. They aspire to work on "projects" rather than daily assignments, and it is not uncommon for a photojournalist to devote anywhere from one week to one year on a project. Meanwhile, the heightened use of graphics helps strengthen the link between the words and pictures, adding to the job we're trying to do.

There is no question that photography can now stand on its own as the interpreter and recorder of our civilization. Whether the photograph be on film or floppy disk, it will leave to the historians a visual record of our time.

The future promises to be just as exciting.

Tony Spina
March 2, 1988

INTRODUCTION
BY
NEAL SHINE

Editors who deal with news pictures often have difficulty explaining, with any amount of precision, what it is they're looking for in a photograph. Ask them to describe just what kind of picture they want and the most informative response you can possibly hope for will be something like: "I don't know what I'm looking for, but I'll know it when I see it."

On the second or third day of the Detroit Riots, in July 1967, the picture editor of the Detroit Free Press moved several dozen pictures on his desk, rearranging them in small piles. The deadline for the first edition was closing in on him and he was obviously creating priorities in a system that only he understood.

Tony Spina came down from the fourth-floor photo lab and dropped a print, still damp, on the pile nearest the picture editor. The editor looked at it for a minute, and then marked it for the first edition and handed it to a copy boy.

Few words were exchanged in the process because the picture, like so much of Tony Spina's work, spoke for itself.

For reasons difficult to explain, either then or now, the photograph became the one that represented all that was happening in Detroit

Tony Spina (front) in the fourth grade at Detroit's Norvell School. Opposite, Tony Spina on the two-way radio as chief photographer in the days of the Speed Graphic camera.

In North Africa, Chief Photographer's Mate, U.S. Navy

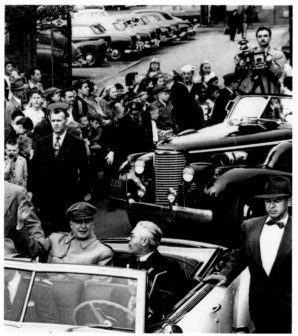

Following General Douglas MacArthur's car on assignment, 1950.

during what the Free Press described at the time as "eight silent days and bullet-broken nights."

It showed a National Guardsman standing in the middle of Detroit's Twelfth Street, bayonetted rifle at his hip, looking anxiously toward the rooftops *(Photo, page 253)*. Behind him, police and civilians watched a single stream of water from a fire hose playing on the burning ruins of a storefront. In the street, where they had been discarded by looters, a broken suitcase, a dresser with its drawers pulled out, and a pile of sofa cushions.

The photograph moved on the national picture wires and ran on the front pages of newspapers around the world. One network news program used a giant reproduction of the picture as the backdrop for its report on the riots. The American Newspaper Publishers Association used it on the cover of its book, "Reporting the Detroit Riot."

One picture that told more about Detroit's pain that week than the thousands of others that had been made. And it was not happenstance.

It typifies the kind of work Tony Spina has done for the Free Press since he joined the newspaper's photographic staff in May 1946.

For more than 40 years, as a photographer, chief photographer and currently chief photographer and special assistant to the managing editor, Spina's camera has captured the images of life in the city, the state, the nation and the

world. History through an eyepiece. The pain and the joy, the sadness and the celebration, caught in an instant and then frozen forever by the camera of Tony Spina.

His subjects have been popes and princes, kings and capitalists, the privileged and the poor. He treats them all with a sensitivity that is a condition not of his camera but of his soul.

This book represents only a portion of what Tony Spina has done. It reflects not only his skill with a camera, but his ability to operate with an emotional capacity and depth of feeling that is a special quality that makes his work equally special.

I remember the first time I accompanied Tony Spina on assignment, and I remember the last time. The first time, in 1955, I was a rookie reporter, in awe of a man whose work was already legendary.

The last time I went on assignment with Spina was in 1985 when we did a story on the closing of the Stroh Brewery. I was senior managing editor of the Free Press and still in awe of the work of this consummate professional.

On our first assignment I helped carry his equipment and felt honored to do so. On our last story together I did the same thing, lugging tripods and lights up and down the stairs of an old brewery.

I felt no less honored in 1985 that I did 30 years earlier.

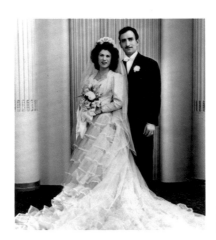

Frances and Tony Spina, married March 2, 1946

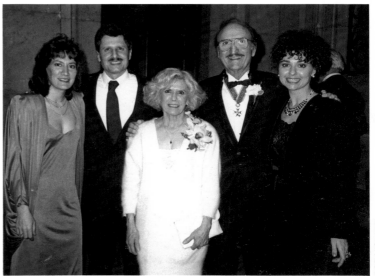

BOB VIGILETTI

The Spina family, 1987, from left: Kathryn Spina Giles, Costan Anthony, Frances, Tony, Julia Spina-Kilar.

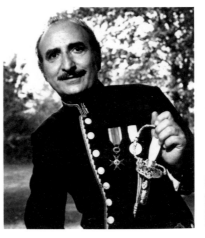

Sir Anthony Spina, Knight of St. Gregory the Great. Knighted by Pope Paul VI, December, 1965.

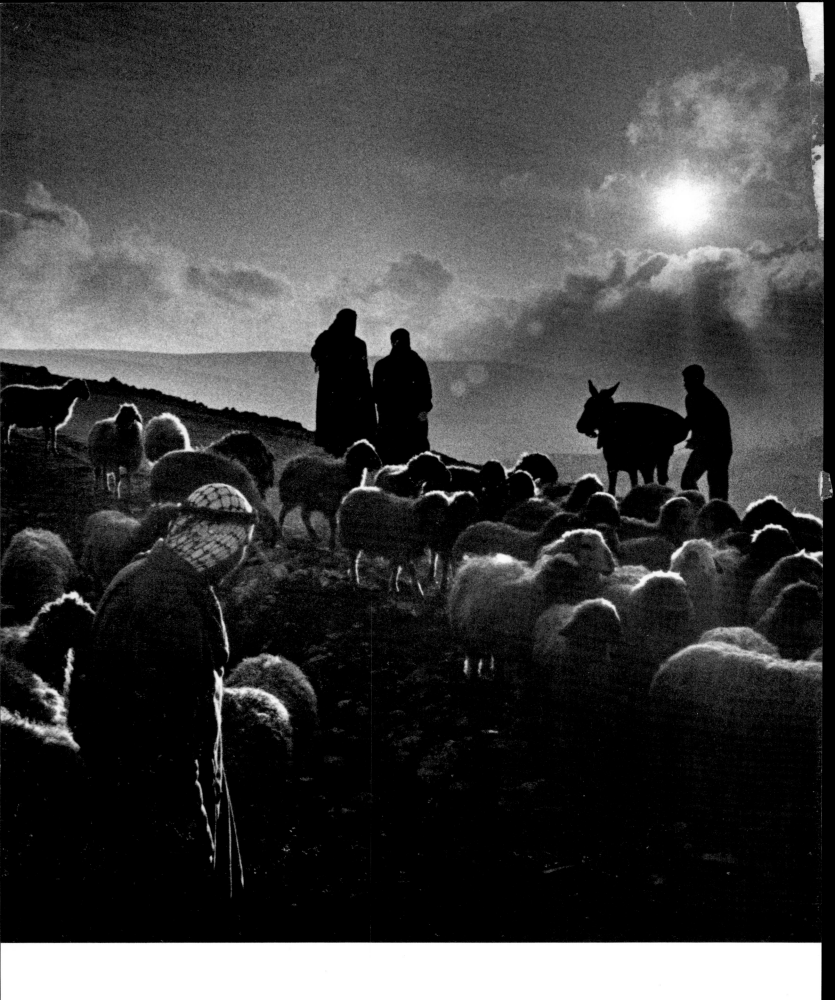

ISRAEL, 1978

**Jesus, known as the keeper of sheep eternally, walked
unrecognized here in Emmaus, seven miles from Jerusalem.**

PASSAGES

Walls, bridges, paths, gateways and other places of meaning

It was a pre-Lenten assignment to photograph places Jesus may have walked.

Archaeologists would say that's impossible since virtually every place he might have been has, in fact, been destroyed and rebuilt any number of times. But the sense that a place is holy or historic or otherwise special stays alive within people's hearts and minds.

This scene outside at Emmaus was particularly timeless and unchanging.

The Book of Luke in the Bible says two of Christ's disciples were passing through Emmaus, sharing their sadness at Jesus' death, when "Jesus himself also drew near and went along with them, but their eyes were held that they should not recognize him." Eventually, he revealed himself to them, proving that he had risen.

Having grown up in a deeply religious family, I was excited about capturing on film some places whose history had become part of my own.

I have had a similar sense of history about some other places you will see on these next pages.

When the shutter clicks, emotions, sometimes unconscious ones, are involved. The photographer's perceptions of people and events shape the decision of what particular moment to record. And in that moment, people in the photos all were doing, thinking and feeling something. Then, in a later moment, the viewer brings his or her perceptions and feelings to the picture. Therein lies the challenge of taking pictures that communicate.

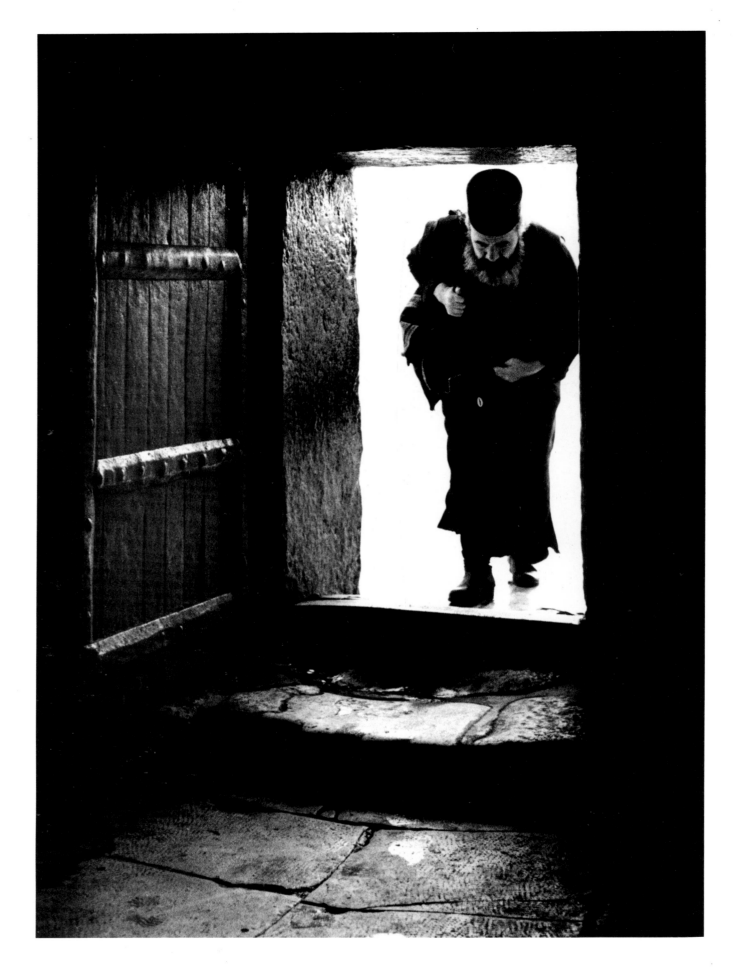

Bethlehem, 1978

When Emperor Constantine built the Church of the Nativity over the birthplace of Christ in the 4th Century, he made the entrance lower than an average person's height so people could not enter the church with their horses. The church has been destroyed and rebuilt several times.

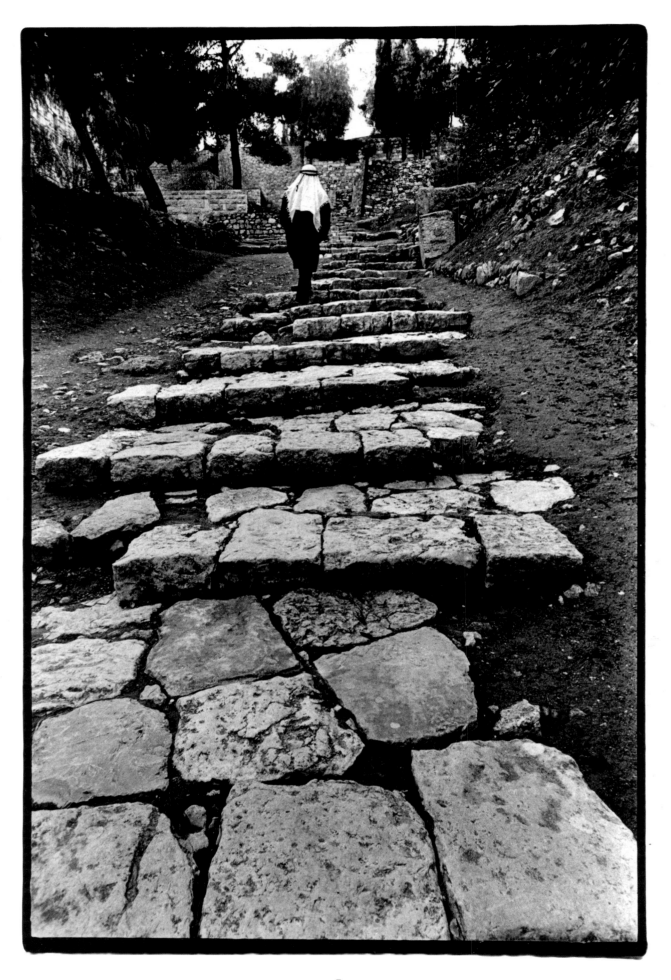

JERUSALEM, 1978

The stairway leading up to Mt. Zion where Jesus and his disciples climbed to go to the Last Supper. This is one of the few places in Jerusalem where a pilgrim can be almost certain of following the steps of Jesus.

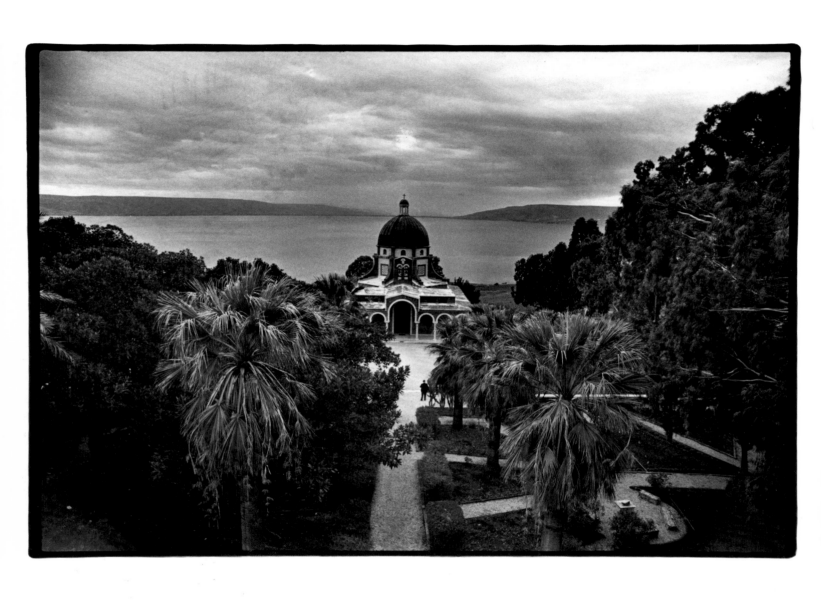

ISRAEL, 1978
The Mount of the Beatitudes overlooking the Sea of Galilee is considered the site of Jesus' Sermon on the Mount. "Blessed are the meek, for they shall inherit the earth . . . "

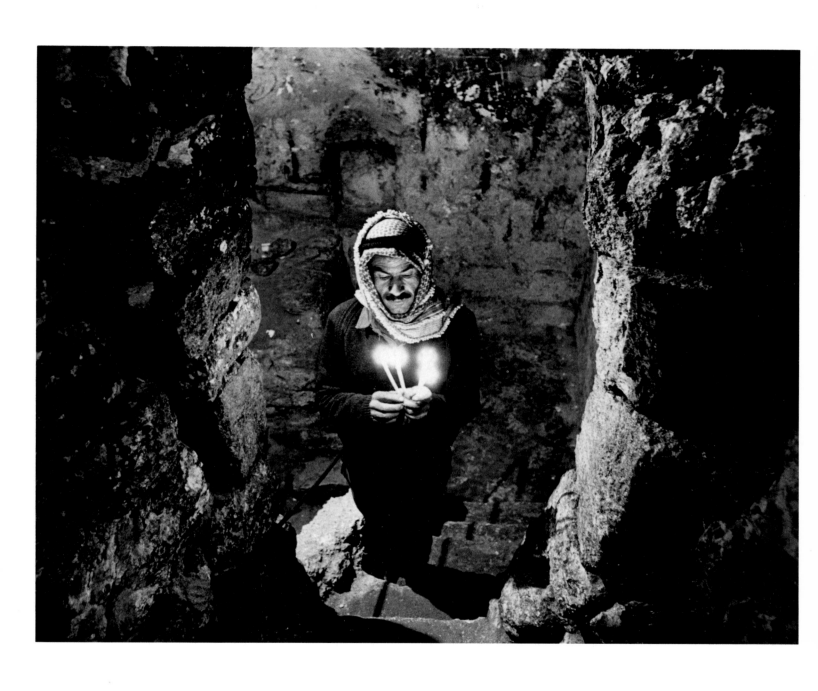

ISRAEL, 1978
The caretaker in the Tomb of Lazarus near Jerusalem.
Lazarus was the brother of two women who knew Jesus. In
weeping over Lazarus' death, Jesus showed a human heart
full of loving compassion, and in raising him to life after he
had been dead for four days, Jesus performed one of his
greatest miracles.

13 □ PASSAGES

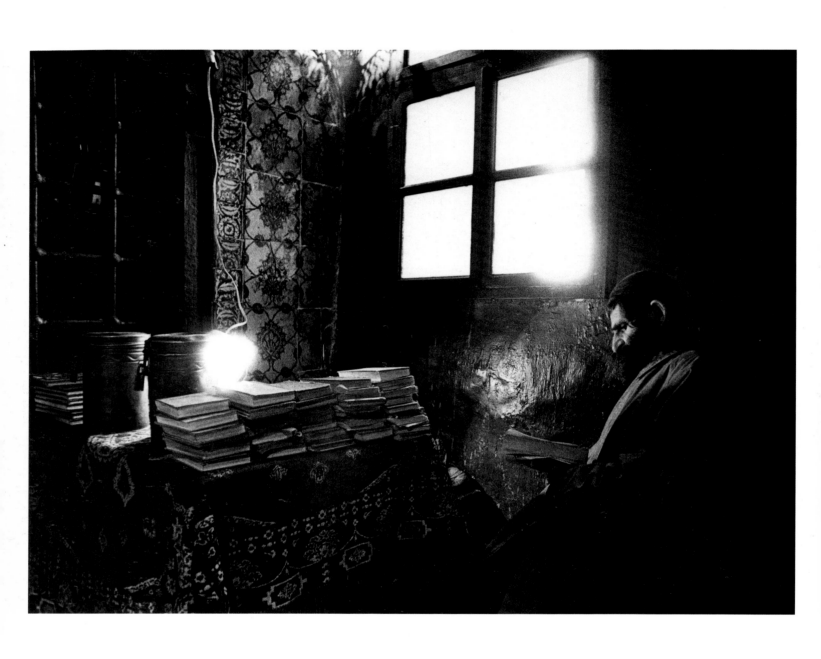

JERUSALEM, 1978
Rabbi seated in the anteroom of King David's tomb in
Jerusalem, where he reads for long hours at a time. It was
silent. I used a range-finder camera, which has a quiet
shutter compared to a single-lens reflex.

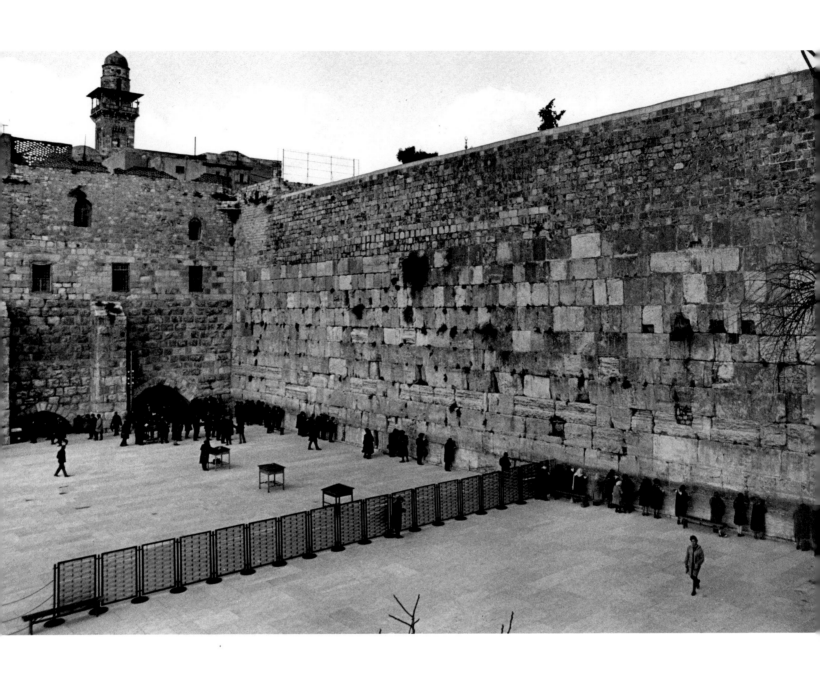

JERUSALEM, 1978

The Western Wall was called the "Wailing Wall" by Jews before Israel's unification of the city of Jerusalem following the Six-Day War in June 1967. It is the only surviving portion of the great Jewish temple that existed before Titus destroyed it in 70 A.D. It is the most revered of Jewish places. Men pray at the left and women at the right. The lower courses of massive stone blocks date back to King Herod's Second Temple. Old houses in front of the wall were pulled down after the Six-Day War, creating the large open square. It is toward these ancient and emotion-laden walls of the temple compound that every synagogue and temple in the world is oriented.

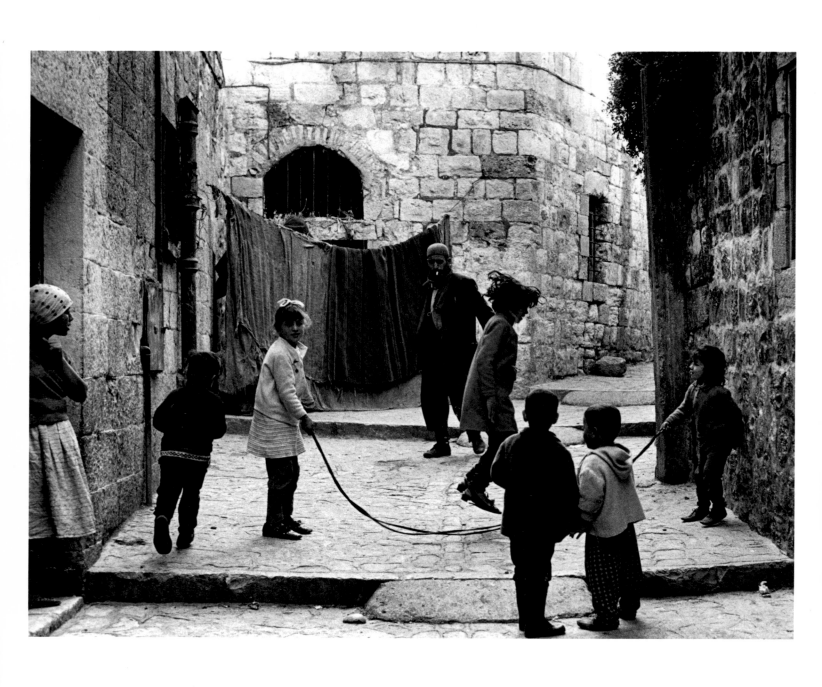

JERUSALEM, 1978
 In Jerusalem, children play in the Via Dolorosa, the narrow
road where Christ walked to Calvary carrying the cross on
which he was to be crucified.

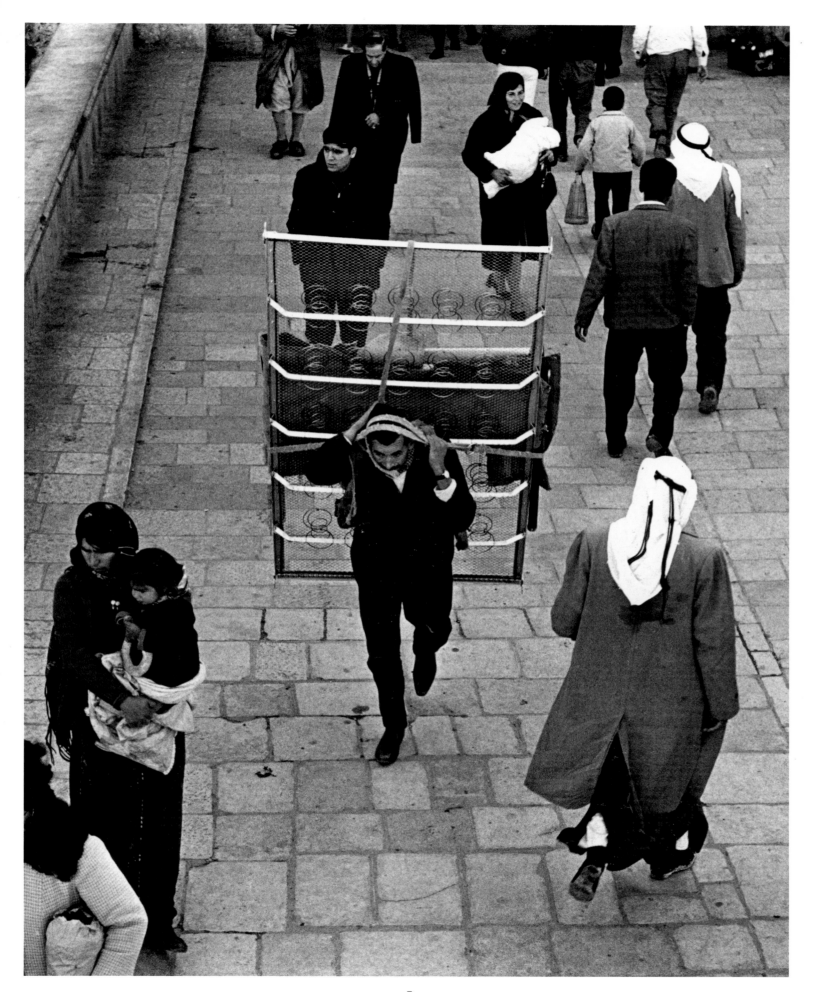

JERUSALEM, 1978
At the Damascus Gate, entering the old walled city of
Jerusalem, a man carries a bedspring on his back because no
vehicles are allowed on the narrow streets.

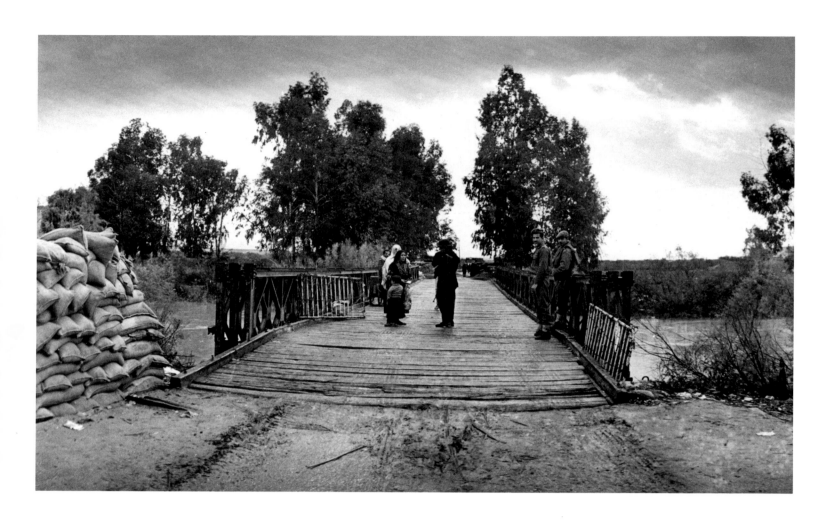

JORDAN, 1978
 The Allenby Bridge, spanning the narrow Jordan River,
 connects Israel and Jordan, but passage back and forth is
 restricted. This was taken from the Jordanian side. The
 soldiers had misgivings about my cameras. The bridge was
 named for the field marshal who directed Britain's Palestine
 campaign during World War I.

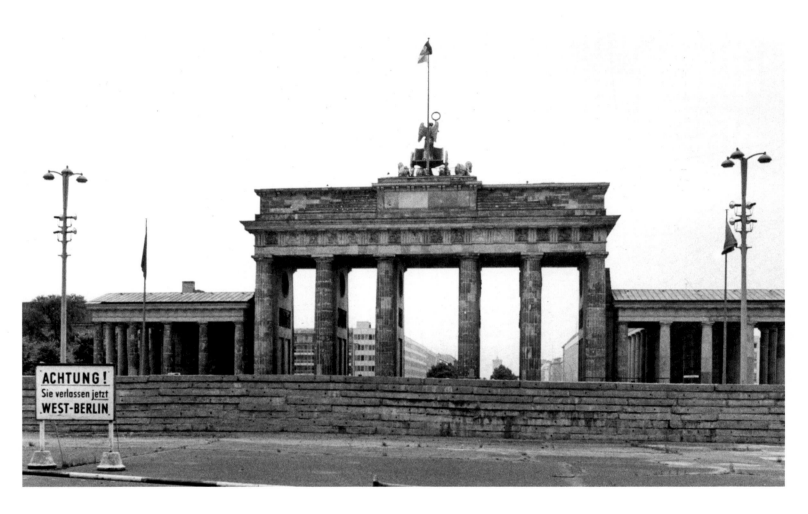

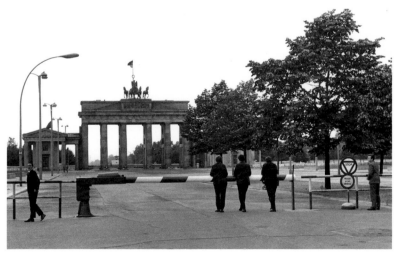

BERLIN, 1972

The Brandenburg Gate, taken from both sides of the border dividing East and West Berlin. The larger photo is taken on the West Berlin side.

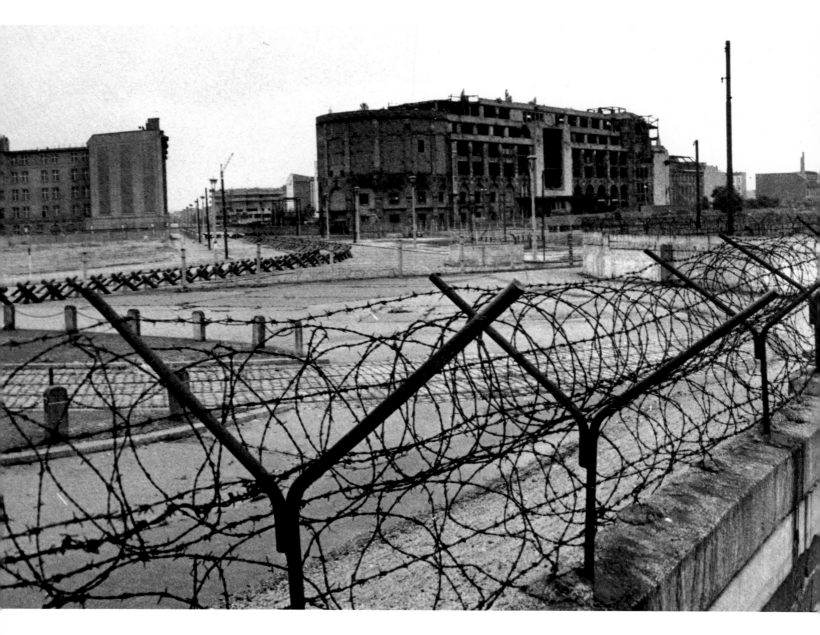

One of the hardest things to realize about West Berlin is that it is situated completely within East Germany.

During the closing days of World War II, the Allies divided Germany into four sectors and did likewise with Berlin, even though the German capital was located within the sector to be controlled by Russia.

The U.S., British and French sectors of Berlin were united and grew in prosperity, in contrast to the Soviet sector. Throughout the '50s, the Kremlin became increasingly disturbed about the numbers of bright and talented people it was losing to the West through West Berlin. That and the continuing inability of world powers to come to agreement about the future of

BERLIN, 1972

A section of the wall with barbed wire entanglements. East Berlin is on the left and West Berlin on the right.

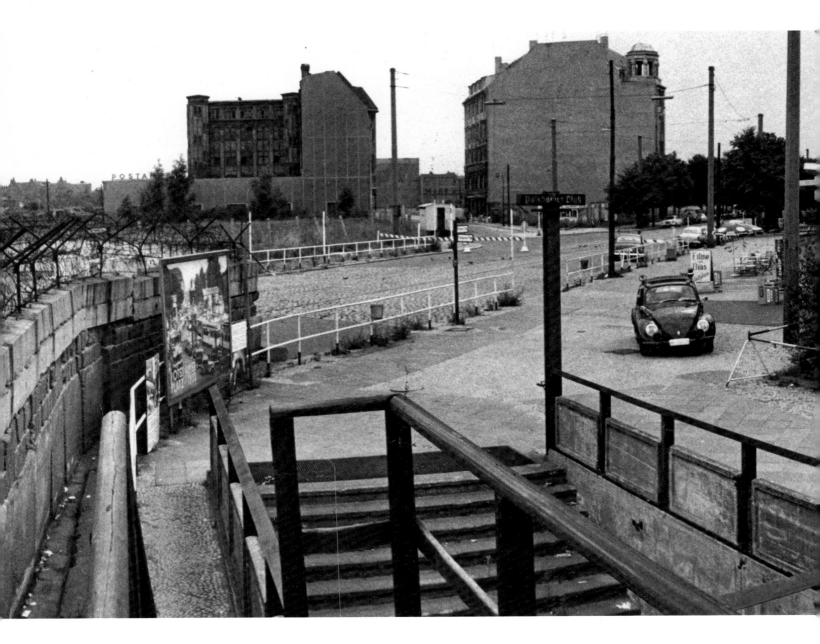

Germany and about other Cold War-era issues came to a head in the summer of 1961. In response to a Soviet threat, President Kennedy asked for and got Congress' permission to call up 250,000 reservists and strengthen the nation's defenses.

The Soviet response, in August 1961, was to begin building the Berlin Wall. It added a physical reality to the gulf between East and West.

The wall was built to no standard specifications. In some areas it consists of built-up slabs of ugly gray concrete, topped with barbed wire entanglements and cut glass, while in other areas the wall is just barbed wire fence and bricked-up buildings.

Along East Berlin's side of the wall is the so-called death strip — a wide sandy area for footprint detection, secondary

barriers of barbed wire and a series of wires along which dogs run, watched by guards in observation towers.

As the wall was erected, hundreds of East Berliners tried to escape to freedom, and many died in the attempt. As I looked at the wall in the early '70s, my mind was filled with stories of those brave people who wanted so much what so many people in my country take for granted.

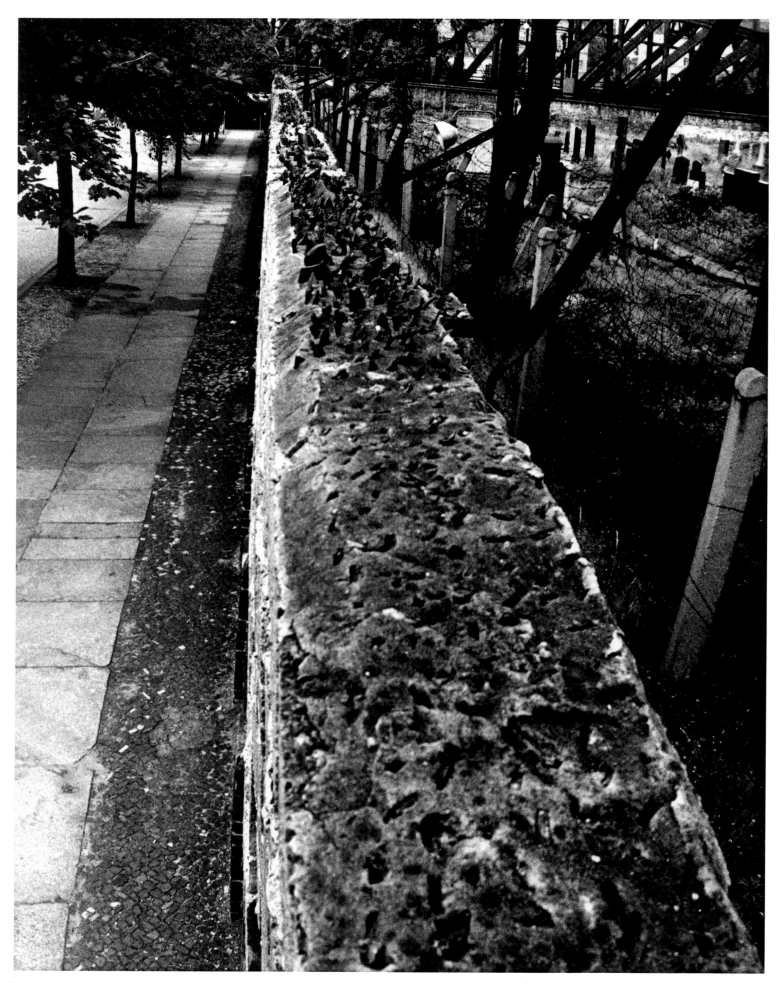

BERLIN, 1972

The wall is topped with cut glass (above); West Berlin is on
the left. Buildings in East Berlin (right) rise beyond a section
of fortifications next to the wall.

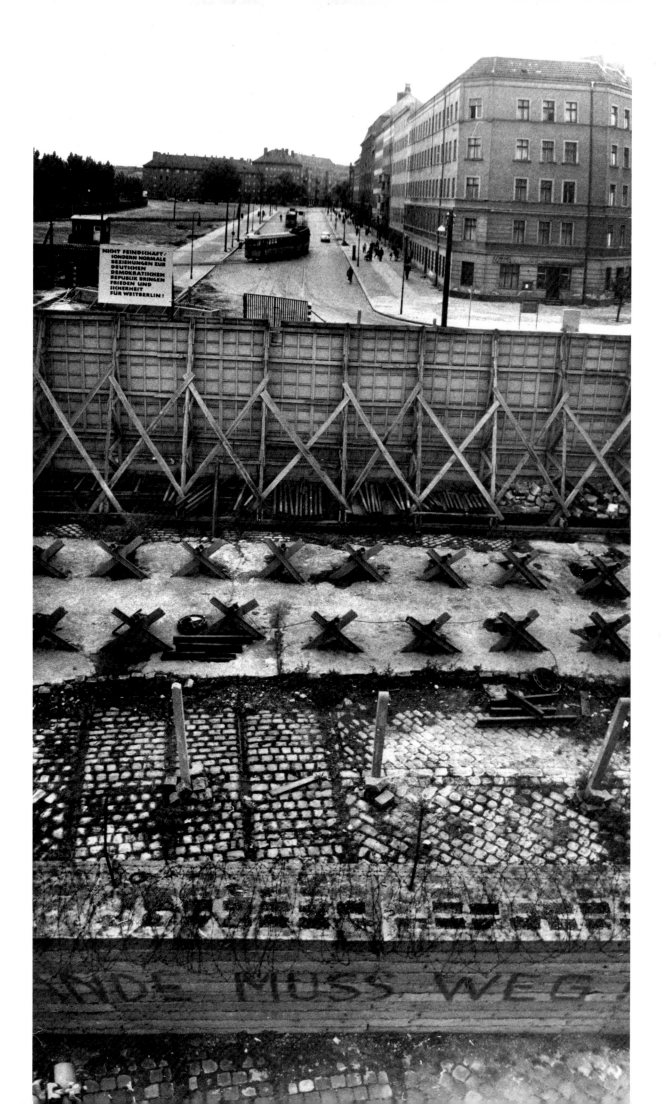

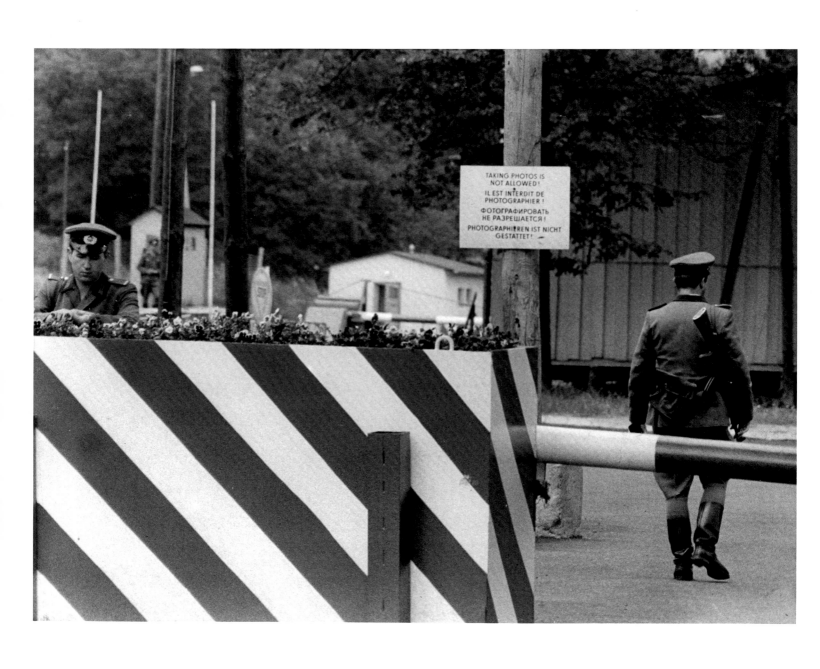

BERLIN, 1972
Pictures are forbidden in this sector, according to the sign.

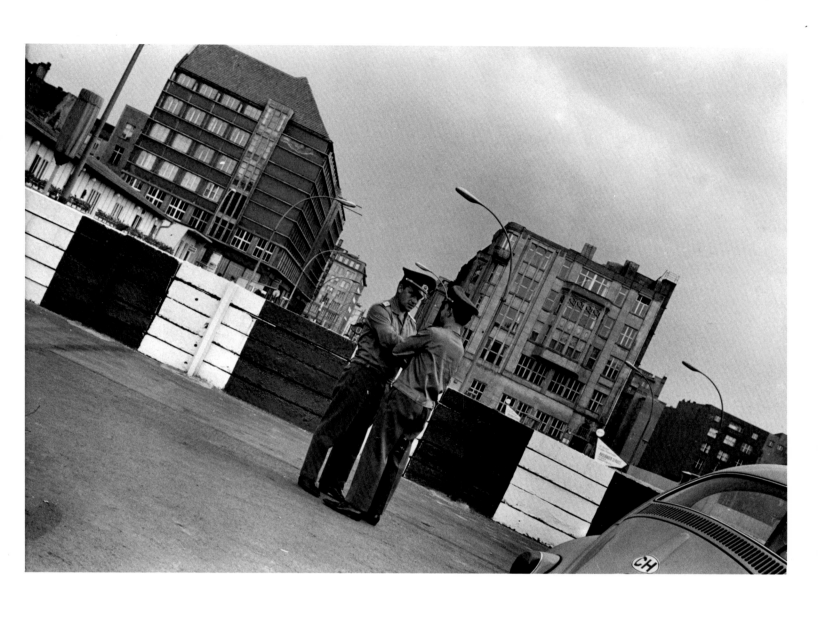

BERLIN, 1972
This was at Checkpoint Charlie, the nickname for the entrance to East Berlin from the U.S. sector. I unobtrusively recorded this scene of two East German guards on the other side.

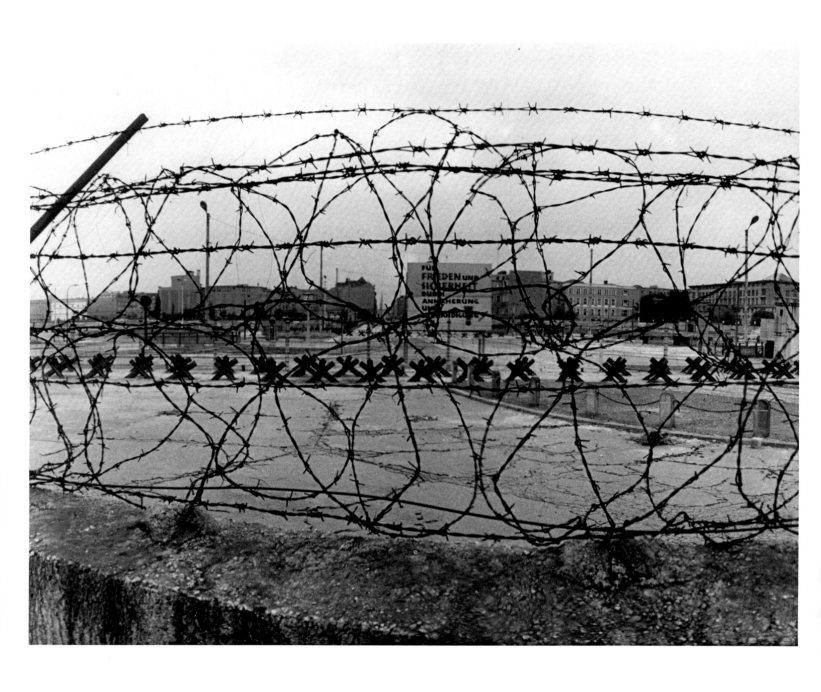

BERLIN, 1972
East Berlin as seen through the barbed wire above the wall.

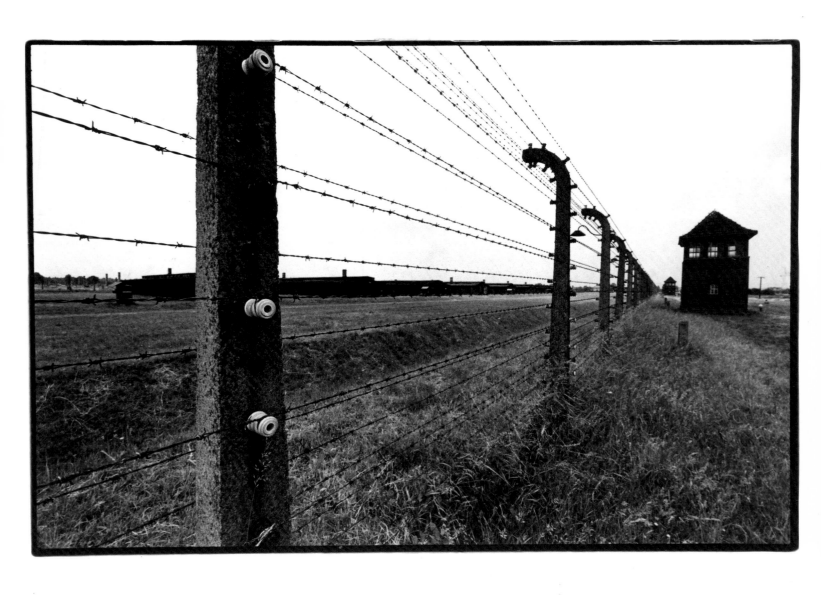

Auschwitz, 1983

This is another place where barbed wire evokes a feeling of helplessness and foreboding. Furthermore, the fence was electrified. There is no forgetting, even after four decades, the terrible atrocities that happened at the infamous Nazi concentration camp in Poland, not far from Krakow.

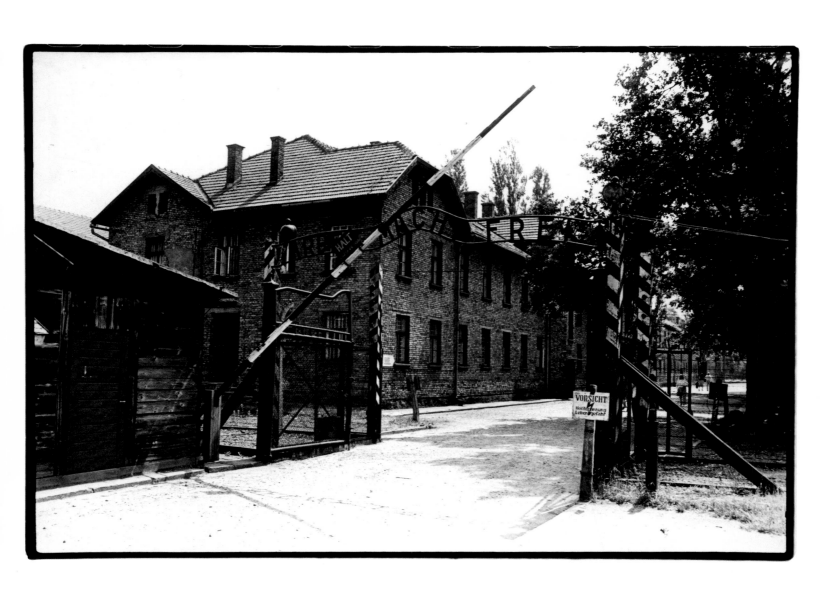

Auschwitz, 1983

**The entrance gate to Auschwitz. Between 1940 and 1945,
when Russian soldiers liberated the camp, an estimated
three million people perished here.**

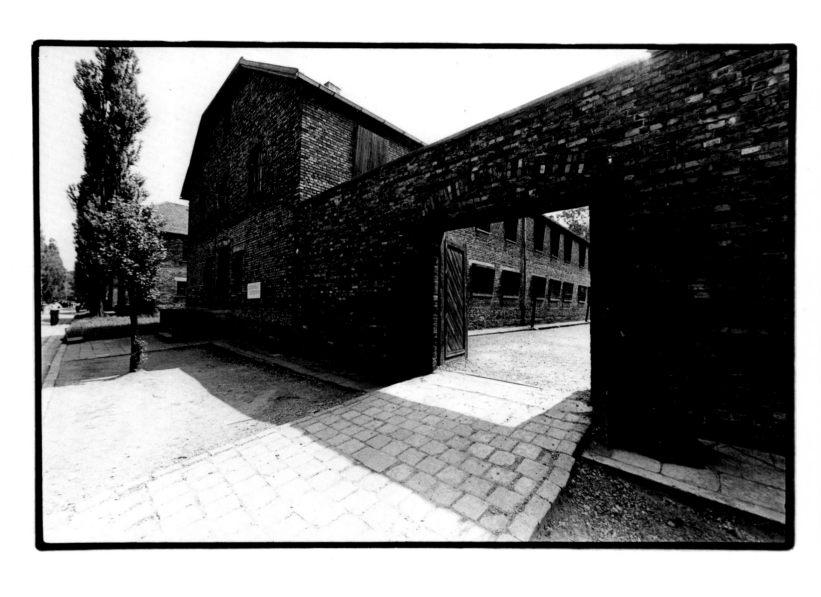

AUSCHWITZ, 1983
This gate led to the gas chambers.

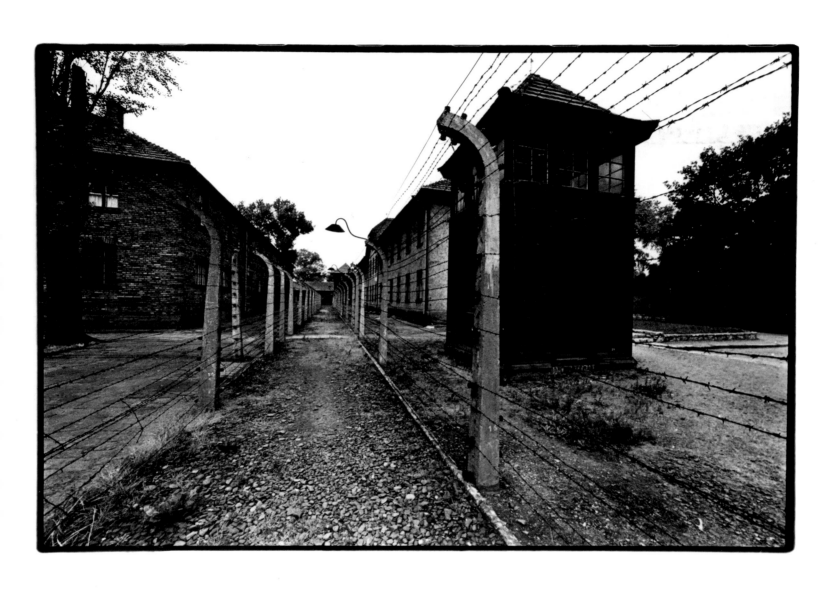

AUSCHWITZ, 1983
The electrified fences between barracks.

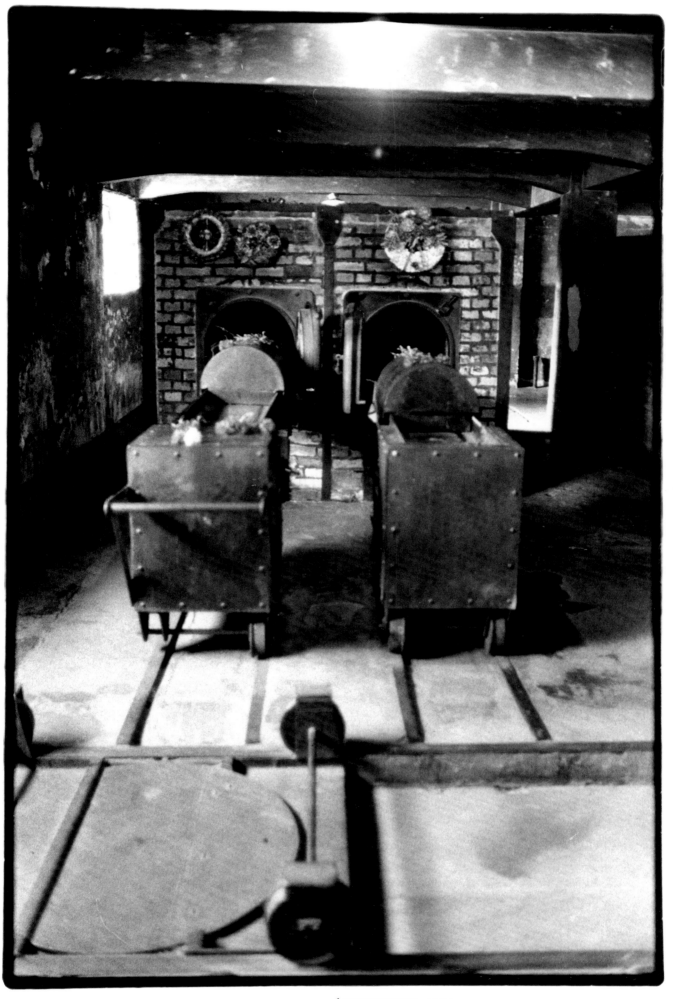

AUSCHWITZ, 1983
The bodies of the dead were placed on these carts and
wheeled into the crematorium.

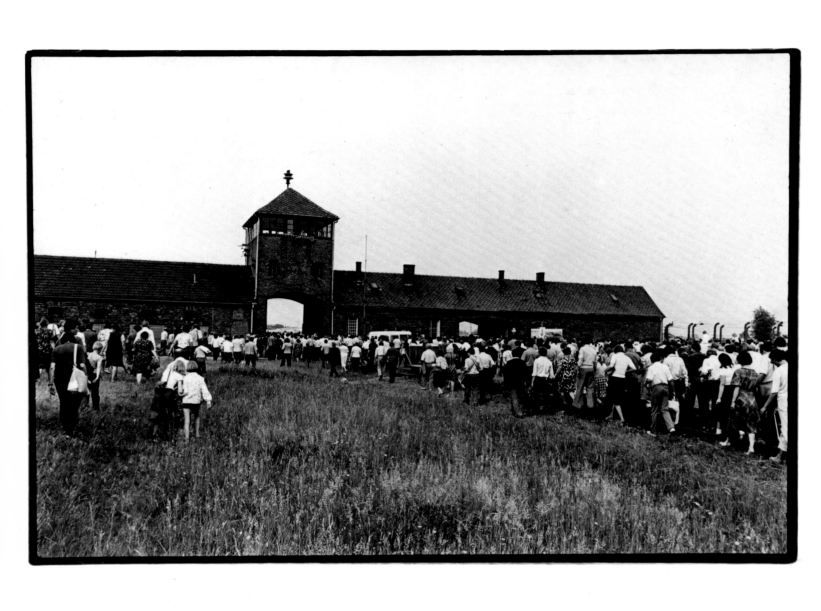

AUSCHWITZ, 1983
 **Polish sightseers walk along the track that once brought rail
 cars full of prisoners into Auschwitz.**

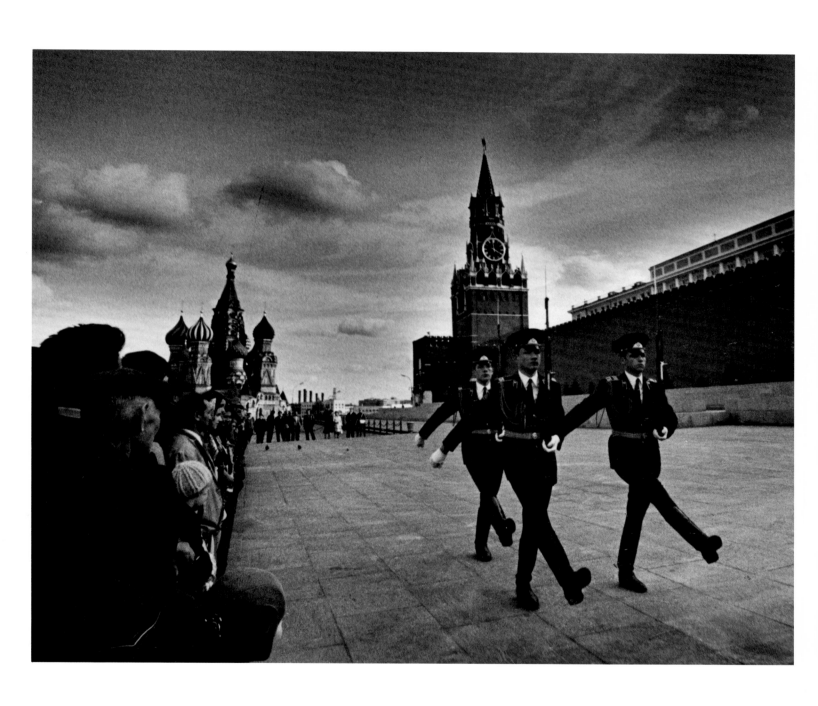

MOSCOW, 1982
Changing of the guard in Red Square. Left is St. Basil's and
on the right is the Kremlin. Though the Russians were our
allies then, no one who lived through World War II can see
this without thinking of goose-stepping Nazi soldiers.

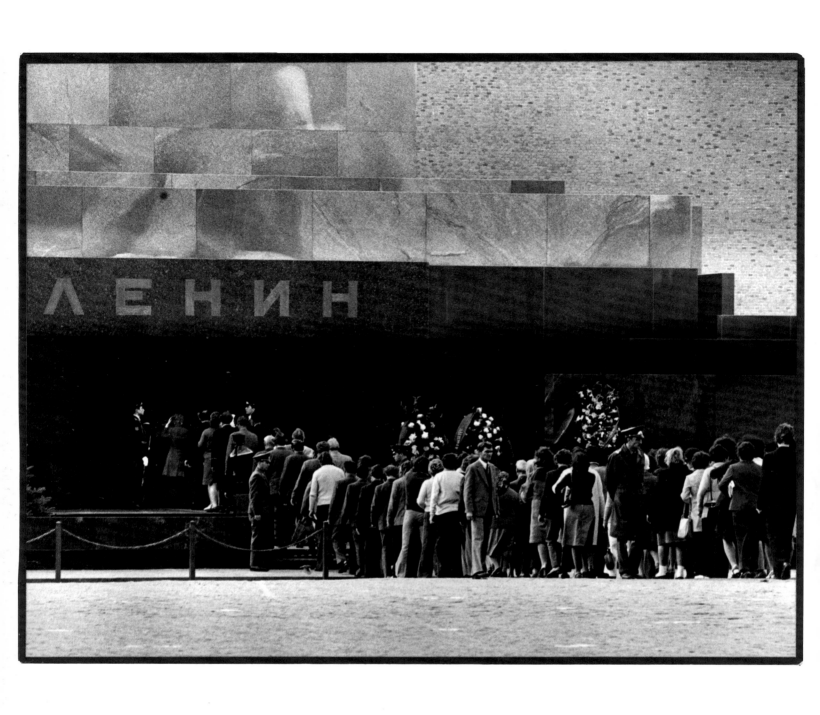

MOSCOW, 1982

Security guards and the KGB, the Soviet secret police, keep a watchful eye on people entering Lenin's tomb. Visitors cannot have their hands in their pockets and must check any packages.

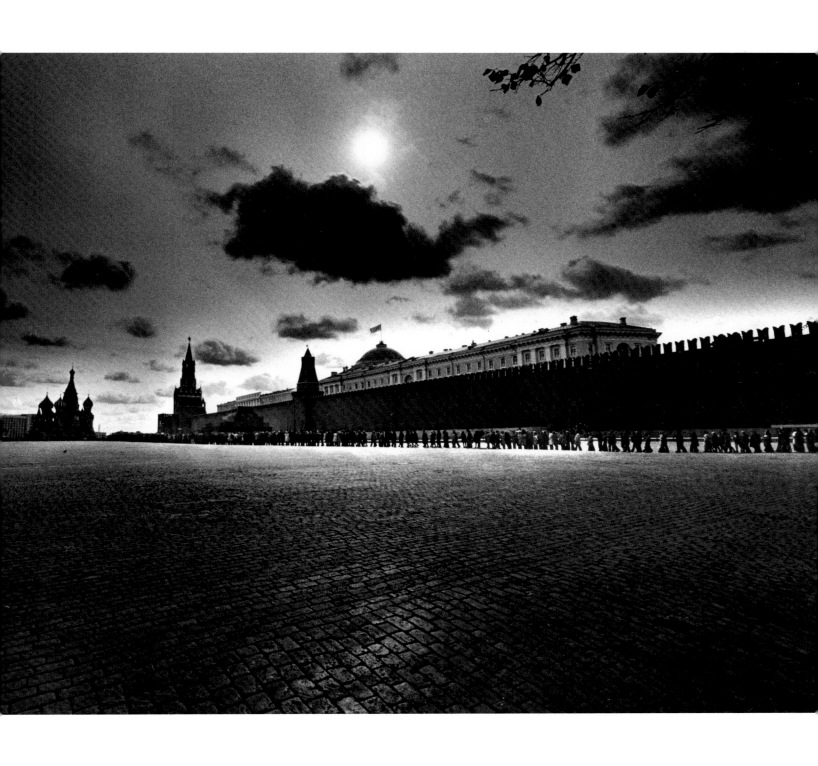

MOSCOW, 1982
I was given special permission to stand in the middle of Red
Square and get this picture of the long line of people waiting
patiently along the Kremlin wall to visit Lenin's Tomb. Lenin
died in 1924, but his preserved body is on display.

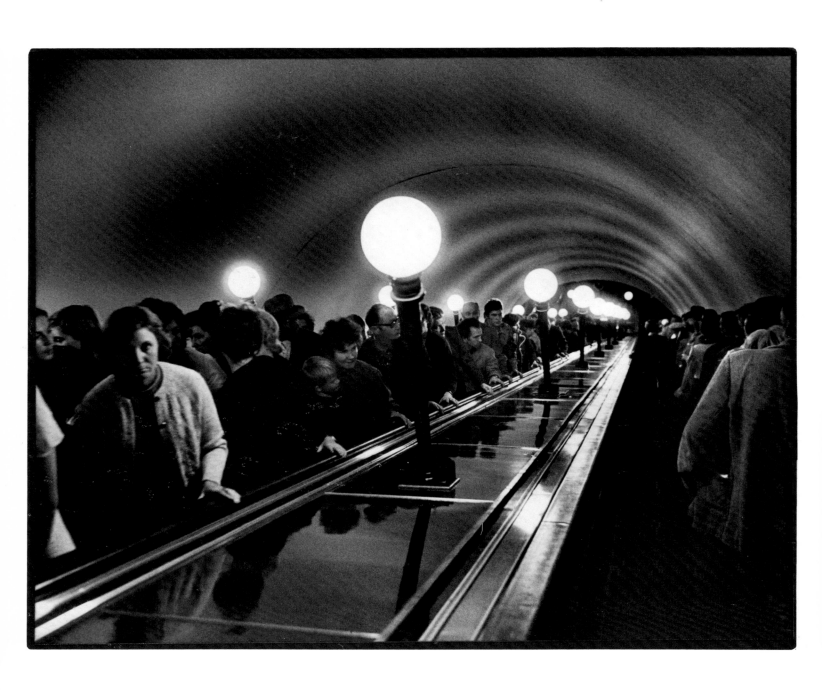

LENINGRAD, 1982
 The subway here is clean, and with no graffiti. During my
visit to Russia, I blocked out the grim images and labels of the
Cold War, and approached the country with an open mind. I
found a considerable beauty, particularly in elegant
Leningrad.

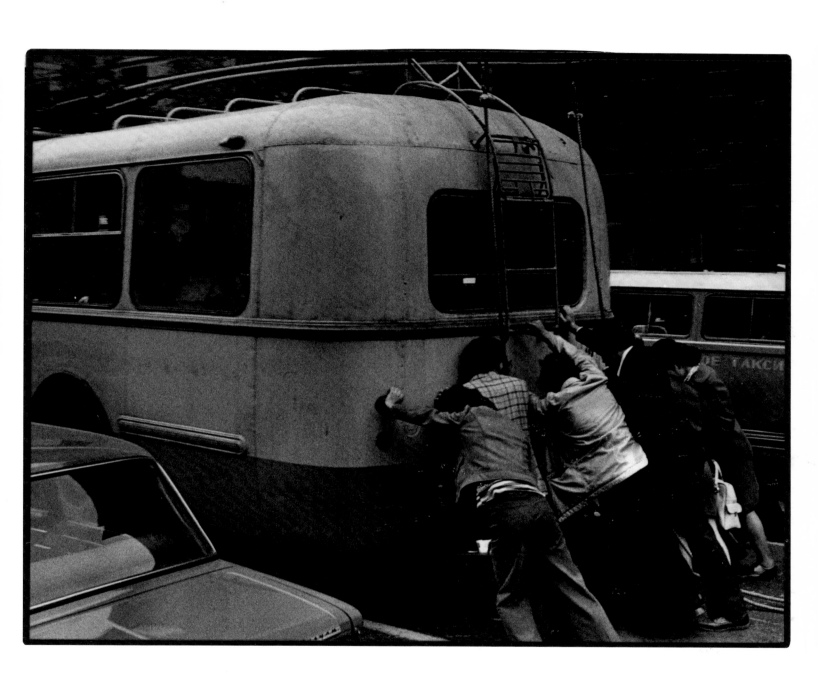

MOSCOW, 1982

On the other hand, for such a vast country, some systems are not reliable. When this trolley couldn't make it over a small hill, some of the passengers got out and helped.

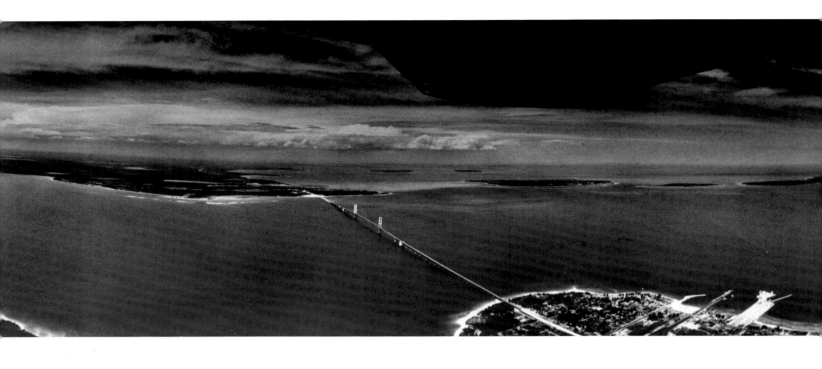

MACKINAW CITY, 1958
 **The Mackinac Bridge spans the four-mile-wide Mackinac
Straits, connecting Michigan's upper and lower peninsulas.
The picture, which looks north, shows an area 30 miles wide
and 60 miles deep. This was taken the day the world's largest
suspension bridge was opened. To cut through the haze, I
used film sensitive to infrared light.**

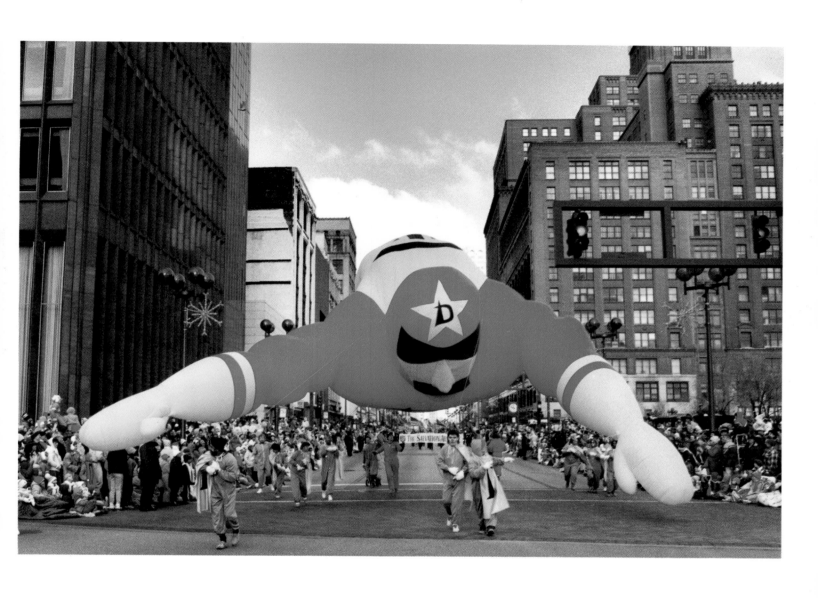

DETROIT, 1987

The 61st annual Michigan Thanksgiving Day Parade
attracted 700,000. The huge balloon, Captain Detroit, floats
down Woodward Avenue past Kennedy Square in Detroit. I
photographed the parade for the Free Press since 1946. It
just wouldn't be a Thanksgiving Day for me without covering
the parade.

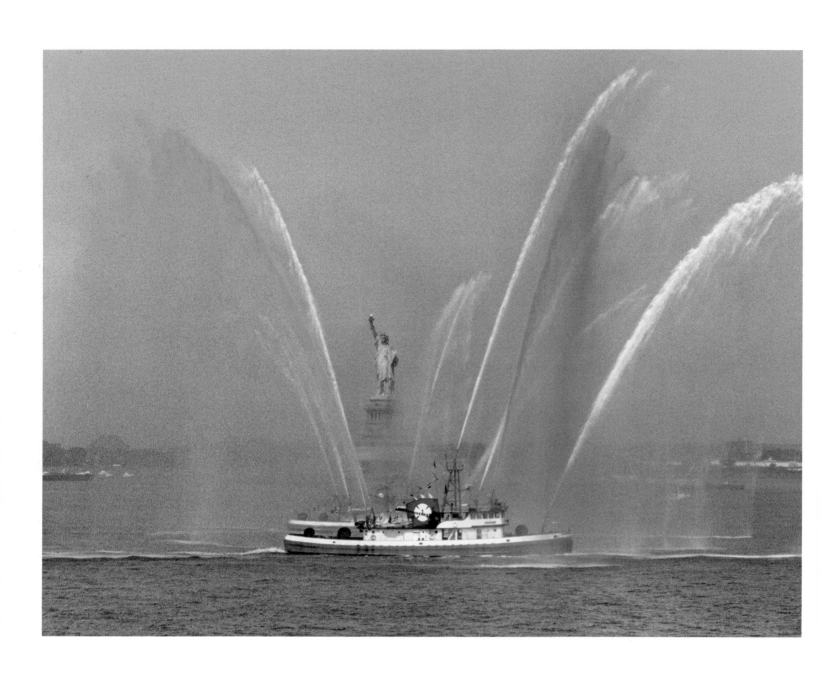

NEW YORK CITY, 1986
Fireboats in New York Harbor shoot multicolored streams of water as it passed by the Statue of Liberty. This occurred at the start of the parade of the tall ships. I was standing on the tip of Governors Island.

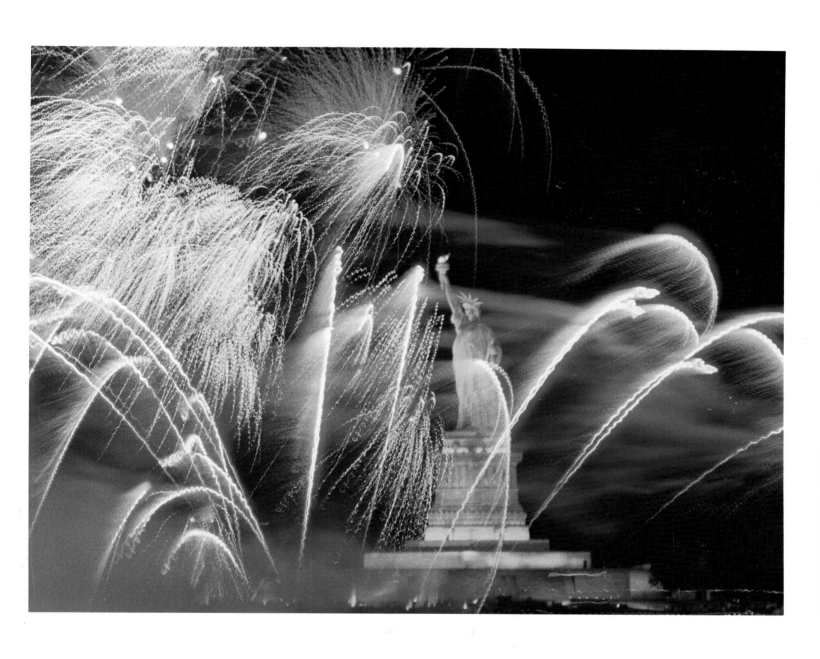

NEW YORK CITY, 1986
The rockets' red glare surrounds our Statue of Liberty in New York Harbor, on the eve of July 4, her 100th birthday. President Reagan pressed the button that lighted the statue and started the fireworks.

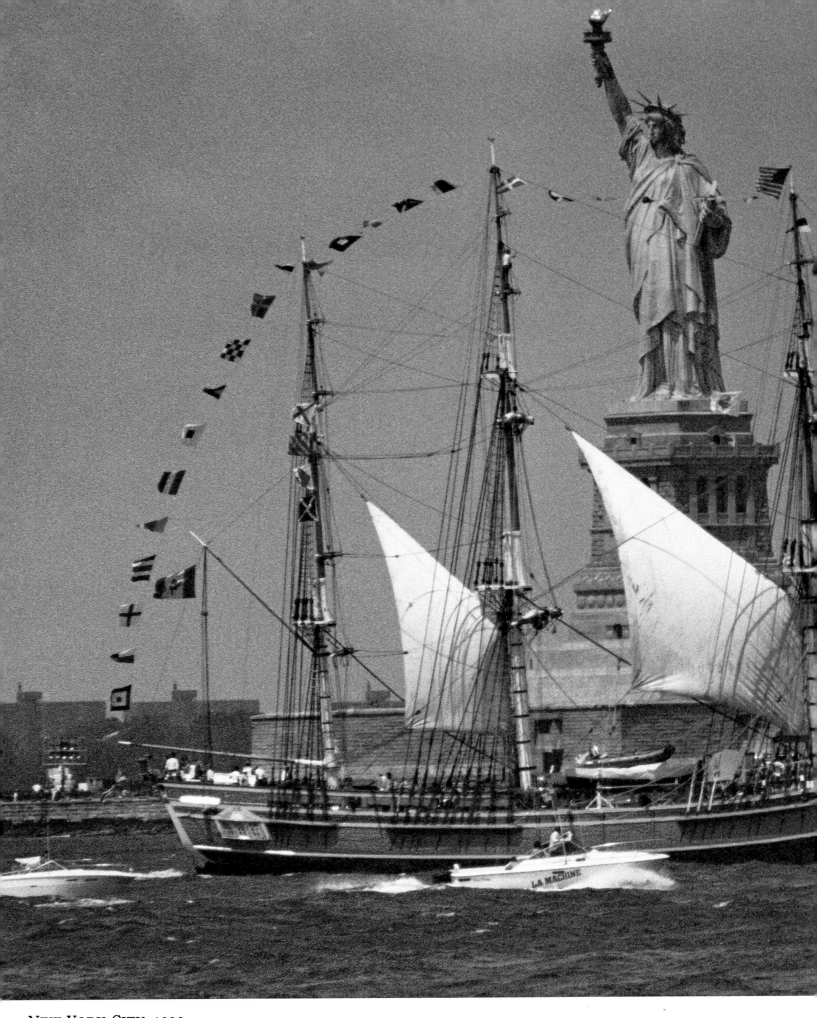

NEW YORK CITY, 1986

The Bounty, one of the tall ships participating in the 100th birthday celebration, sails past the Statue of Liberty.

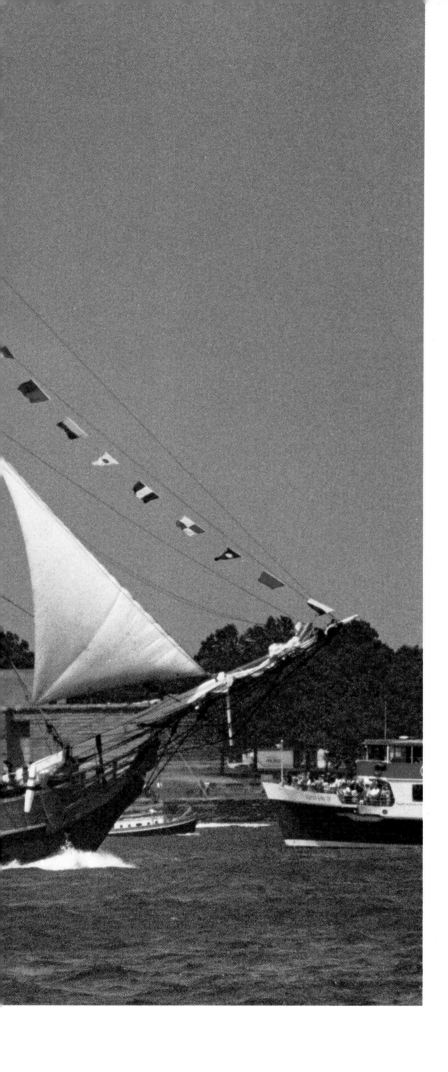

This is one of the most famous passages of all — the passage through New York Harbor from the Atlantic Ocean, past this great lady who symbolizes a land of freedom and opportunity.

The Statue of Liberty was a gift of the French in 1886. My parents saw it when they arrived from Italy at the turn of the century. And on its 100th anniversary, I was among the "huddled masses" of journalists crowded onto Governors Island, competing for the best vantage point for the biggest, showiest four-day birthday celebration I ever witnessed.

The 151-foot statue had undergone a three-year, $66 million restoration. On the eve of the Fourth of July, an estimated one and a half billion people were watching in person or on worldwide television as President Ronald Reagan flipped the switch lighting Lady Liberty's 15-foot torch.

The President expressed the hope that her torch will always be lit.

Watching her through my camera lens, I had the same thought.

PEOPLE

When photojournalists go into a place, we see a lot more of the surroundings than other people. Most of all, we see the light. That's the only thing that makes pictures.

When you're trying to capture a person on film, you create this mental image of the person and scene and the reason he or she is being photographed, and you know where you need to move to get the light.

Pictures do reveal a lot about a person. You are dealing with people, and they're human. If a famous person rubs his eyes or scratches his nose, my camera isn't going to be among those clicking like mad.

I have always preferred to show the good side of people, not the bad side. Most people in life are mostly good. In the long run, you do an honest job of reporting when your pictures reflect that.

MAYOR COLEMAN YOUNG, 1985
From the roof of the Riverfront apartments, the city of Detroit is a panorama behind its mayor. I wanted a casual picture of him. He said, "For Tony Spina, I'll come down there."

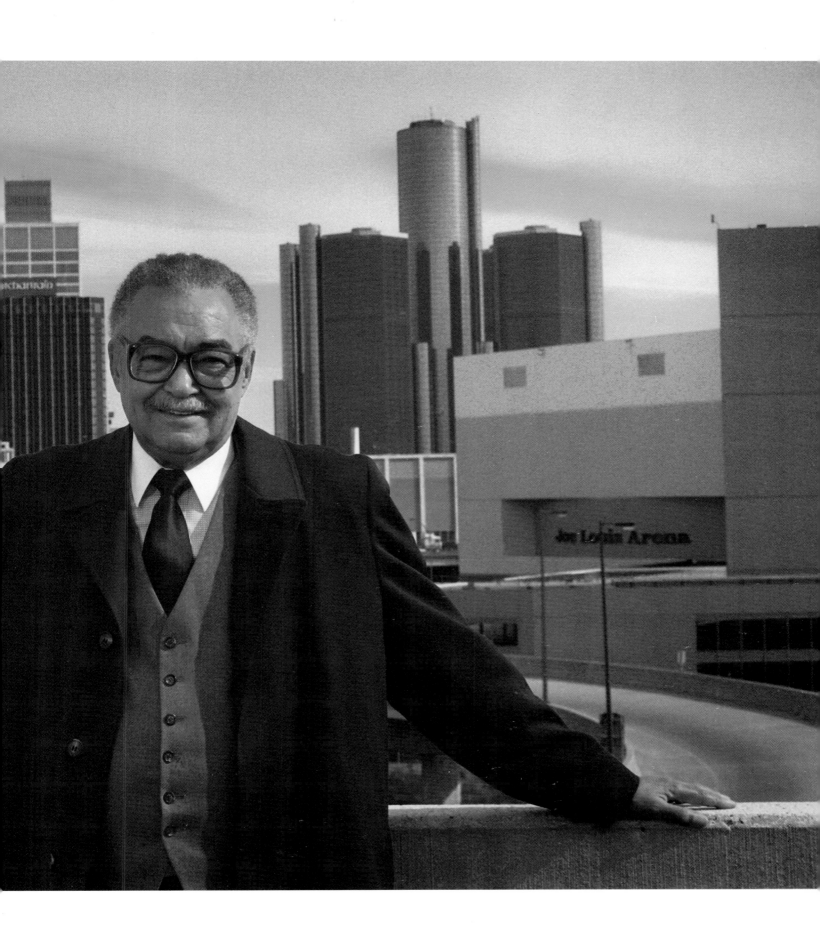

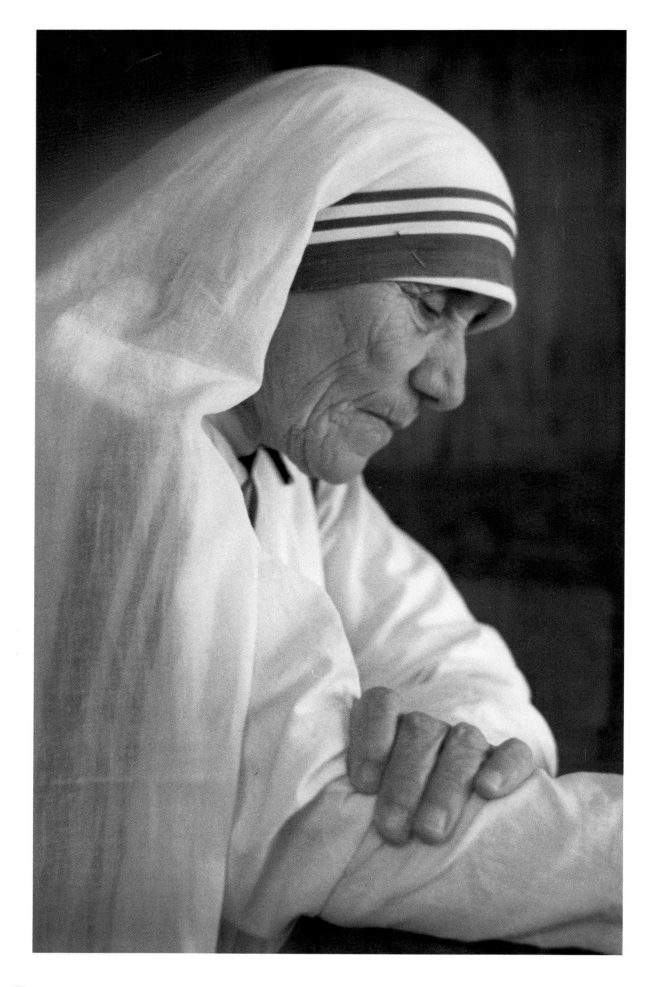

MOTHER TERESA, 1979
 Her order, the Missionaries of Charity, opened a convent to
 serve people in one of the poorest areas of Detroit. I went over
 there to get a picture, and she was meditating, thinking.
 Later that year, she won the Nobel Peace Prize.

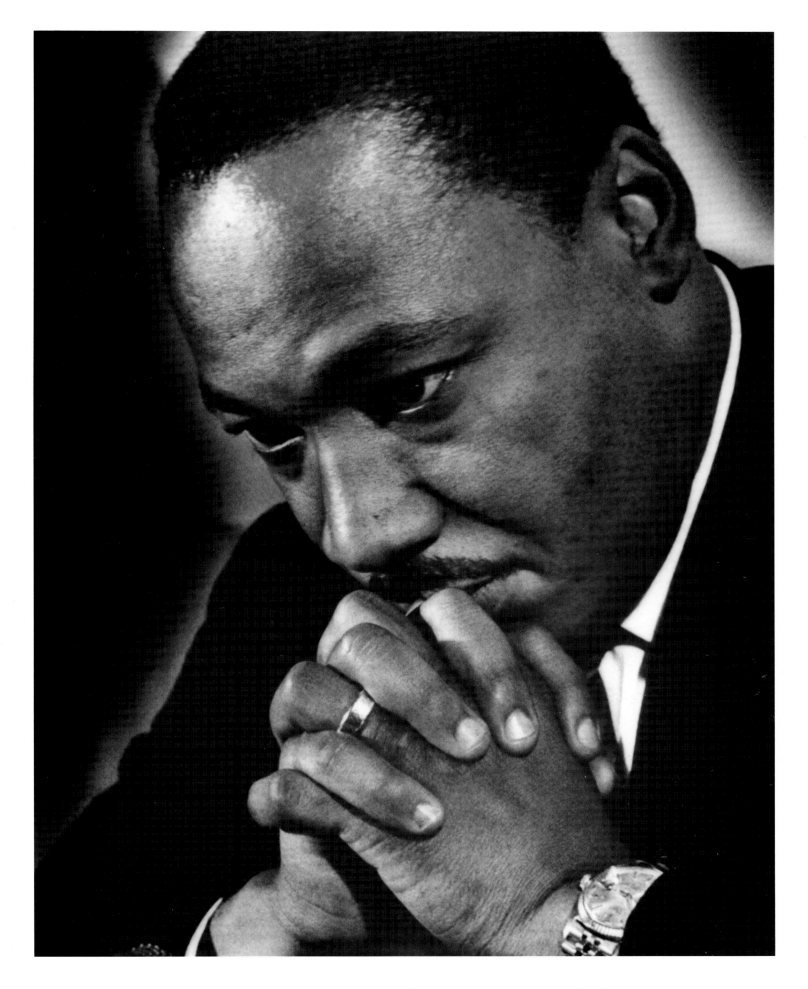

REV. MARTIN LUTHER KING, 1968

The civil rights champion was in Detroit two weeks before he was assassinated. They were demonstrating outside Grosse Pointe High School, where he was going to give a speech. He took time for a moment of prayer.

47 □ PEOPLE

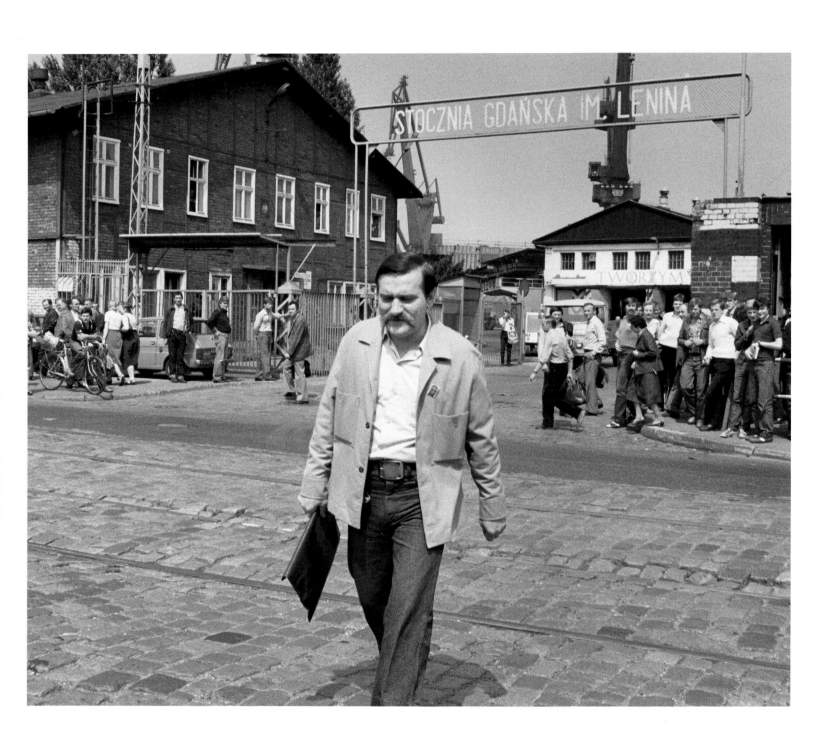

LECH WALESA, 1983

I wanted to get a picture as the leader and founder of
Solidarity, Poland's outlawed labor organization, left the
shipyard in Gdansk at 2 o'clock, the end of his shift. He had to
come to his van, so I positioned myself there, where he would
be in the foreground as he walked from the gates. I had to be
unobtrusive, because the authorities didn't want us there.

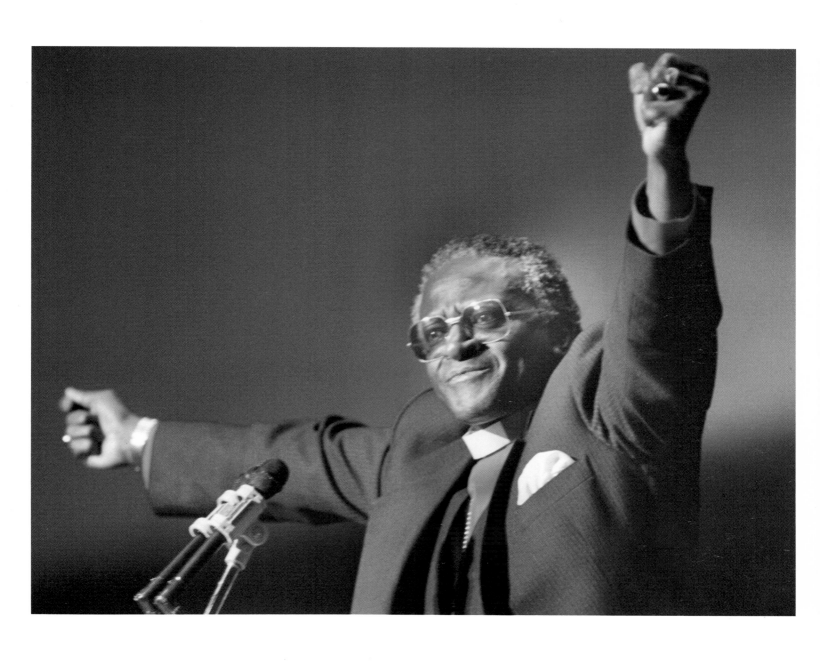

REV. DESMOND TUTU, 1986
The Anglican bishop had come from South Africa to Cobo
Arena, looking for support in his fight against apartheid.

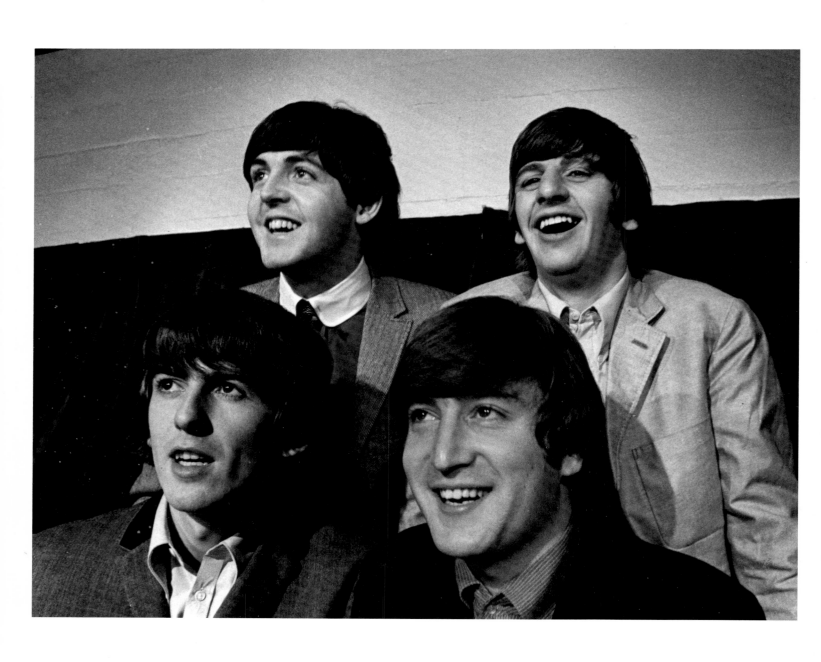

The Beatles, 1964

George Harrison, Paul McCartney, John Lennon and Ringo Starr were on their first American tour. Everyone wanted a picture. The general manager at Olympia told me, "Come on in, I'll get them together for you."

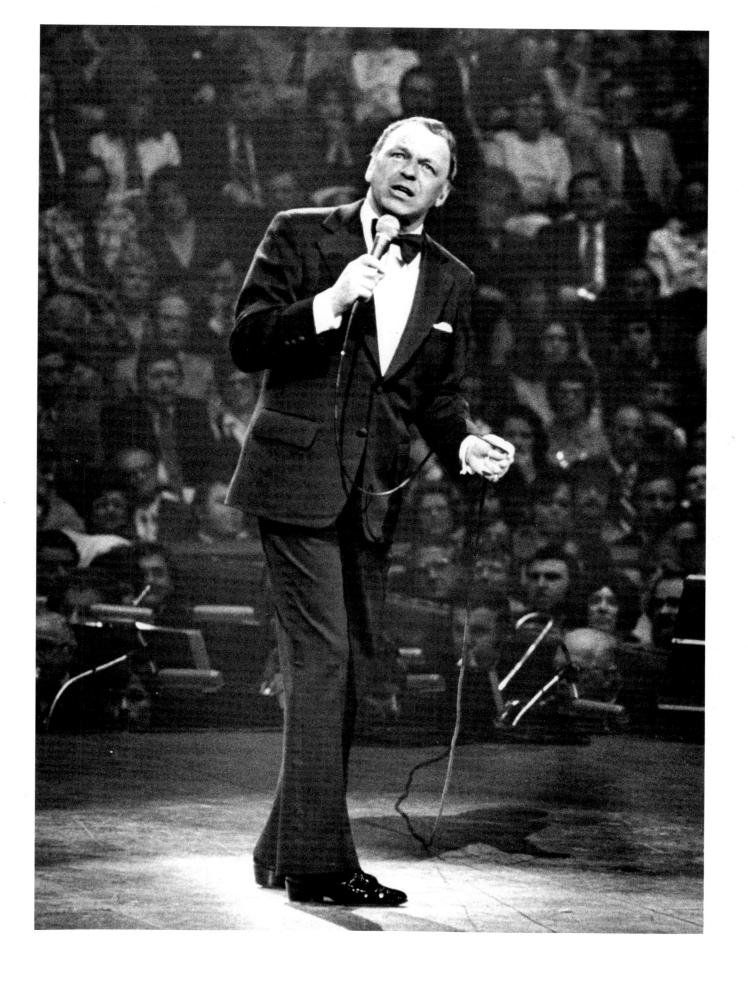

FRANK SINATRA, 1974
More than 16,500 people filled Olympia for his performance
in the round. He didn't want anybody to take a picture while
he was singing, but I was up there in front.

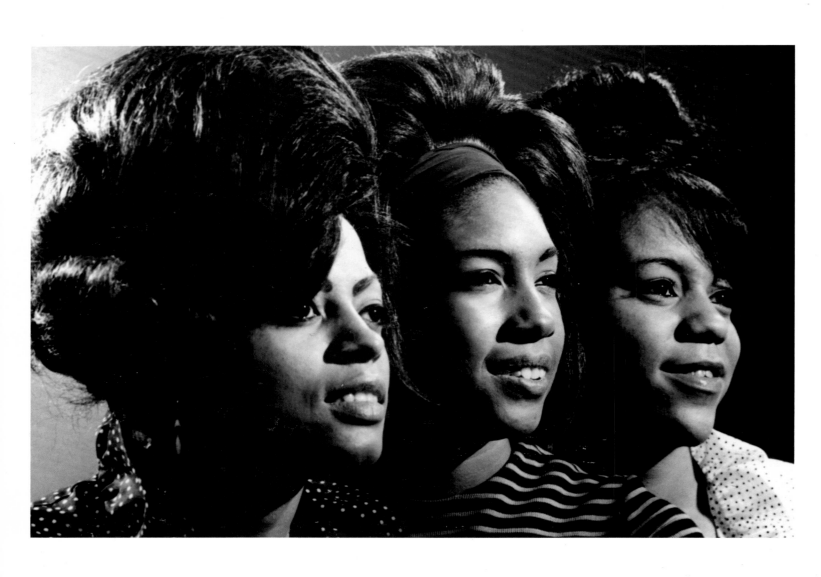

THE SUPREMES, 1968

From left, Diana Ross, Mary Wilson, Florence Ballard. The Supremes came down to the Free Press studio and posed for me. They sang a song for me while they were here, and later they used this picture on one of their albums.

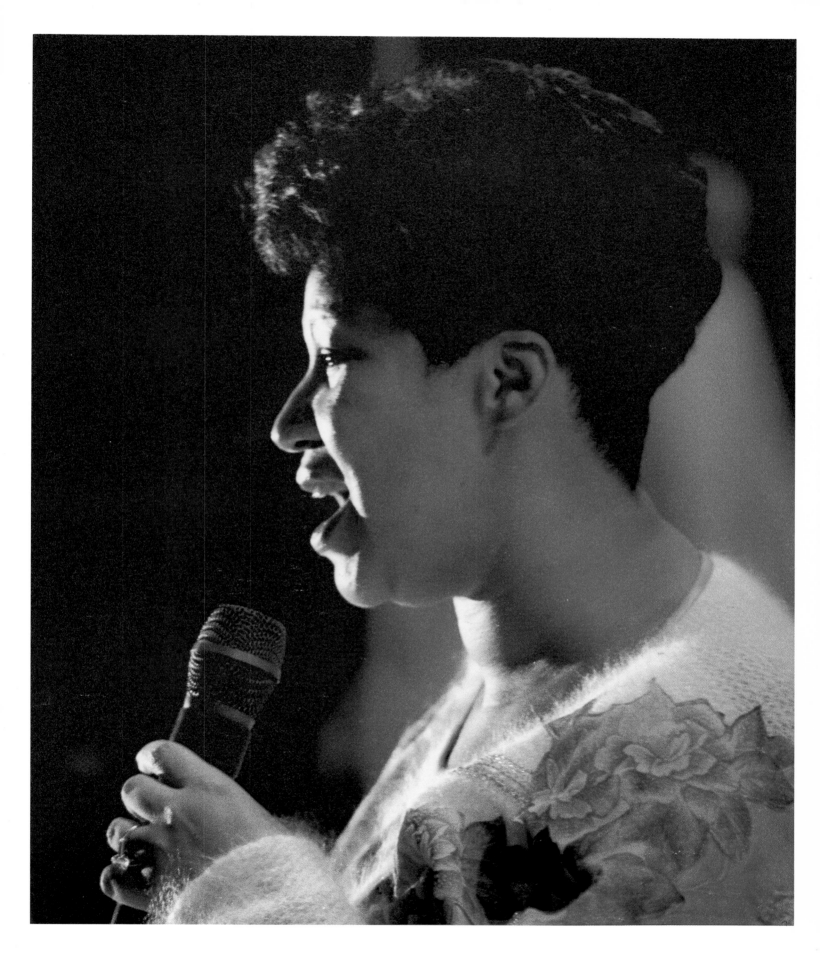

ARETHA FRANKLIN, 1987

She invited me up to the stage at Music Hall while she was making a TV special. I wanted to get her in profile, because you don't see that view so often. I first photographed her maybe 20 years ago standing in front of her father's church, where she got her start singing gospel.

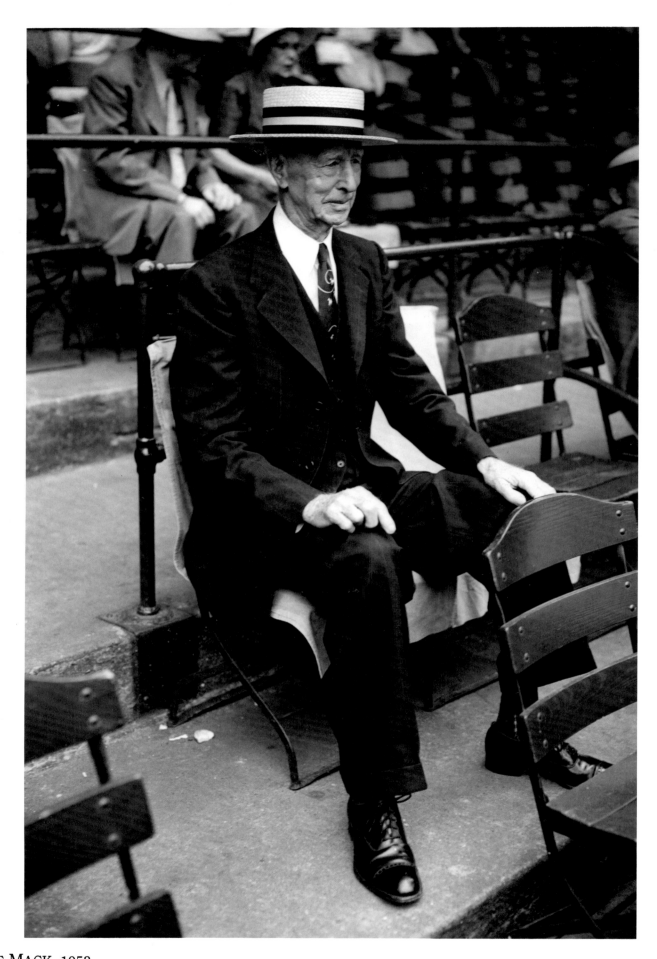

CONNIE MACK, 1953
This is how he always sat in the dugout when he was managing his Philadelphia A's, never wearing a uniform. Mr. Baseball, as he was called, was at Briggs Stadium, home of the Detroit Tigers. We ran this picture across the back page.

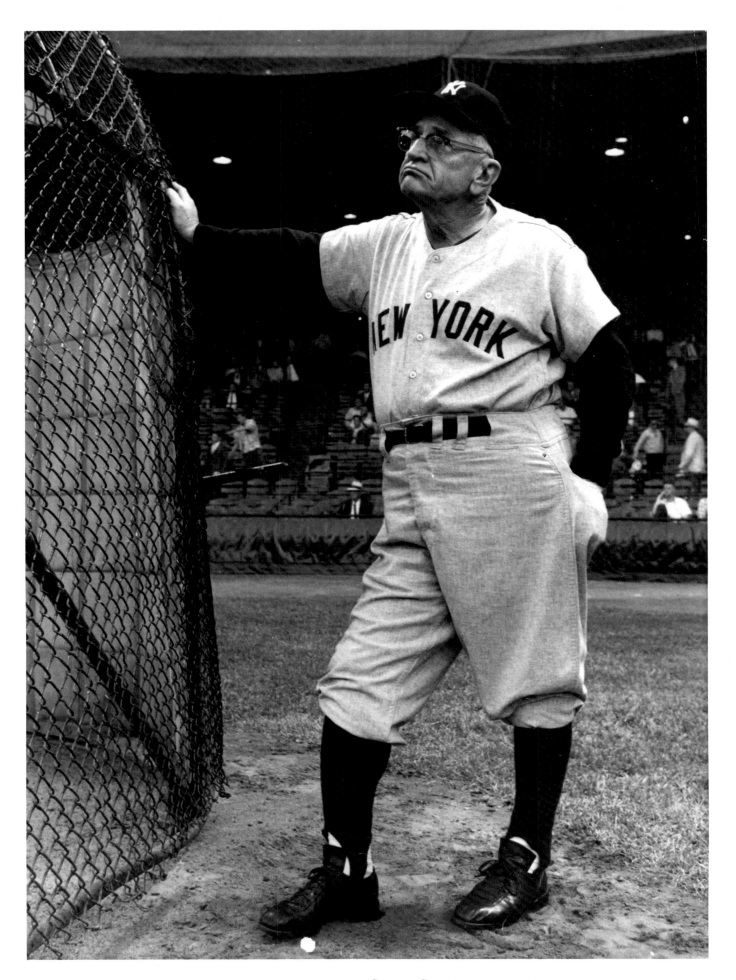

CASEY STENGEL, UNDATED

He's pouting at Tiger Stadium, watching the Yankees take
batting practice. This was during the '50s, when the Yankees
were winning so many pennants.

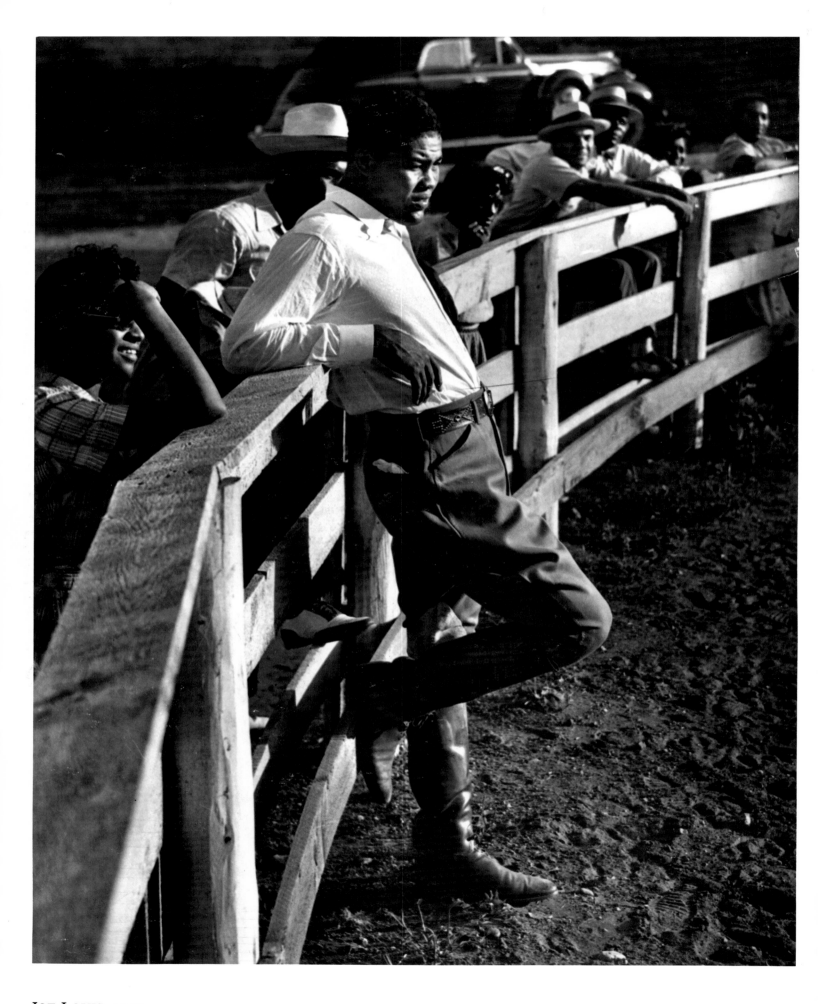

JOE LOUIS, 1946

He was at his Springhill Farms in Utica, and he told me to come on out. I wanted a casual picture, and he was leaning back against the fence, watching people ride horses.

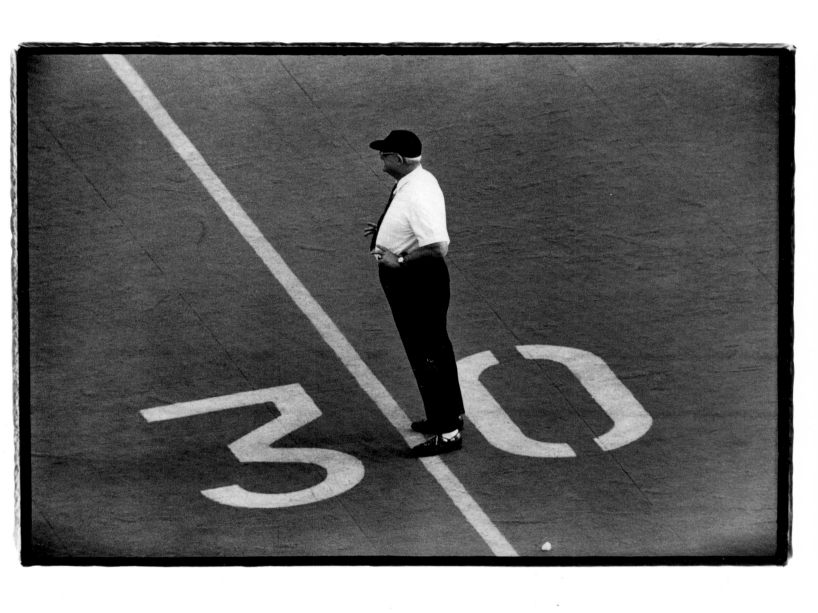

WOODY HAYES, 1969

The Wolverines and Buckeyes were playing at University of
Michigan stadium, another chapter in this great football
rivalry. As he often did, the explosive Ohio State coach had
edged out onto the field where he shouldn't be, giving signals
to his team. The Buckeyes lost. This picture took on extra
meaning when he died in 1987 at age 74, because "30" is the
newspaper symbol for the end of a story.

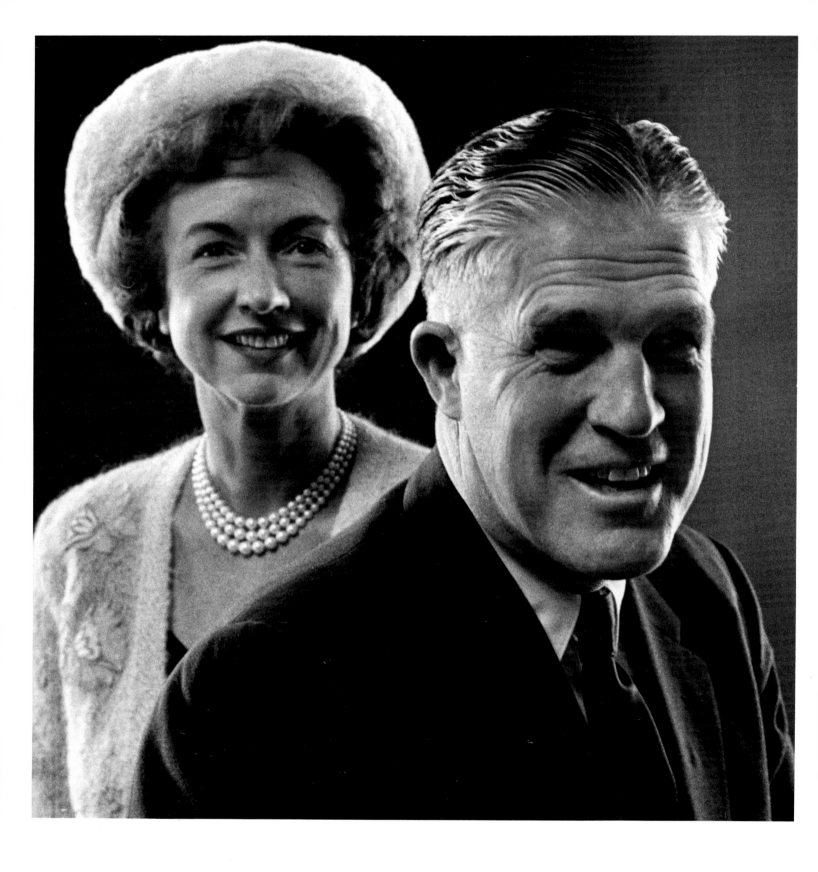

GEORGE AND LENORE ROMNEY, 1963
We were very good friends. He always had an open door for me, and I took this inauguration portrait of the two of them in Lansing on his first day in office.

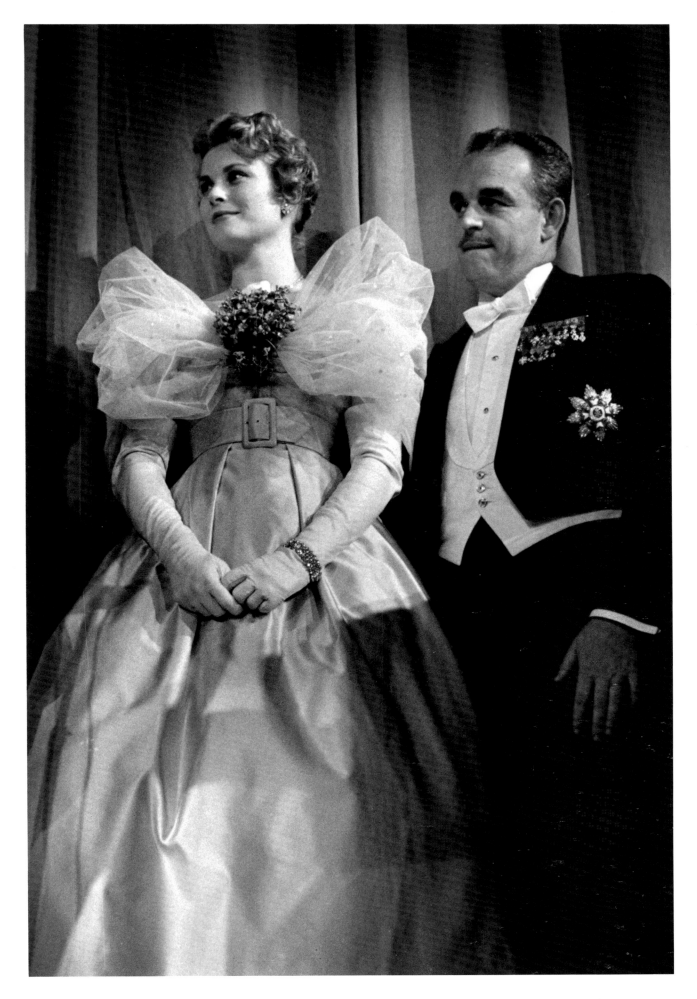

PRINCESS GRACE, PRINCE RAINIER OF MONACO, 1958
They were in New York, guests of the Chrysler Corporation, which was giving the Imperial Ball.

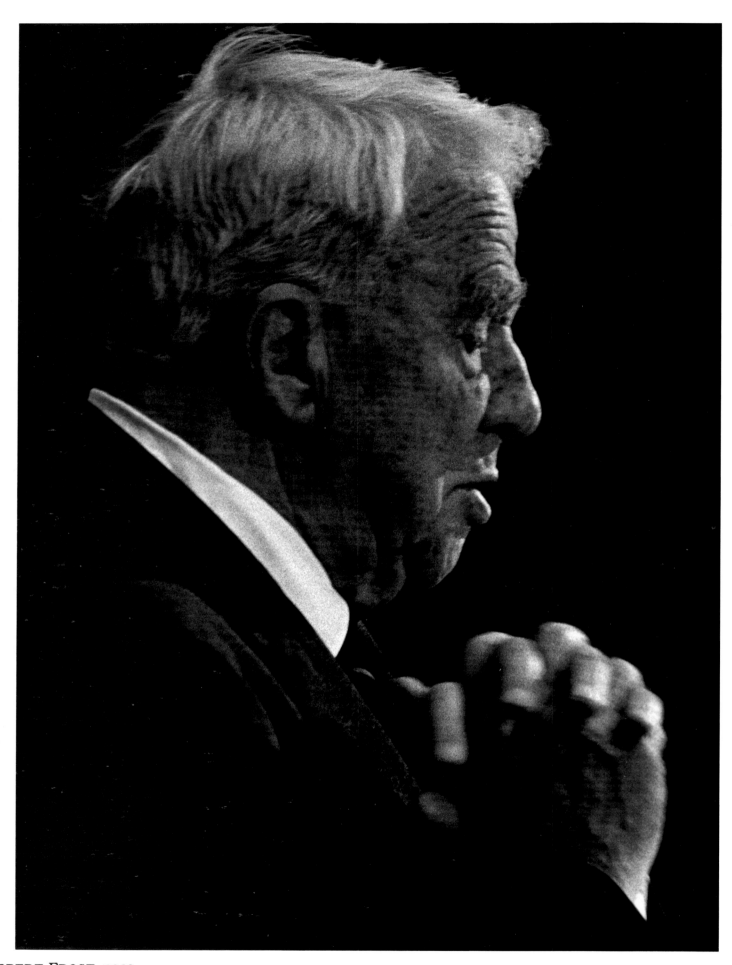

ROBERT FROST, 1962

A year before his death, the poet visited the University of
Detroit at the invitation of Father Celestin Steiner, then
president. I just watched until he stopped reading, folded his
hands and started reciting some of his favorite poems. That's
when he came alive, and it made a great picture.

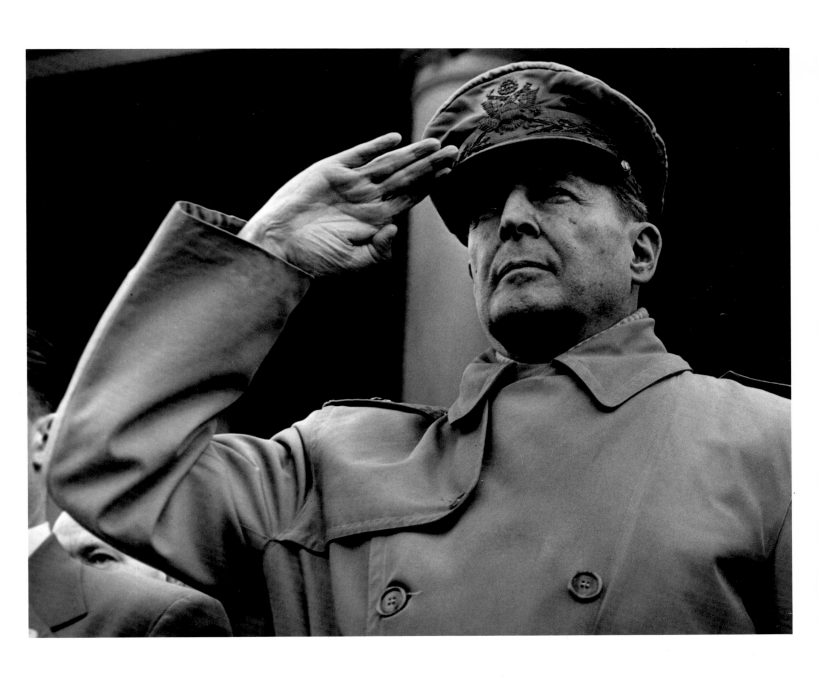

GEN. DOUGLAS MACARTHUR, 1951

After Truman called him back to this country from Korea, he made speeches everywhere. I had considerable access because I was the only photographer with him on his entire trip through Michigan. Here, he was saluting during the National Anthem at Michigan's Capitol building.

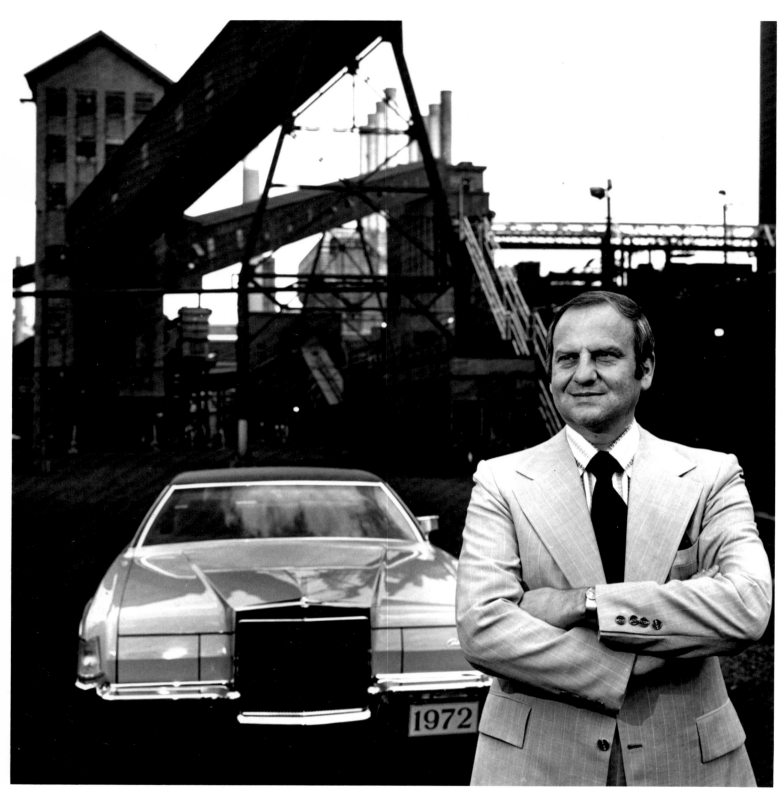

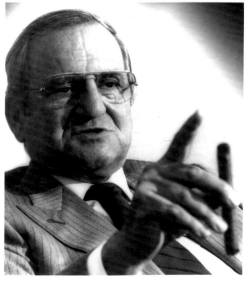

LEE IACOCCA, 1972 and 1984

Lee Iacocca was president of Ford. For the above portrait, I brought him and the car out to this spot overlooking Ford's vast Rouge River plant in Dearborn. Iacocca came from a much different background than Henry Ford. He was not born into anything. Even though he became more famous later as chairman of Chrysler (left), his earthy personality was always the same.

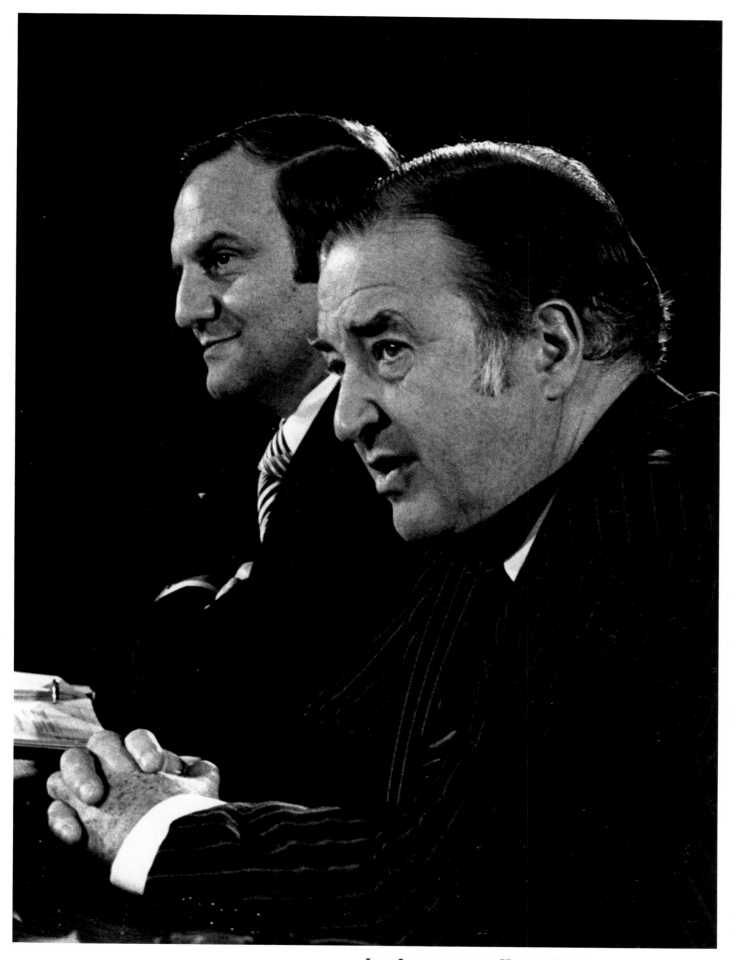

LEE IACOCCA AND HENRY FORD, 1977

I waited for this shot of their profiles at a Ford stockholders
meeting, president and chairman, close together. In 1978,
Ford shocked the automotive industry by abruptly firing
Iacocca. I never asked Henry about his relationship with Lee.
It wouldn't have been right to presume on our relationship.

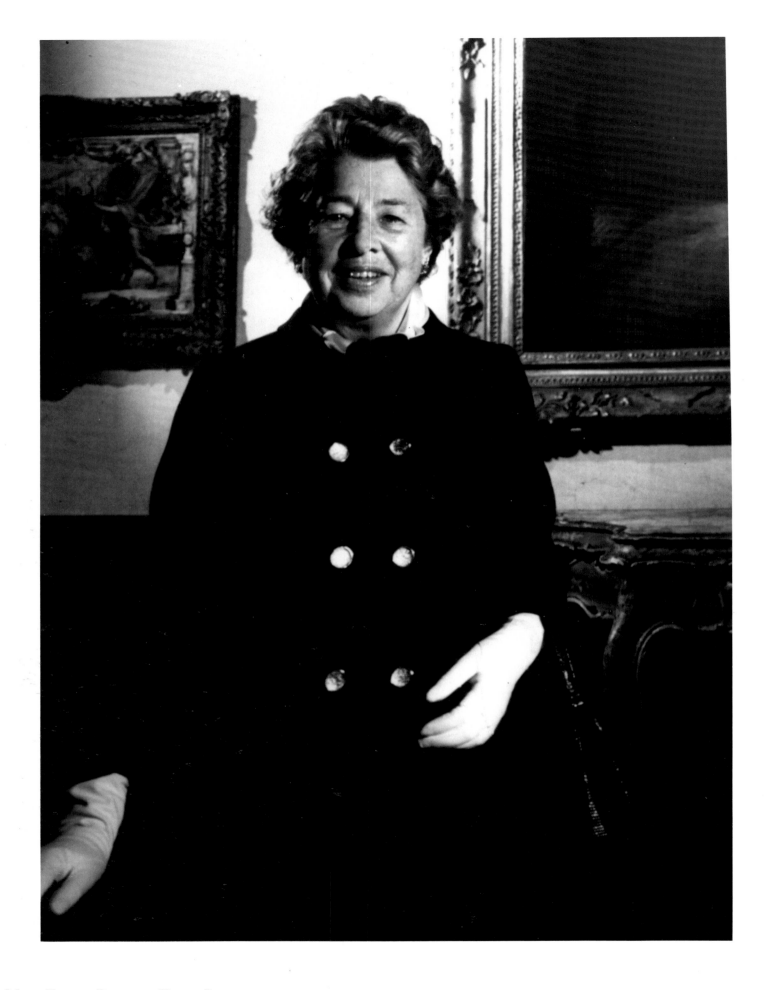

MRS. EDSEL BRYANT FORD I, 1972

Eleanor Clay Ford, mother of Henry Ford II, was a terrific patron of the arts. She normally never went out, but especially for me she came to the Detroit Institute of Arts for this portrait. She died in 1976.

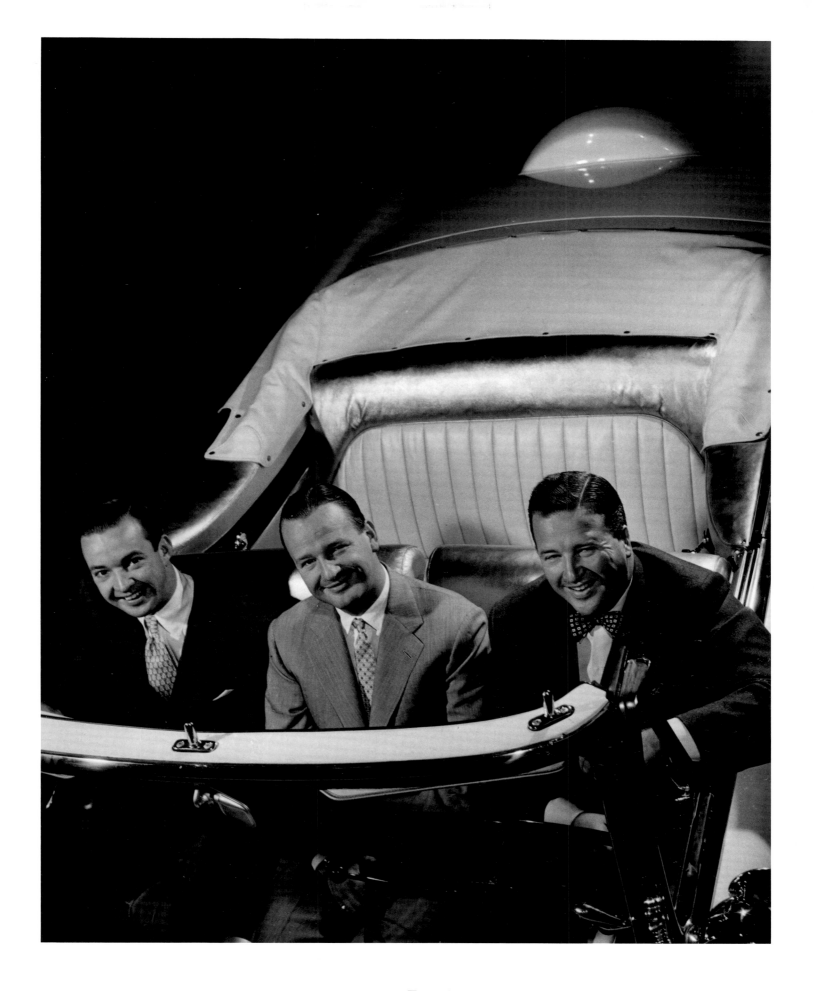

THE FORD DYNASTY, 1953
Brothers William Clay Ford, Benson Ford and Henry Ford II in a new Lincoln convertible. They wanted something different, so I got a ladder and set up three or four lights and they posed for me.

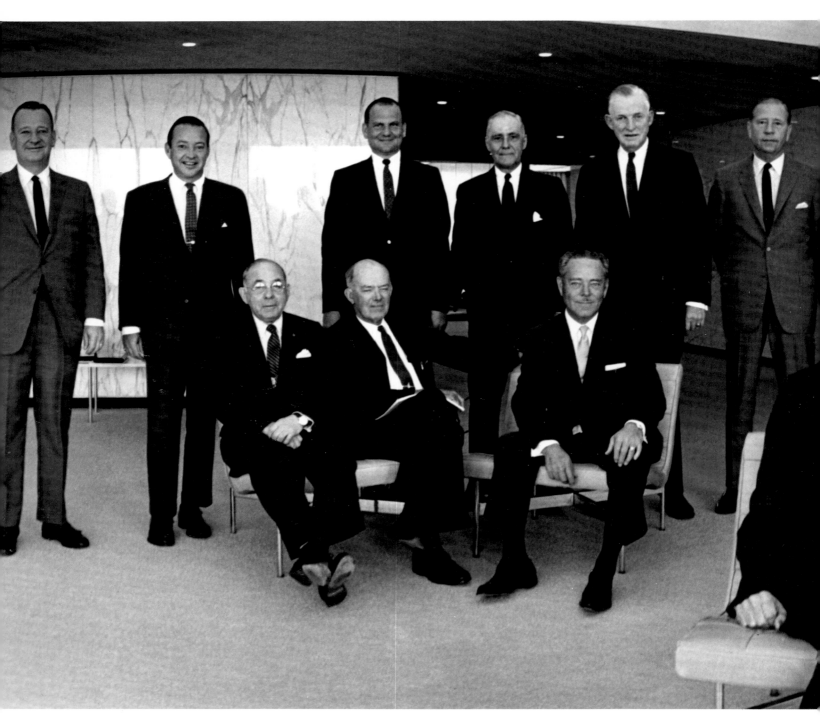

FORD MOTOR CO. BOARD OF DIRECTORS, 1965

The portraits on the wall are Edsel Ford and Henry Ford, Henry II's father and grandfather. This was to be a different sort of portrait. It was used in the company's annual report. Standing, from left, are Benson Ford, William Clay Ford, Lee Iacocca, Harold Boeschenstein, Irving Duffy, John Bugas, Donald David, Henry Ford II, J. Edward Lundy, Carter Burgess. Seated, from left: Sidney Weinberg, Paul Cabot, Ernest Breech, Arjay Miller, Charles Patterson, A. Thomas Taylor and Franklin Murphy. Henry was chairman and his brothers were vice presidents, along with Iacocca, Duffy, Bugas and Lundy. Miller was president; Patterson, executive vice president. The rest were outside directors.

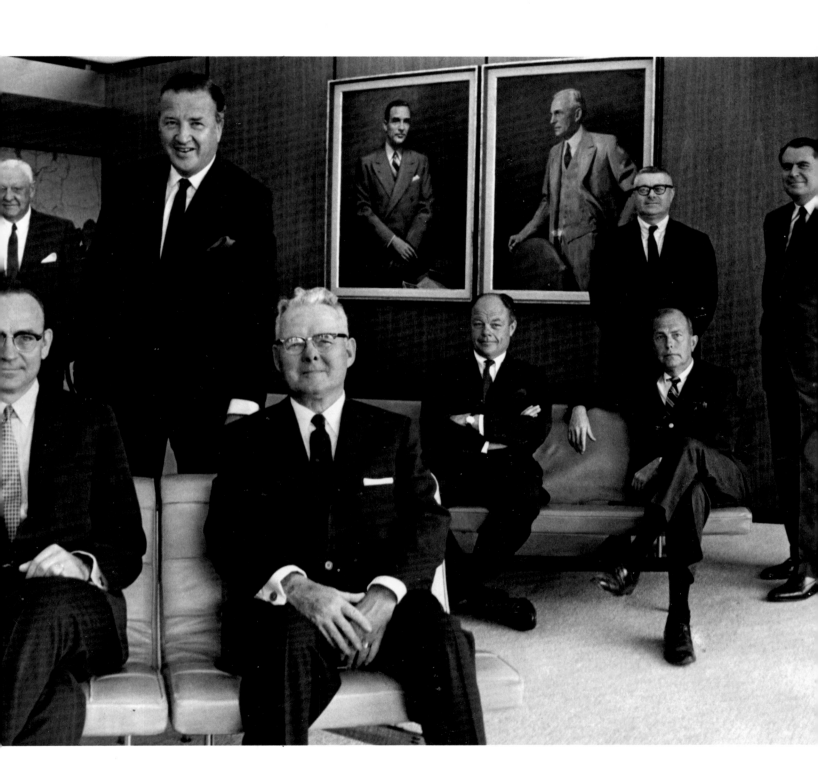

HENRY FORD II AND ELEANOR CLAY FORD, 1959
**Henry danced with his mother at daughter Charlotte Ford's
debutante party at the family's home in Grosse Pointe Farms.**

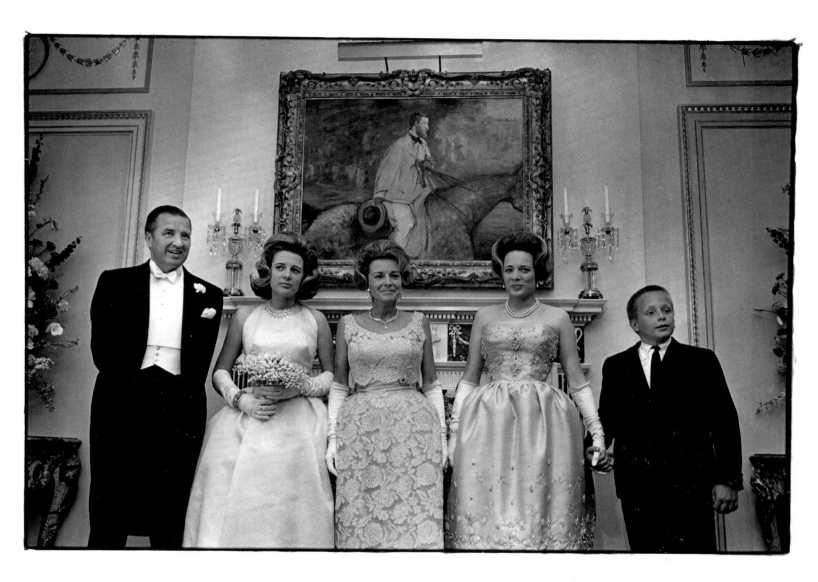

T he first Ford I photographed, early in my newspaper career, was Henry Ford I. The dynasty he established is the closest thing Detroit has to royalty. The Fords were always making news, and I got my share of those assignments. Eventually, they came to know who I was and feel comfortable around me. That's how Henry Ford II came to invite me to photograph so many important family occasions. When he died, his third wife, Kathy, sent me a telegram inviting me to his funeral.

THE FORDS, 1961
Henry stands with his family at his daughter Anne's debutante party. It rained and rained that night. Anne is next to him, then his wife Anne, daughter Charlotte and son Edsel.

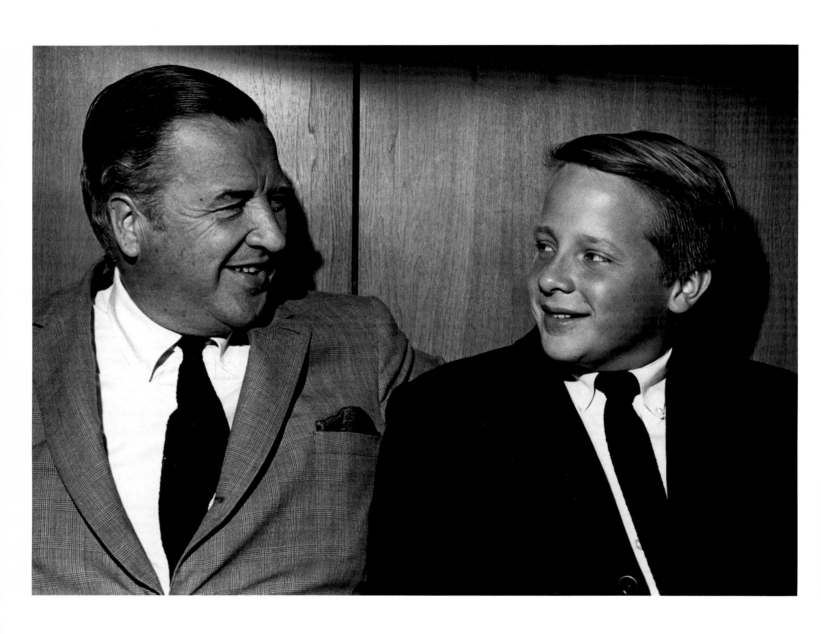

FATHER AND SON, 1965

I met Henry Ford II and Edsel Ford II at the Ford terminal near Metro Airport for a five-minute photo session on July 4. Edsel, who was 17 then, was leaving on vacation aboard the company plane. His stepmother, Cristina, was going, too. She had brought a box of cannoli for the trip.

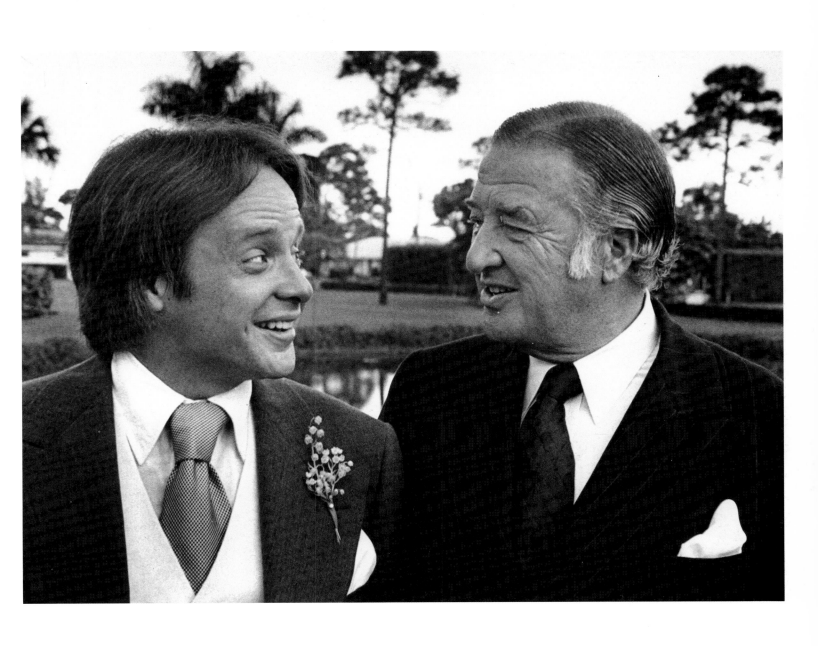

FATHER AND SON, 1974

Edsel Ford II asked me to photograph his wedding. He was marrying Cynthia Neskow, daughter of an oral surgeon, in Tequesta, Fla. I have served as a wedding photographer fewer than a half-dozen times in my life, and I did this as a wedding present. I told Edsel I'm not one to go for gimmicks. He said that's why they wanted me to be the photographer. So, I posed nothing. This moment between father and son was my favorite.

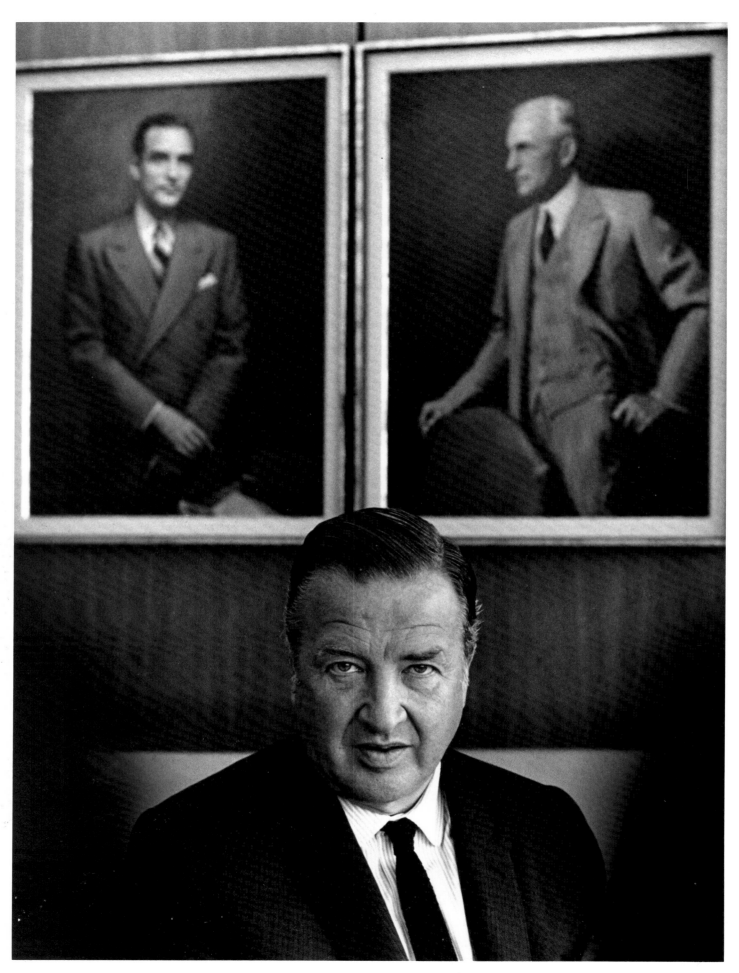

DYNASTY, 1965
 After the board left the room at Ford World Headquarters in
 Dearborn, Henry posed in front of the portraits of his father
 and grandfather. Ford stepped down as chairman in 1980.
 He died in Detroit in 1987 at age 70.

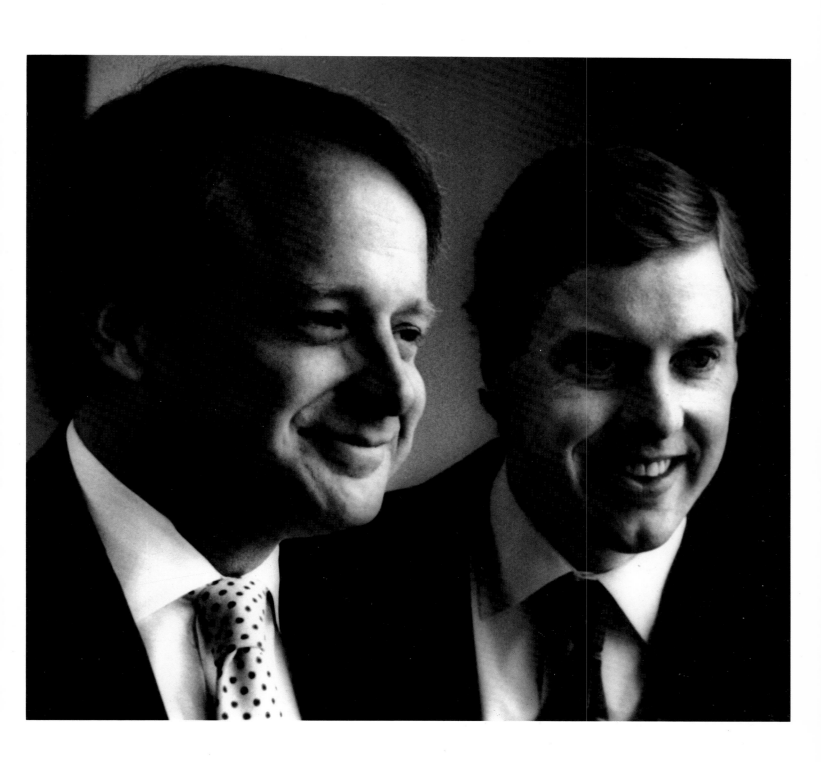

FORDS FOR THE FUTURE, 1988
Cousins Edsel Bryant Ford II, left, and William Clay Ford Jr. become the fourth generation of their family to serve on the Ford Motor Co. board of directors.

These were the last photos taken of former Teamsters president Jimmy Hoffa. In 1975 there was talk of Hoffa trying to regain the Teamsters presidency, which he lost in 1967 when he went to prison for four years for mail fraud and jury tampering. Because I personally knew Jimmy Hoffa, he agreed to see me July 24.

When I arrived at his home in Lake Orion, he had just finished breakfast. He asked me where I wanted to take his picture, and I told him that I would prefer outside his home for an informal look.

He took a last sip of coffee and said, "Let's go."

We talked while I was shooting; this is the best way to get candid expressions and keep the subject relaxed and less aware of the camera.

A week later, July 30, 1975, he met two men at the Machus Red Fox restaurant in Bloomfield Township and then disappeared.

After a picture ran in the Free Press, the FBI came to the paper to talk with me to see if I had heard any mention as to whom he planned to meet for lunch. The clothes he was wearing in these photographs were the same ones in which he was last seen, according to his aide. Newsweek magazine ran a photo on the cover.

As of this date, Jimmy Hoffa is still missing.

JIMMY HOFFA, 1975
The last photos of Jimmy Hoffa.

POLITICS

My newspaper career has spanned ten presidential election campaigns, and I have covered 18 national political party conventions.

My first national conventions were in Chicago in 1952. I roamed the convention floor with John S. Knight, who had bought the Free Press in 1940. He wrote a regular column for us and his other papers. I did my darkroom work at the Chicago Daily News, which he also owned.

That was also the year television networks started covering the conventions, changing them forever. Harry Truman, the first president to have a media adviser, was just another face in the crowd when I photographed him at the 1952 convention, where the party torch was passed to Adlai Stevenson. By the '80s, political conventions had become slick, prime-time television productions totally devoted to giving the best possible exposure to the candidate. I'm not complaining. That works for my deadlines, too.

The political landscape has changed in other ways, too. When I started covering politics, women and black people were to a large degree not part of the process. Blacks had to march in the streets to call attention to the infringement of basic rights. Women had a struggle of their own. Gradually, their influence came to be felt at the top levels in local, state and national politics — a positive trend.

I'm not a political person. My interest is a good story. And politics has all the elements: winners and losers, personalities and issues, hoopla and pageantry.

DWIGHT EISENHOWER, 1952

His car was coming down Woodward Avenue in Detroit, passing by the world's largest flag at the J. L. Hudson Co. He knew I was waiting for him there; I wanted the flag in the background. They slowed down a little bit, and he turned toward me so the picture would be right. I had only one shot, working with a four-by-five Speed Graphic.

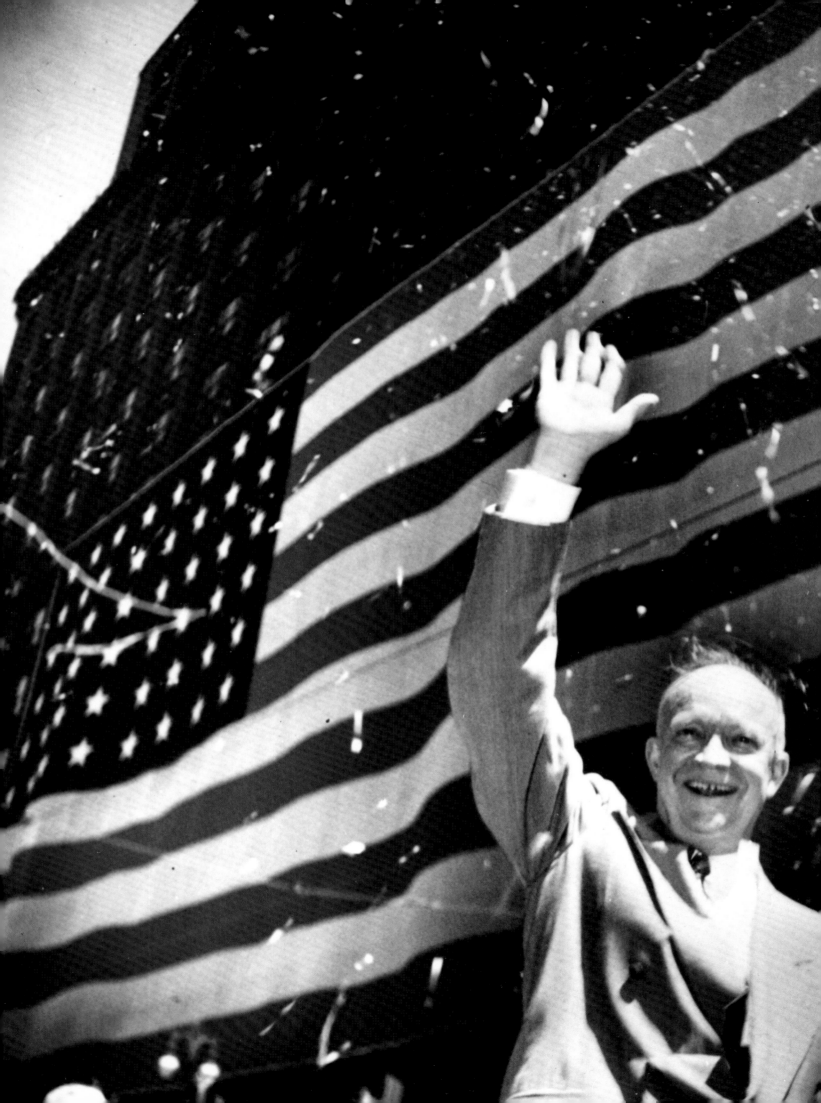

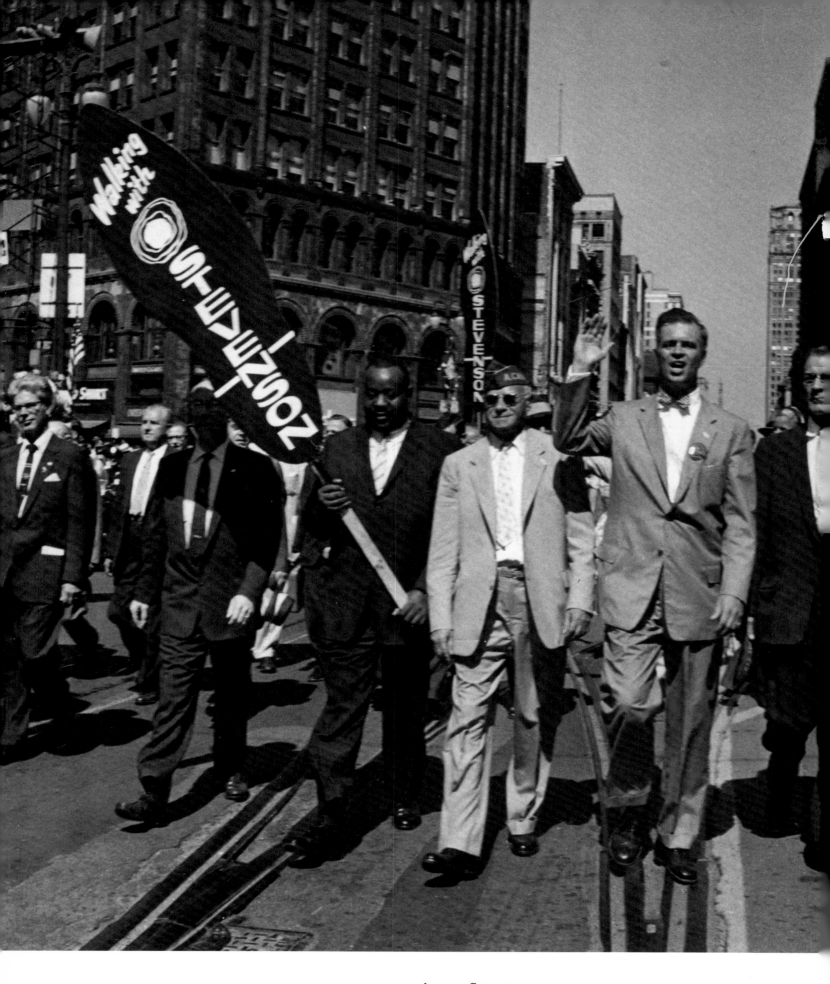

Adlai Stevenson, 1952

The Democratic presidential candidate (near the center,
wearing a spotted tie) joined Michigan dignitaries for
Detroit's Labor Day parade down Woodward Avenue. Gov. G.
Mennen Williams is wearing his trademark bow tie and

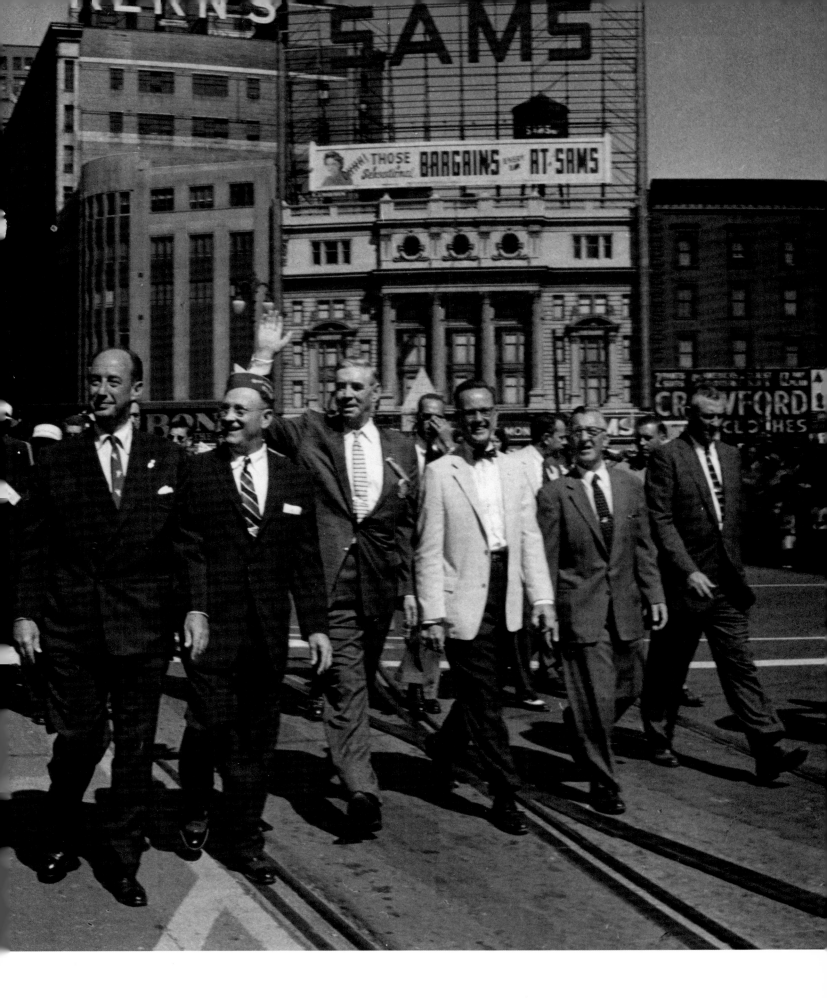

waving. Alex Fuller, executive vice-president of the AFL-CIO, is carrying the sign. On the right, under the Sam's sign, are AFL-CIO president Mike Novak (in hat), Sen. Patrick McNamara (waving) and Sen. Phil Hart (in white jacket).

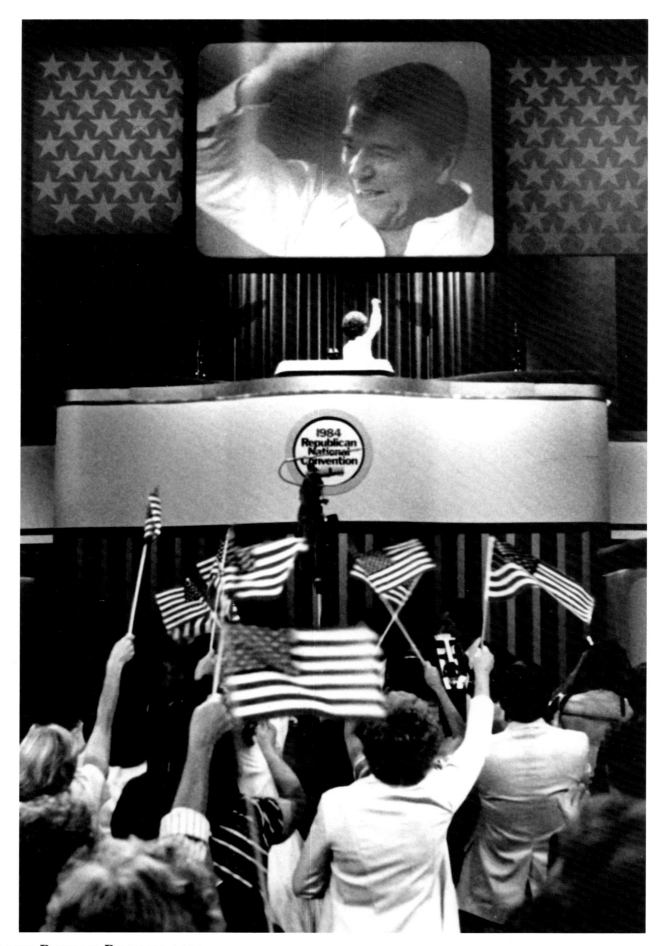

NANCY AND RONALD REAGAN, 1984

"Let's make it one more for the Gipper," Nancy Reagan told
a cheering, flag-waving crowd after her husband was
nominated for a second term at the Republican National
Convention in Dallas. The president, watching from his hotel
room, appeared on large-screen TV. She turned and said, "Hi,
honey." His major speech was the following night.

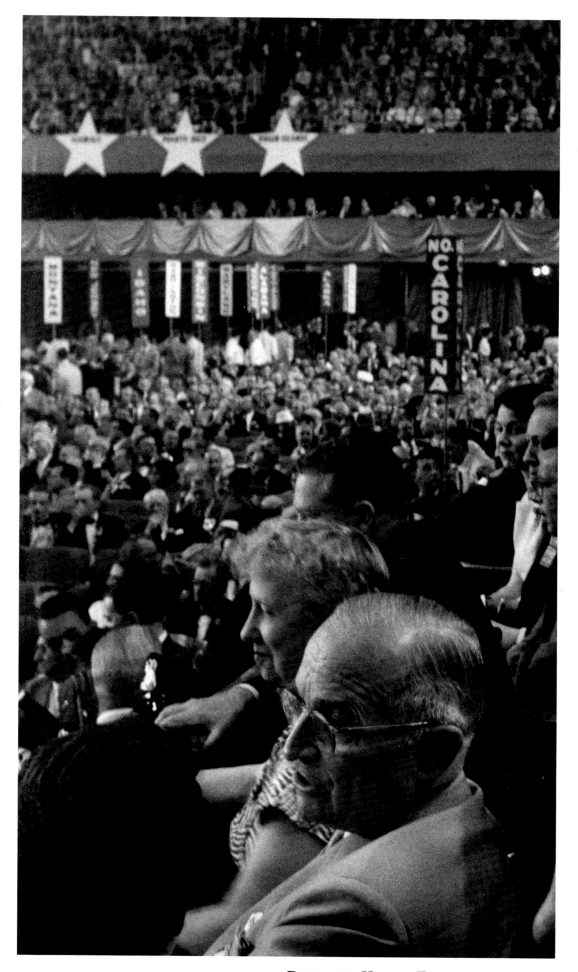

BESS AND HARRY TRUMAN, 1952
I wanted the two of them together, with the Democratic
Convention in the background. He was still president, but he
wasn't running again. There were a few Secret Service
agents around, but they let me get close.

81 □ POLITICS

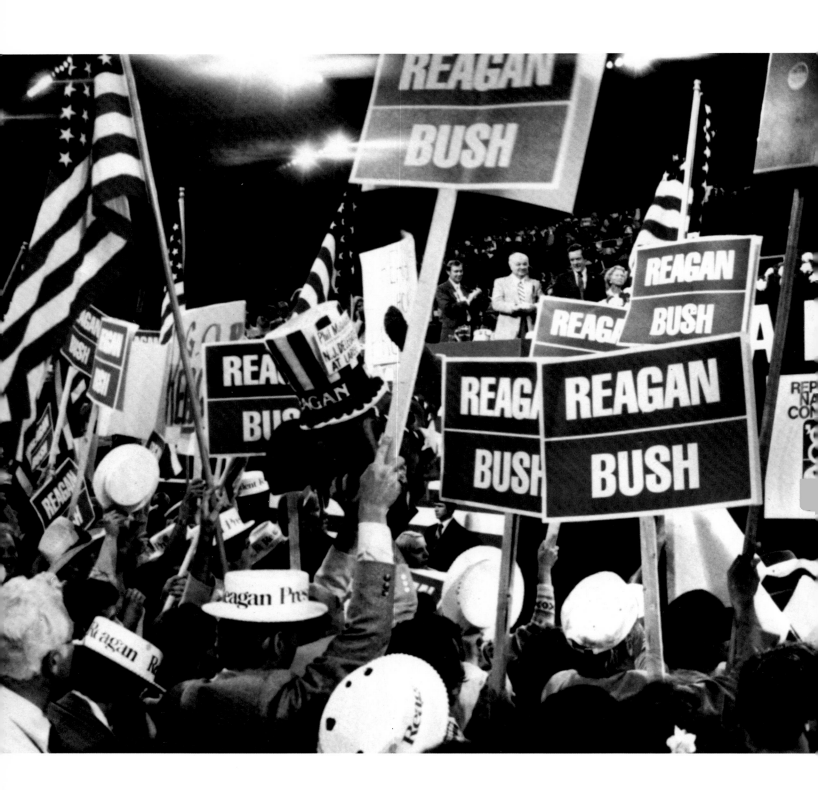

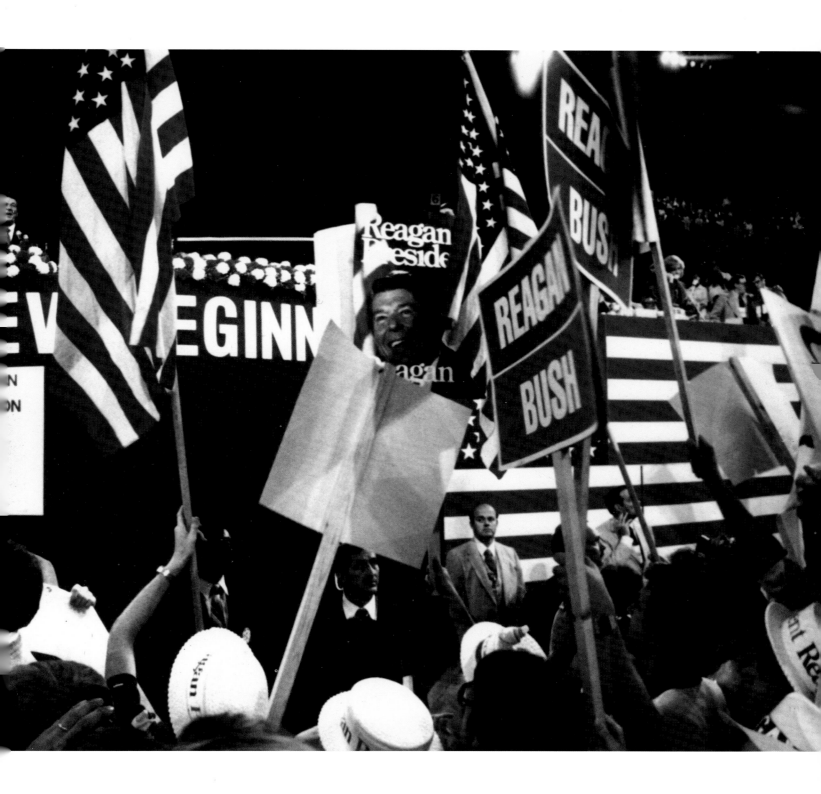

RONALD REAGAN, 1980

Ronald Reagan is nominated for the presidency by the
Republican National Convention in Detroit's Joe Louis
Arena. The panoramic view catches the pandemonium of the
moment. The Free Press was on strike during the convention,
but I covered it myself. After the strike was over, this ran
across the back page. Eastman Kodak made a mural of it.

83 □ POLITICS

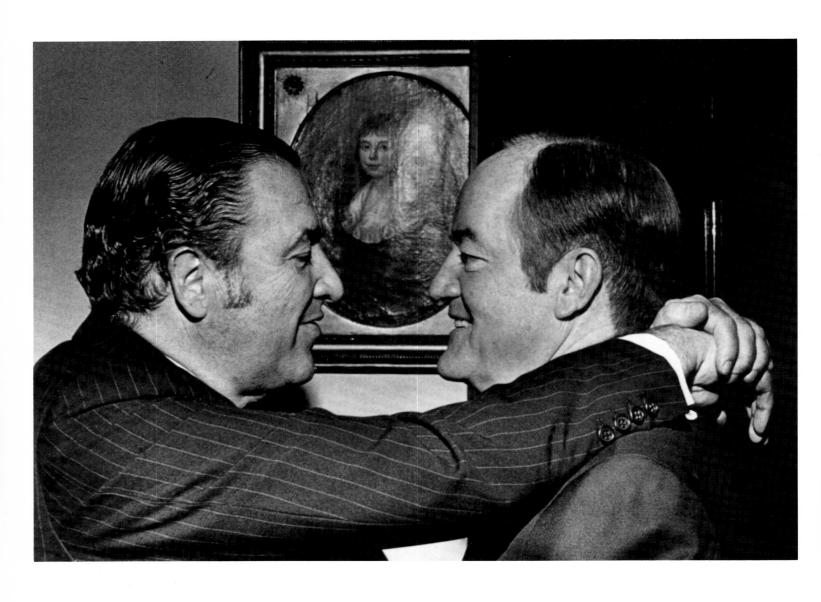

HENRY FORD AND HUBERT HUMPHREY, 1967

**This was a private party at the F Street Club in Washington,
D.C. No pictures were allowed in the club, but Henry invited
me to take photos and since it was his party, the club could
not object. Humphrey was vice-president and a year away
from making his own run at the Oval Office, losing to Richard
Nixon. Henry Ford II was considered to be a Republican, but
he was a major supporter of Democratic President Lyndon
Johnson.**

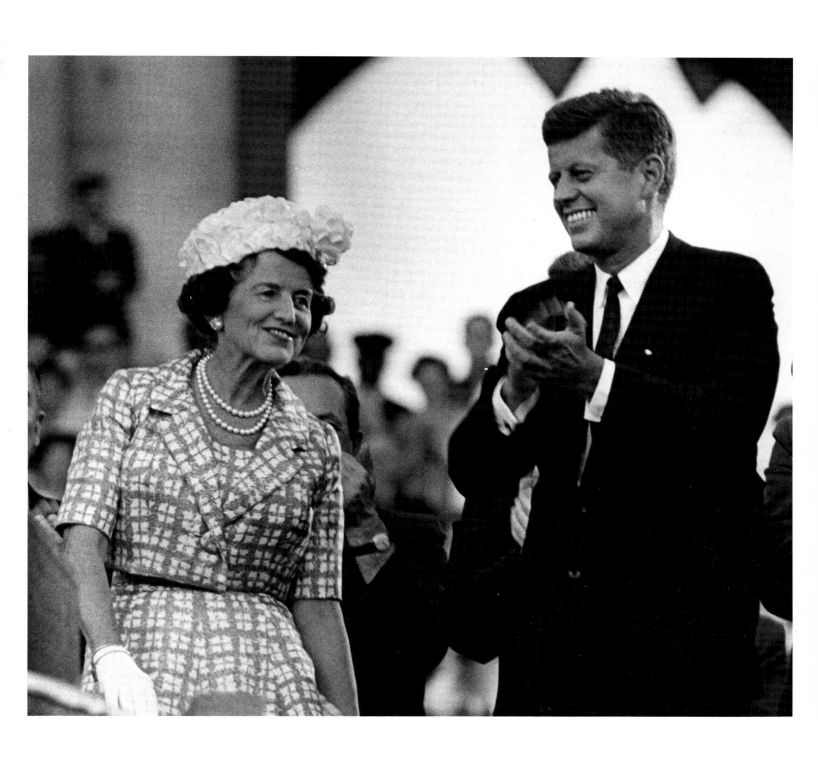

ROSE AND JOHN F. KENNEDY, 1960
The presidential candidate introduces his proud and happy
mother to a rally of friends and supporters at the Los Angeles
Coliseum the day after being nominated at the Democratic
convention.

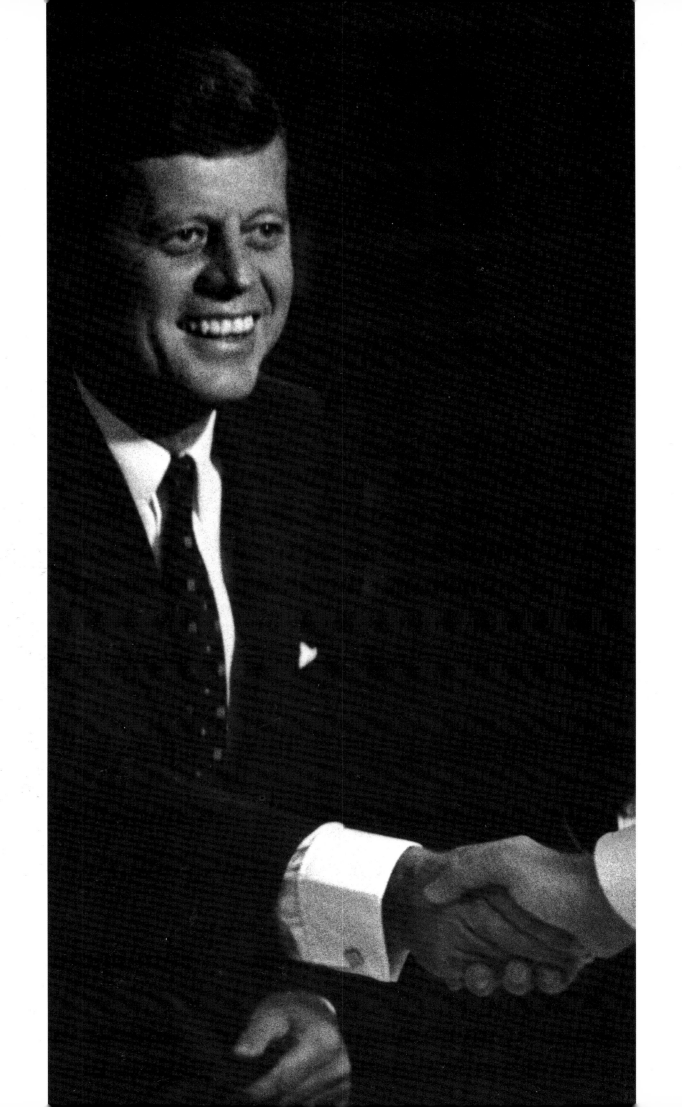

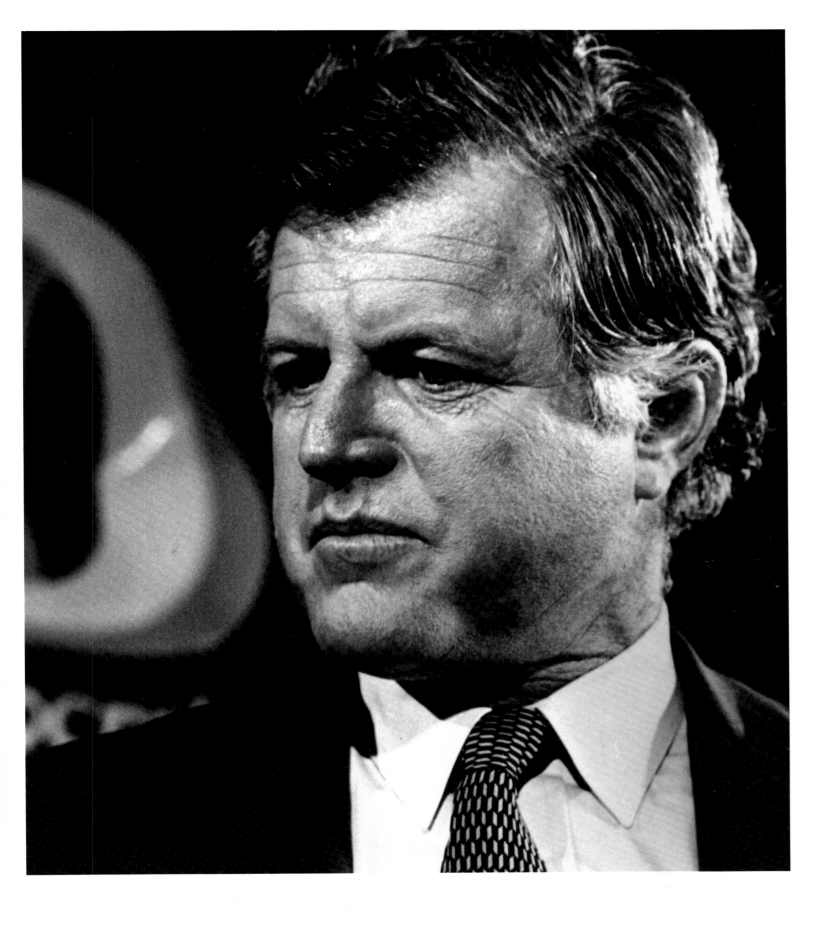

TWO KENNEDY BROTHERS, 1960 and 1980

Ted Kennedy, photographed at the 1980 Democratic
convention in New York City, had a difficult time coming
behind brothers Jack (opposite, during the campaign) and
Bobby, whose lives were at once charmed and tragic. The
White House seemed to elude him, but he became very
influential as a senator.

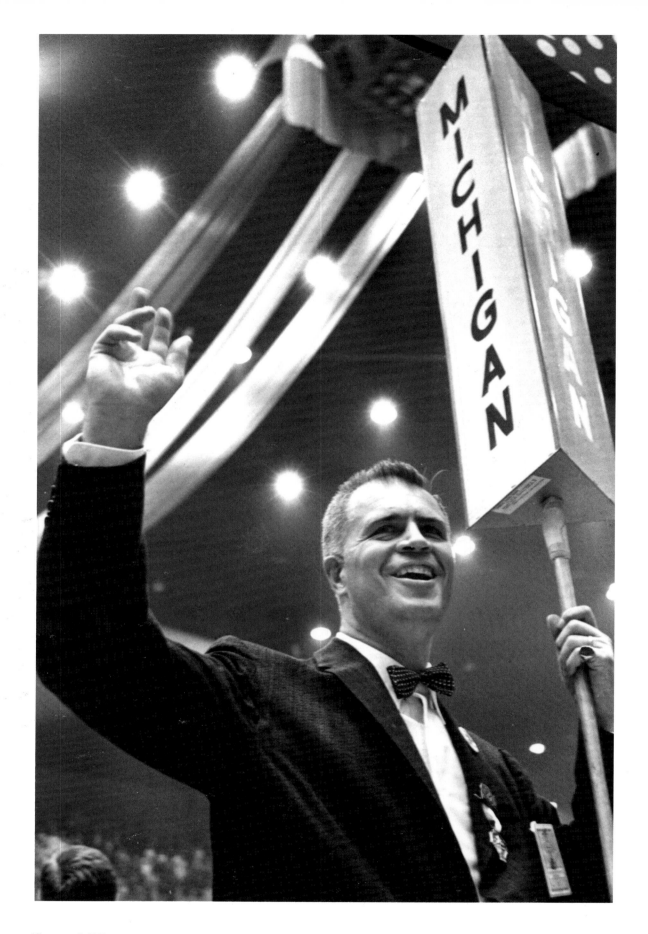

G. MENNEN (SOAPY) WILLIAMS, 1960

**The governor of Michigan holds the Michigan sign topped by
his trademark bow tie at the Democratic National
Convention in Los Angeles. Soapy Williams was governor for
six two-year terms, 1948 to 1960. During the presidency of
John F. Kennedy, he was assistant secretary of state for
African affairs. Later, he was elected chief justice of the
Michigan Supreme Court. He died in 1988, just short of his
77th birthday.**

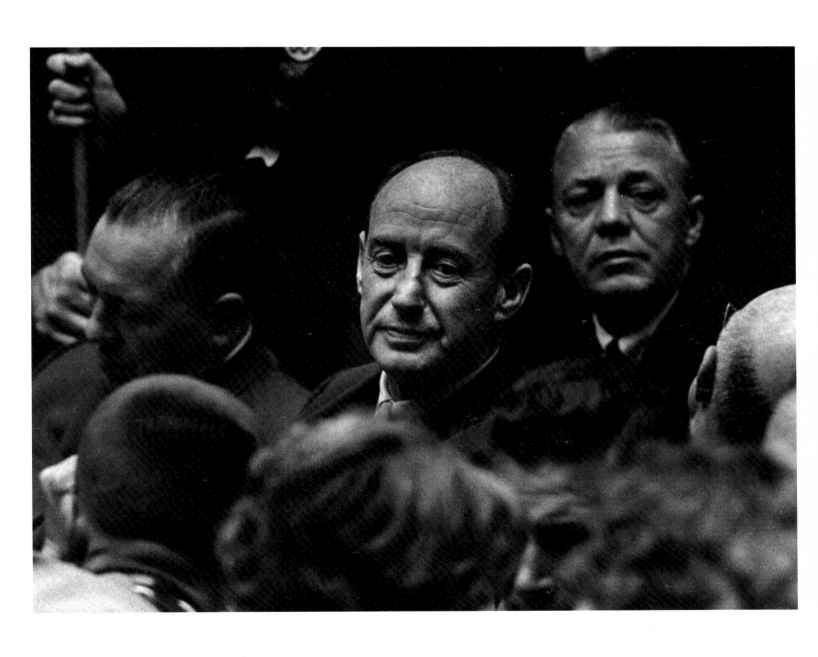

ADLAI STEVENSON, 1960

He's at the Democratic convention in Chicago, after two failed attempts to win the presidency. Here's a man who had been through it all.

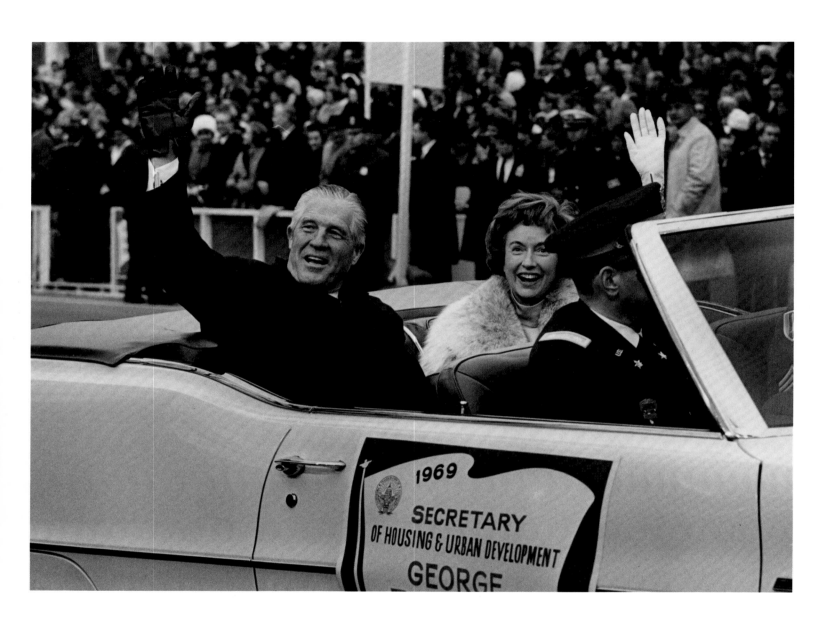

GEORGE AND LENORE ROMNEY, 1969

Michigan's former governor was an early dropout in the presidential race the year Richard Nixon won. He got to go to Washington anyway when the president appointed him secretary of Housing and Urban Development. They are waving to the crowd during the inaugural parade in Washington.

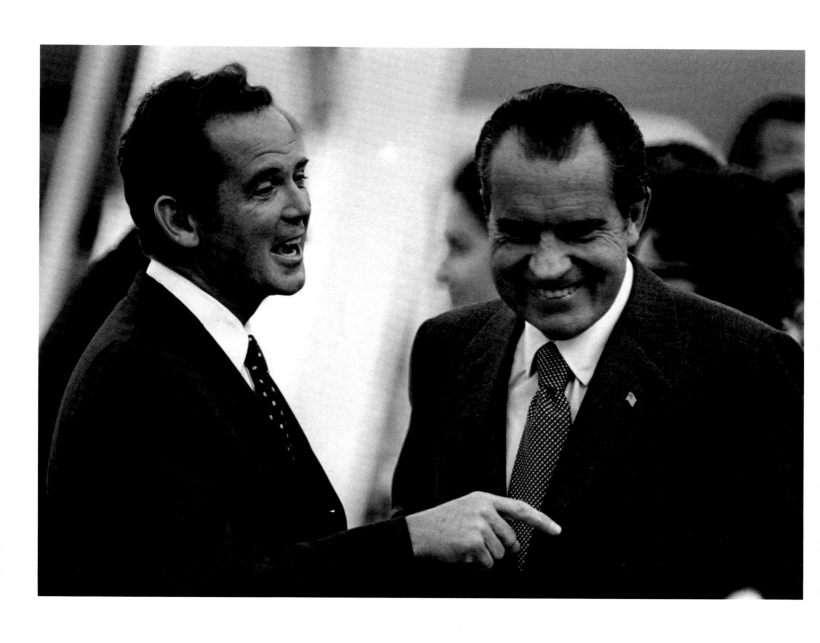

WILLIAM MILLIKEN AND RICHARD NIXON, 1971

President Nixon flew into Metro Airport on Sept. 23, and Michigan Gov. Milliken came down to meet him. Nixon appeared before a nighttime session of the Economic Club of Detroit and, in a question-and-answer format, talked about his economic policy goals. About 4,700 business leaders and Republican Party stalwarts heard him speak. Outside Cobo Hall, an equal number of demonstrators protested the Vietnam War and Nixon's economic policy.

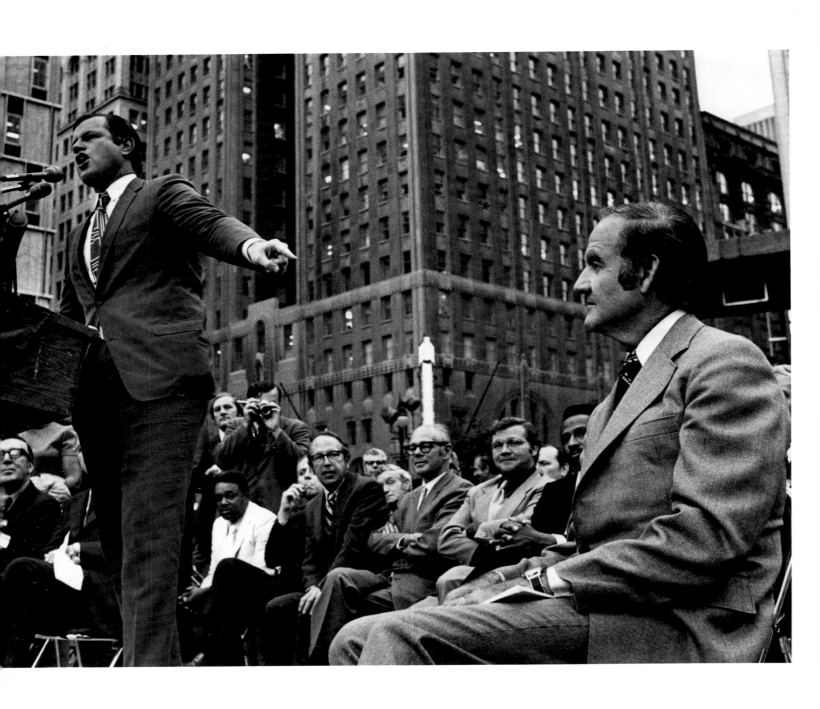

TED KENNEDY AND GEORGE MCGOVERN, 1972

This has all the elements. It was a political rally in Detroit's
Kennedy Square, and sitting behind them are Leonard
Woodcock (far left), William Cahalan in striped tie, Philip Van
Antwerp, Gov. John B. Swainson and John Conyers. The
picture captures the moment that Sen. Kennedy endorsed
candidate George McGovern. He pointed and said, "That's
my man for president."

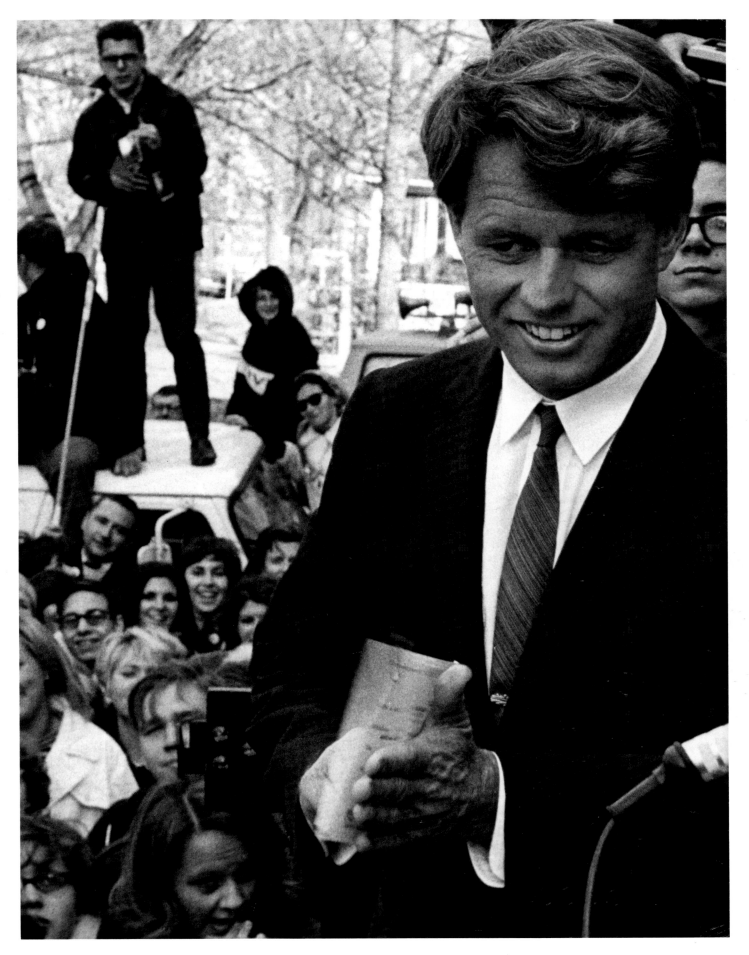

ROBERT KENNEDY, 1968

Robert F. Kennedy campaigned for the presidential nomination in May 1968 on the Eastern Michigan University campus in Ypsilanti. He was assassinated the following month in Los Angeles.

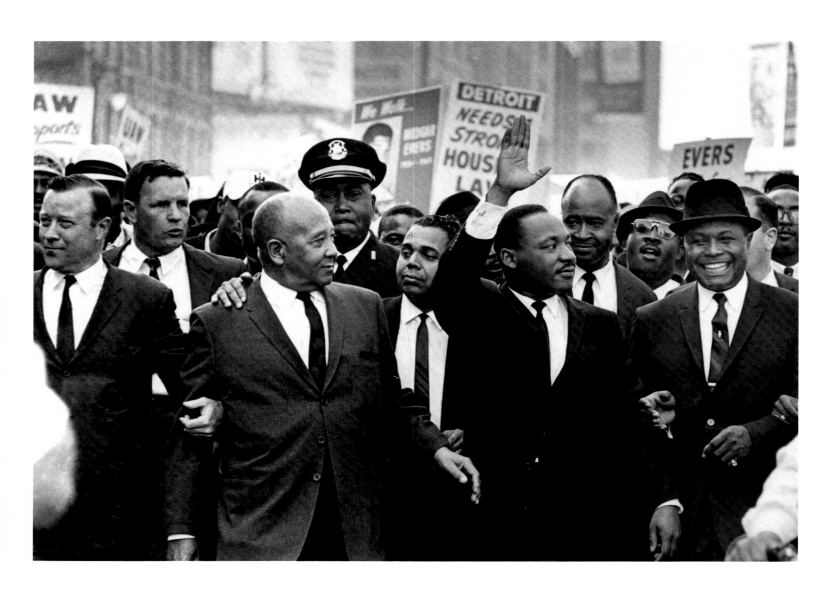

REV. MARTIN LUTHER KING, 1963

The civil rights leader (waving) was marching down
Woodward to City Hall June 23 leading the Detroit Council
for Human Rights "Walk to Freedom." About 125,000
people participated. With him in the front row are Detroit
leaders Walter Reuther, Benjamin McFall and the Rev. C. L.
Franklin. The police officer is Inspector George Harge. In
back of King, on the left, is James Del Rio, before he became
a judge.

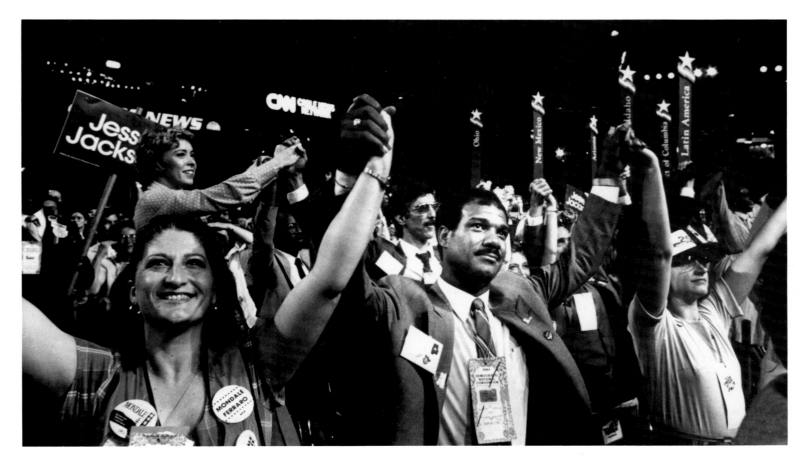

Rev. Jesse Jackson, 1984

Jesse Jackson made a run for the presidential nomination in 1984. After his stirring speech at the Democratic convention in San Francisco, the delegates all held hands and sang in praise of unity.

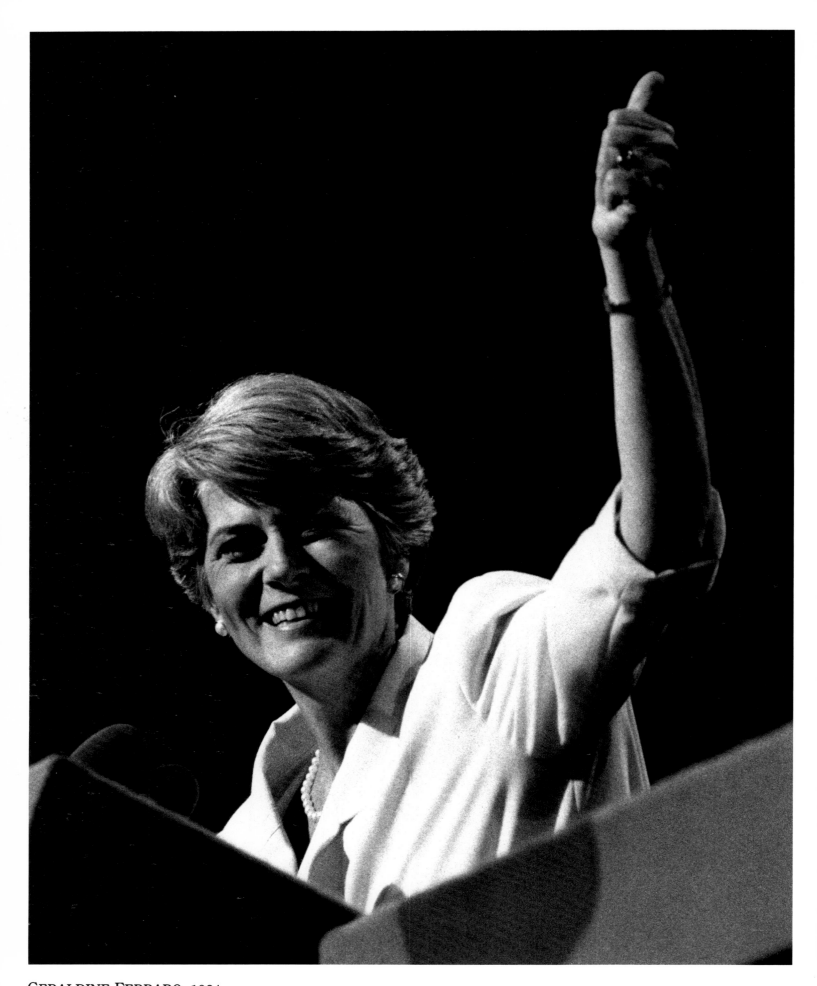

GERALDINE FERRARO, 1984
For the first time, a woman was nominated on a major party
ticket for vice-president. She gives thumbs up after her
acceptance speech at the Democratic convention in San
Francisco. She loved this picture and got a copy of it.

PRESIDENTS

Anytime a photojournalist covers a president, it's a major assignment — one that might make history, who knows?

When I first started covering presidents, photographers were using the 4-by-5 Speed Graphic. You had one lens, one strobe and could take one picture at time. You had to pick your spot well because if the presidential party was moving quickly, you might end up with only two to a half-dozen shots. You had to anticipate situations and trip that shutter at the peak of the action.

That was good discipline for later years. Even though camera and film technology improved greatly, the key was still to anticipate and to wait for the peak of the action, for the moment that tells a story. If you miss the shot, it's gone forever.

I have covered eight presidents during an era of political change and turmoil. One president was assassinated. One resigned in disgrace. One decided not to seek re-election in the face of opposition to his Vietnam war policies. Two tried but failed to win second terms.

But I never treated them as political figures. To me, they were presidents — with the respect each was due as our nation's Chief Executive and Supreme Commander.

I treated them all alike, and they knew it. Republican or Democrat, it didn't make any difference. People in both parties respected me. It is the only way to be a good photojournalist. The success of my pictures lies not in their conveying how I feel about someone or something but in how clearly and well they tell the story. And thousands of people whom you will never see or never meet will decide that.

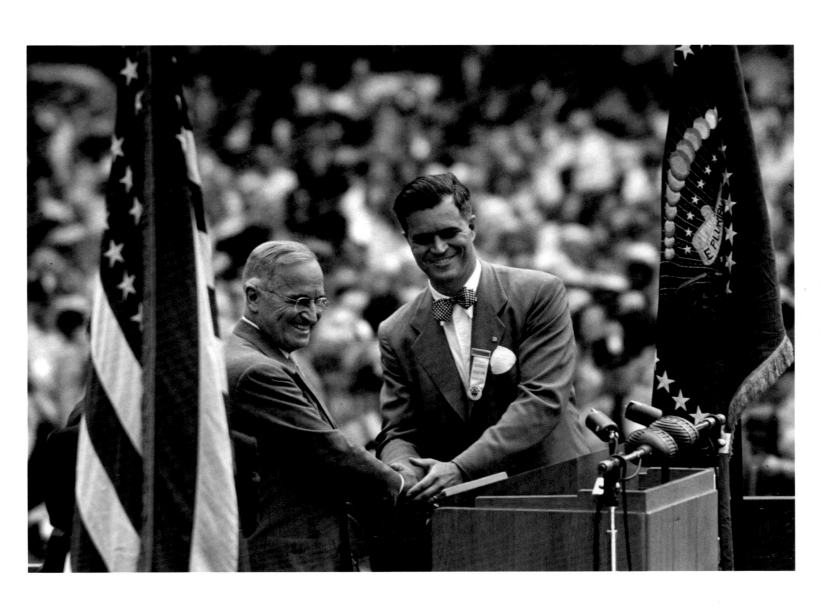

DETROIT, 1951

President Harry Truman came to Detroit July 28 for the 250th anniversary of the city. He was on the reviewing stand (left) in front of the old City Hall for the big parade down Woodward. Michigan Gov. G. Mennen Williams introduced Truman to the crowd. Truman was the first president I photographed for the Free Press.

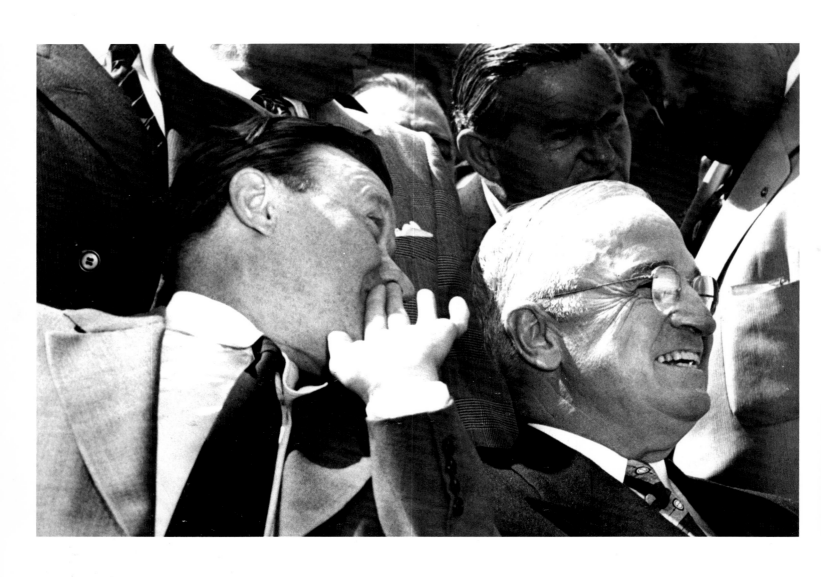

DETROIT, 1953
 Walter Reuther, United Auto Workers president, whispers to Truman during Labor Day festivities Sept. 7. I took this with a 4-by-5 Speed Graphic.

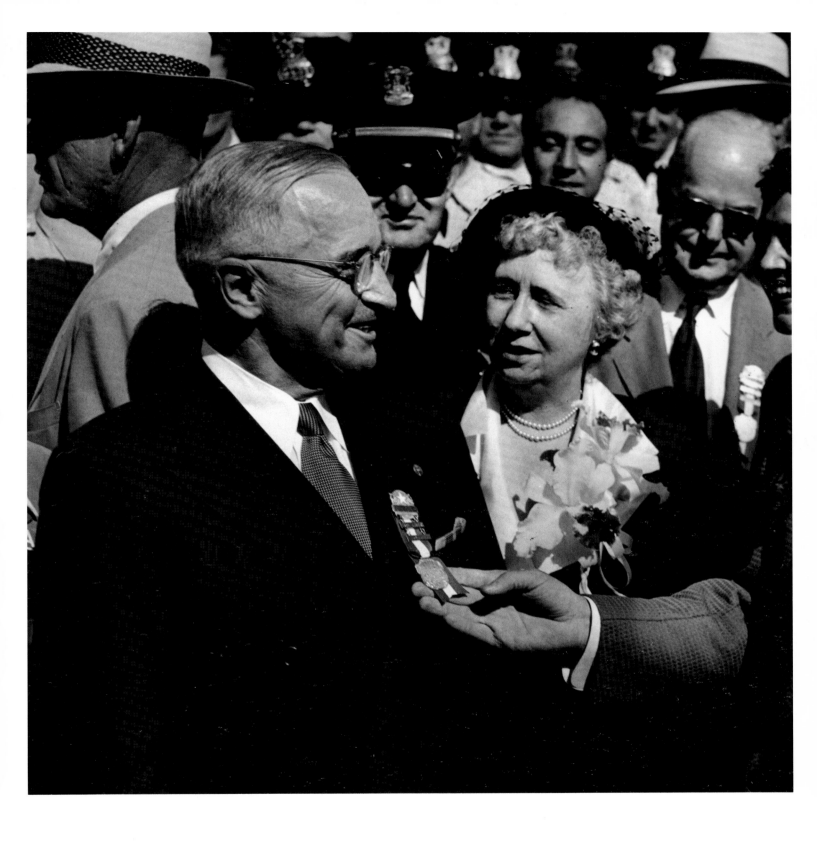

CHICAGO, 1952
Friends greeted President Truman and his wife Bess at the airport when they arrived for the Democratic convention. He was not running for another term and endorsed Adlai Stevenson.

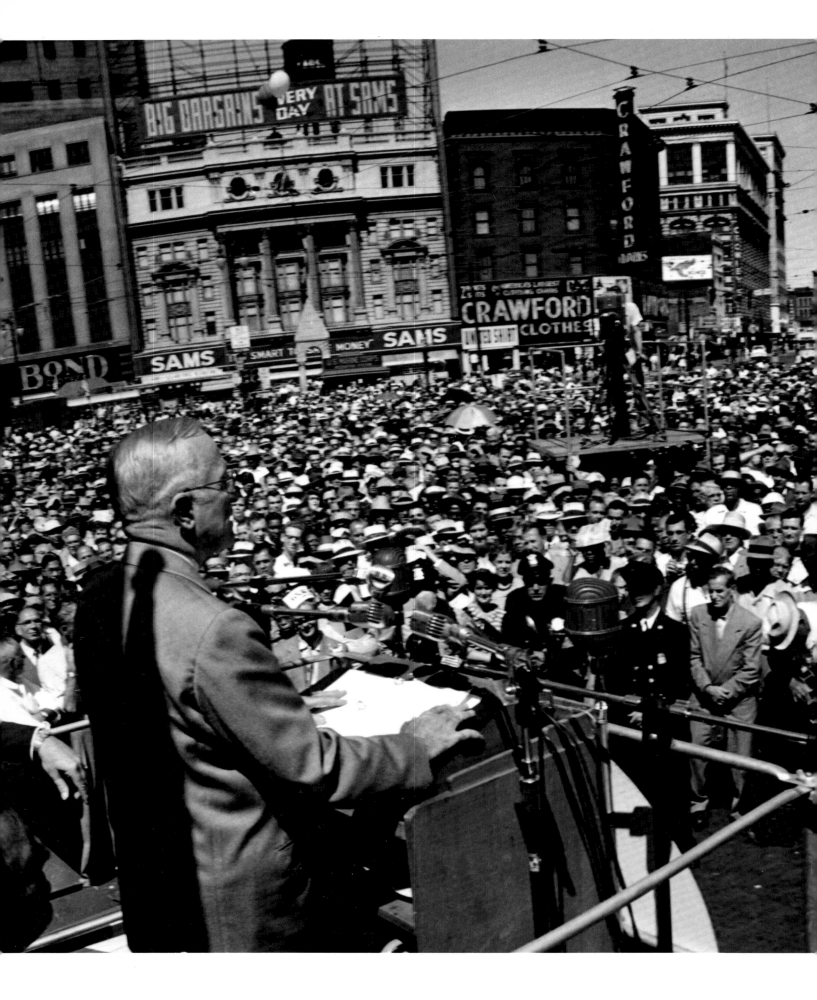

DETROIT, 1953

Detroit has had a good Labor Day parade for years, and Harry Truman drew especially large crowds. This was taken with a Panon, a panoramic camera. I wanted to get the whole, historic picture.

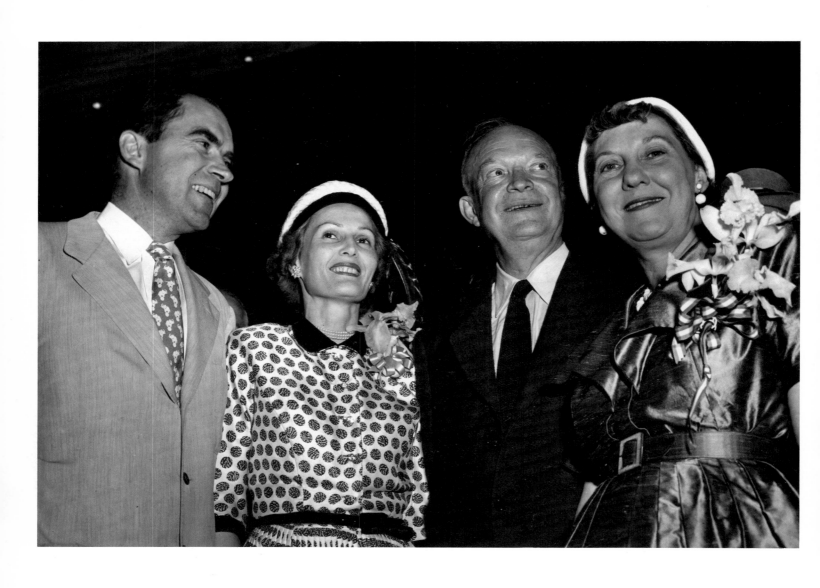

CHICAGO, 1952

**Richard and Pat Nixon and Dwight and Mamie Eisenhower
smile after the men were nominated for vice-president and
president at the 1952 National Republican Convention.**

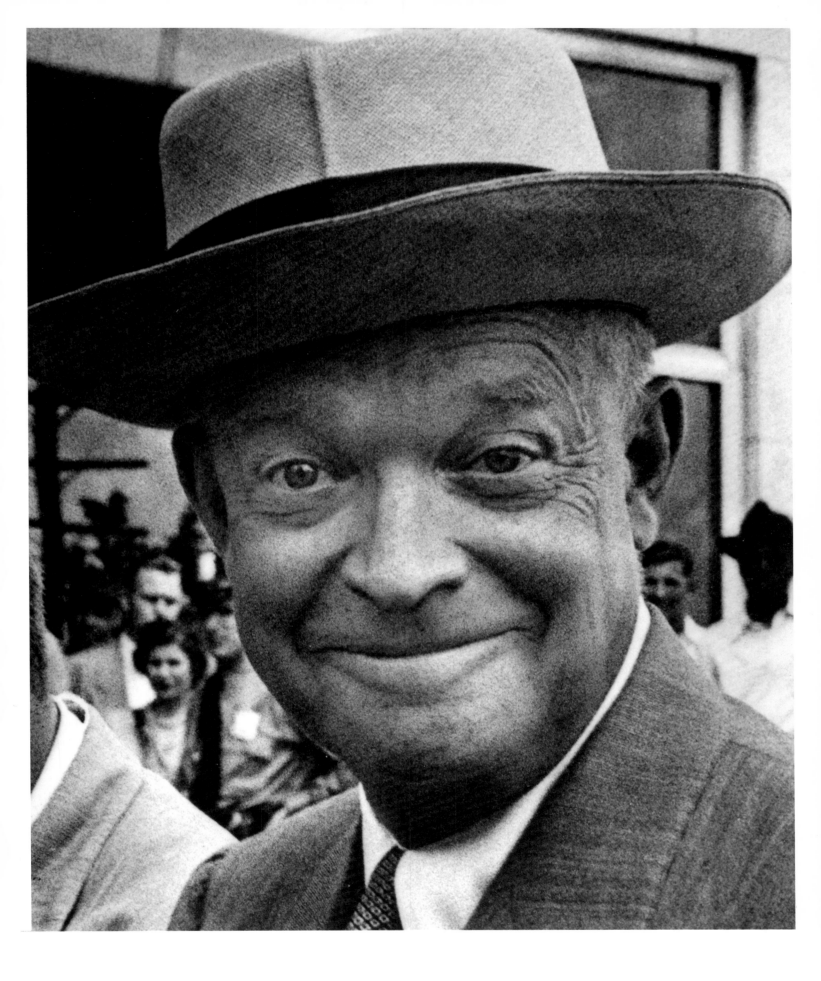

DETROIT, 1952
**Gen. Eisenhower was campaigning in front of the Book
Cadillac Hotel. Always photogenic, he knew where the
camera was and played to it.**

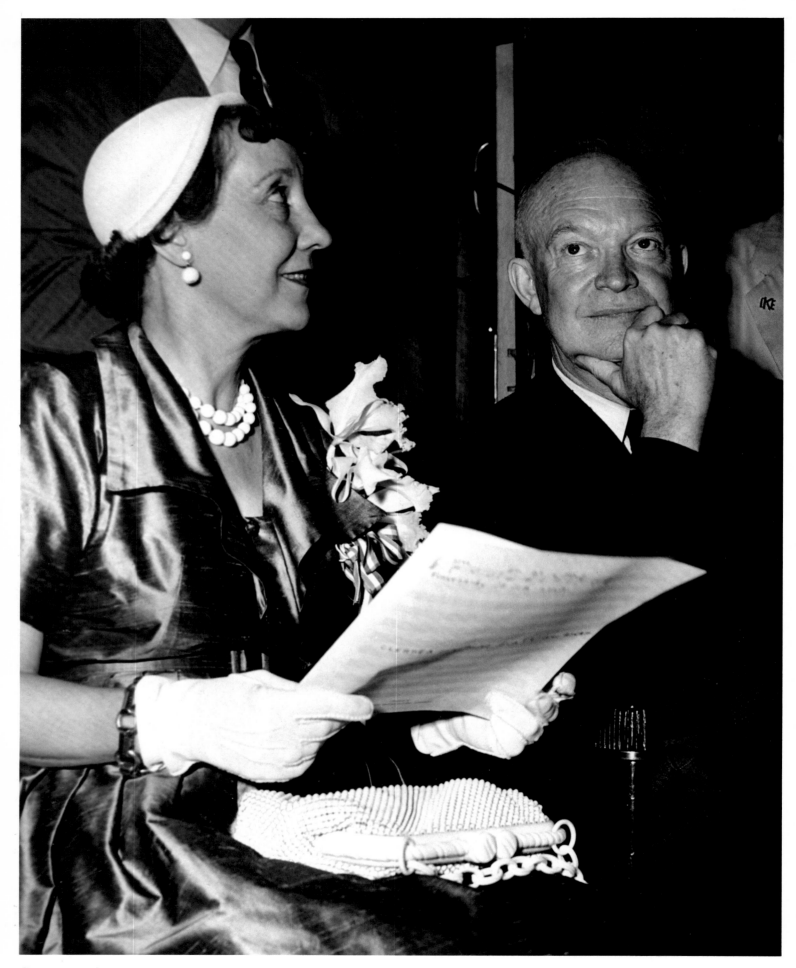

CHICAGO, 1952

In those days, once the Secret Service got to know you, you didn't have much of a problem with access. This shot of Mamie and Ike was taken right after the nomination with a 4-by-5 Speed Graphic.

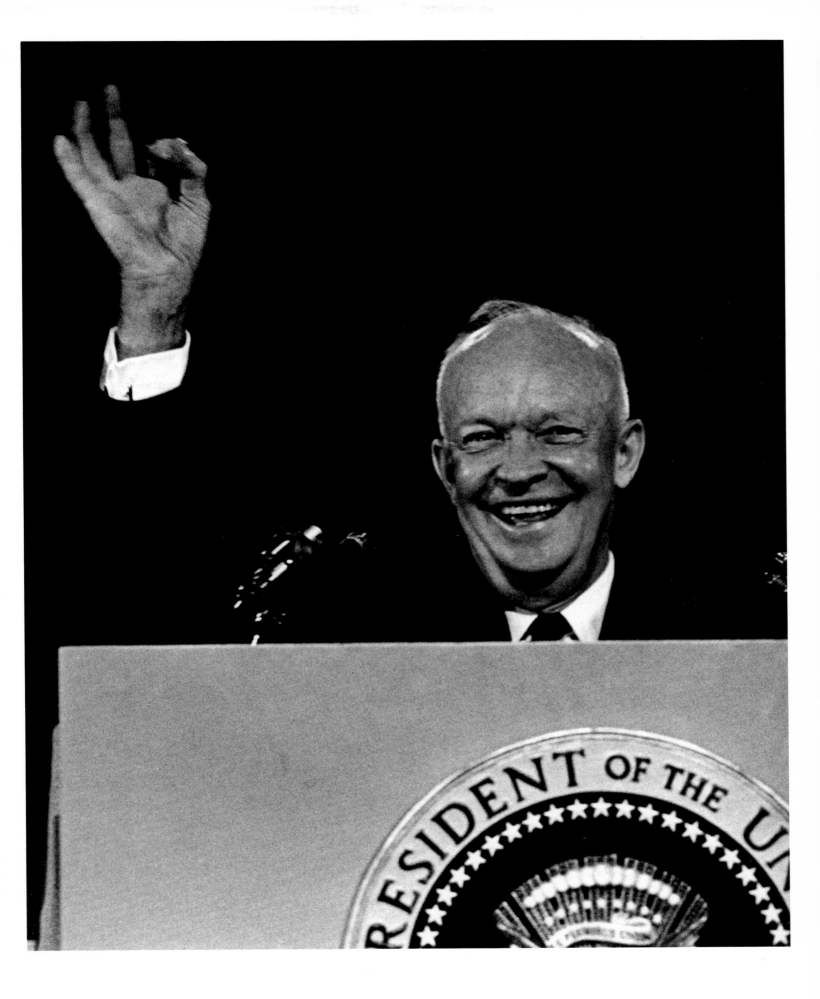

CHICAGO, 1956

Dwight David Eisenhower gives an OK sign during the National Republican Convention.

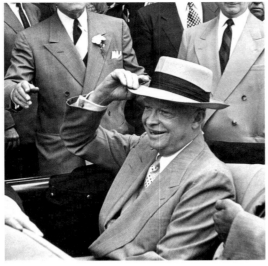
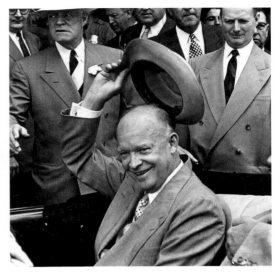
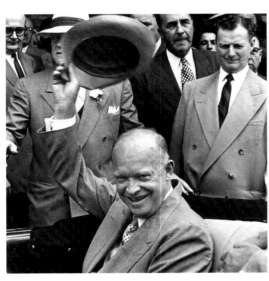
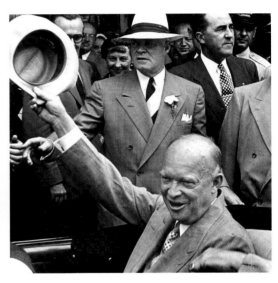
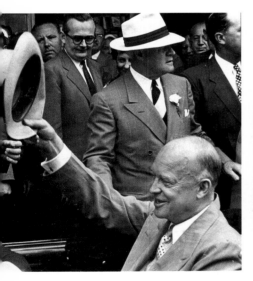
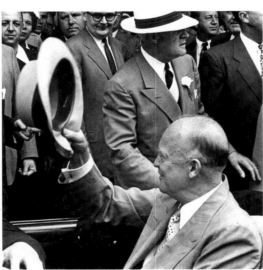
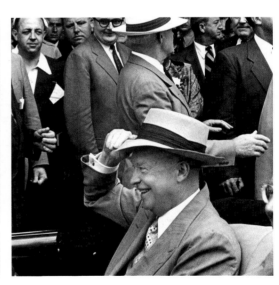

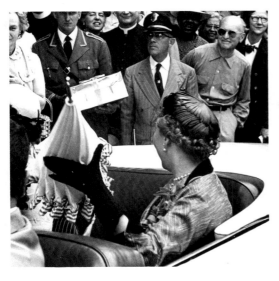
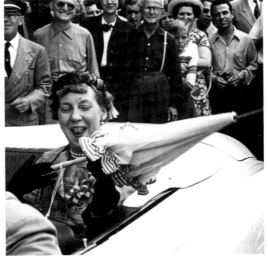
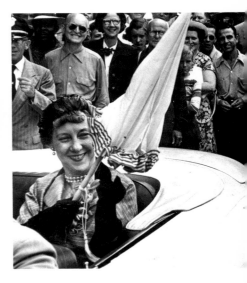
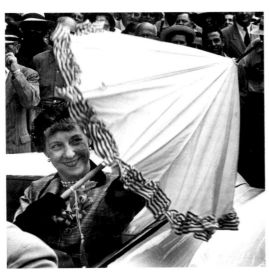
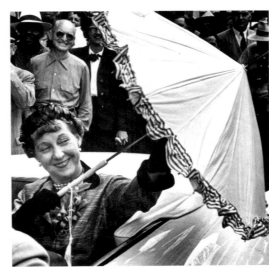
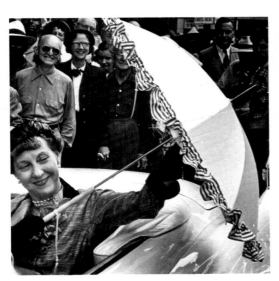
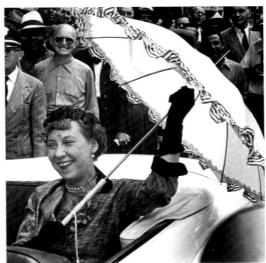
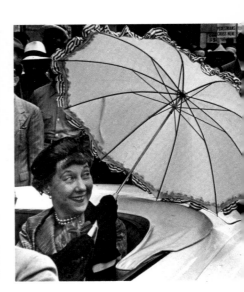

DETROIT, 1952

During the 1952 presidential campaign, I had a sequence camera, a modified movie camera. I wanted to get something different. These were taken with an Eyemo 35mm movie camera that I converted to take still pictures by altering the shutter mechanism; that increased the shutter speed to 1/560th per second when shooting 12 frames per second. When Eisenhower got into the car, he tipped his hat to the crowd. You can see Mamie in the back in some frames, getting ready to get into her car, where she opened her umbrella. The camera held a 100-foot spool of 35mm film; I just shot about 10 feet of film on each of them. We ran a back page on both of them.

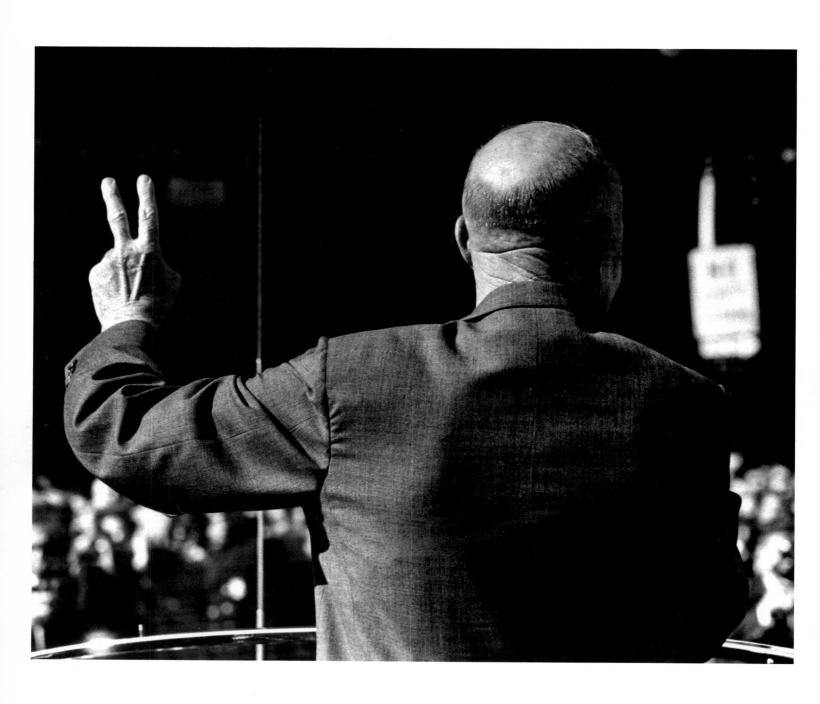

DETROIT, 1960

President Eisenhower gives the victory sign for Richard
Nixon during a campaign appearance at Cobo Hall.
Eisenhower was the first president I got to know. He always
noticed the many kinds of cameras I carried and would ask
questions about them. One time Eisenhower was at a dinner
with Lester (Tex) Colbert, who was chairman of Chrysler. I
had my Panon wide-angle camera, one of the first in the press
corps. The lens moved across the film, so it could take a
picture across 140 degrees. Eisenhower said, "What kind of
camera is that?" and we talked about it.

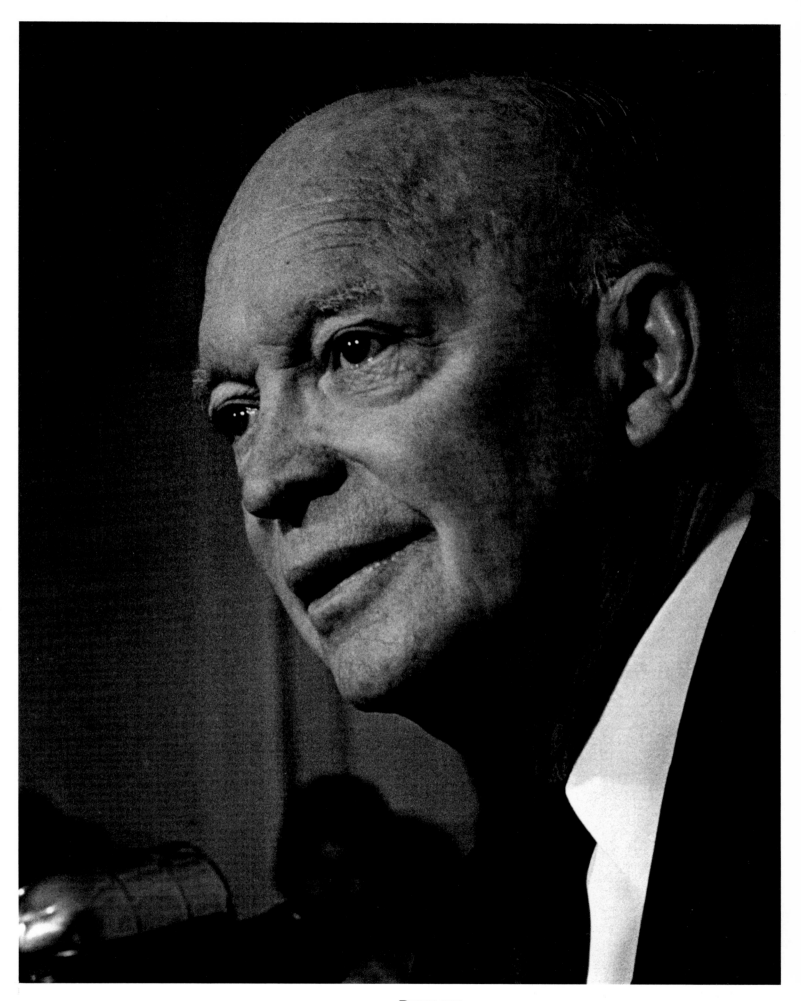

DETROIT, 1960
This was in Cobo Hall, during the campaign for Nixon. Ike autographed it for me. He liked the picture.

111 □ PRESIDENTS

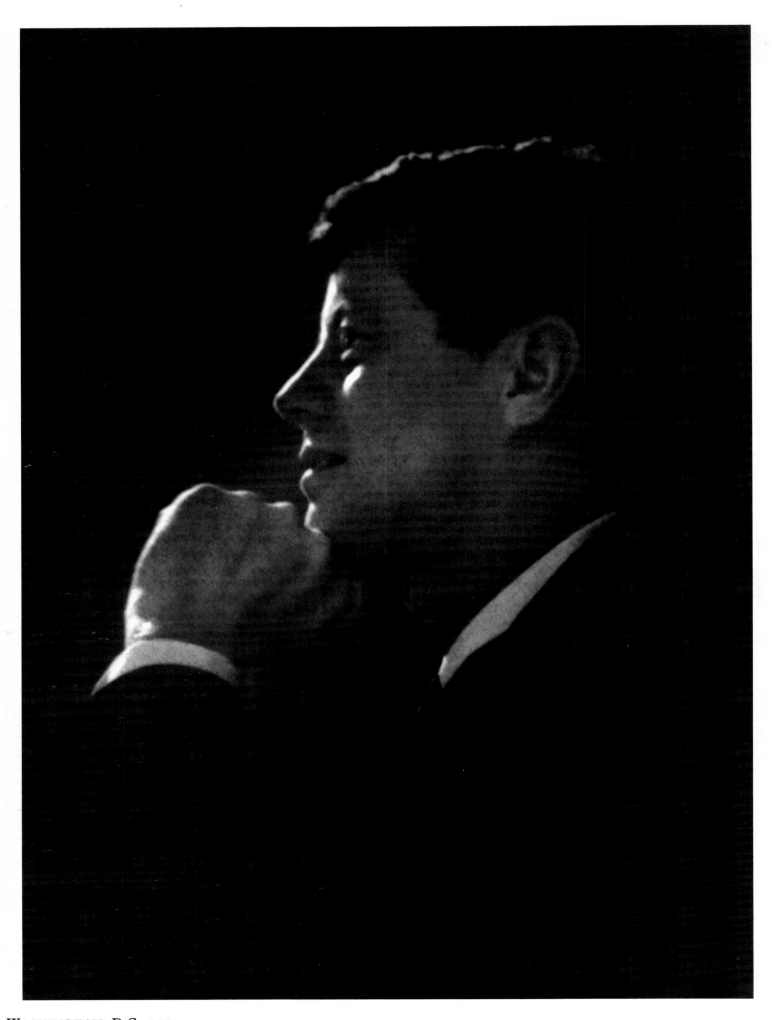

WASHINGTON, D.C., 1961
President John Fitzgerald Kennedy.

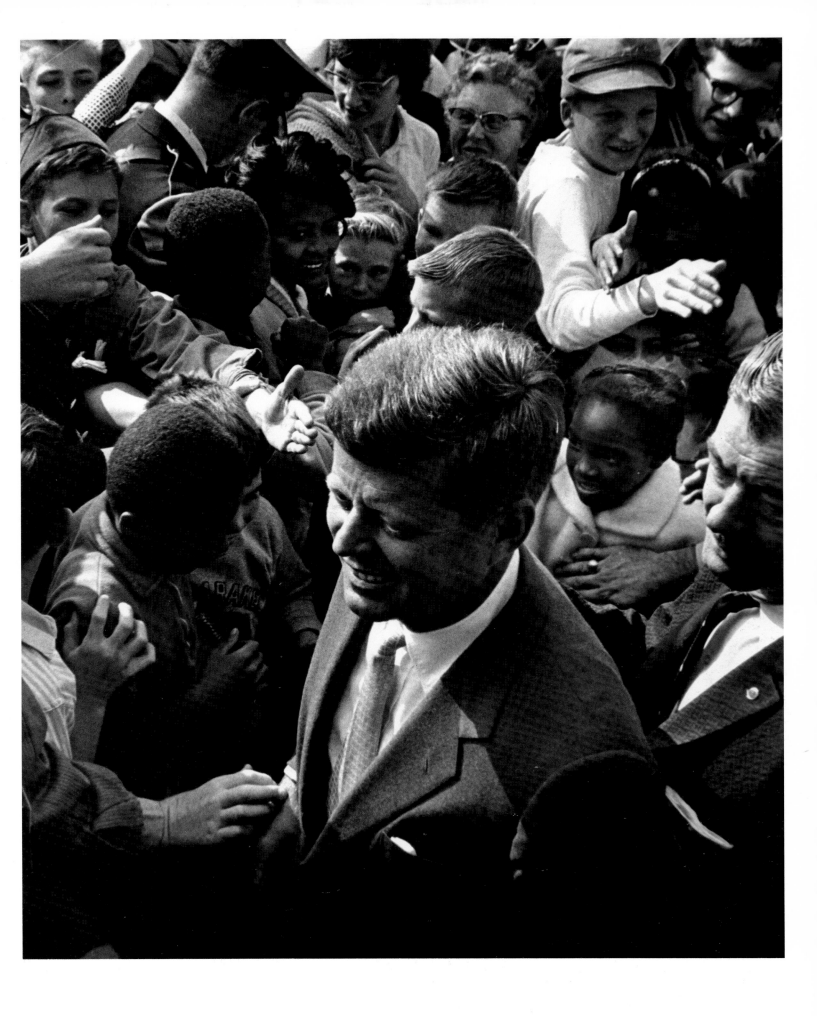

DETROIT, 1960
Kennedy mingles with the crowd.

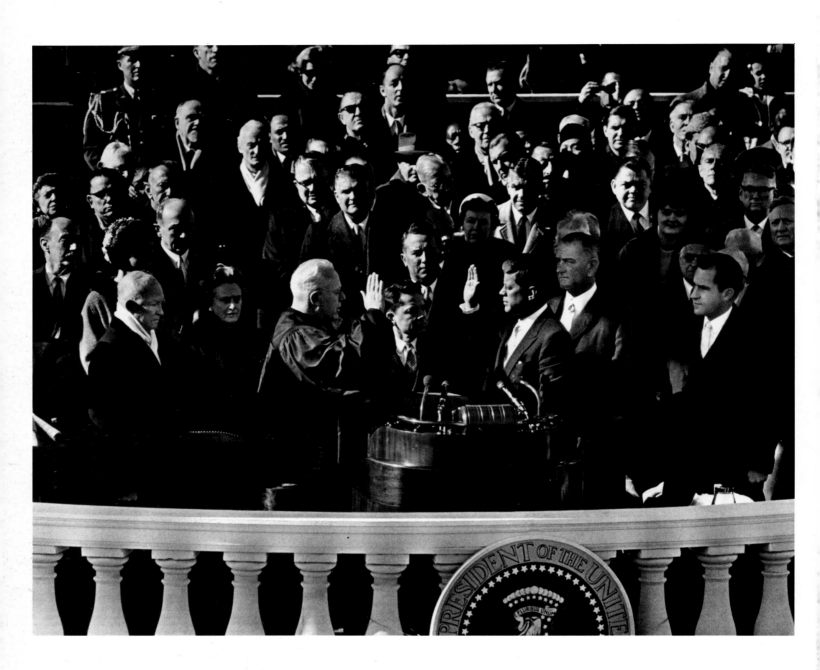

Washington, D.C., 1961

The inauguration of John Fitzgerald Kennedy, the 35th
president of the United States of America. Administering the
oath of office is Chief Justice Earl Warren. Four presidents
are seen in this photograph: Outgoing president Dwight
Eisenhower, Kennedy taking the oath of office, Vice-
President Lyndon Johnson and outgoing vice-president
Richard Nixon. I decided to go for the scene instead of just the
close-up, because it was so historic.

President John Kennedy's inaugural address (opposite):
"Ask not what your country can do for you; ask what you can
do for your country."

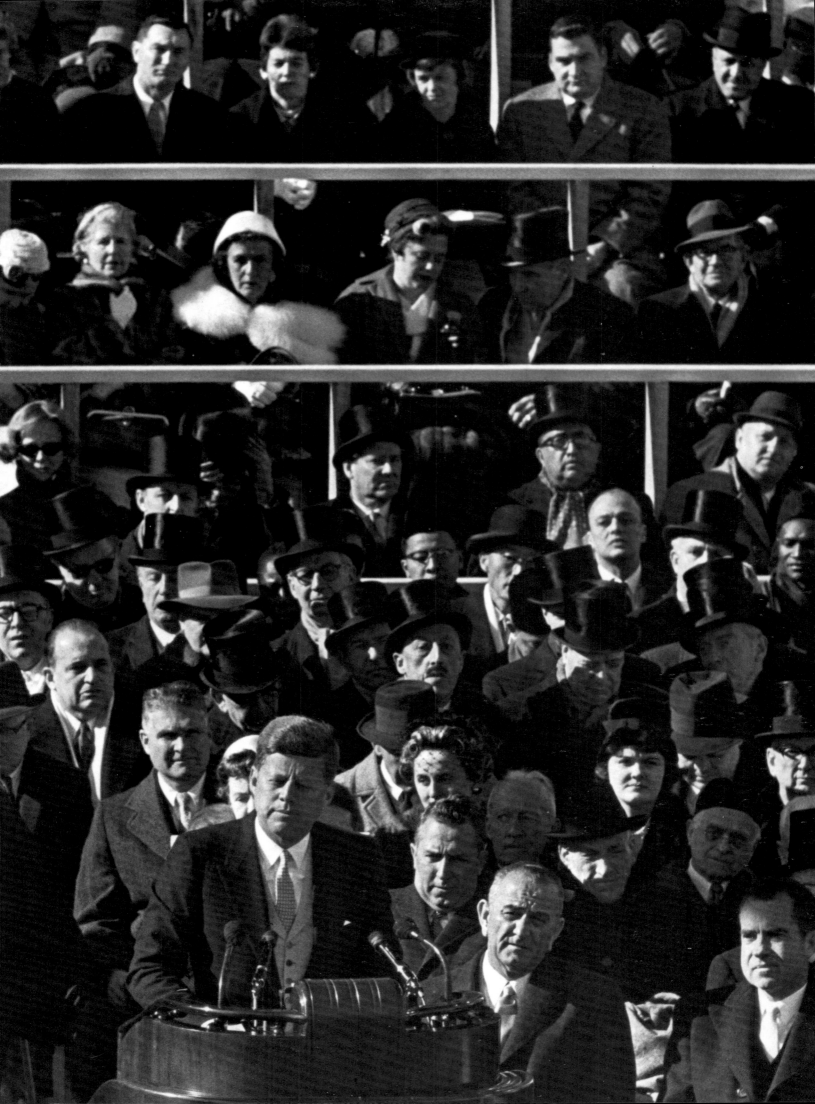

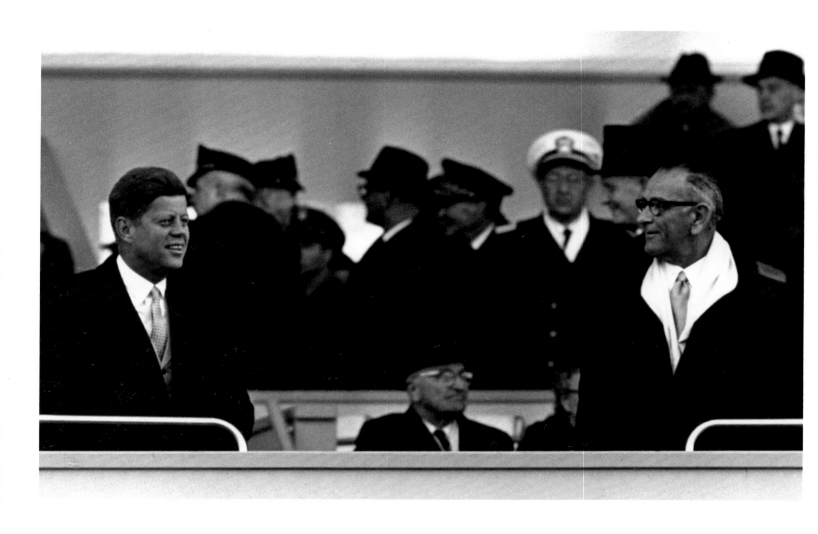

WASHINGTON, D.C., 1961
President Kennedy and Vice-President Johnson each gaze into the crowd. Former President Harry Truman is seated in the center. This is on the inaugural parade reviewing stand in front of the White House.

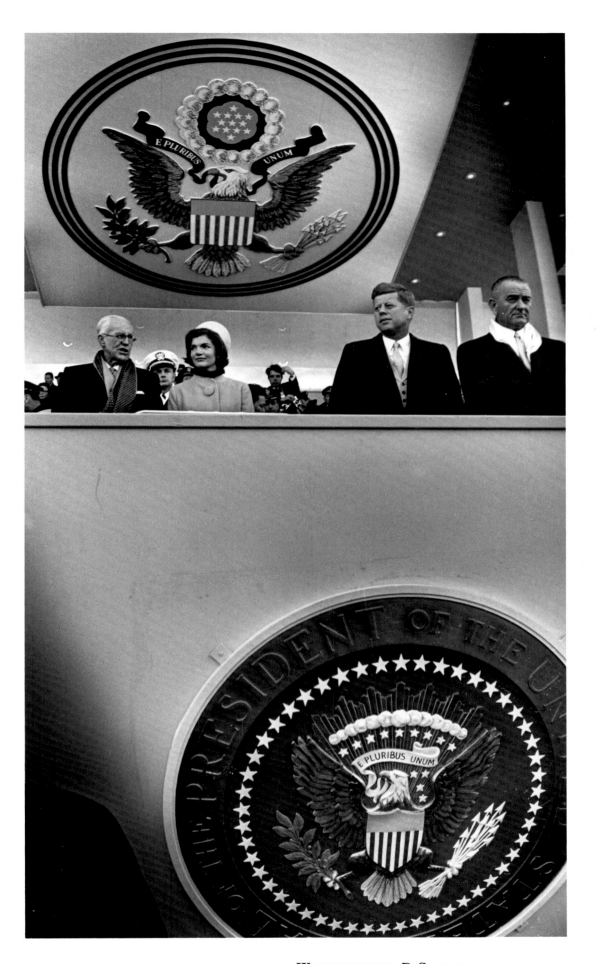

WASHINGTON, D.C., 1961

At the parade reviewing stand, there were two seals, one on bottom, one on top, and I wanted to get them both in one shot. Watching the parade are Joseph Kennedy, the president's father, First Lady Jacqueline, President Kennedy and Vice-President Johnson.

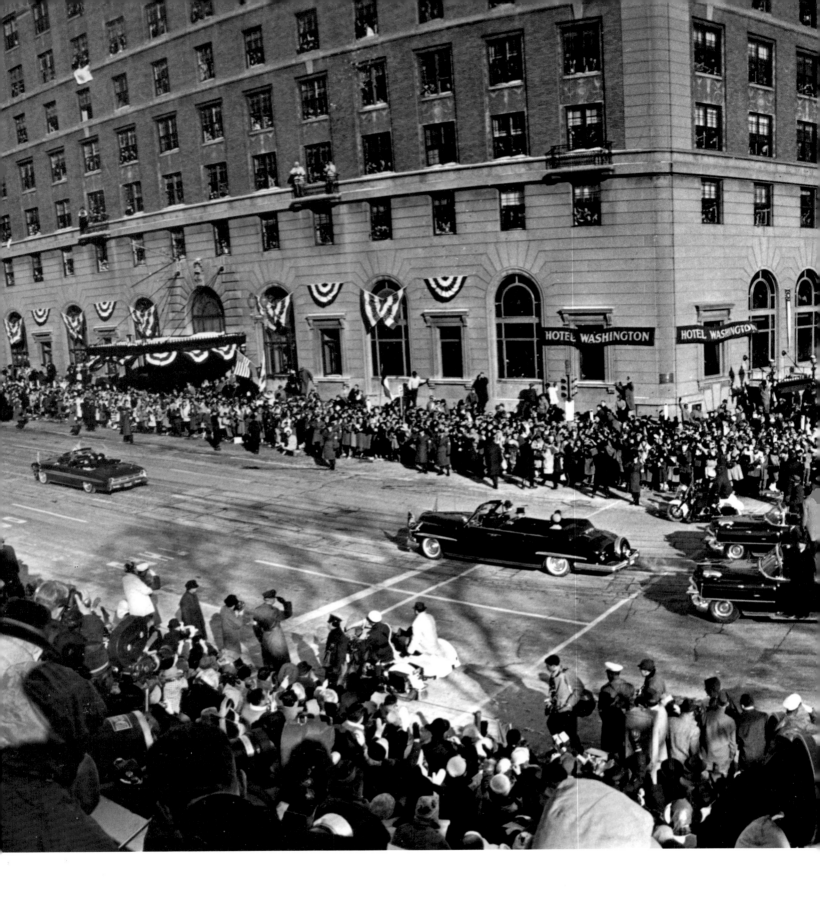

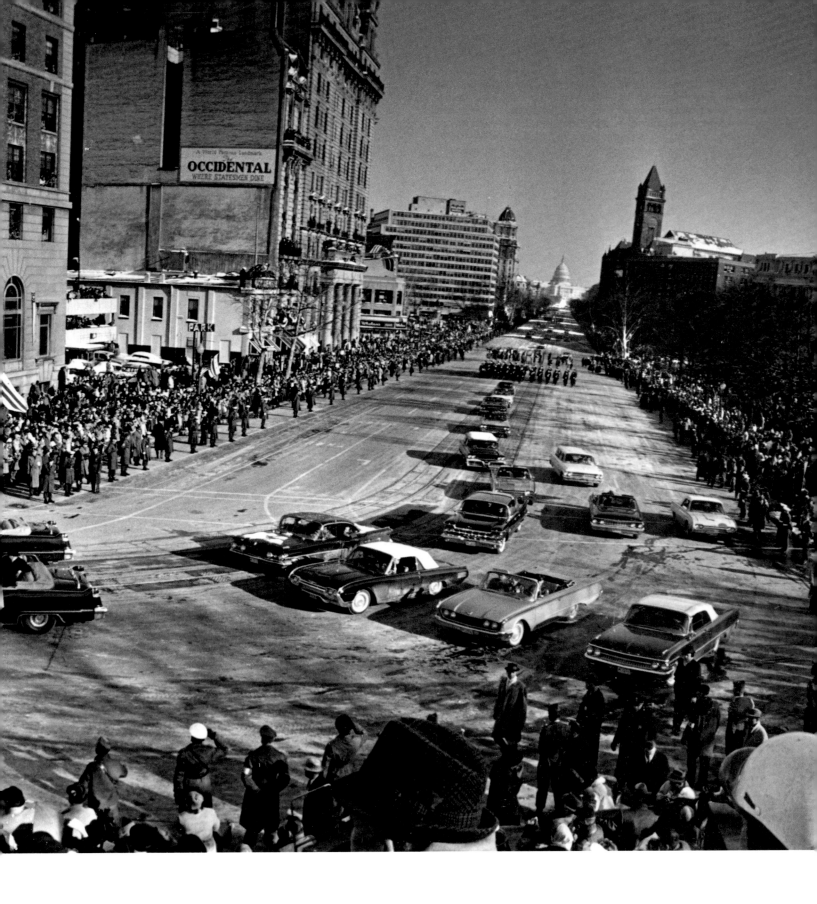

WASHINGTON, D.C., 1961
The inaugural parade makes its way down Constitution
Avenue to the reviewing stand in front of the White House. It
had snowed eight inches in Washington the previous day, but
the three-mile parade route had been plowed completely.

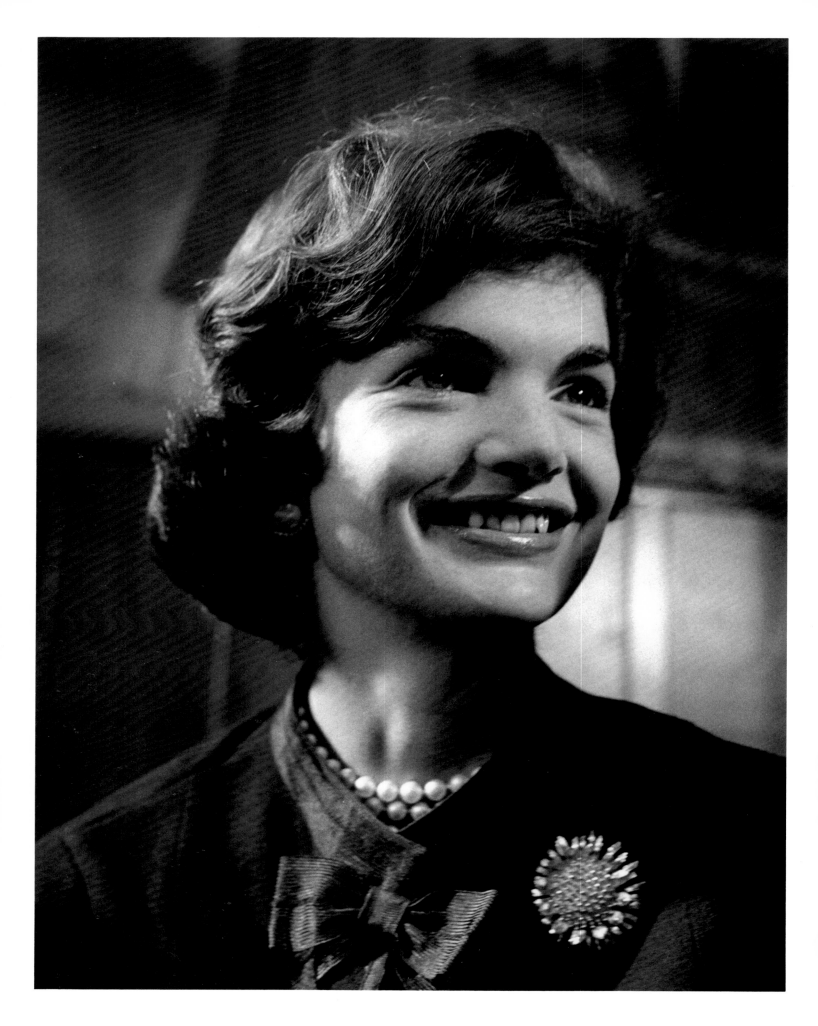

WASHINGTON, D.C.
Jacqueline Kennedy

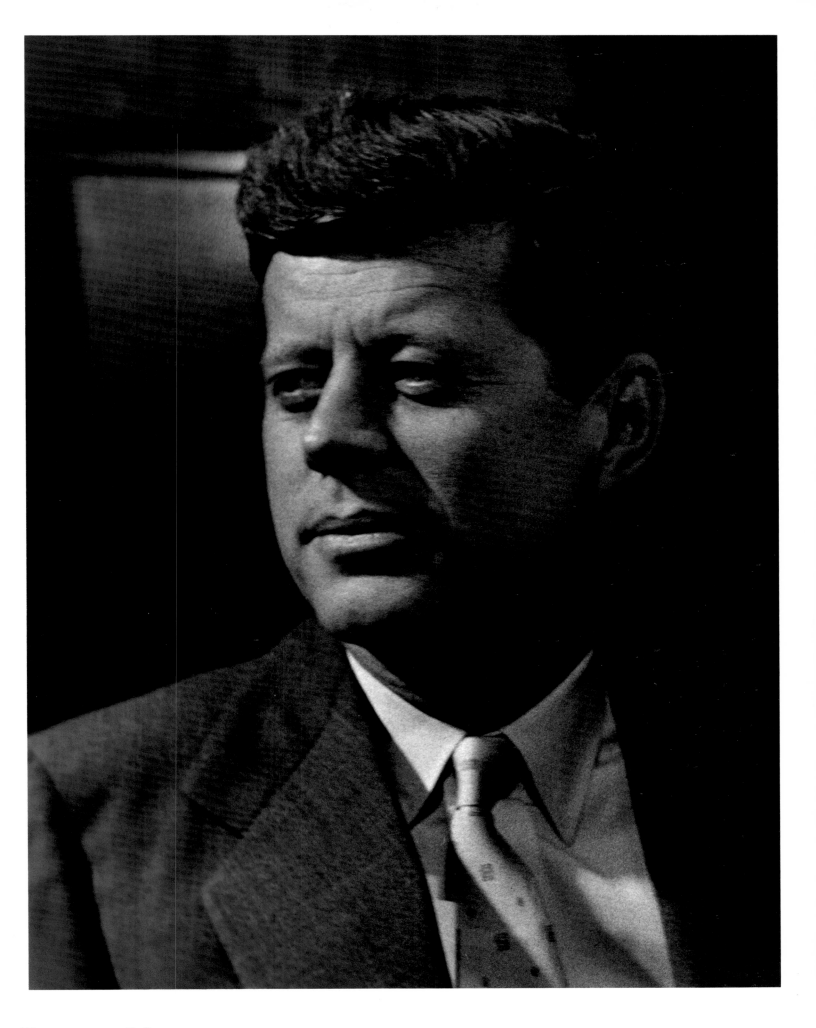

WASHINGTON, D.C.
President John Kennedy

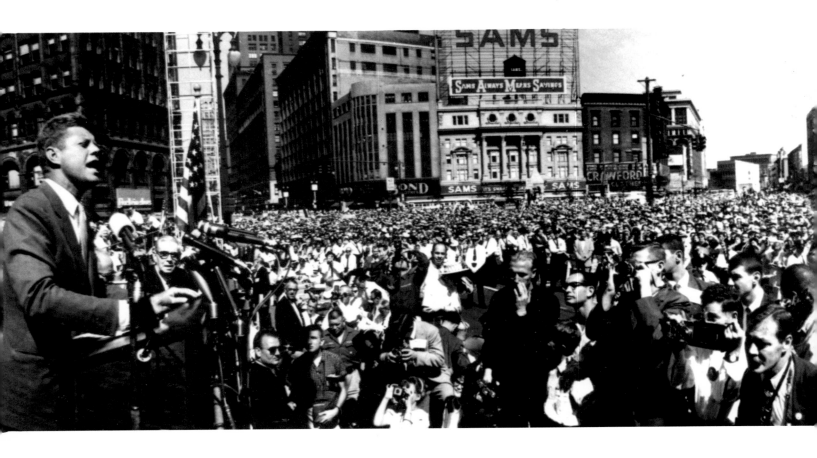

They were twins in many ways, although they were not born together.

John Fitzgerald Kennedy was born May 29, 1917, brother Robert Francis Kennedy on Nov. 20, 1925. In their mid-years — when Jack decided to seek the presidency — they became united in philosophy and purpose. Bobby served Jack as attorney general. In a strange way, they died together, struck down by the guns of assassins sick with hate. It was a long journey from the time a bullet entered the head of John Kennedy to the time another bullet entered the head of Robert Kennedy — from Nov. 22, 1963, to June 5, 1968.

THE KENNEDYS IN KENNEDY SQUARE, 1960 AND 1968

Two brothers, two presidential campaign speeches in Detroit, eight years apart.

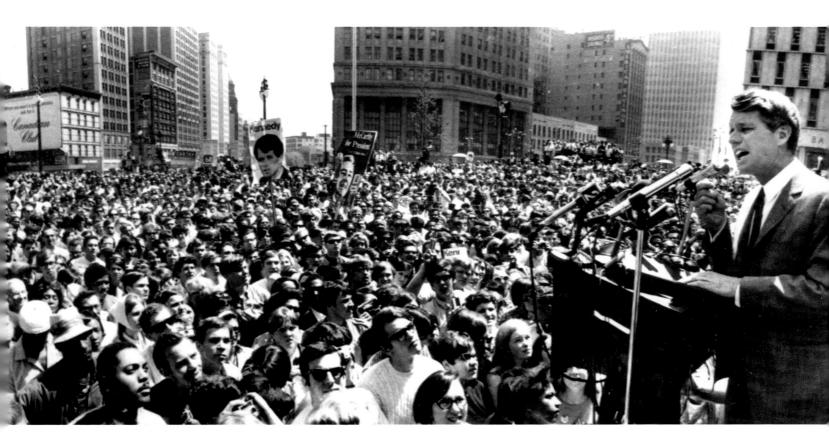

I photographed Jack and Bobby
Kennedy eight years apart, using the
identical camera. The time of the day
was the same, even the weather was the
same, with clear skies and temperatures
in the high eighties on both days.

I fused the two pictures together,
forming one of the most unique pictures
of my career.

When John Kennedy made a
presidential campaign speech there on
Labor Day, 1960, it was called Cadillac
Square. Eight years later, when Robert
Kennedy spoke there on May 15, 1968,
it was Kennedy Square. Three weeks
later, he died.

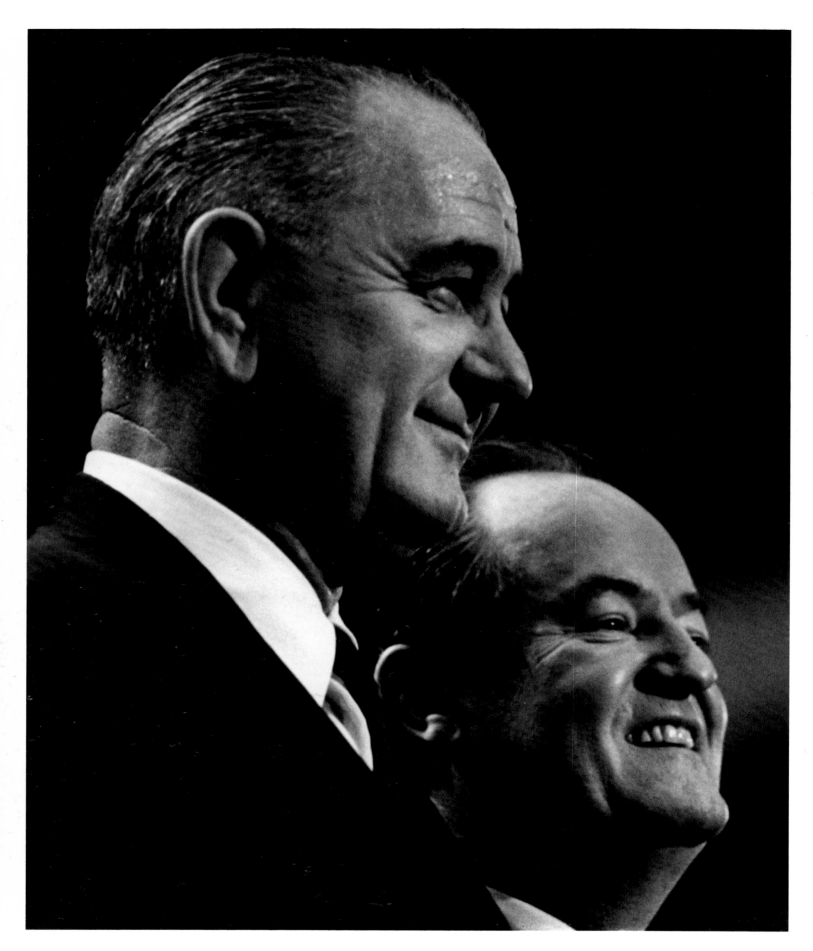

ATLANTIC CITY, 1964

I took this at the Democratic National Convention, when
Lyndon Johnson was president and Hubert Humphrey was
nominated to be his vice-president. Johnson called me at the
Free Press. He was giving a party, and he wanted this photo
on the invitations. I told him he could borrow the negative. He
returned it with a nice letter, autographing the picture.

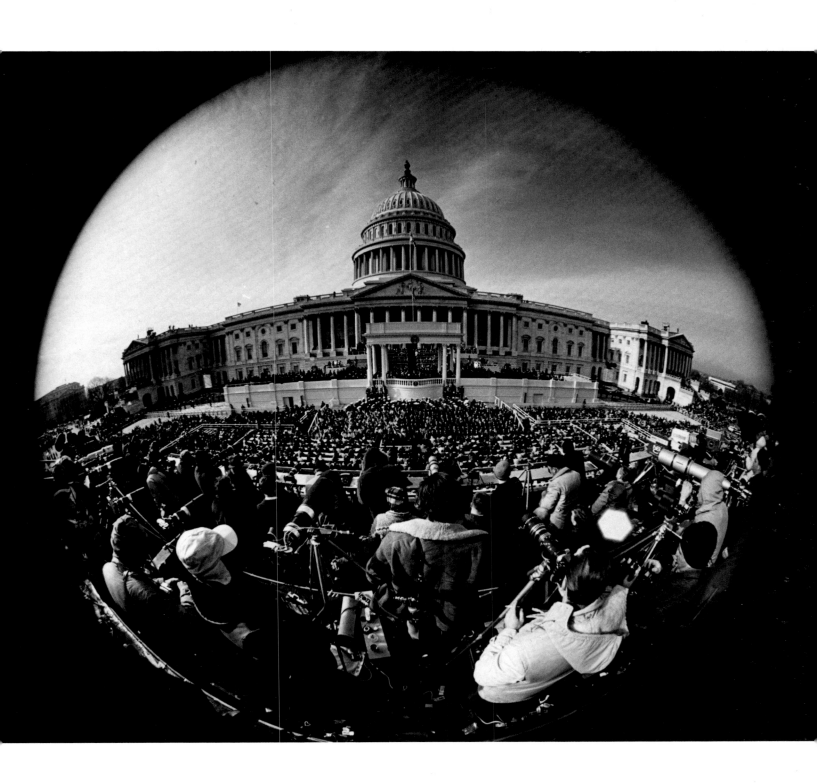

WASHINGTON, D.C., 1965

He first took the oath of office aboard Air Force One in
Dallas, after Kennedy's assassination. But now Johnson had
won the job at the polls and the U.S. Capitol was ready for his
inauguration, Jan. 20. A fish-eye lens captures 180 degrees
horizontal and vertical. You capture the feel of everything,
the whole Capitol, all the people, the photographers, the
media. An overall picture preserves the sense of an historic
moment. I always find a way to do that, on anything I cover.

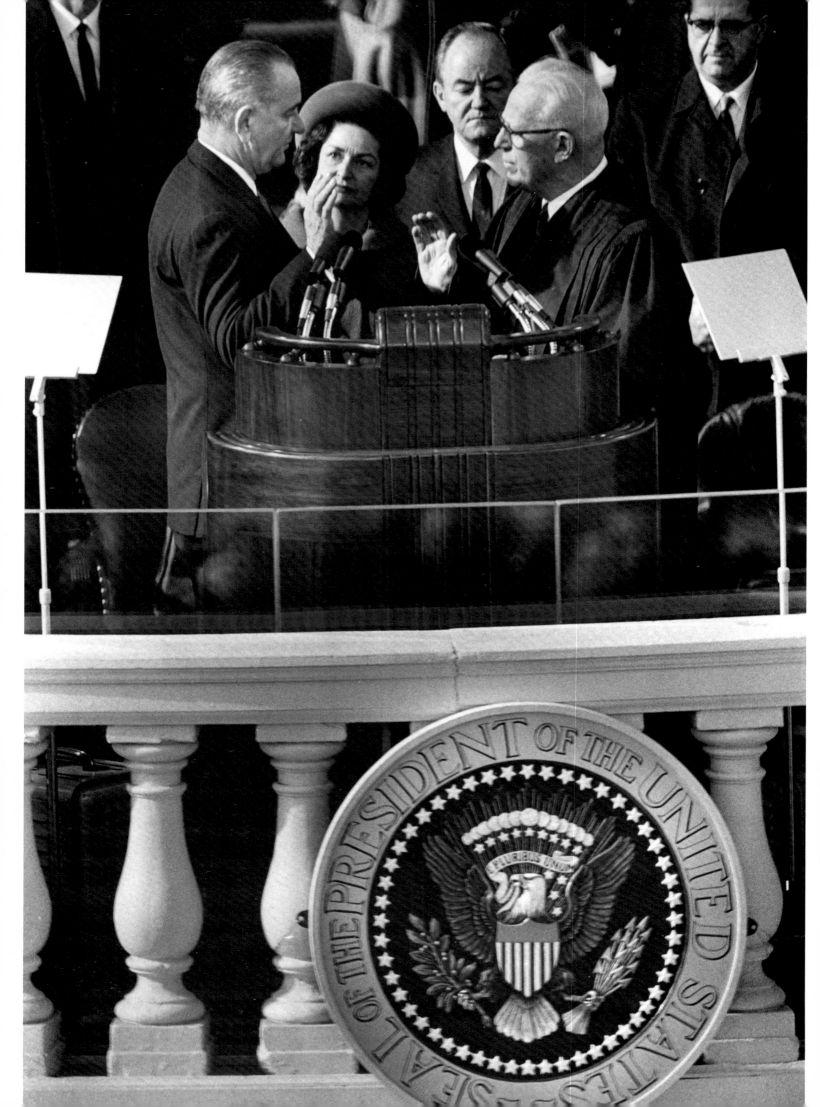

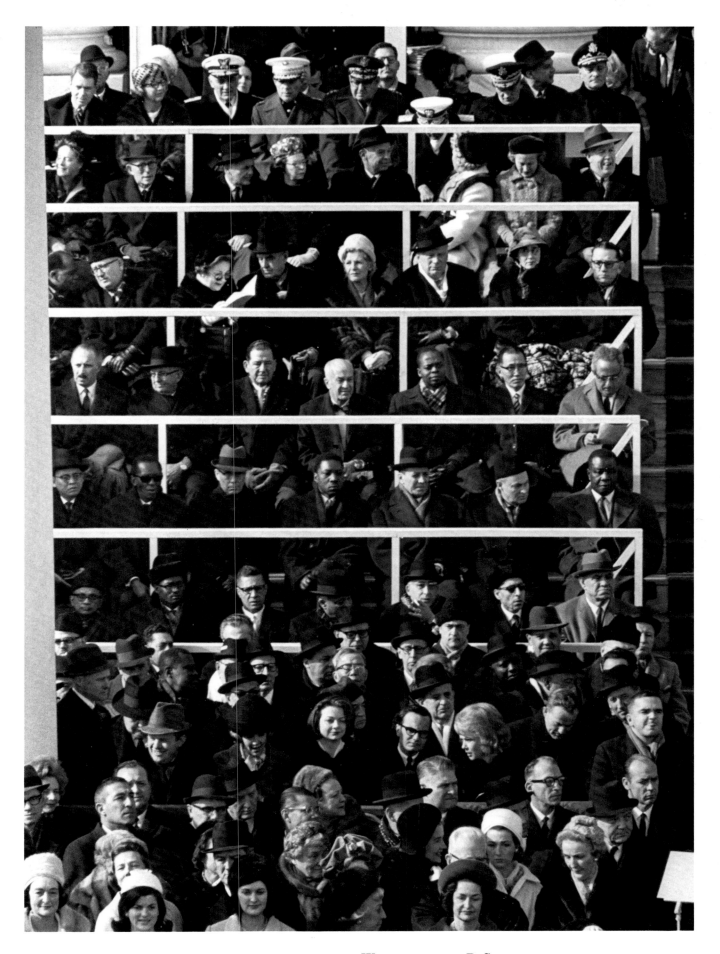

WASHINGTON, D.C., 1965
Lyndon Baines Johnson is sworn in as the 36th president of the United States of America by Supreme Court Chief Justice Earl Warren (left). Lady Bird and Hubert Humphrey stand by. Johnson family members Luci, Lynda and Lady Bird (above) are in the front row of the stands in front of the Capitol steps.

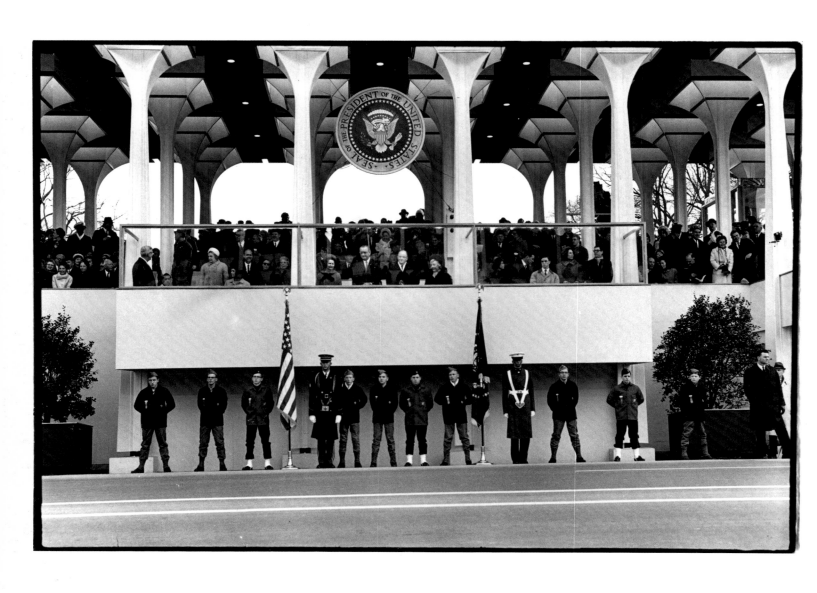

WASHINGTON, D.C., 1965
**The presidential parade reviewing stand in front of the White
House. With the heightened sense of security following John
Kennedy's assassination, this stand was built with bullet-
proof glass.**

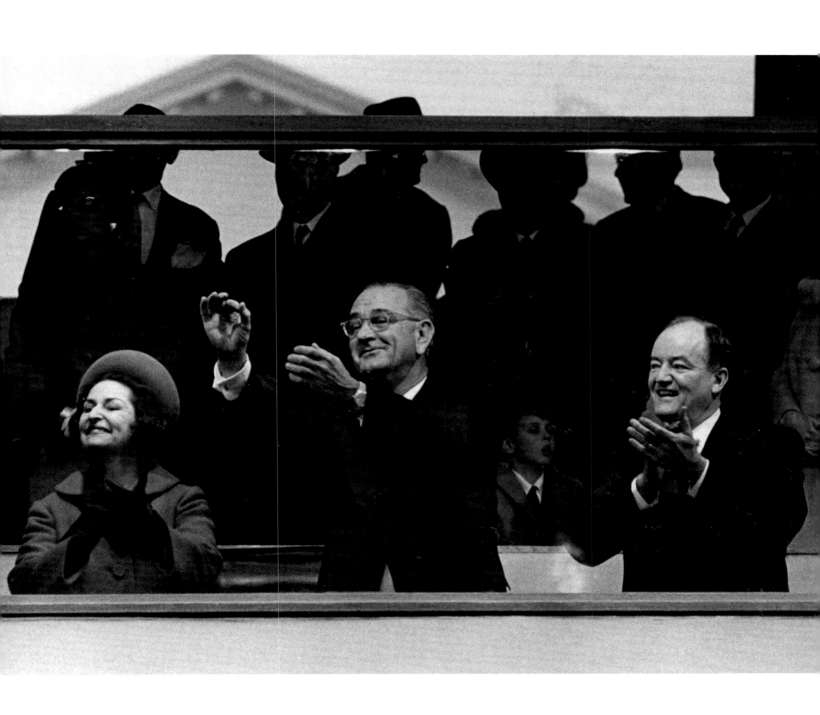

WASHINGTON, D.C., 1965
**Lady Bird, President Johnson and Vice-President Hubert
Humphrey enjoy the inaugural parade.**

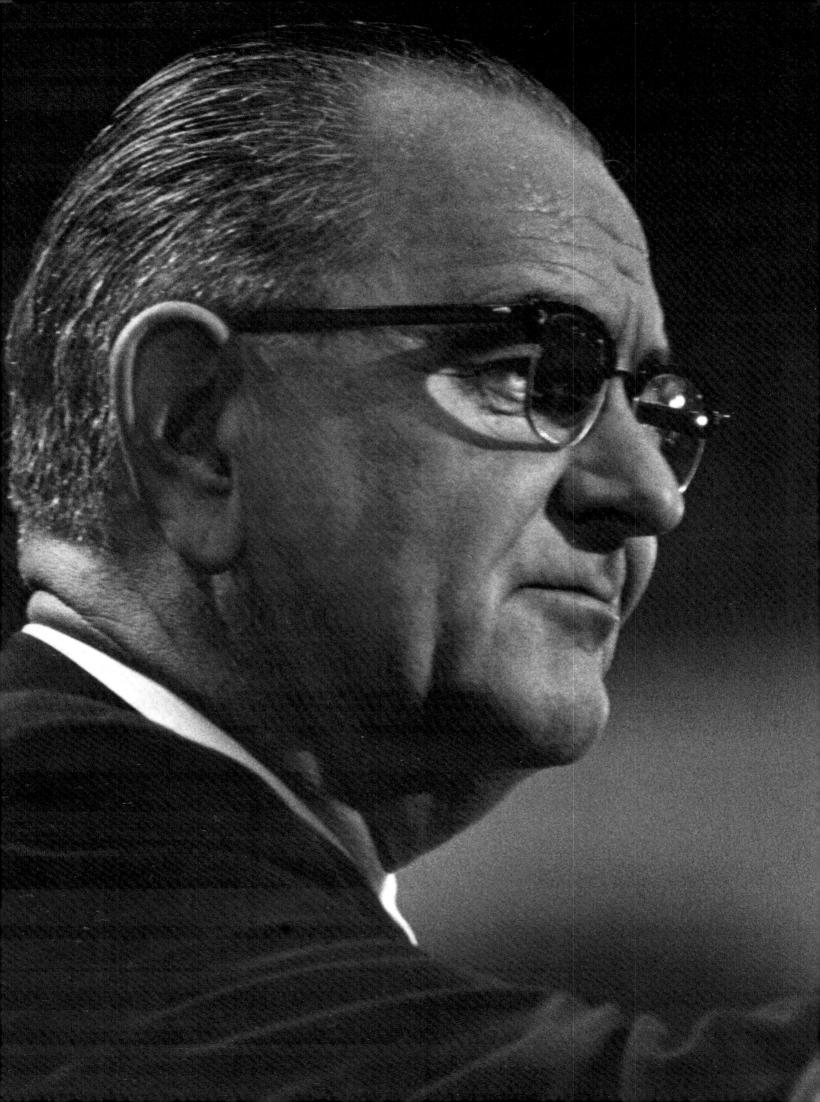

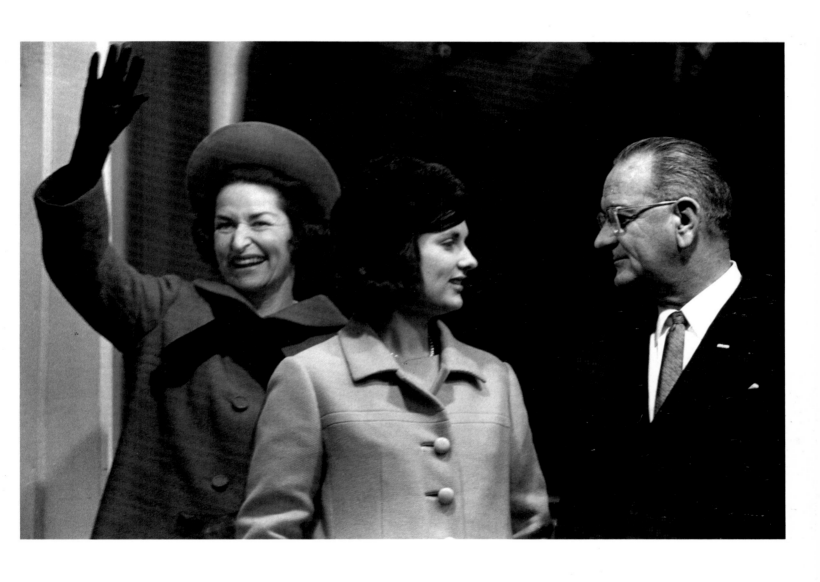

WASHINGTON, D.C., 1965
The First Lady, daughter Lynda and Lyndon Johnson during the inaugural parade, and a portrait (left) of the president.

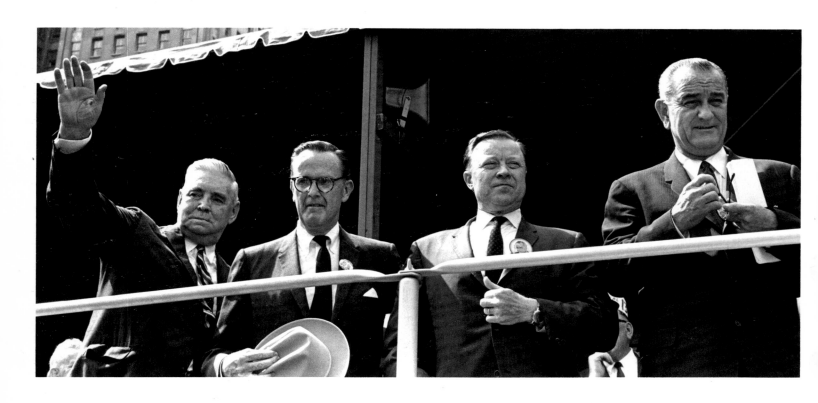

DETROIT, 1964

Президент Johnson came for the Labor Day parade. On the
stand with him, from left, are Michigan's U.S. senators, Pat
McNamara and Phil Hart, and Walter Reuther, president of
the United Auto Workers.

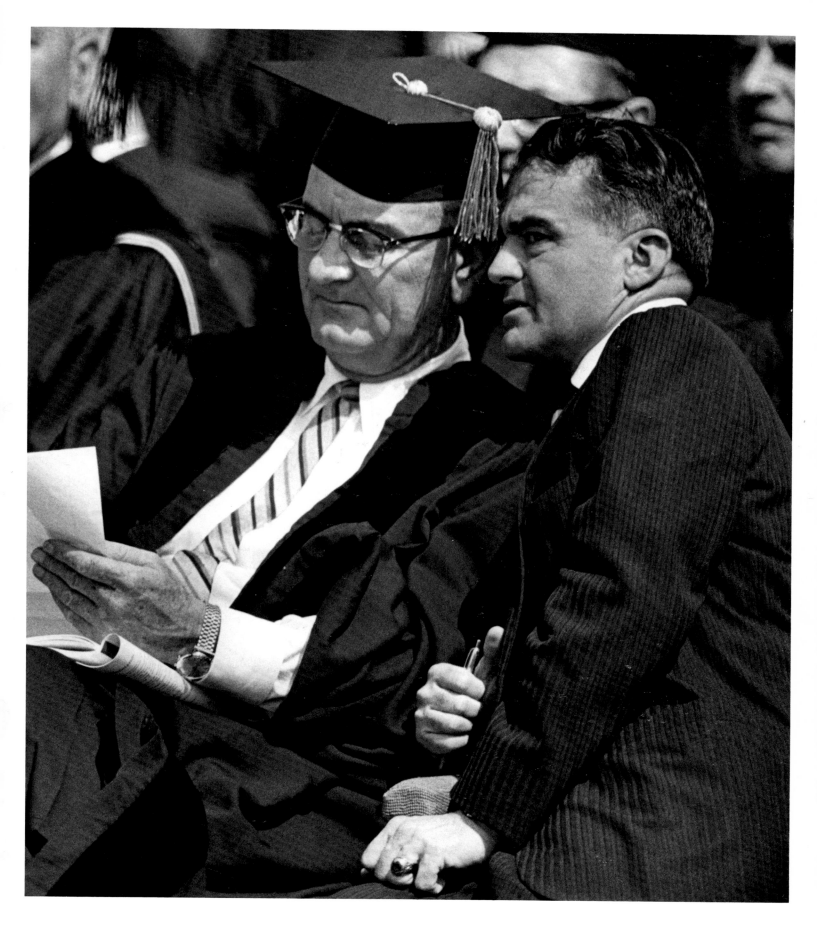

ANN ARBOR, 1964

Aide Jack Valenti with Johnson at the University of Michigan, six months to the day after he became president. Before a crowd of 90,000, he received an honorary degree and, in a 15-minute speech, outlined the theme of his presidency — to build a "Great Society."

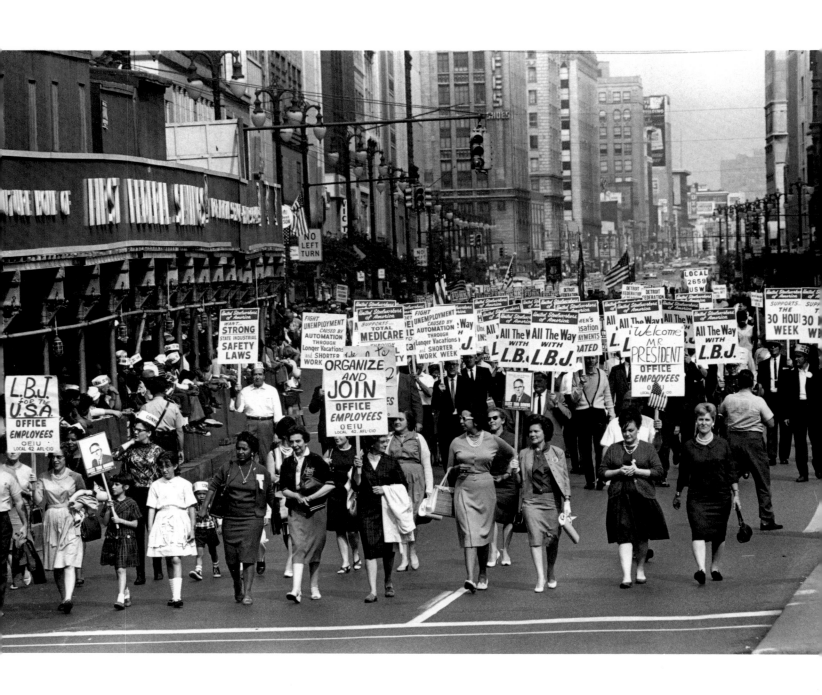

DETROIT, 1964
**Office employees show their support for President Johnson
as they march down Detroit's Woodward Avenue in the Labor
Day parade Sept. 7.**

DETROIT, 1964
Lady Bird Johnson waves at the office employees as they march past the reviewing stand at the Labor Day parade.

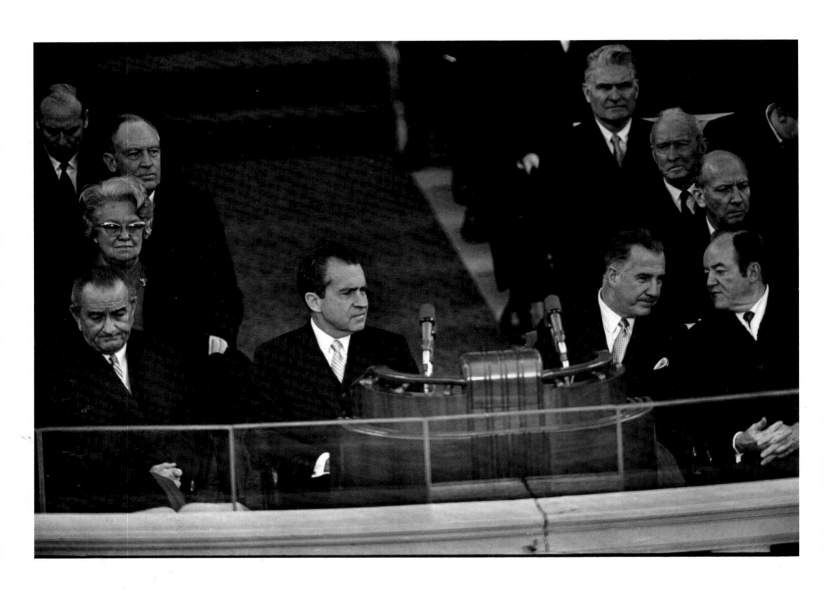

WASHINGTON, D.C., 1969
**Moments before the inauguration of Richard Nixon.
President Lyndon Johnson, President-elect Richard Nixon,
Vice-President-elect Spiro Agnew and Vice-President Hubert
Humphrey. Johnson could have run for another term, but
under pressure to resolve the Vietnam war, he decided not to.
Nixon had narrowly defeated Humphrey to win the election.**

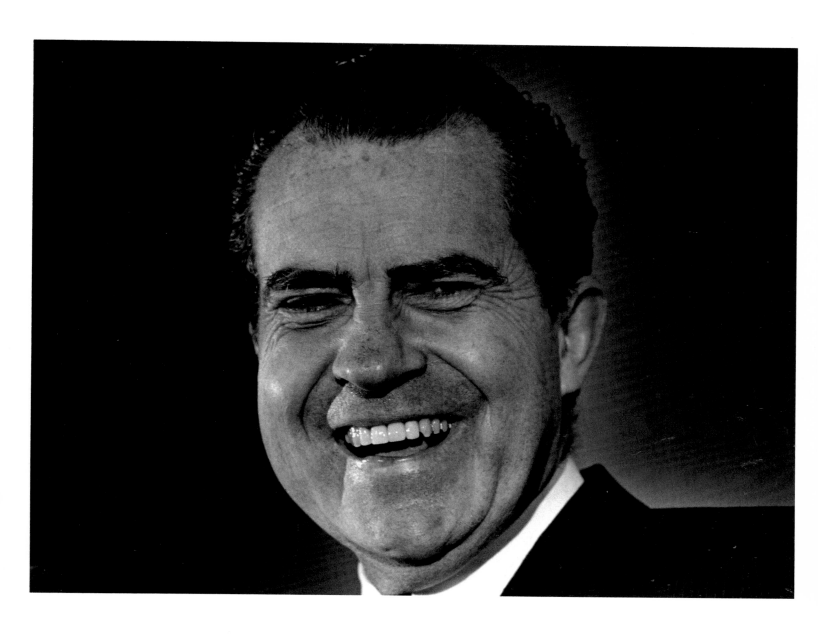

WASHINGTON, D.C.
Richard Nixon, 37th president of the United States.

141 □ PRESIDENTS

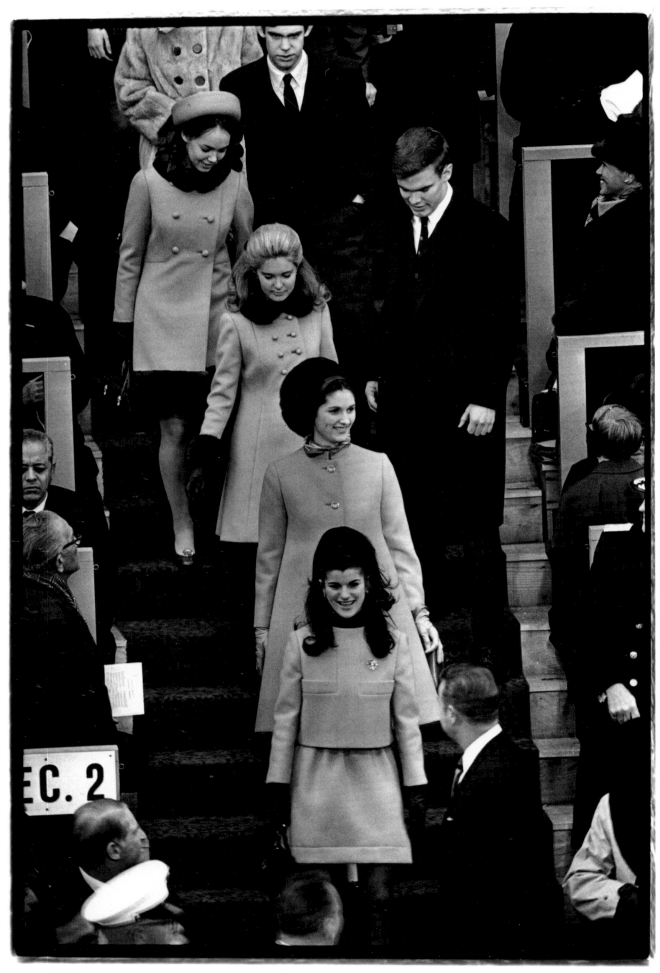

WASHINGTON, D.C., 1969

Four famous daughters at the inauguration, from top: Julie Nixon, Tricia Nixon, Lynda Johnson, Luci Johnson.

David Eisenhower and Julie Nixon Eisenhower watch the inauguration (opposite). They were married a month earlier.

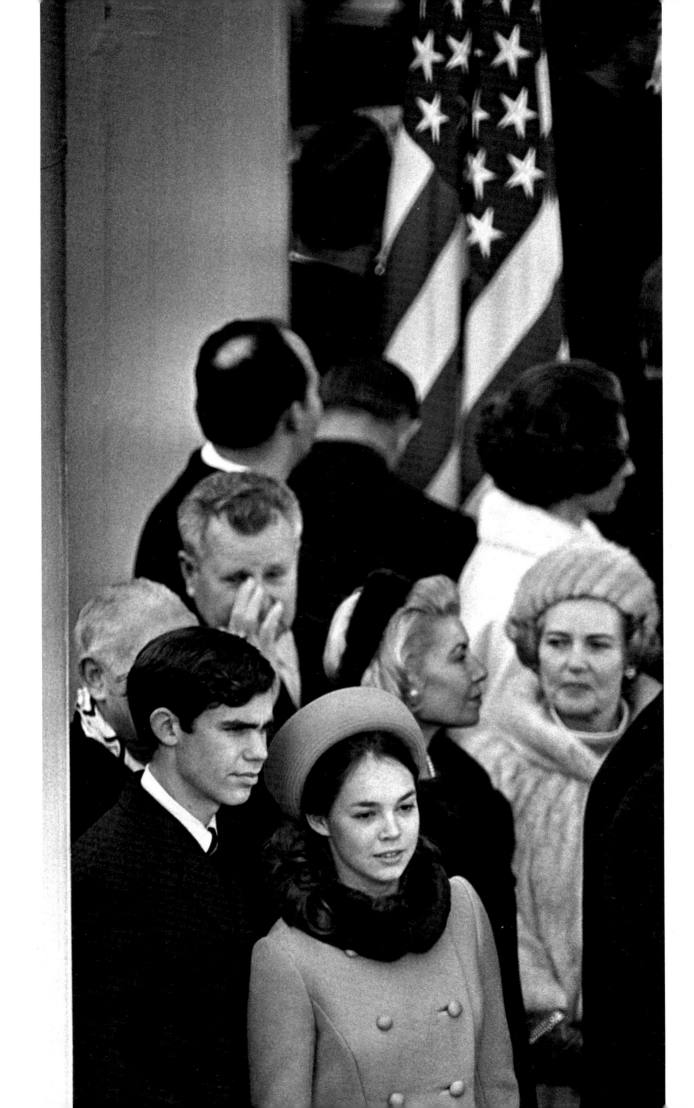

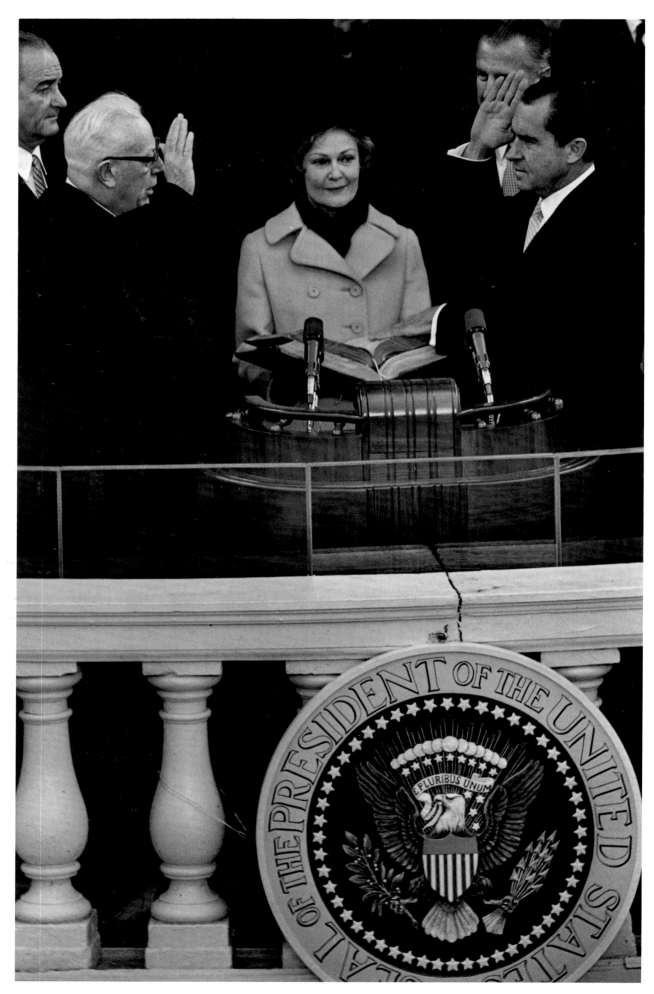

WASHINGTON, D.C., 1969
Chief Justice Earl Warren swears in Nixon. Pat holds the
family Bible.

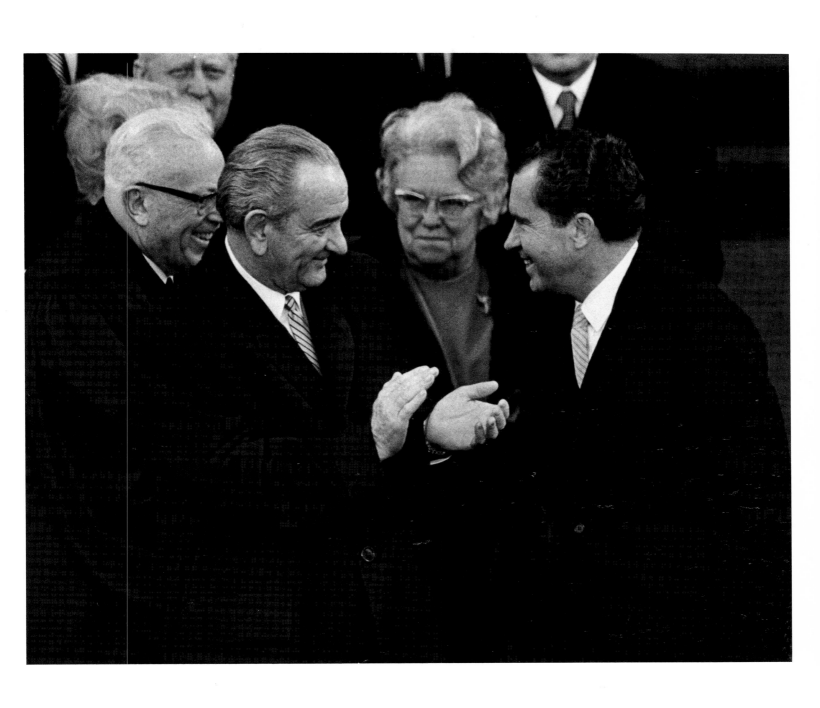

WASHINGTON, D.C., 1969

I caught a happy moment after Richard Nixon took the oath of office, as he was being congratulated by Chief Justice Warren while outgoing President Johnson applauded.

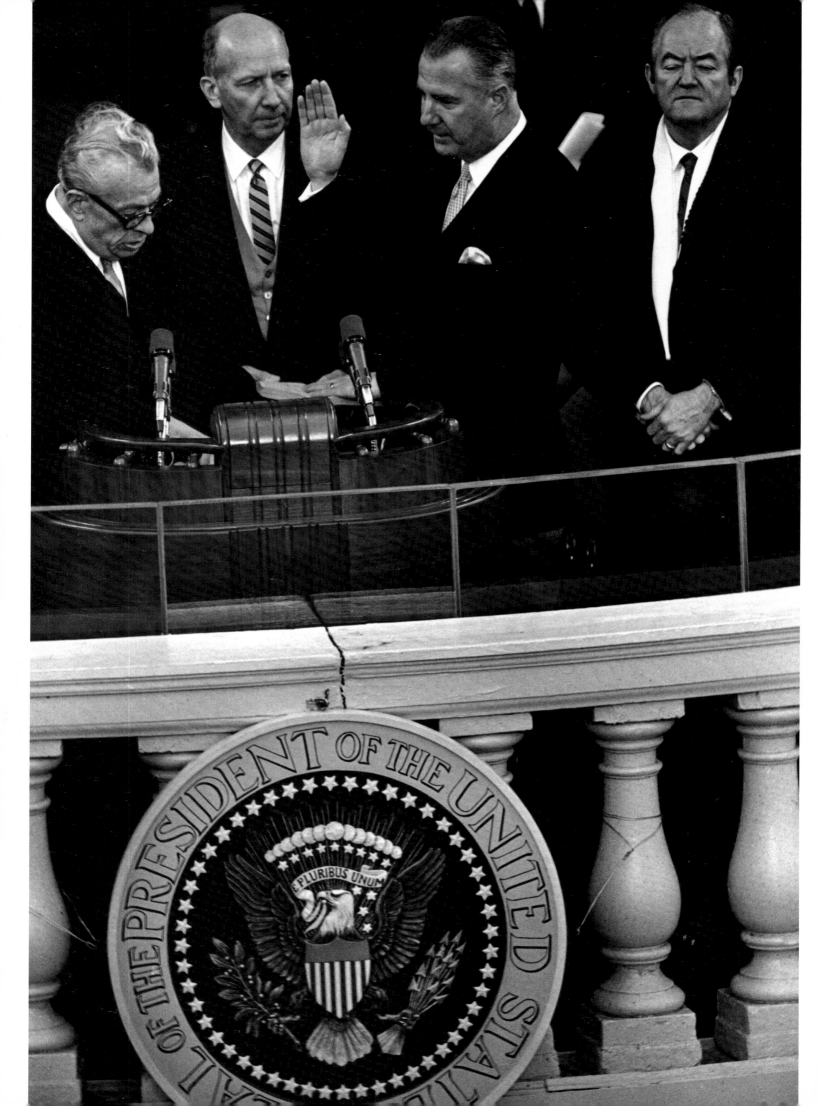

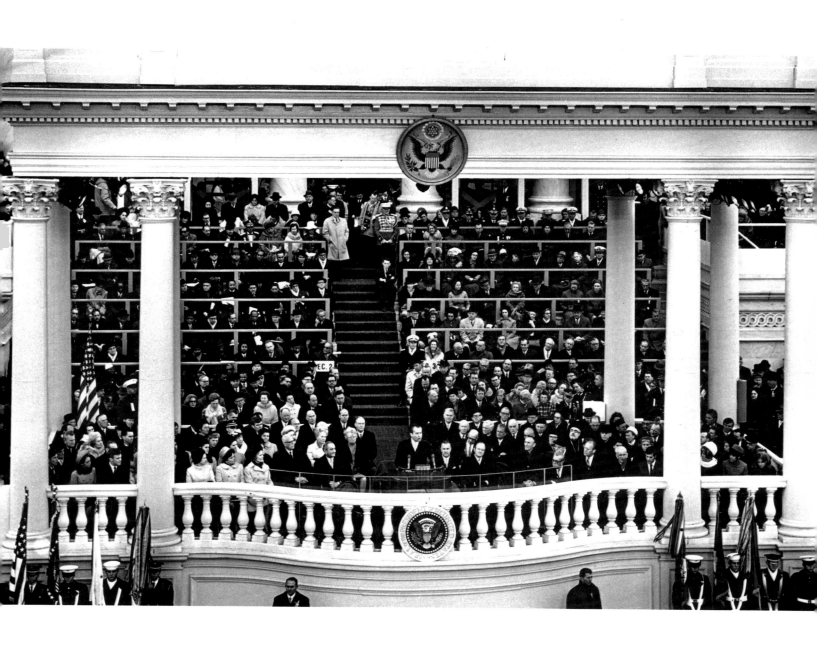

WASHINGTON, D.C., 1969

Inaugural scene (above) at the east front of the Capitol,
facing the Supreme Court building. Sen. Everett Dirksen, the
minority leader (opposite), swears in Spiro Agnew as vice-
president. Outgoing Vice-President Hubert Humphrey, at
right, was probably one of the most capable men to run for the
presidency. Like Adlai Stevenson, he tried and tried and
never made it.

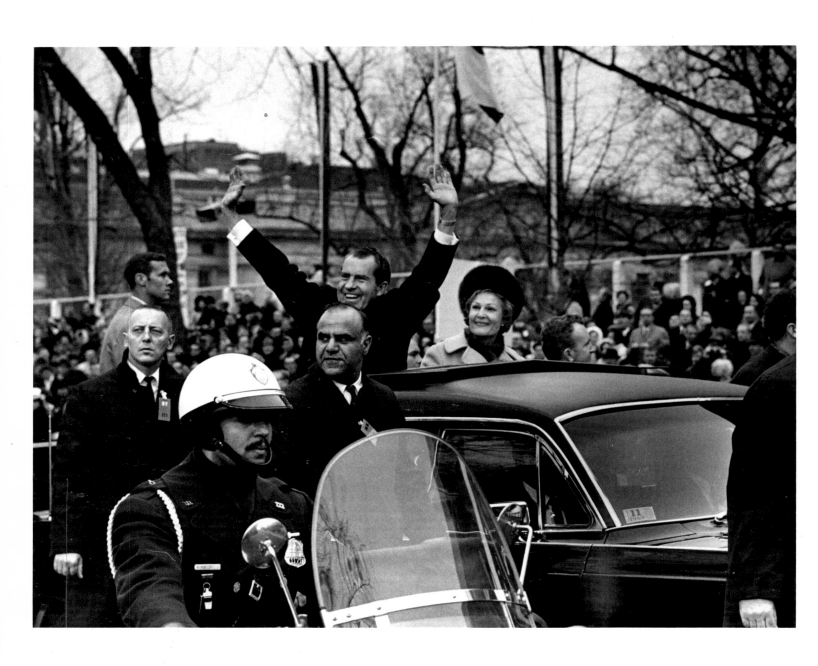

WASHINGTON, D.C., 1969
 **President Richard Nixon and the First Lady, Pat, during the
 inaugural parade.**

 **About four photographers were present when Richard Nixon
 and the First Lady approached the White House for the first
 time as its occupants (opposite). He turned to us at the
 entrance and said, "I hope the key fits."**

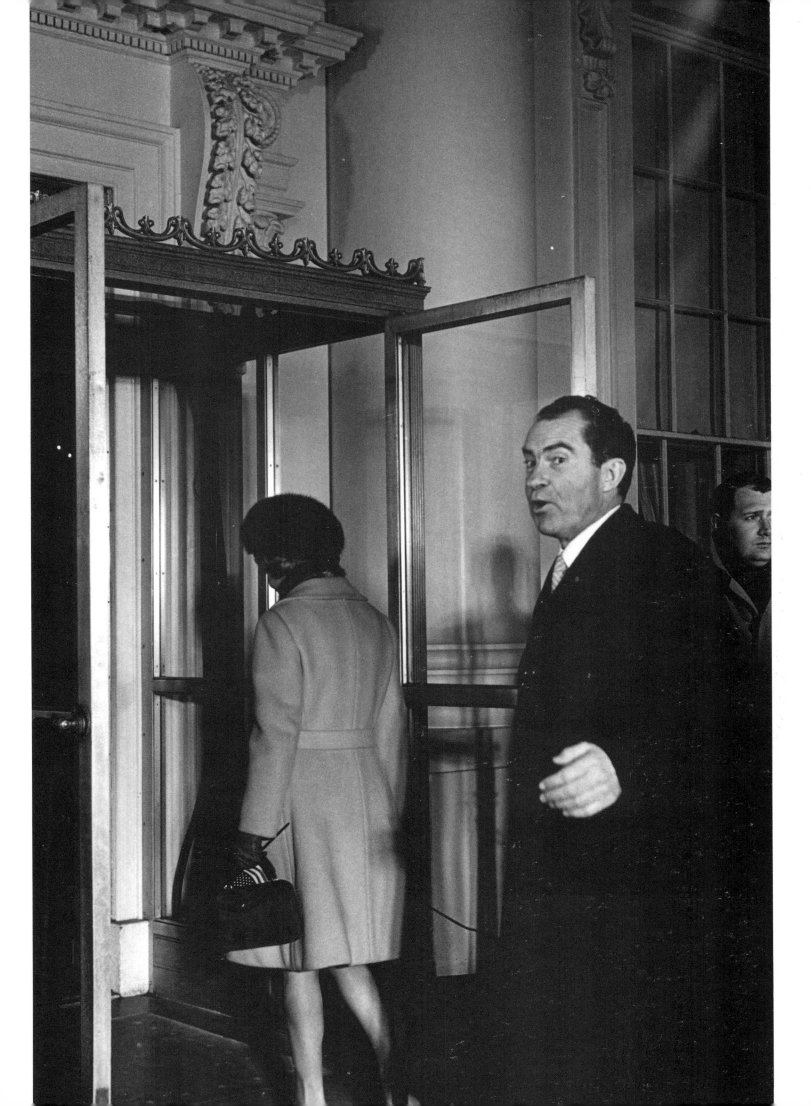

DETROIT, 1971

Richard Nixon makes some notes in his car. He was real good
with photographers. He was informal, down-to-earth with
me, and I liked him. He autographed a picture for me: "With
appreciation for the artistic skill of one of America's best
photographers, from his friend, Richard Nixon."

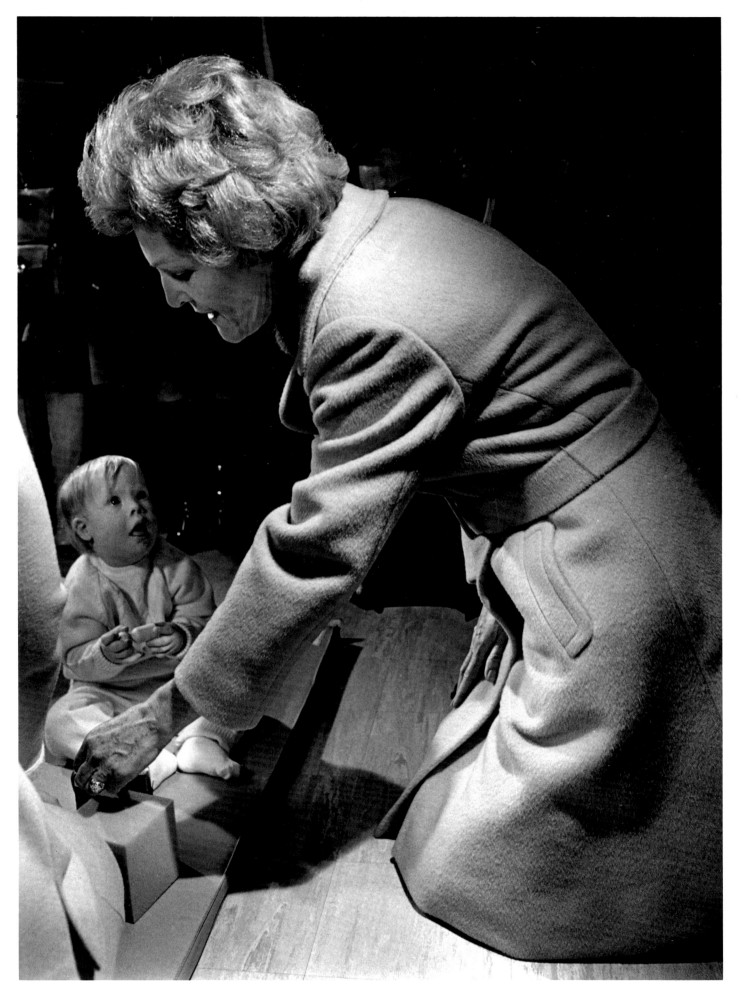

DETROIT, 1971
First Lady Pat Nixon visits a facility for mentally retarded children.

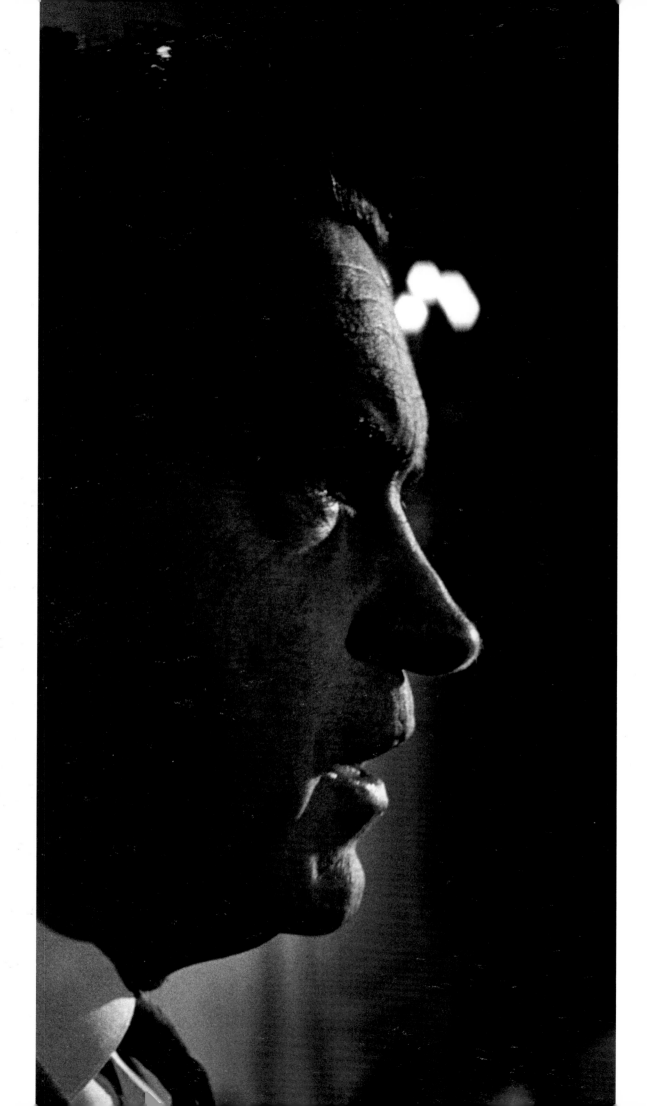

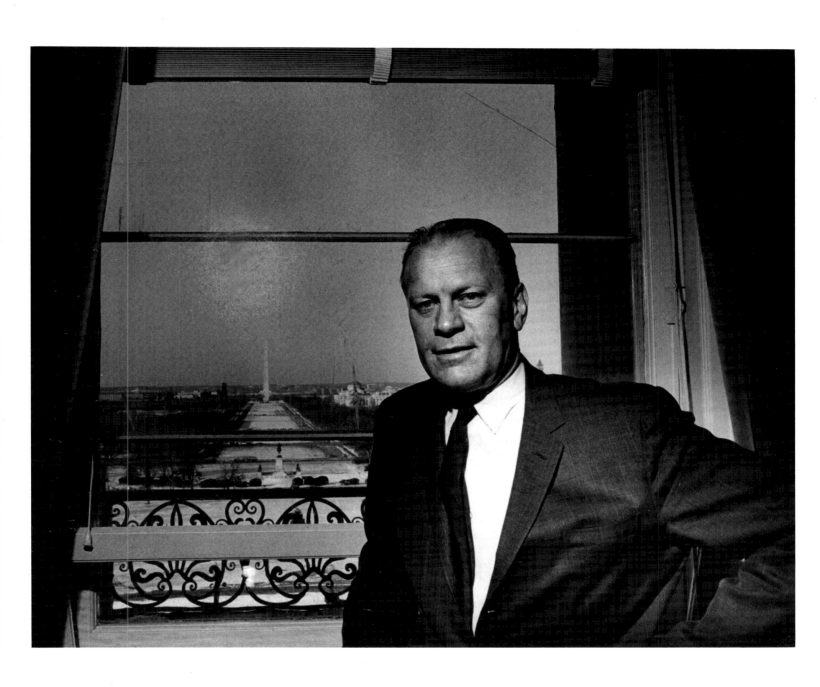

MICHIGAN CONGRESSMAN, 1956

On the previous pages, the Michigan delegation welcomes U.S. Rep. Gerald Ford and his wife Betty in front of the Congress Hotel at the Republican National Convention in Chicago. They nominated Ford for vice-president as a favorite son. Above, the view of the National Mall from Ford's office.

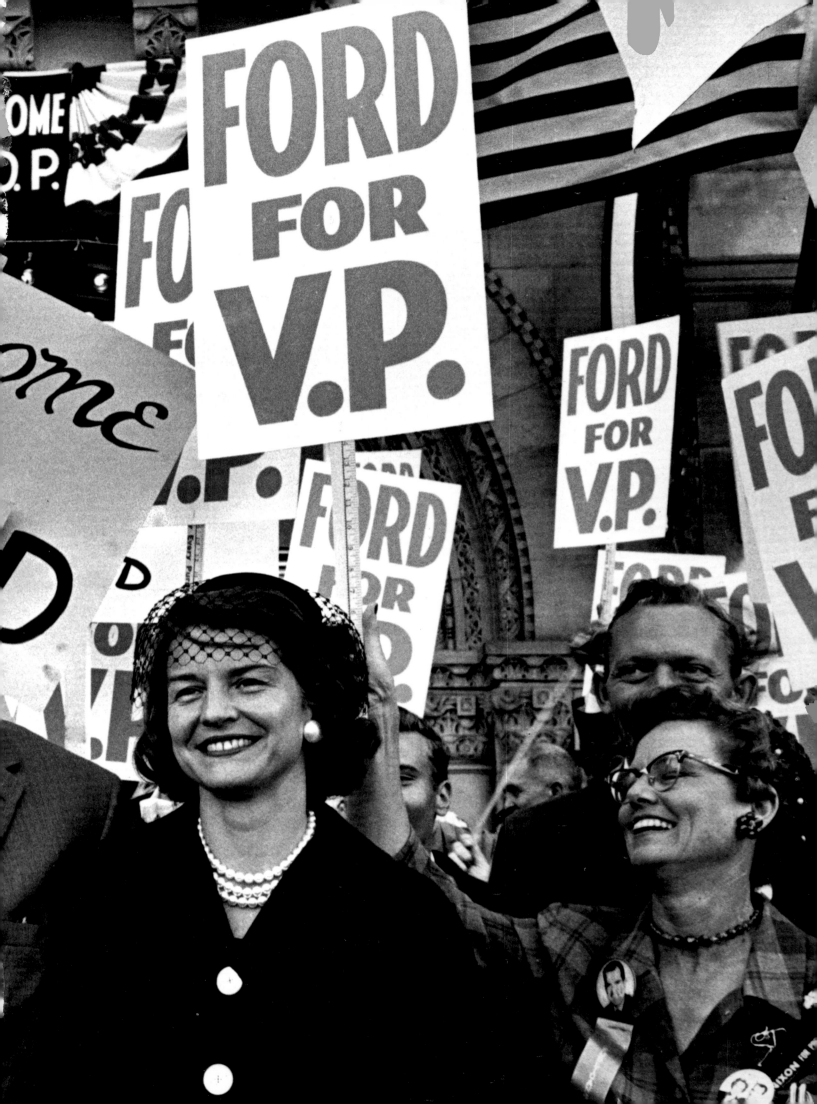

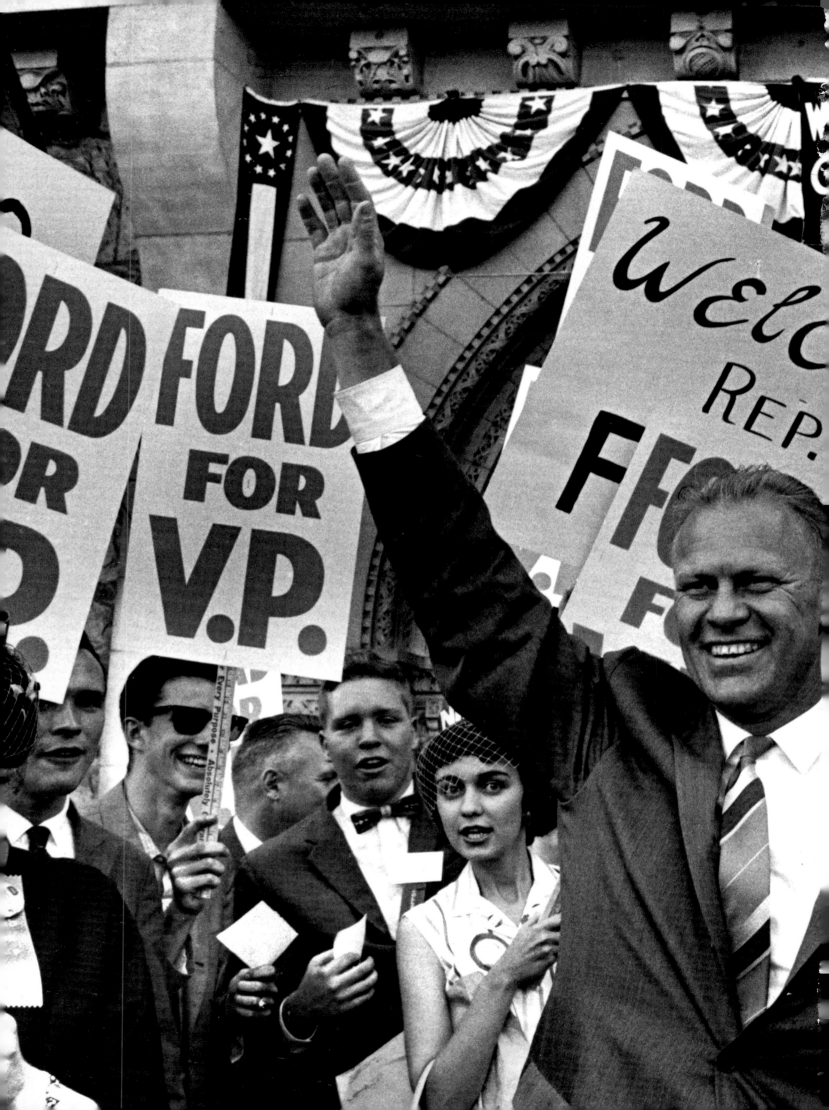

PRESIDENTS IN PROFILE, 1974 AND 1976

For the second time in a decade, a vice president assumed the presidency without having been elected. Richard Nixon (left) resigned in the aftermath of the Watergate scandal. Gerald Ford moved into the Oval Office.

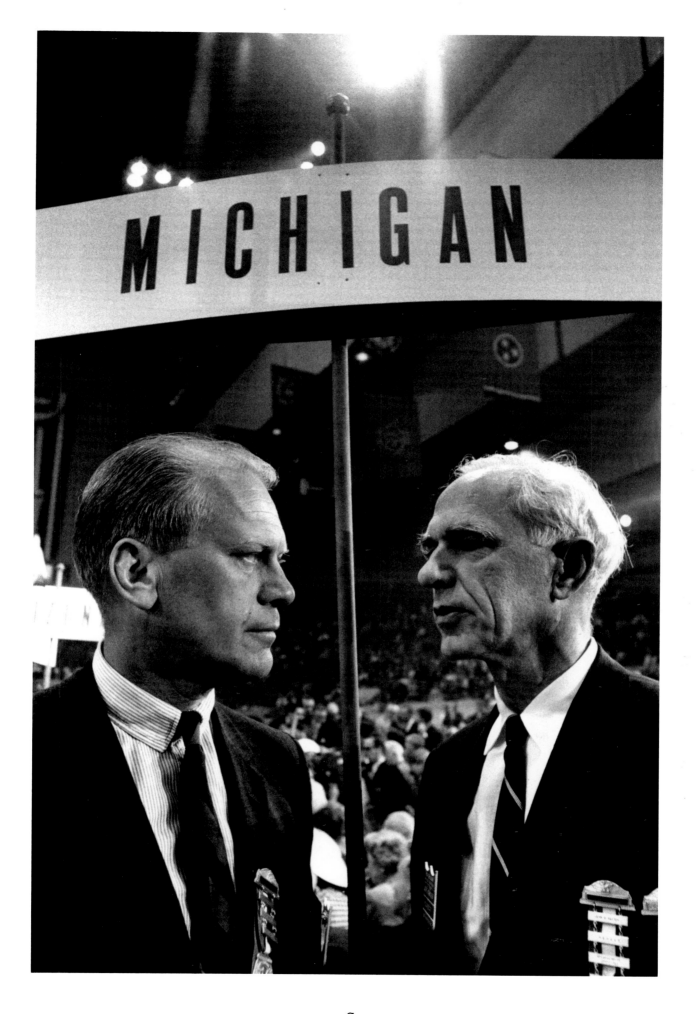

CHICAGO, 1956

U.S. Rep. Gerald Ford and John B. Martin, Jr., Republican national committeeman, on the convention floor in Chicago.

CHICAGO, 1952

This was at the Republican convention when he was a young congressman from Grand Rapids. Because Ford was from Michigan, I knew him throughout his political career. He always says hello.

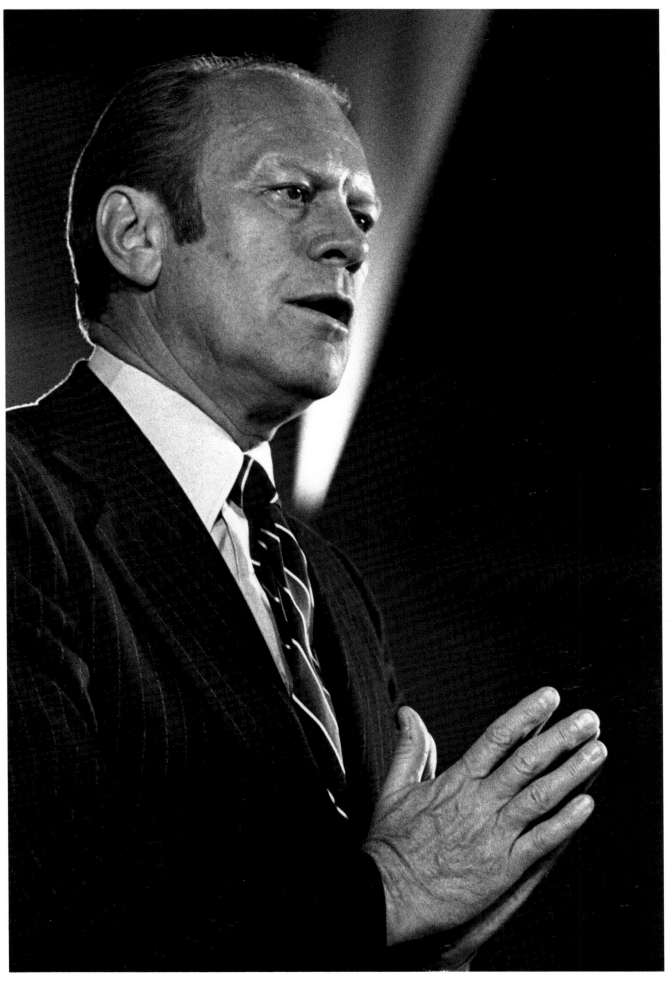

DETROIT, 1976
**During his campaign for election, Ford held a press
conference at the Detroit Press Club for young journalists.**

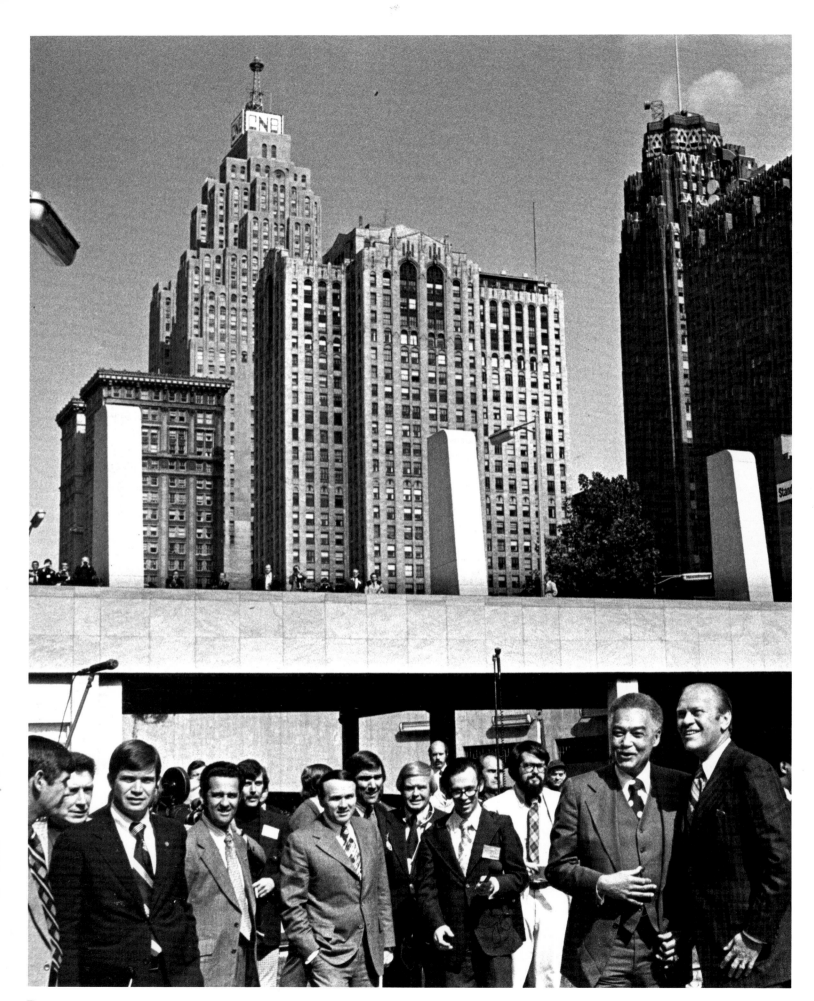

DETROIT, 1974

The press crowded around President Gerald Ford when he came to Detroit and met with Mayor Coleman Young outside Cobo Hall Sept. 23.

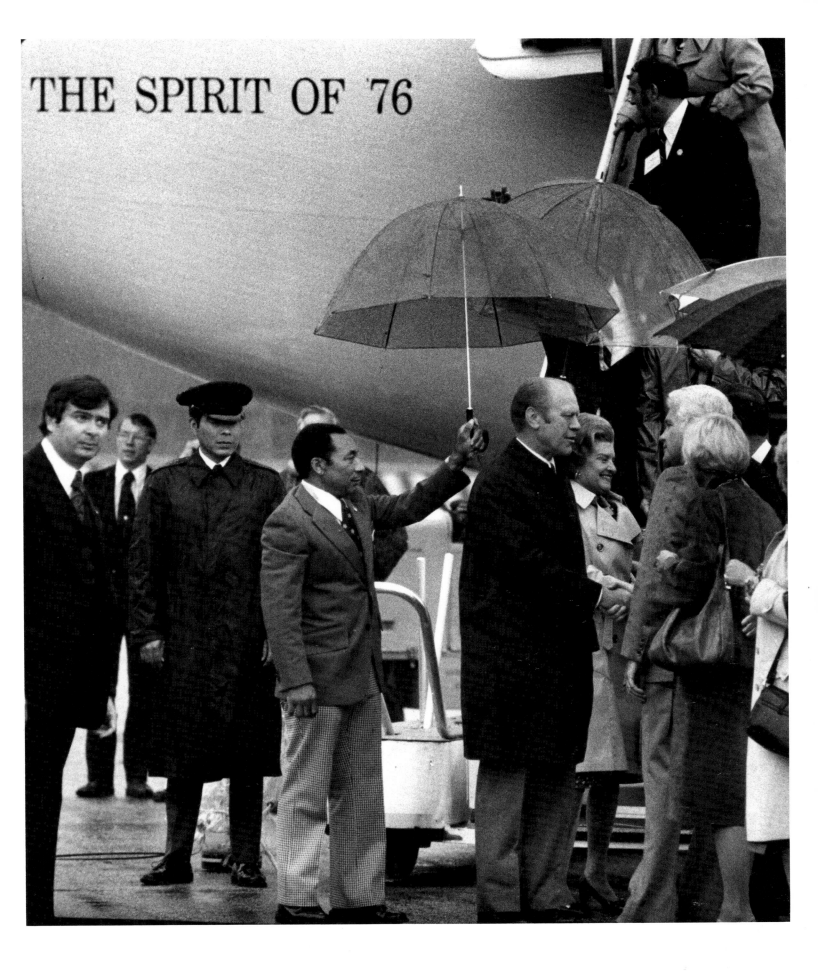

THE SPIRIT OF '76

VAN BUREN TOWNSHIP, 1976
The Spirit of 1976 brought the president and Mrs. Ford to Willow Run Airport, west of Detroit, in a pouring rain during the campaign.

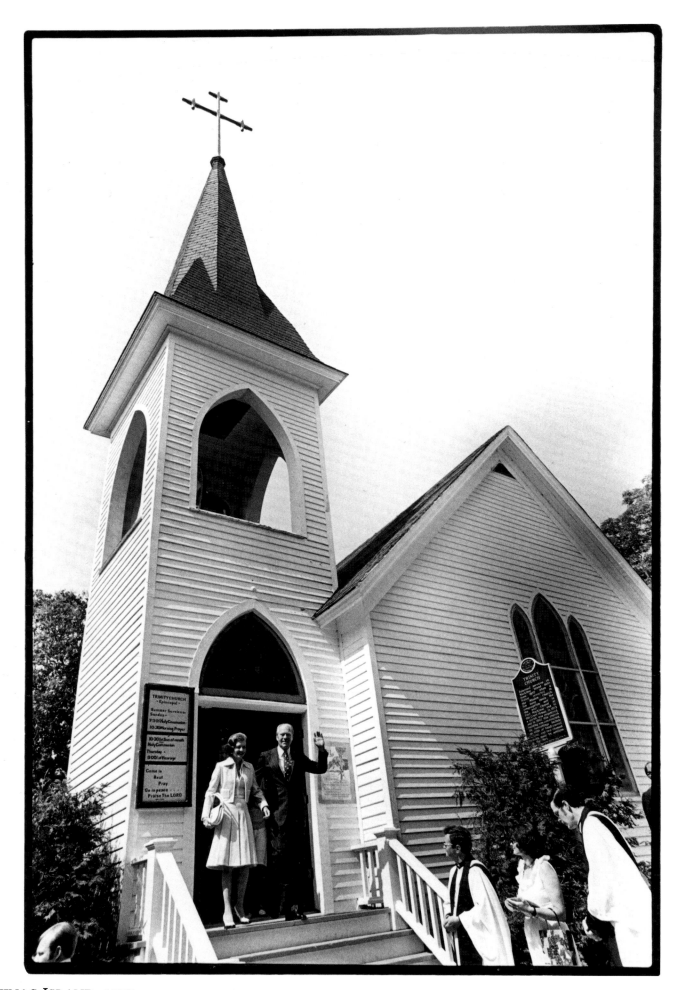

Mackinac Island, 1976
**The Fords leave the Trinity Episcopal Church in July. He had
campaigned by train through Michigan, then took a
helicopter to the island.**

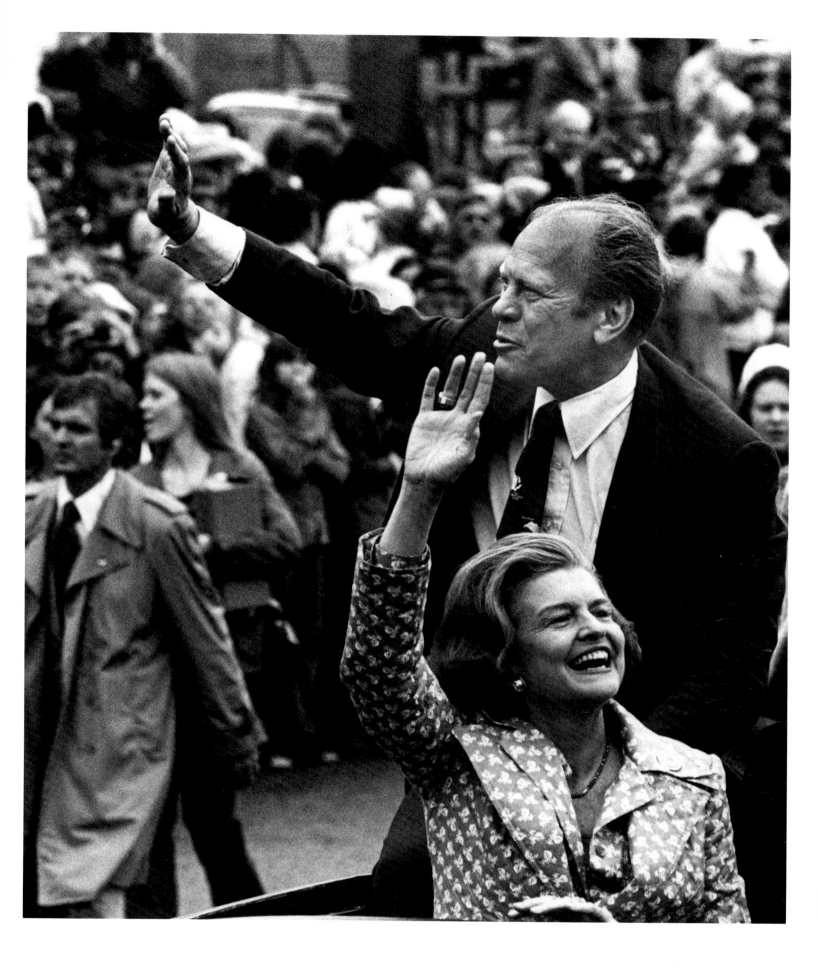

MUSKEGON, 1976
The president and the First Lady campaign with gusto.

163 □ FORD

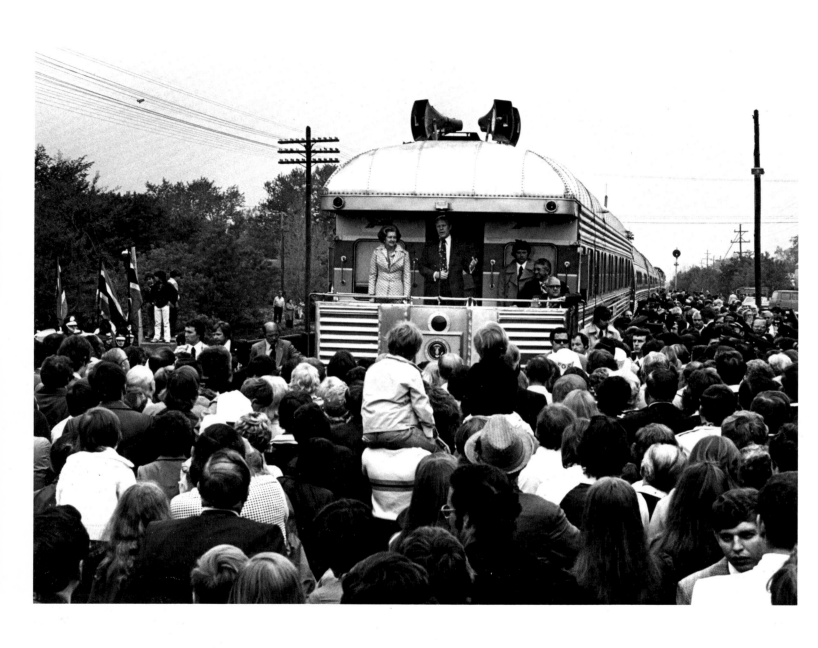

KENT COUNTY, 1976
**This was a whistle stop near Grand Rapids, President Ford's
hometown.**

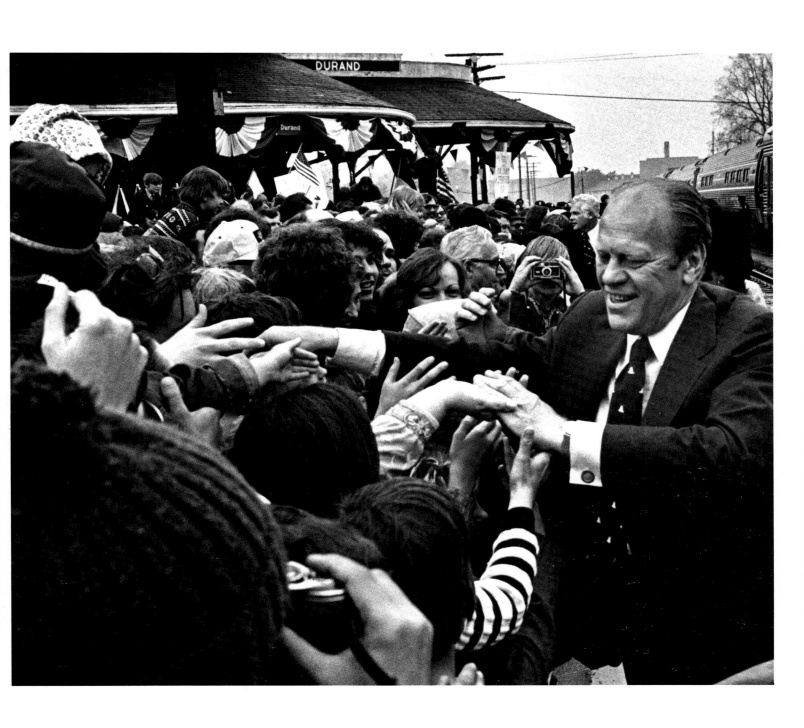

DURAND, 1976
**Ford shook as many hands as possible, but Jimmy Carter won
the election.**

165 □ PRESIDENTS

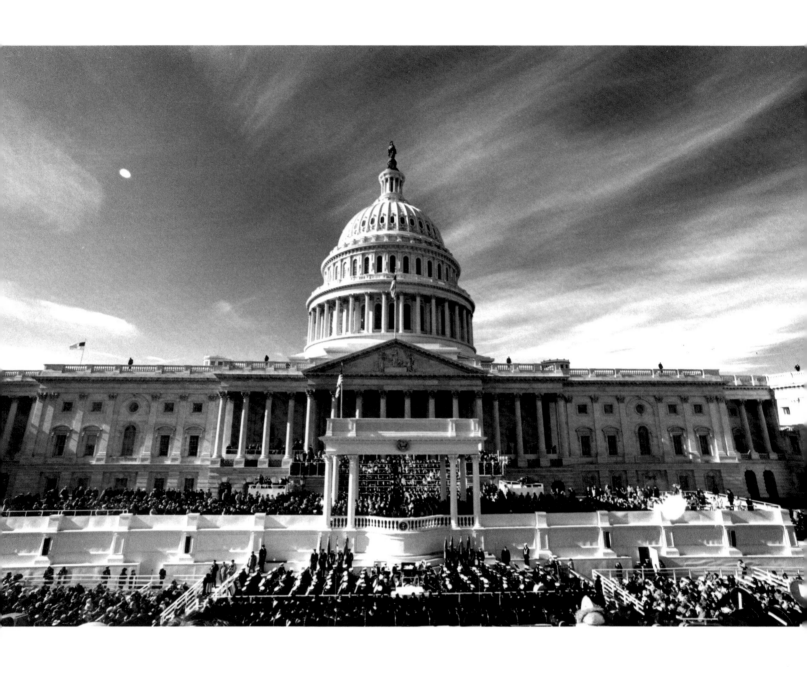

WASHINGTON, D.C., 1977
**The inauguration of President Jimmy Carter at the east front
of the Capitol on Jan. 20.**

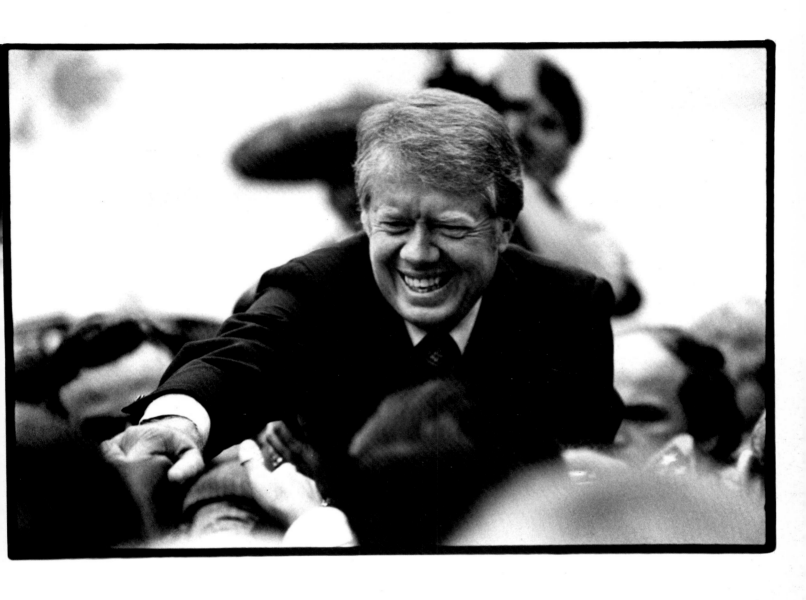

SAGINAW, 1976

Jimmy Carter campaigning. I went with reporters Remer
Tyson and Billy Bowles. We got a flat along the way, in a Free
Press car. Despite the lack of a tire iron to change the tire,
eventually we got there, and I got this picture.

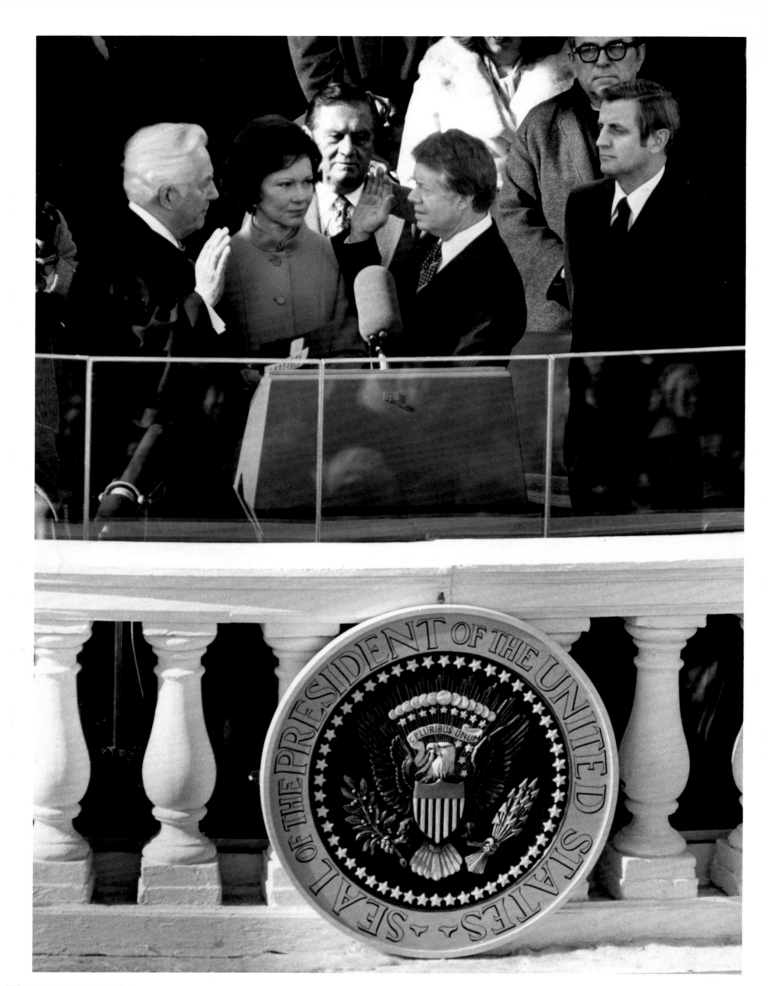

WASHINGTON, D.C., 1977

President Jimmy Carter takes the oath of office as the 39th president of the United States. His wife Rosalynn holds the family Bible. Walter Mondale is on the right, and Chief Justice Warren Burger gives the oath.

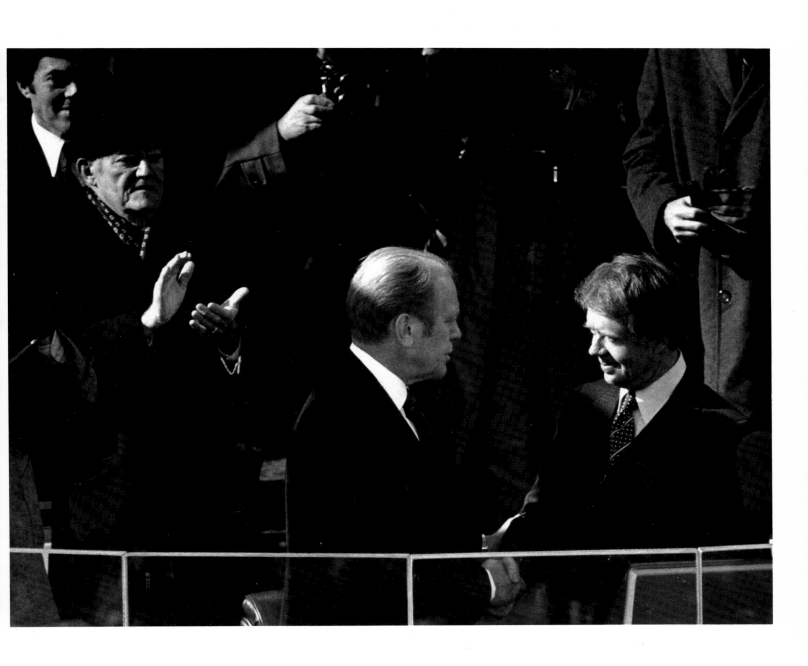

WASHINGTON, D.C., 1977

**Former President Gerald Ford congratulates President
Jimmy Carter. I love this picture. While the two presidents
shake hands, Hubert Humphrey applauds. It was cold, and he
was ill with cancer and within a year would be dead. I wonder
whatever went through his mind, watching these two men
who had the job he had wanted so badly.**

WASHINGTON, D.C., 1977

The inaugural parade passes by the reviewing stand in front
of the White House. President Carter wanted his stand built
so it faced Pennsylvania Avenue, but still showed the White
House behind. All the other presidents I covered had the
stand built right in front.

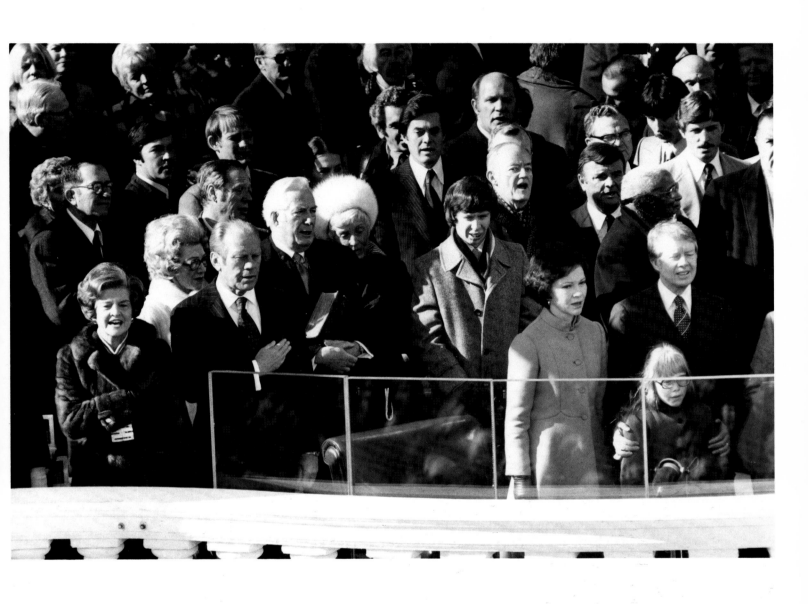

WASHINGTON, D.C., 1977
Everyone is singing "America the Beautiful." That's son
Chip, Rosalynn and daughter Amy Carter by the president.

171 □ PRESIDENTS

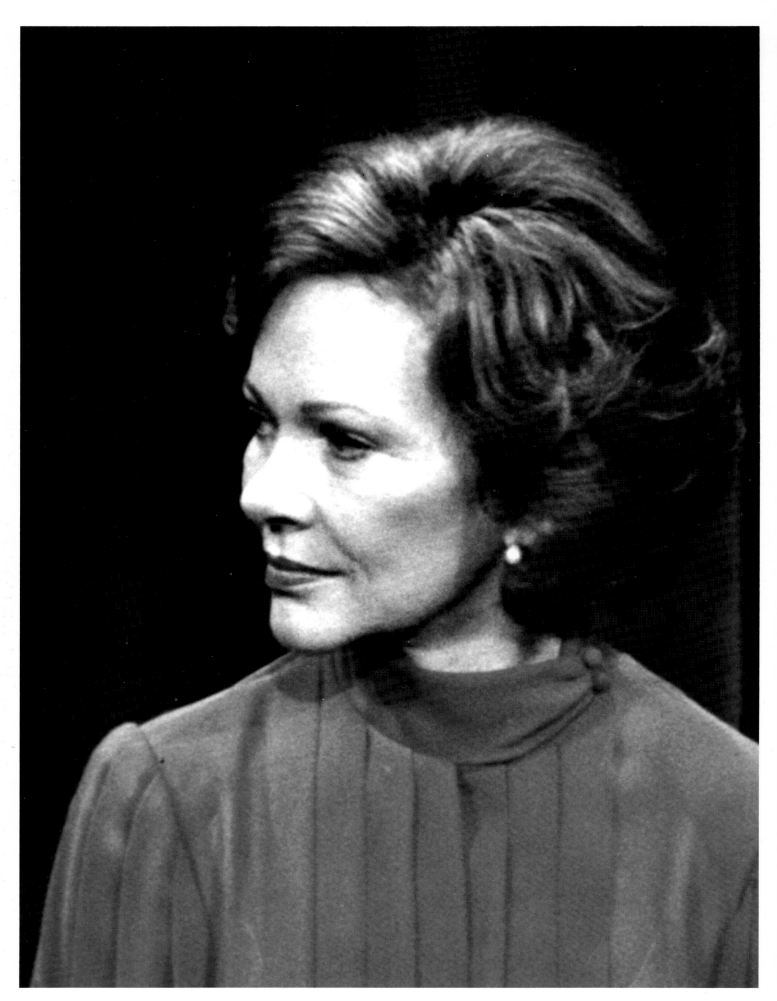

NEW YORK, 1976
**This portrait of Rosalynn Carter was taken during the
convention in New York's Madison Square Garden.**

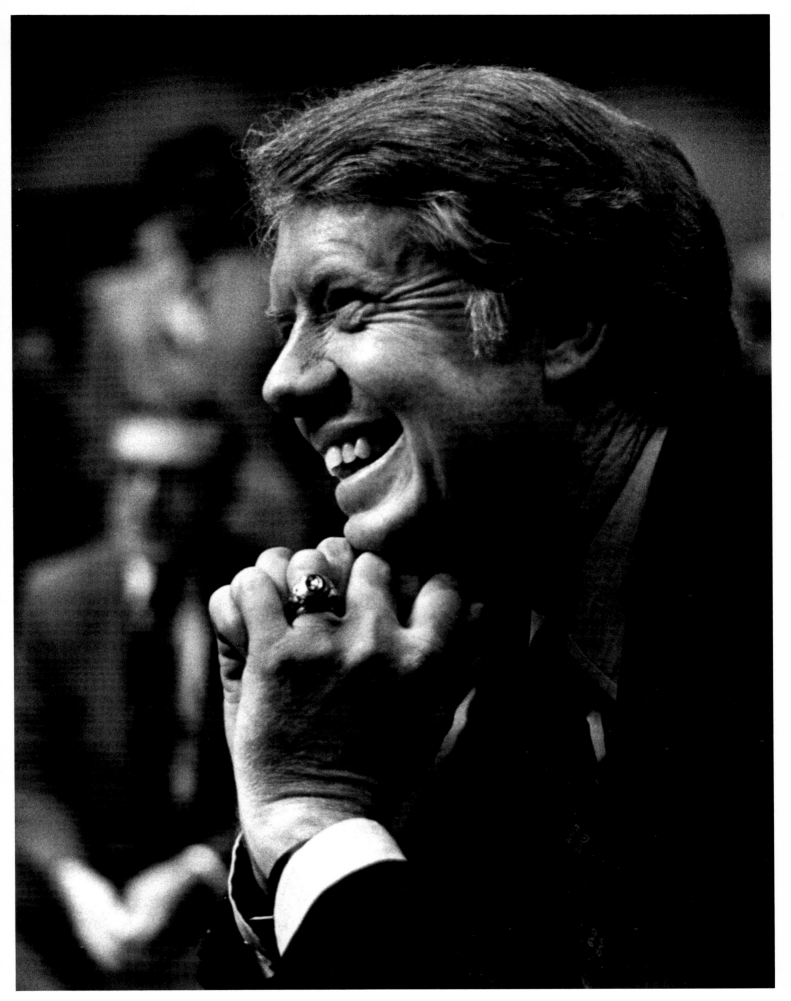

PRESS CONFERENCE, 1976
President Jimmy Carter, during his successful campaign.

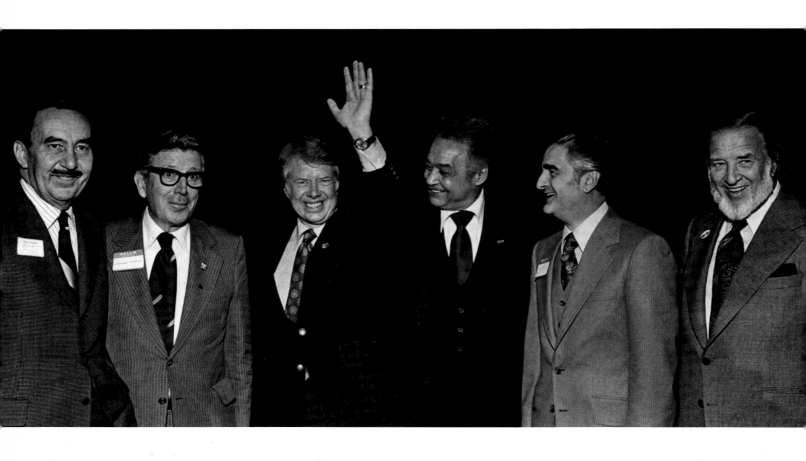

DEARBORN, 1976

They used this picture all over the world. During the
campaign, a reception for Carter was held at Fairlane Manor.
I knew all these people, and I asked them to get together for a
group shot. It's a prestigious group. From the left are Pete
Estes, president of General Motors Corp.; Leonard
Woodcock, president of United Auto Workers, who became
the first ambassador to China; Jimmy Carter; Detroit Mayor
Coleman Young; John Riccardo, chairman of Chrysler Corp.;
Henry Ford II, chairman of Ford Motor Co.

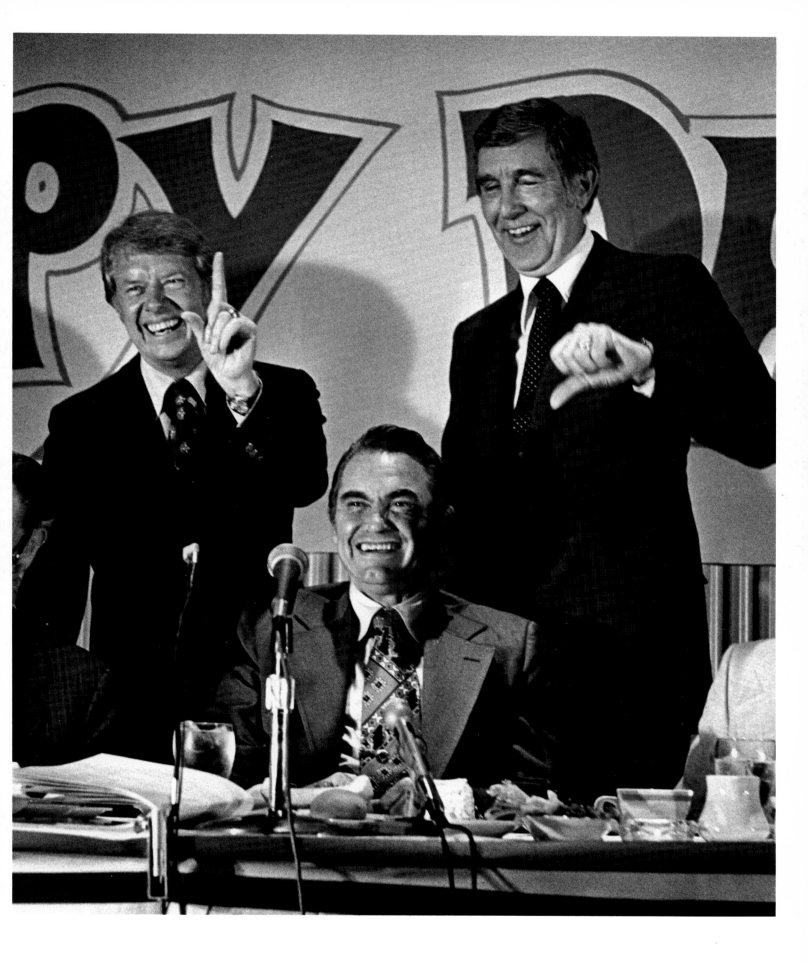

DETROIT, 1976

In an appearance before the primary election, these
Democrats running for the nomination shared a little humor:
Jimmy Carter, George Wallace and Morris (Mo) Udall.

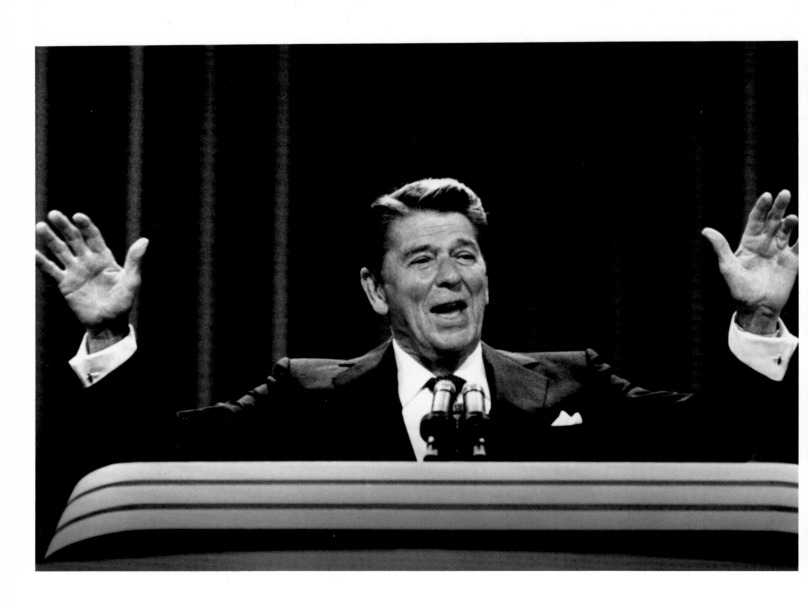

DALLAS, 1984
President Ronald Reagan makes his acceptance speech after being nominated for a second term at the Republican convention.

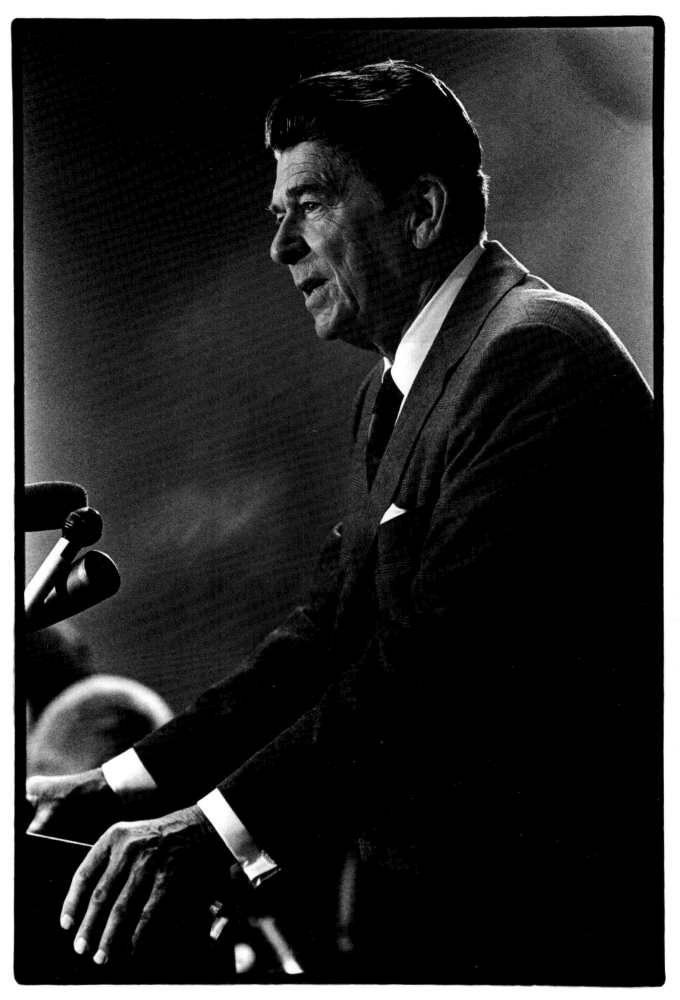

DETROIT, 1980
This is my favorite black and white photograph of Reagan.

177 □ PRESIDENTS

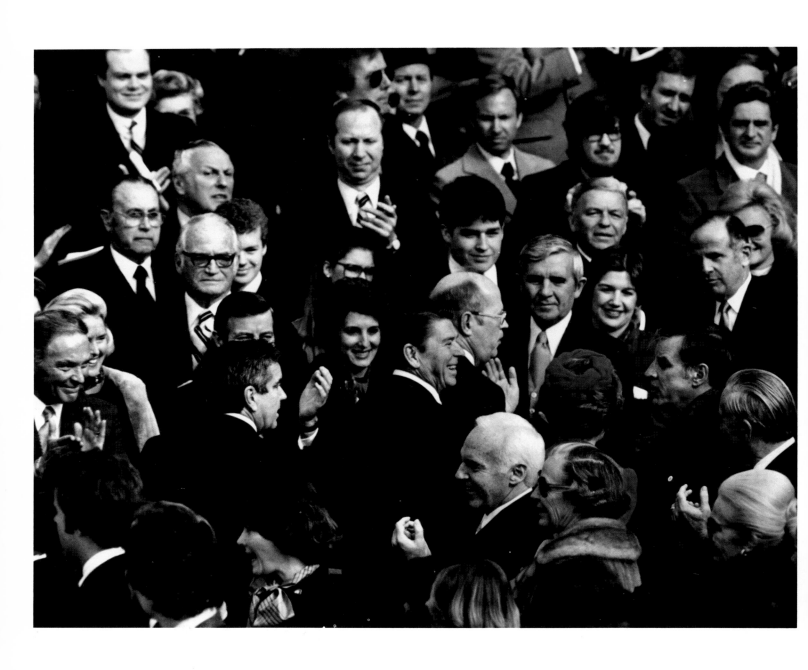

WASHINGTON, D.C., 1981
**President and Nancy Reagan leave the inaugural ceremonies
to the applause of his friends, including Sen. Barry
Goldwater and Frank Sinatra.**

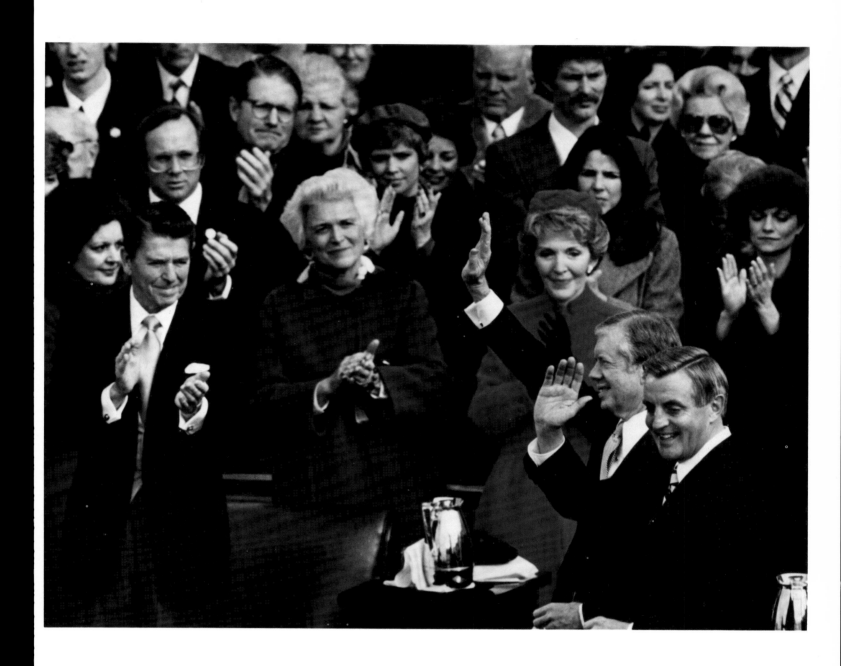

WASHINGTON, D.C., 1981

Changing of the guard. President Jimmy Carter and Vice-
President Walter Mondale wave farewell to the nation.
President-elect Ronald Reagan applauds. These two photos
illustrate a reassuring ritual: No matter how hard anyone
fought to get the job or keep the job, there is always a smooth
transition of presidential power.

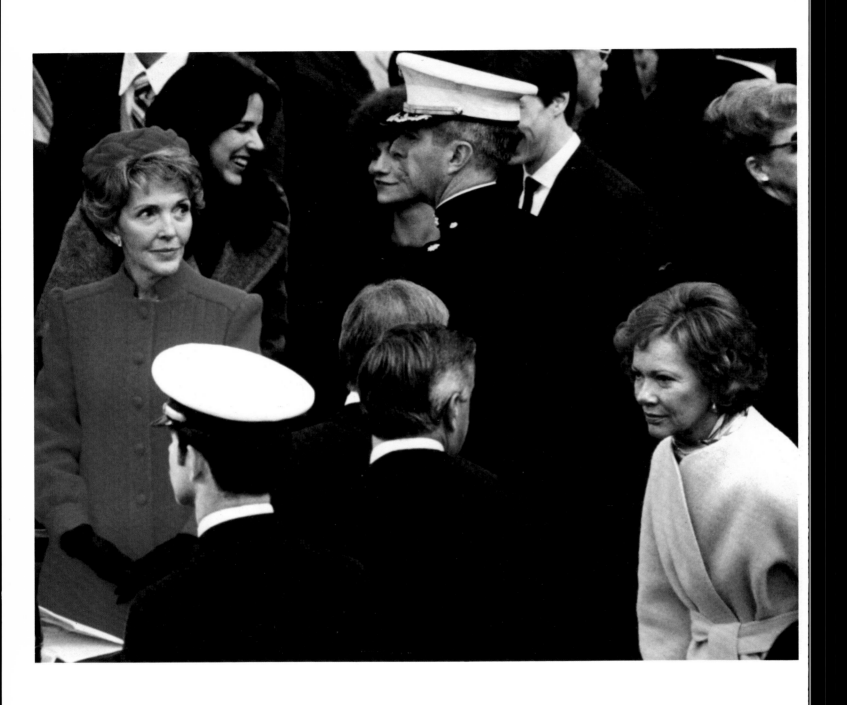

WASHINGTON, D.C., 1981
Nancy Reagan and Rosalynn Carter in the crowd. Both
seemed such strong women, each in her own way.

WASHINGTON, D.C., 1981
Arm-in-arm with the new president, First Lady Nancy Reagan turns for a split second and shakes hands with Rosalynn Carter on the inauguration stand.

WASHINGTON, D.C., 1981
 **President-elect Ronald Reagan waits to take the oath, his
 inaugural speech in hand. For the first time ever (opposite),
 the swearing-in was at the west front of the Capitol, facing
 the White House, instead of at the east front, facing the
 Supreme Court. I set up a remote control camera to capture
 the scene while I was on the main photographers' stand.**

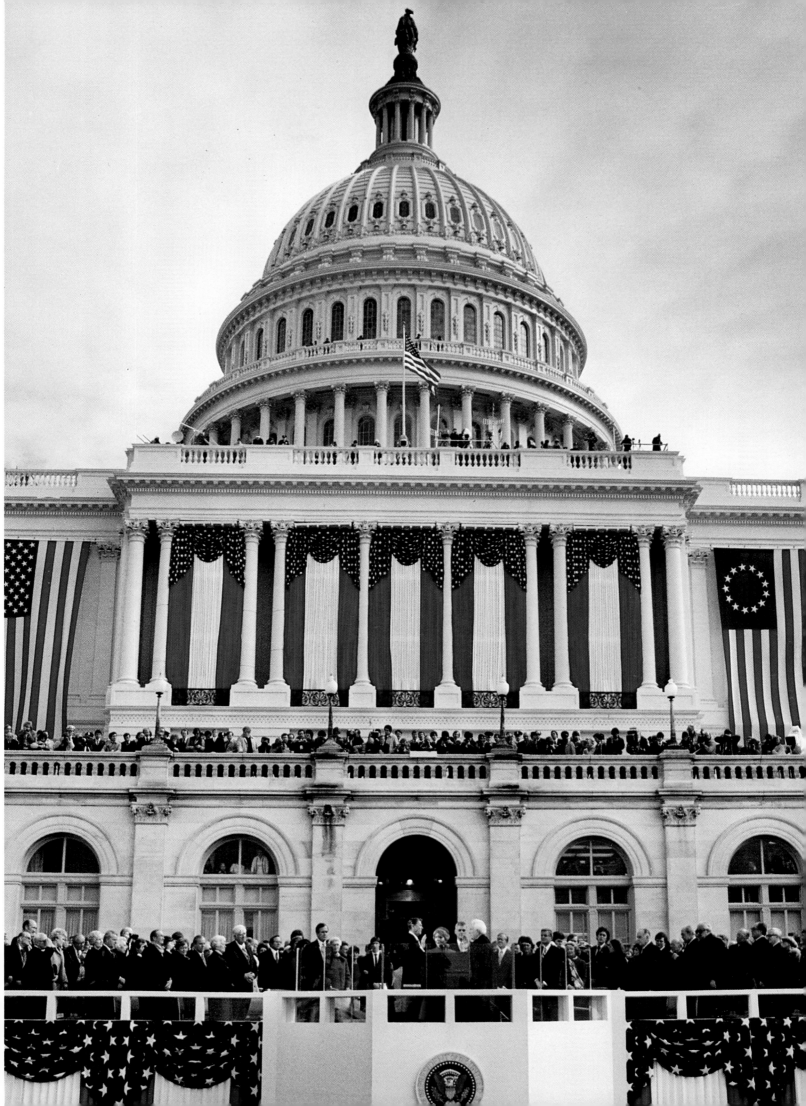

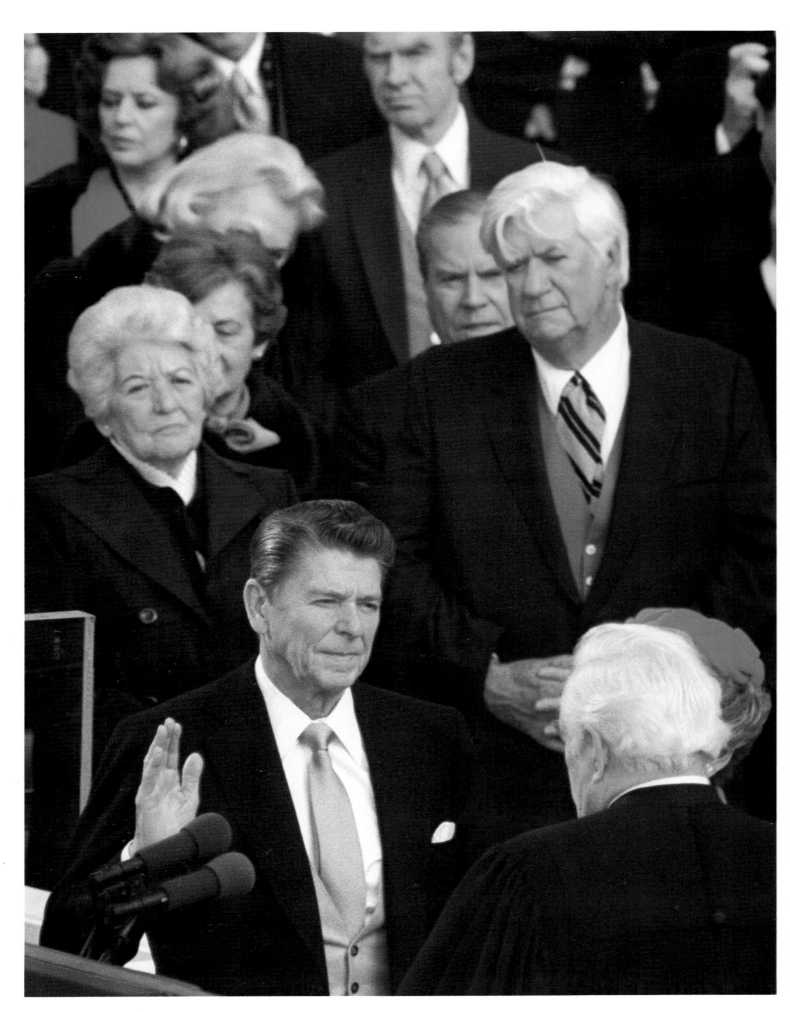

WASHINGTON, D.C., 1981
**Ronald Reagan is sworn in as the nation's 40th president by
Chief Justice Warren Burger, Jan. 20.**

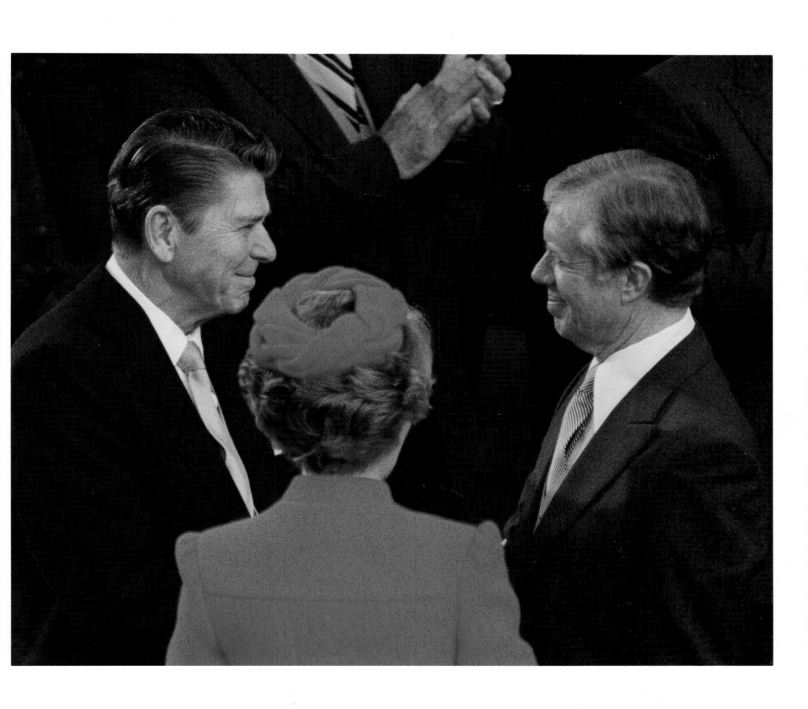

WASHINGTON, D.C., 1981
Immediately after the swearing-in, President Reagan turned around and shook hands with Jimmy Carter. What was said I don't know. It was the briefest of moments.

185 □ PRESIDENTS

TOGETHER ... A NEW

REPUBLICAN
NATIONAL
CONVENTION
'80

ACCEPTING THE NOD, 1980 AND 1984

On the previous pages, Ronald Reagan makes his acceptance
speech after winning nomination at the party convention in
1980, Joe Louis Arena. I wanted to make sure I got the
waving of the hats, the flags, the signs. I always believe a
single picture should contain all the elements. Four years
later, in Dallas (above) the Republican convention was more
or less a coronation of President and Nancy Reagan.

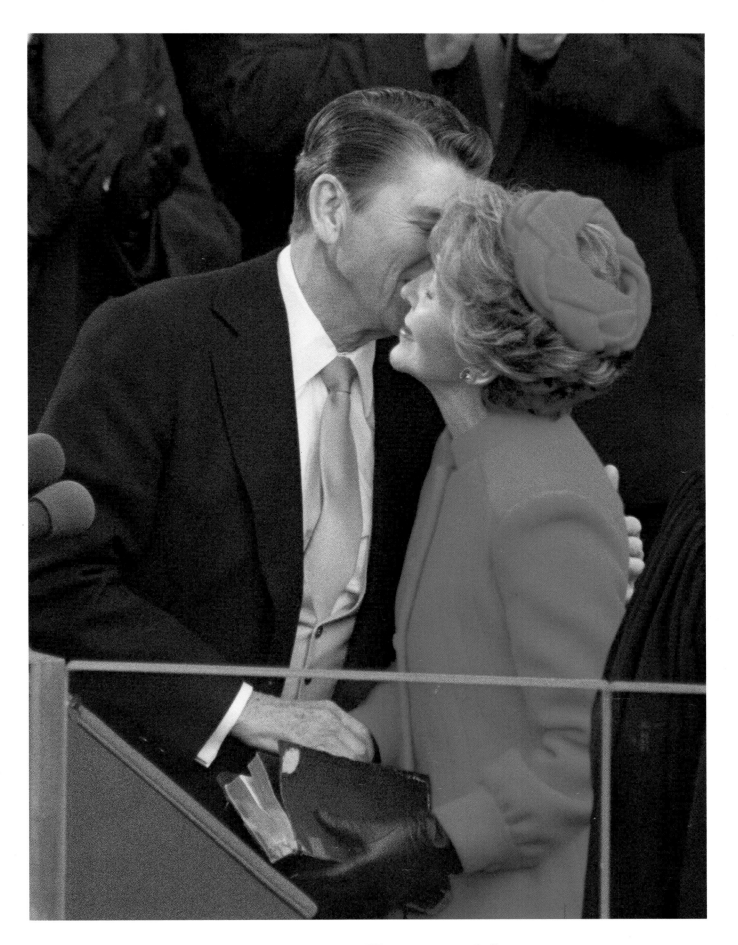

WASHINGTON, D.C., 1981
**President Ronald Reagan turns to kiss Nancy on the cheek
after being inaugurated. In her hand is the Bible upon which
he swore the oath of office.**

POPES

Roman Catholics believe the ultimate authority for church doctrine has been handed from pope to pope to pope since the church was founded by St. Peter, one of Christ's apostles.

I was raised hearing stories about how the church got started, how it survived despite persecution and political turmoil, and how it grew. All of this history becomes part of someone after a while.

For a person who shares this faith, it is inspiring even to be able to see or hear a pope. To meet him, to photograph him is a rare privilege indeed.

All four popes I photographed were very special, each a different way.

Pope John XXIII was a very jolly person. He had that human element about him; meeting him made me feel very special. In Pope John XXIII, I saw the humanity of Christ.

Pope Paul VI was an intellect, conservative and refined. I had three audiences with him and spent an entire day photographing him. In Pope Paul VI, I saw the divinity of Christ.

There isn't much to say about Pope John Paul I, because he died just 33 days after becoming the pontiff. I photographed him when he was elected and again at a gathering in the audience hall. I never met him personally.

Pope John Paul II has a lot of energy and spirit. I consider him a pastoral pope, with a strong sense of his mission. In John Paul II, I see a latter-day disciple of Christ.

JOHN PAUL II, DETROIT, 1987
The pope prays in the chapel of the Cathedral of the Most Blessed Sacrament. Detroit was the last stop of a 10-day tour of the U.S., this pope's second visit to our country.

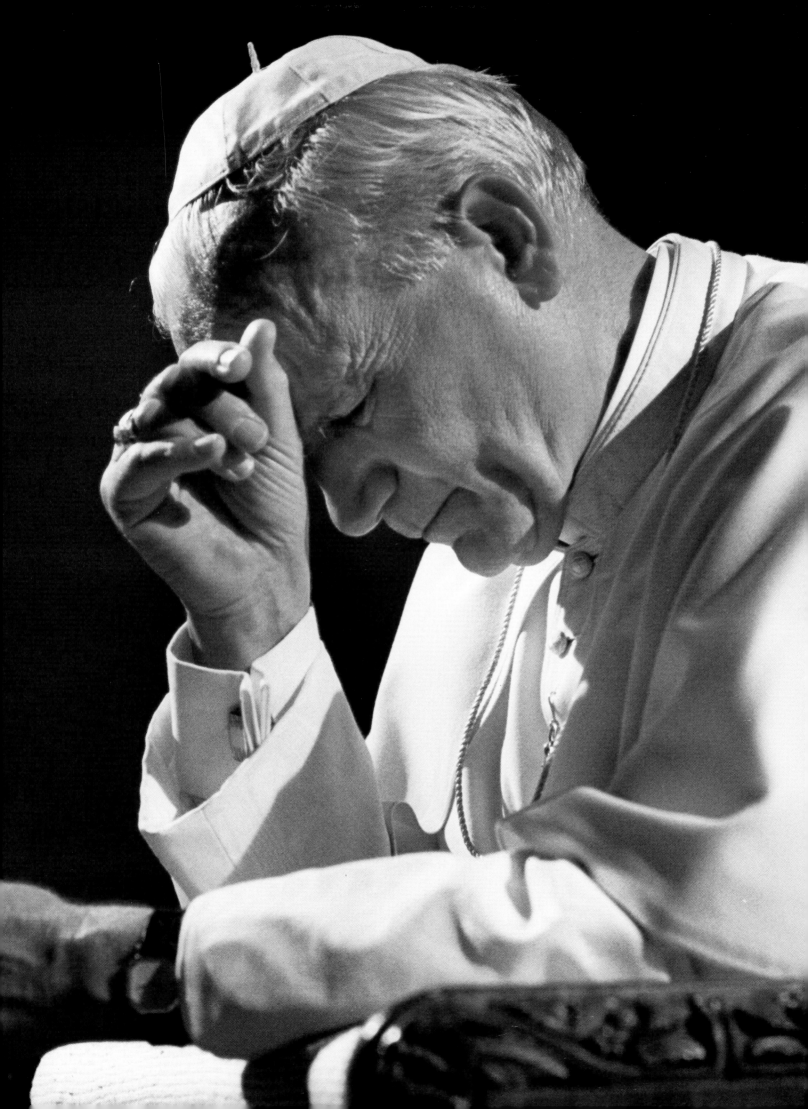

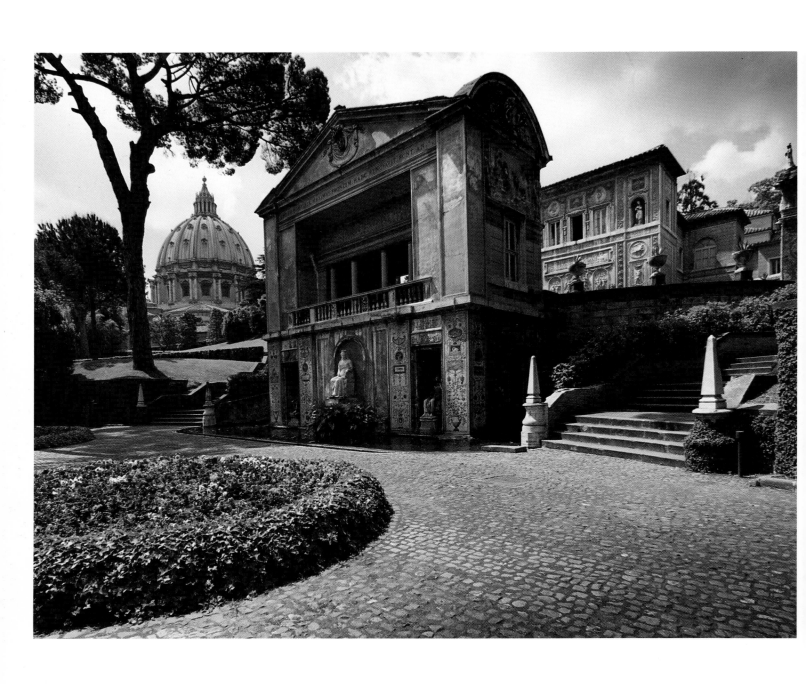

VATICAN CITY, 1987

**The Casina of Paul V, hidden in the May greenery of the
Vatican's gardens. To the left is the dome of St. Peter's
Basilica. This was one of Pope John XXIII's favorite places.**

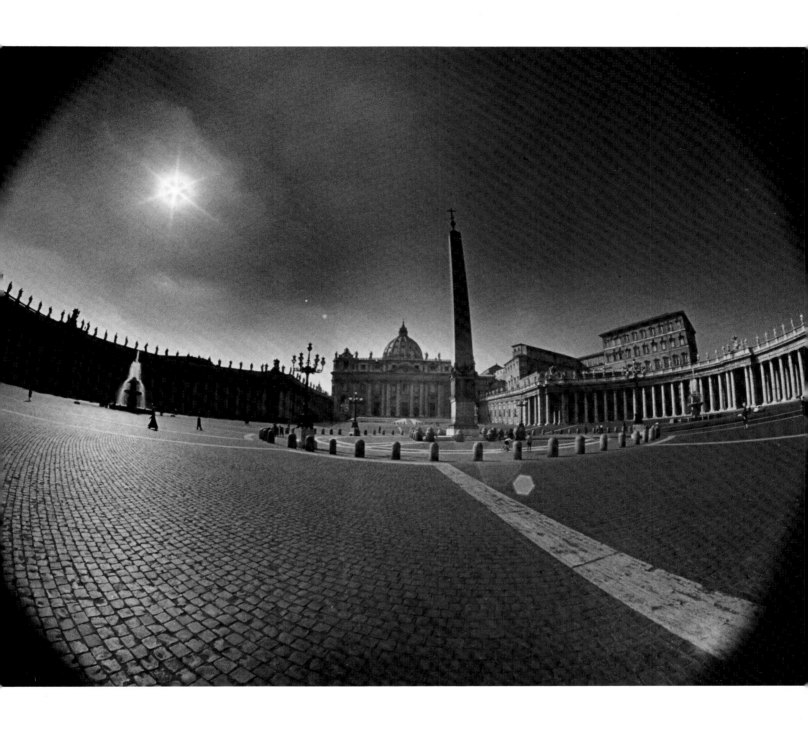

VATICAN CITY, 1962

The grandeur of St. Peter's Basilica, as seen through my fish-eye lens, just before the beginning of the historic ecumenical council called Vatican II. They temporarily closed the square to the public. This was taken with a 180-degree fish-eye lens. It captures everything, the cobblestones, the buildings, the clouds. This is a rare sight, as there are often as many as 250,000 people on the square during appearances by a pope.

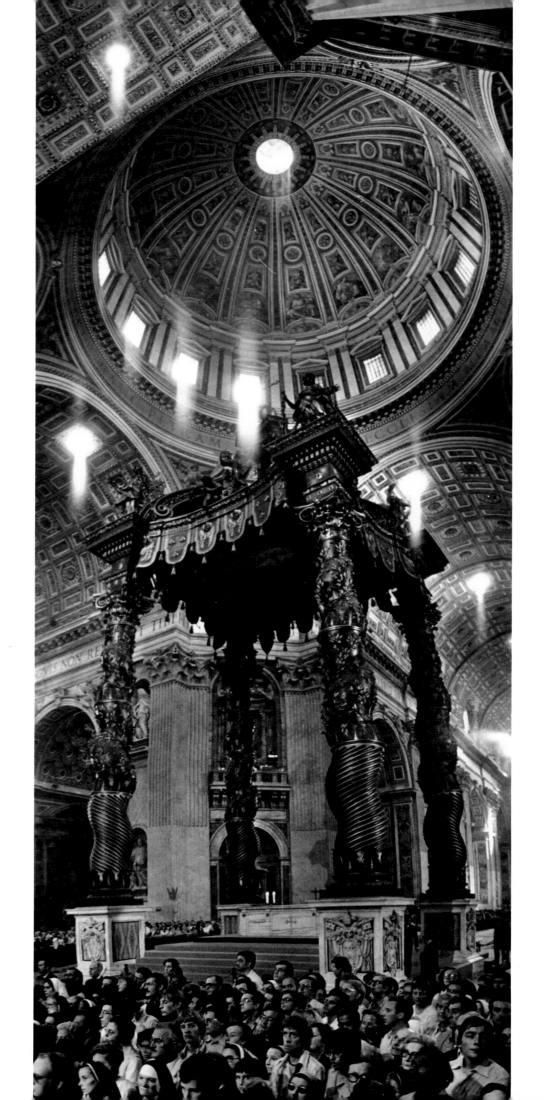

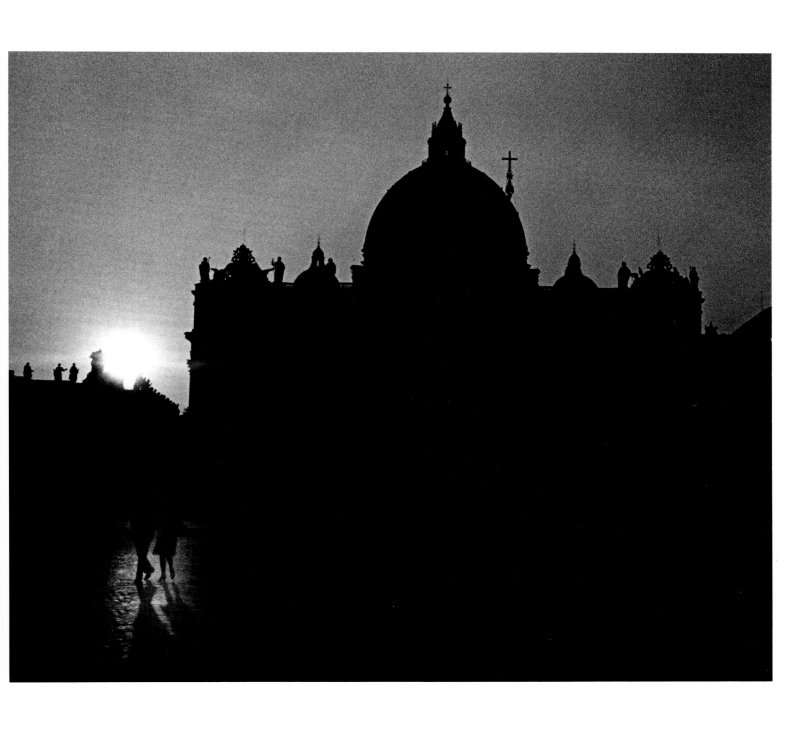

VATICAN CITY, 1978

The setting sun silhouettes the facade of St. Peter's (above).
The faithful watch the cardinals leave St. Peter's Basilica
(opposite) for the start of their conclave to choose a new pope.
The photograph shows 140 degrees of view, vertically,
including the Bernini Altar and the dome.

At half past four on the afternoon of May 12, 1960, I was being escorted through the ornate and imposing halls of the Vatican's Apostolic Palace, on my way to meeting and photographing Pope John XXIII.

It was too late now to worry about whether I was carrying the right equipment. Having no idea of the arrangement of the room or the lighting conditions, I had gambled on using the existing light, no artificial light. I selected two 35mm Nikon cameras, one with a 35mm lens and the other with an 85mm. I loaded one camera with color and the other with black and white film.

At five o'clock exactly, the door on the other side of the small anteroom opened, and Monsignor Loris Capovilla, the pope's personal secretary, announced: "The Holy Father is ready."

My heart was pounding. I walked slowly into the study to where Pope John was standing, knelt to kiss his ring, and then immediately started to take pictures. I had been told I could have five minutes.

I had taken more than a half-dozen pictures when the pope turned to his secretary with a quizzical look and asked, "When is the photographer going to start?" Obviously, he was expecting me to set up lights. Understanding Italian, I quickly explained that with a combination of fast lenses and film I could depend on the existing light in the room and that I already had taken several pictures. The pope's face brightened and with a warm smile he said, "I like pictures like that." I will never forget those words, the first that a pope ever said to me. After five minutes, I made a move to leave, but the pope gestured for me to continue. Believe me, I was only too happy to oblige.

As I was leaving nearly two hours later, Pope John called me to his desk. He handed me a red box containing a silver medallion embossed with a likeness of himself. Speechless, I tried to show my gratitude. He smiled and said, "That's all right, I gave Eisenhower one not too long ago."

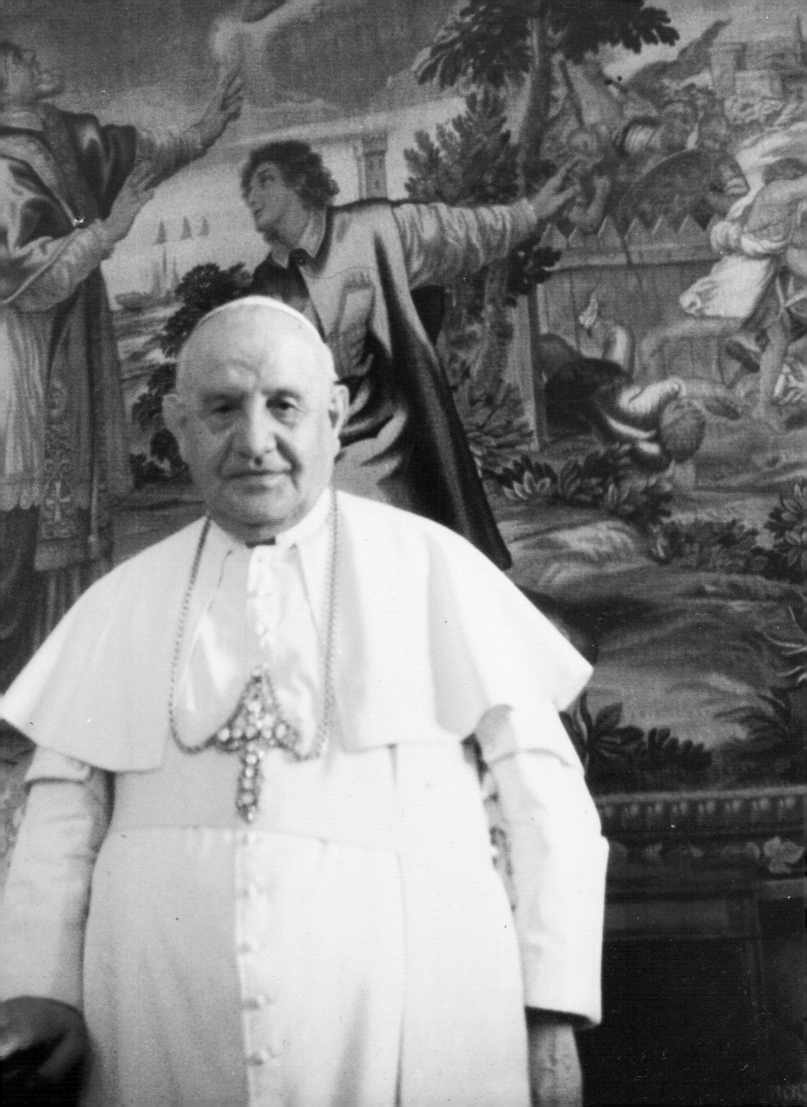

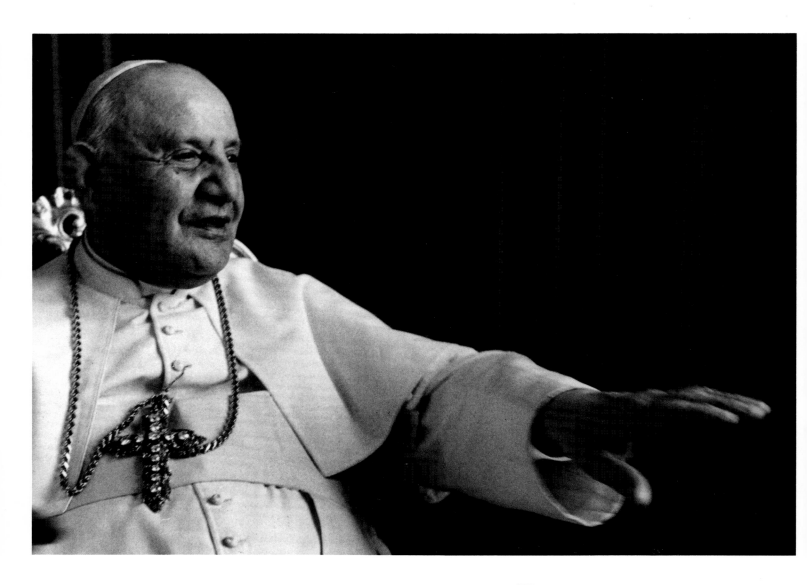

John XXIII was 78 years old when I photographed him, two years after his election as pope. I will always remember him as a very gracious, jovial and friendly human being, able to put the ordinary person completely at ease. At one point, he pointed to the cross he wore and admonished me to either include it entirely in the photo or delete it entirely. Naturally, I complied.

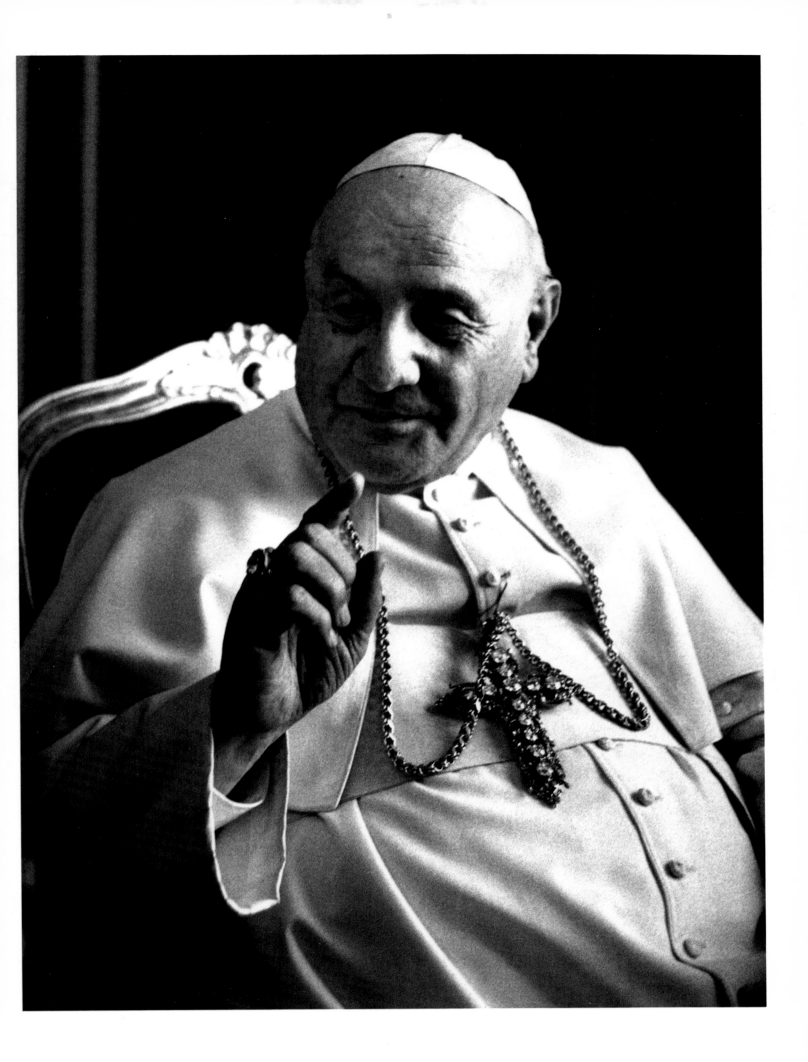

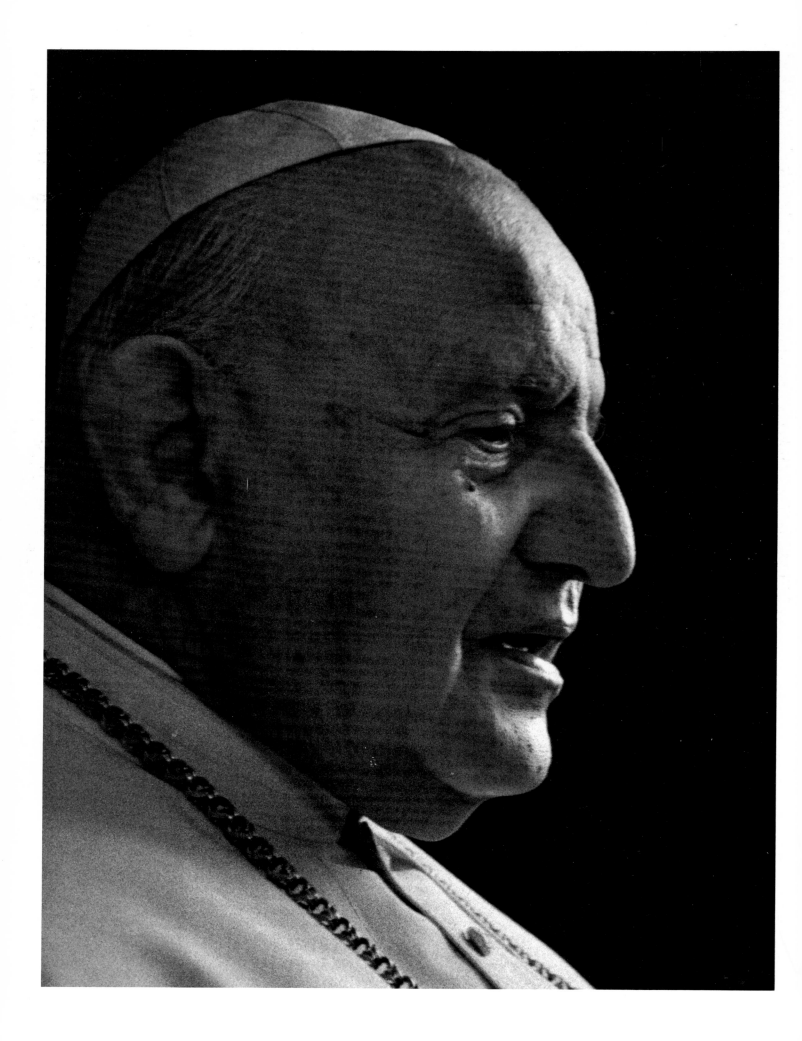

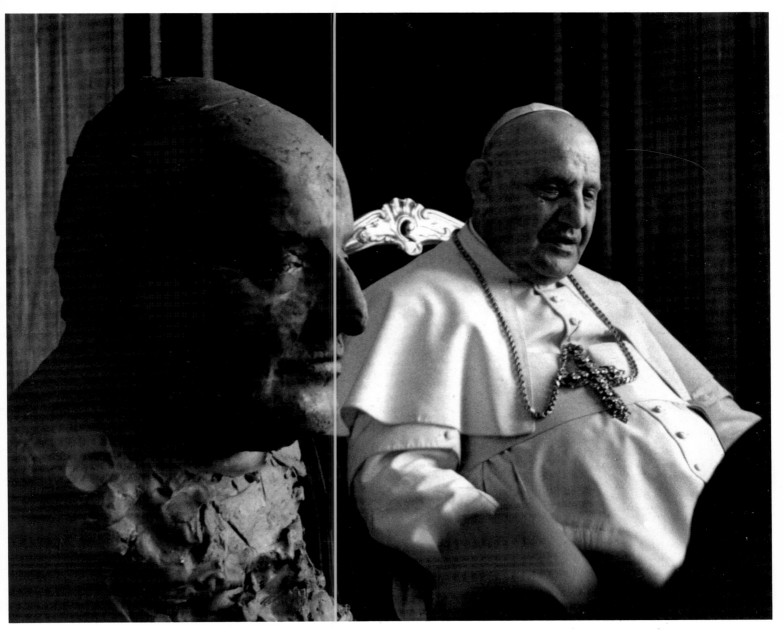

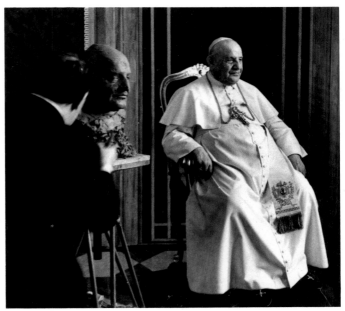

A sitting had been scheduled with the great sculptor Giacomo Manzu. Manzu had been waiting in the anteroom, and he entered carrying the half-finished clay head. He set the figure on a stand near the window.

Thinking that my session was over, I started to put my equipment away, but the pope, invited me to stay.

What an opportunity for pictures. I took several of Manzu working with Pope John seated on the throne. The Pope smiled and nodded almost imperceptibly, letting me know he approved. I moved in for close-ups.

When the ten minutes allotted to him was up, Manzu picked up the still-uncompleted bust and left.

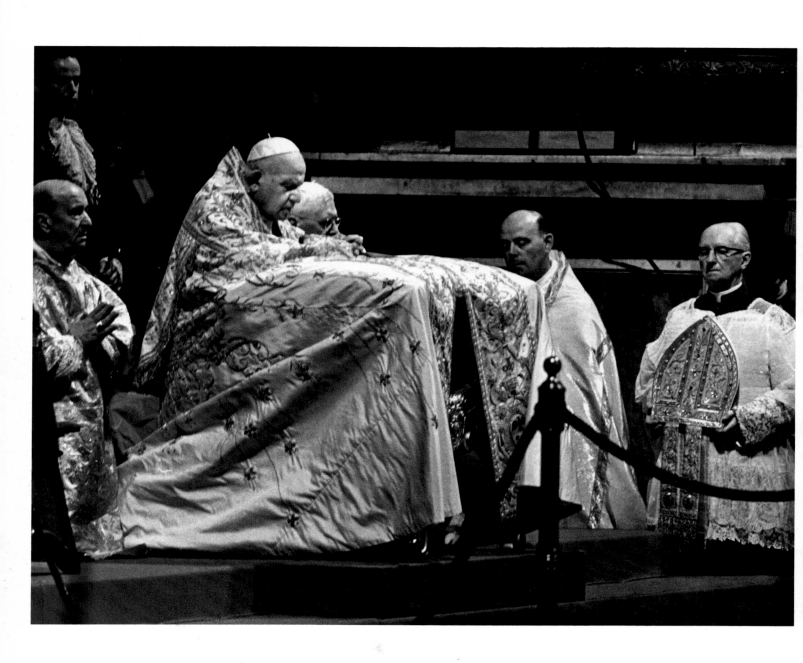

VATICAN CITY, 1962

Pope John XXIII prays for the success of the ecumenical council in front of the Bernini Altar in St. Peter's.

Pope John XXIII opens the first session of the ecumenical council known as Vatican II (opposite) from the Bernini Altar in St. Peter's Basilica, Oct. 11. The first such worldwide church council held in 100 years, it was convened to update Roman Catholic doctrine. I had access to all the good vantage points because of the relationship I had developed over the years with the Vatican.

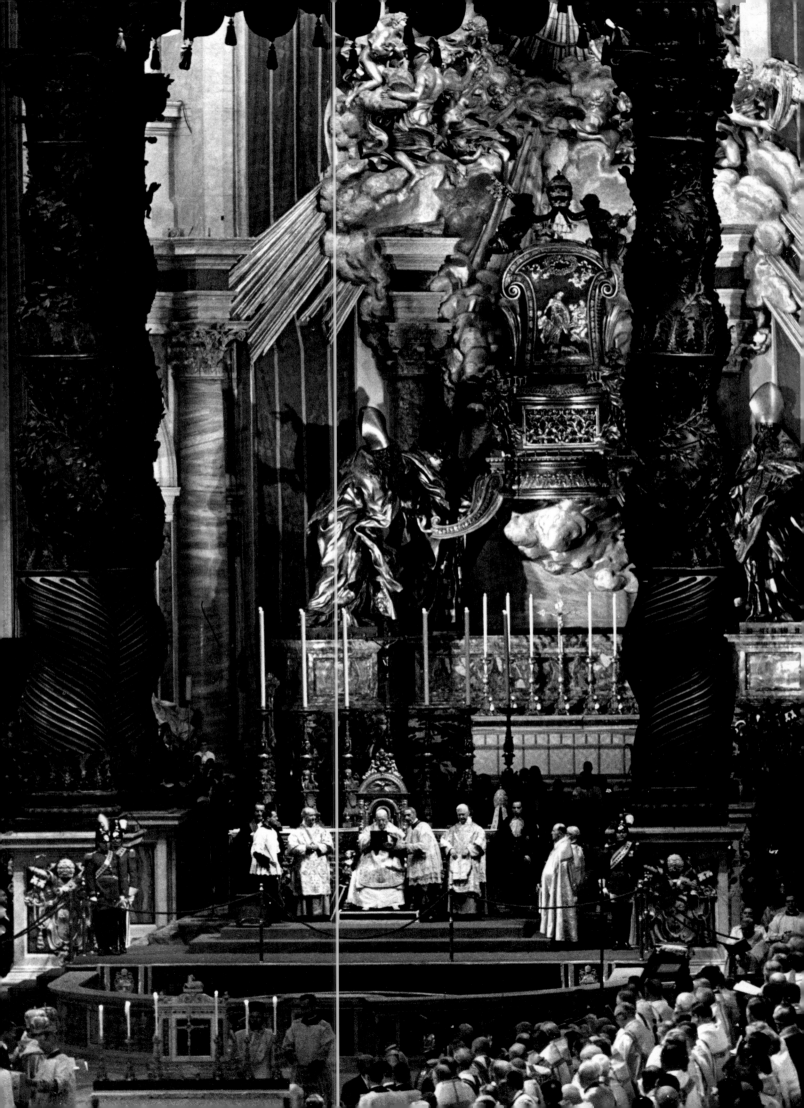

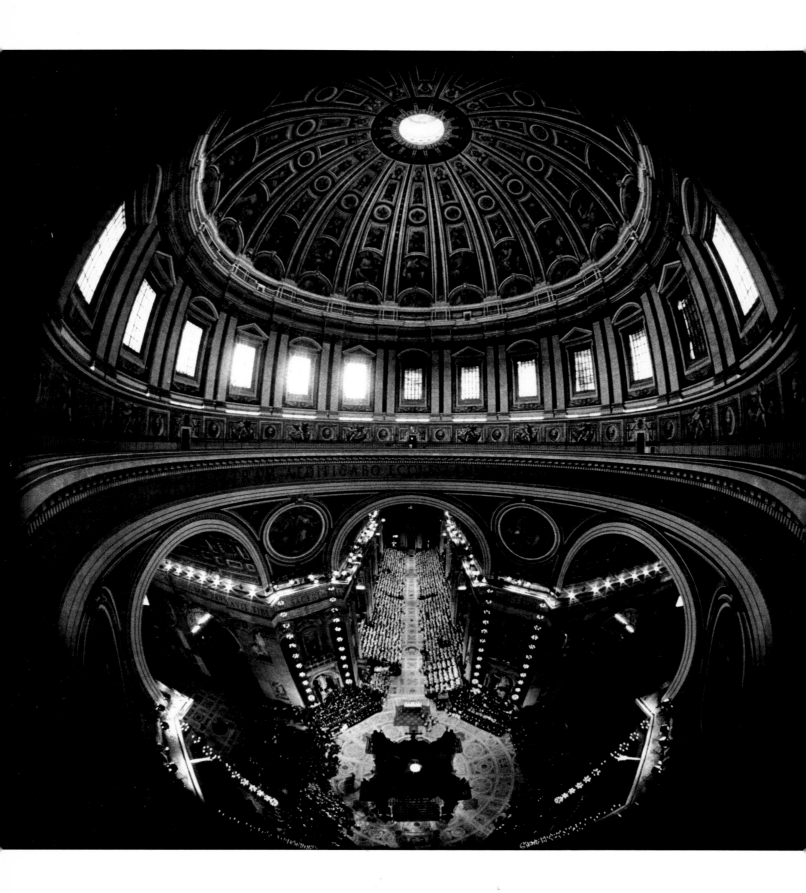

VATICAN CITY, 1962

With special permission, I was permitted to go to the top of the dome for this fish-eye view during Vatican II. This view captured two-thirds of St. Peter's Basilica, the dome, the Bernini Altar and the 3,000 council fathers from all over the world, seated in the central nave of the basilica, which is the world's largest church.

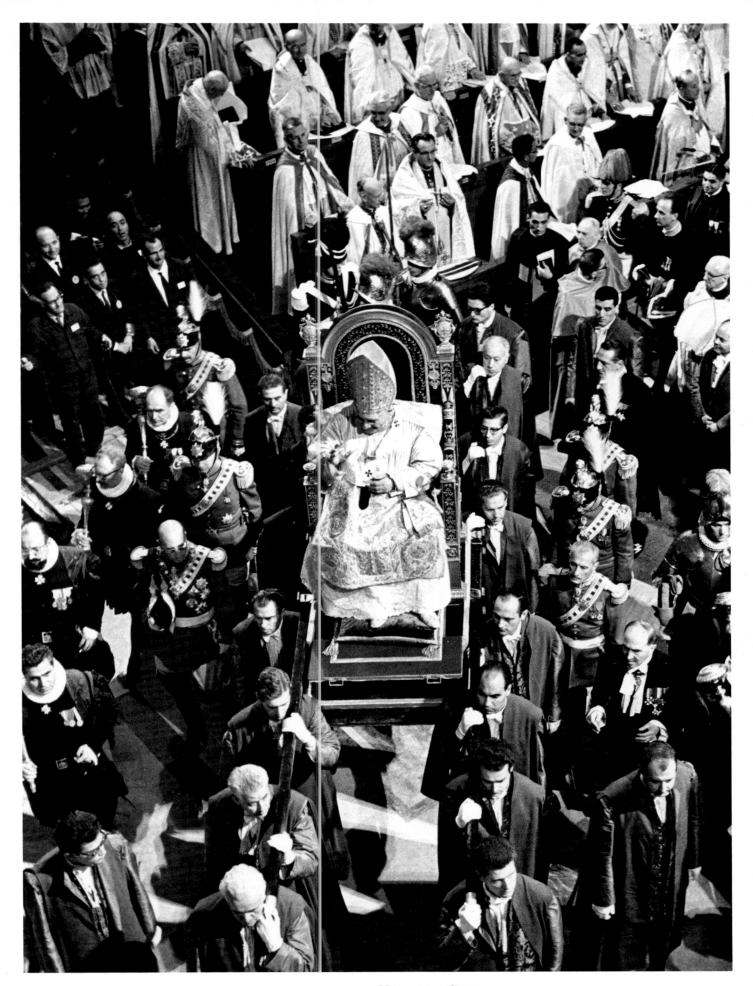

VATICAN CITY, 1962

After the opening session of Vatican II, Pope John is borne out of St. Peter's Basilica. This was the last picture I took of him. He died the following year.

205 □ POPES

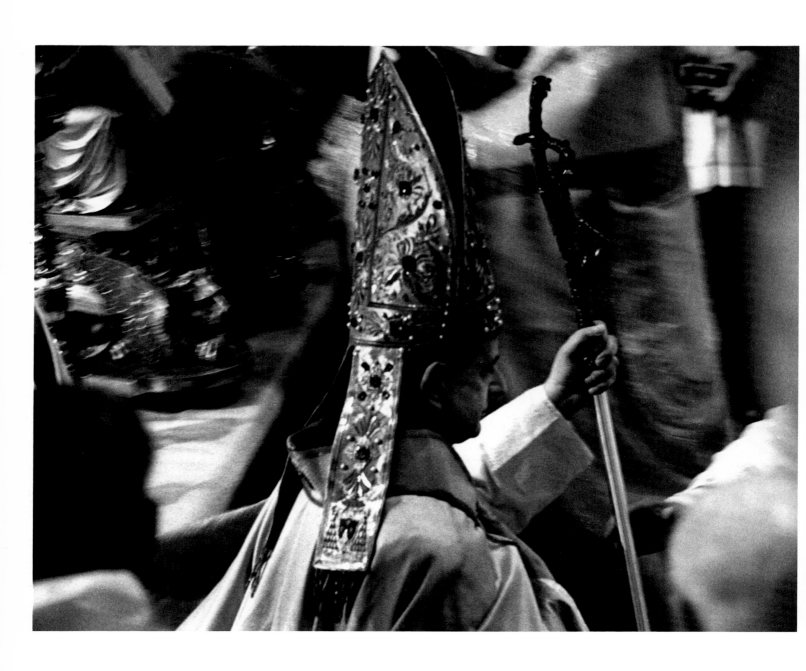

VATICAN CITY, 1963

**Pope Paul VI, walking into St. Peter's Basilica for the second
session of Vatican II, the ecumenical council. The council,
convened by Pope John XXIII, had four sessions, the last one
ending in December 1965.**

VATICAN CITY, 1967
Pope Paul VI ascends to the throne for the audience he holds every Wednesday. I was privileged to spend the entire day with him. We ran it in the Free Press: "A Day in the Life of Pope Paul VI."

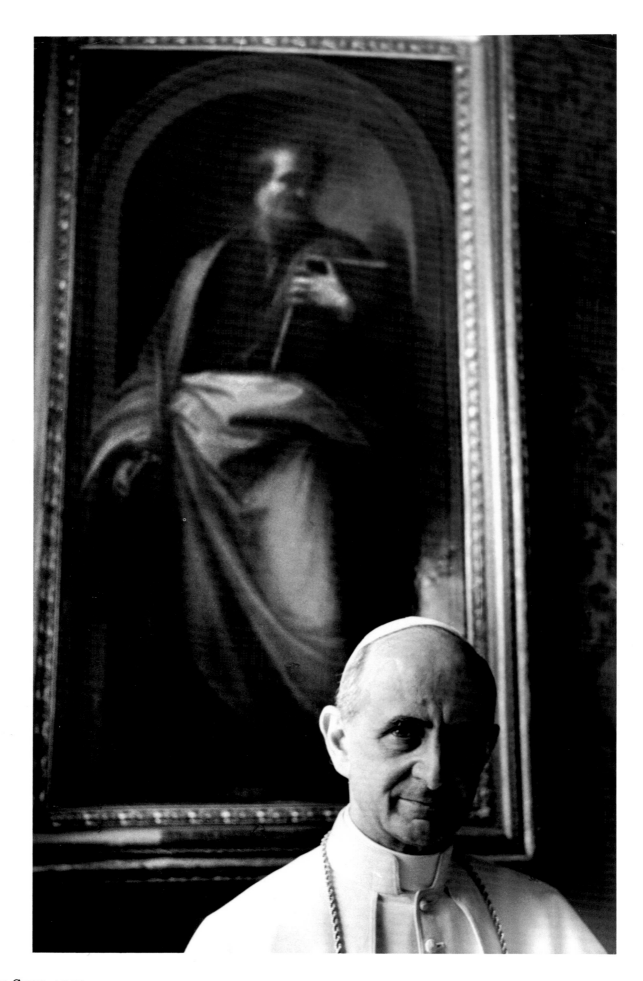

VATICAN CITY, 1967
I asked Pope Paul if he would pose for me next to one of the famous paintings in his private study. He walked to the painting of St. Peter, by Raphael.

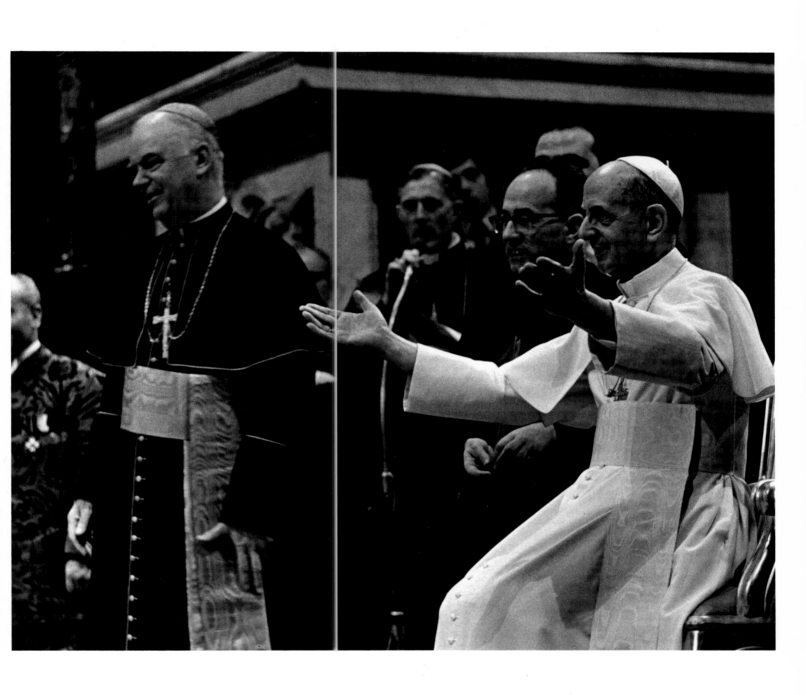

VATICAN CITY, 1969

John Cardinal Dearden, who had been archbishop of Detroit, was called to St. Peter's Basilica to receive his cardinal's hat from Pope Paul VI. "Go in peace to your diocese in Detroit," the pope said. Next to him is his personal secretary, Don Macchi.

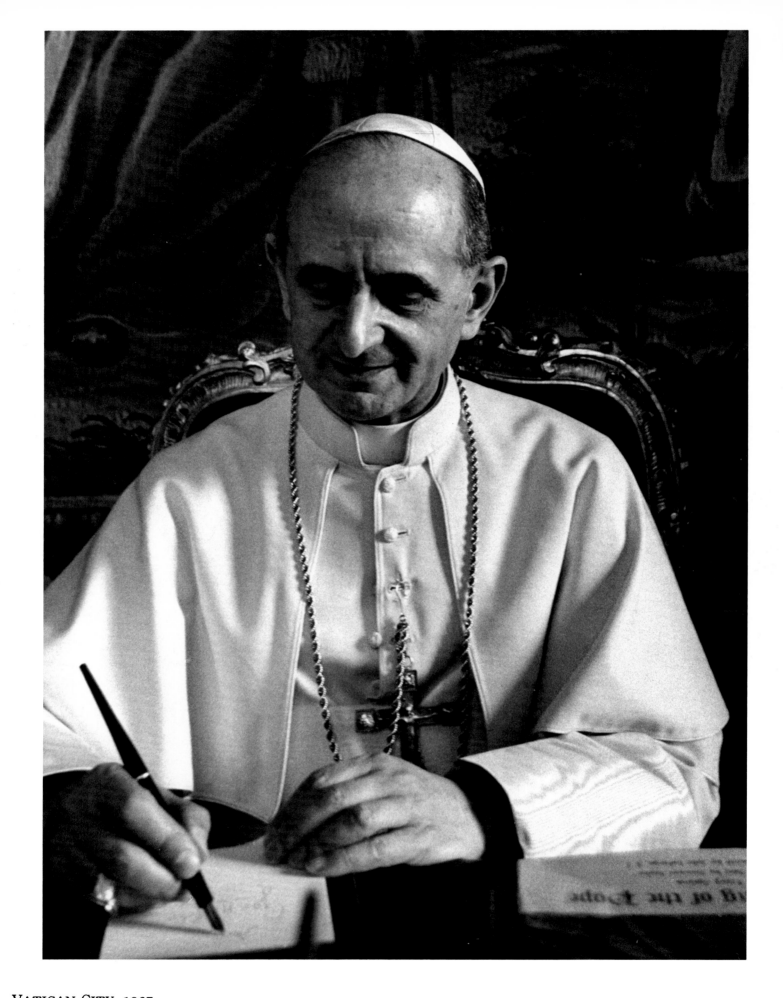

VATICAN CITY, 1967
**While I was with him, Pope Paul reviewed my book about
John XXIII, "The Making of the Pope." He told me, "That's
really Pope John."**

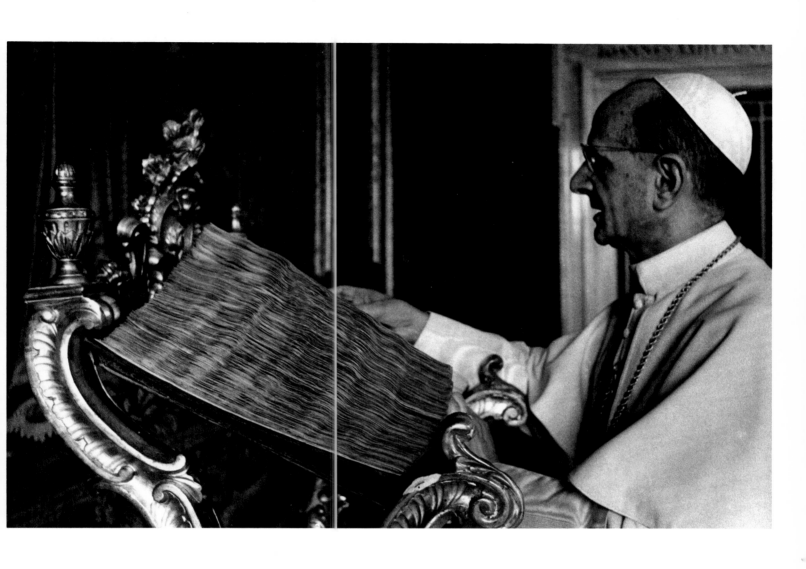

Vatican City, 1967

Paul VI then walked over to the other end of his private study and started to read scriptures from a Bible more than 1,000 years old, all hand-written on parchment. This, I was told, was the first photograph taken of a pope reading this Bible.

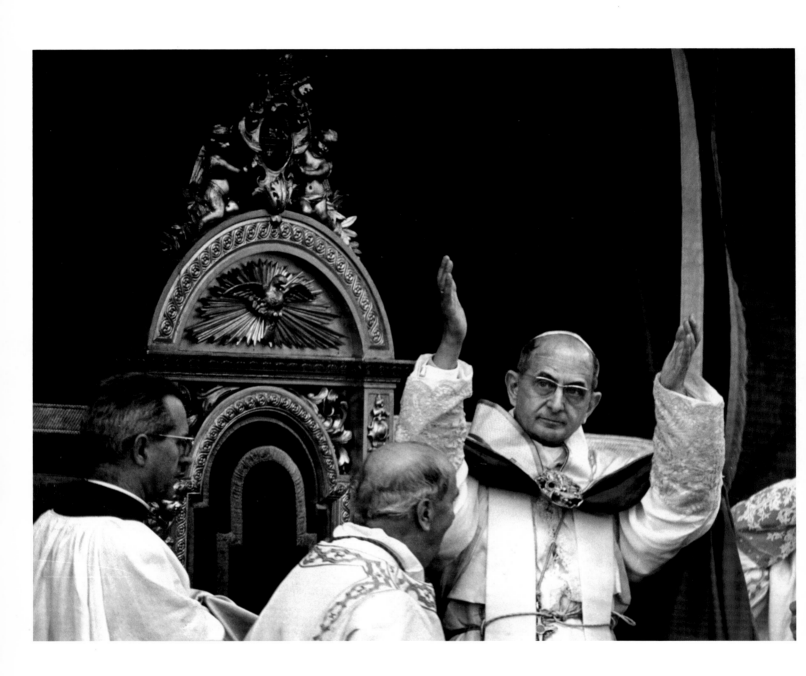

VATICAN CITY, 1965

"Ete in Pace" . . . go in peace, said Pope Paul VI to all the
council fathers and the faithful in St. Peter's Square as the
historic Vatican II ecumenical council came to an end on Dec.
8. Through his secretary, Pope Paul requested several prints
of this photo.

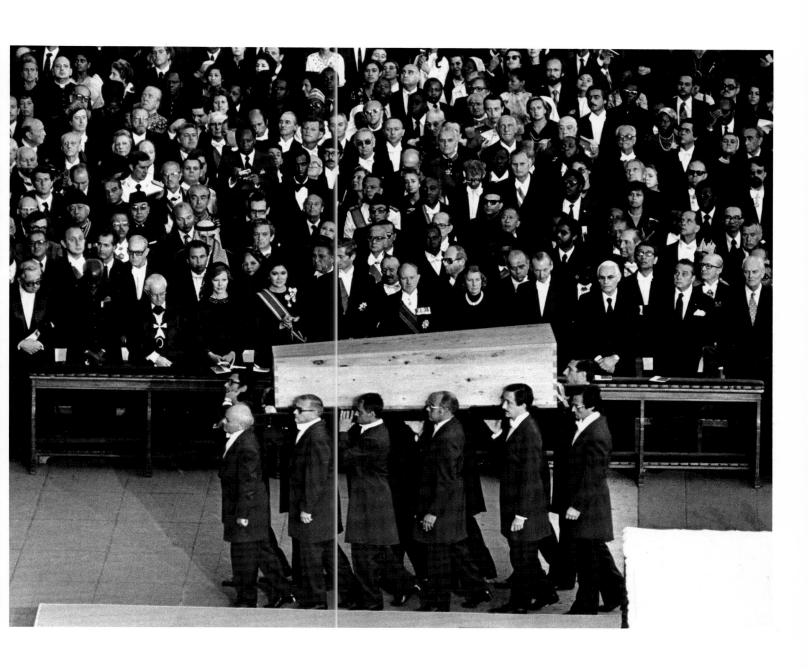

Vatican City, 1978

The simple cypress casket carrying the body of Pope Paul VI is carried past world leaders for burial inside St. Peter's Basilica. In the front row, fourth from the left, is Rosalynn Carter, representing the United States. Imelda Marcos of the Philippines is to her left. Fourth from the right in the front row is Kurt Waldheim, then secretary general of the United Nations. On the next two pages, you see the whole scene: The world's 110 cardinals lined up in front of the entrance to St. Peter's; clergy and friends seated in the section at the bottom of the photo, world leaders in the top section. The casket is dwarfed by its surroundings.

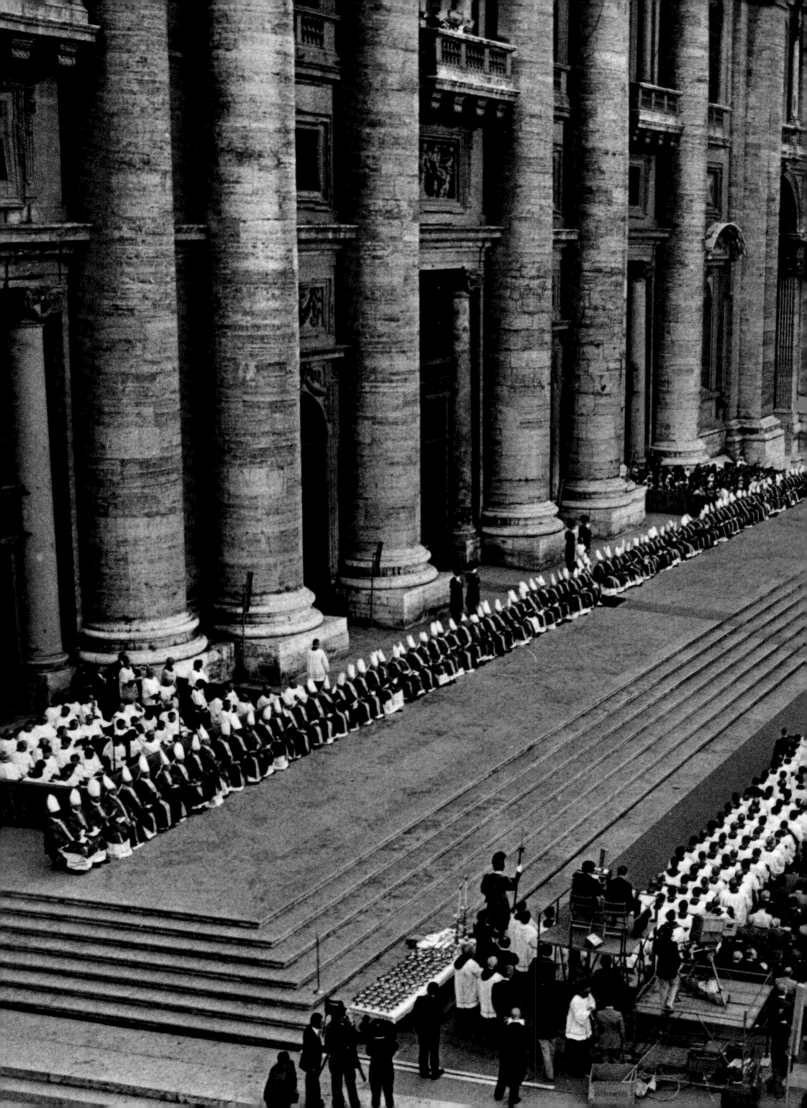

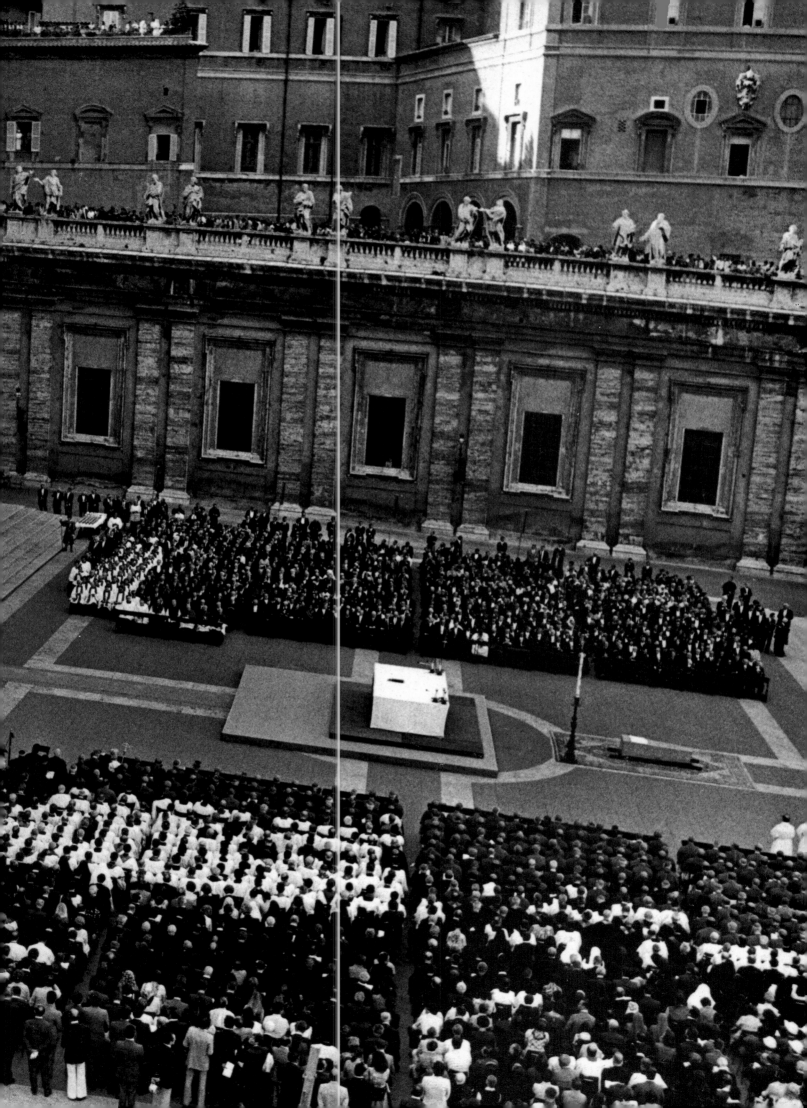

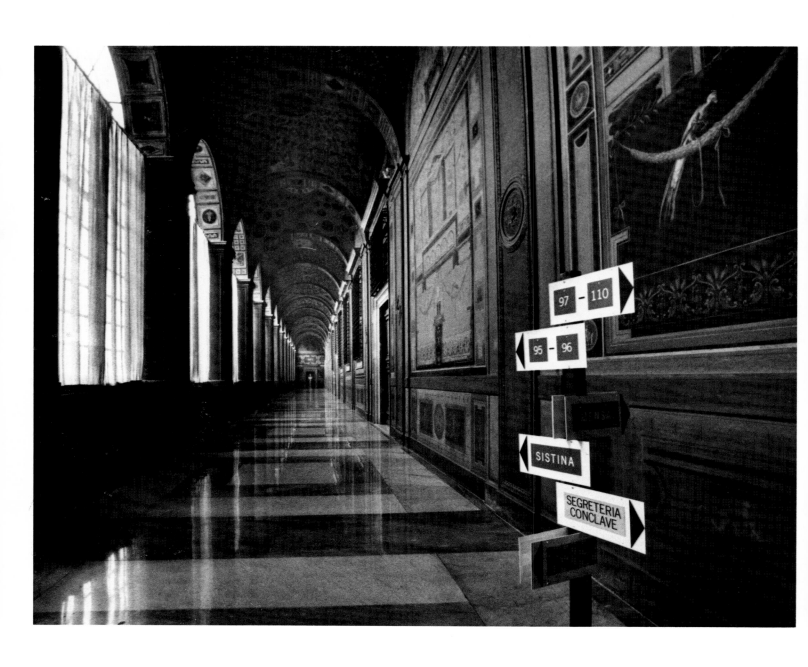

VATICAN CITY, 1978

The Apostolic Palace is ready for the conclave to elect a new pope to succeed Pope Paul. This is the scene on the third floor with directions for the cardinals, who stay until they elect a pope.

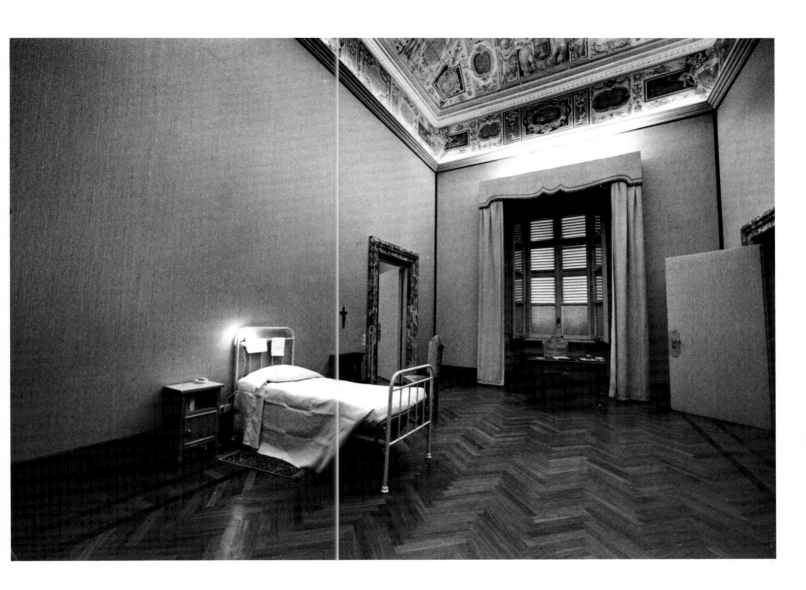

W hen a pope dies, the world's cardinals are summoned to Rome to pay their respects and to select a successor. They meet in secret and, in a tradition dating to the 13th Century, they are sealed off with a small staff from the rest of the world. Doors and windows of the Apostolic Palace are bricked up for the duration.

VATICAN CITY, 1978
During the conclave, each cardinal is assigned a cell, or bedroom. All are furnished this sparsely.

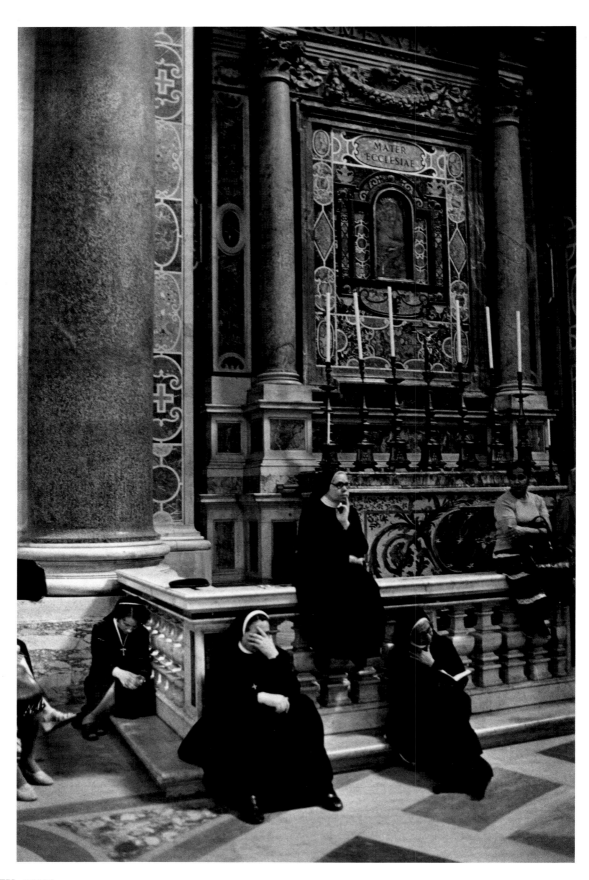

VATICAN CITY, 1978
 **The long wait begins. Walking through the basilica, I saw
 these nuns seated by one of the side altars in St. Peter's.**

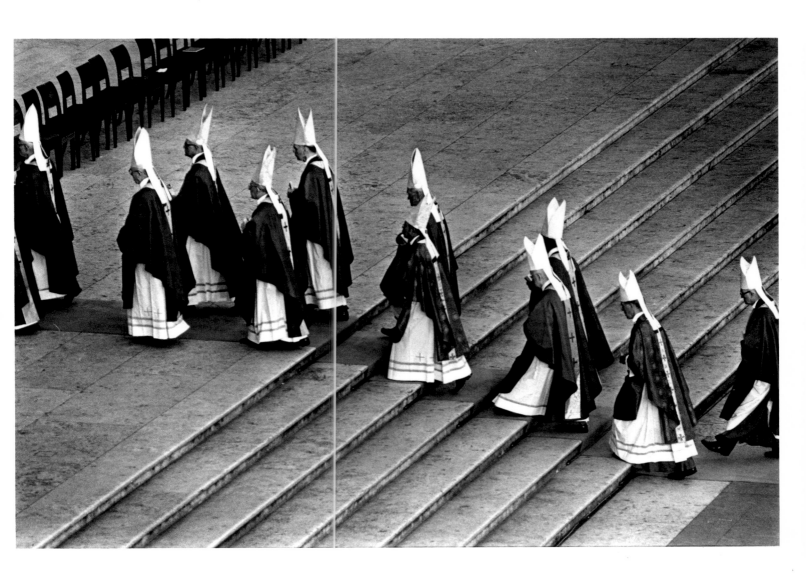

During a conclave, the cardinals meet twice a day in the Sistine Chapel. Any of three election methods may be chosen, but they usually use ballots. A winner is declared when someone gets a majority of two-thirds plus one. The ballots are burned after they are counted, at noon and five each day. If a pope is elected, the ballots are burned with dry straw, sending up white smoke. If they have not elected a pope, the ballots are burned with wet straw, sending up black smoke. The whole world knows at the same time when a pope has been elected.

VATICAN CITY, 1978
The 110 cardinals enter the conclave to elect one of their number as the new pope.

VATICAN CITY, 1978

The Sistine Chapel, where the cardinals will convene twice a
day until they elect a pope from among their number. At left
is the stove where ballots are burned after they are counted.

VATICAN CITY, 1978
**The gate to the San Damaso courtyard of the Apostolic
Palace, where the cardinals are sealed until they elect a pope.
All these were taken the day before the conclave started.**

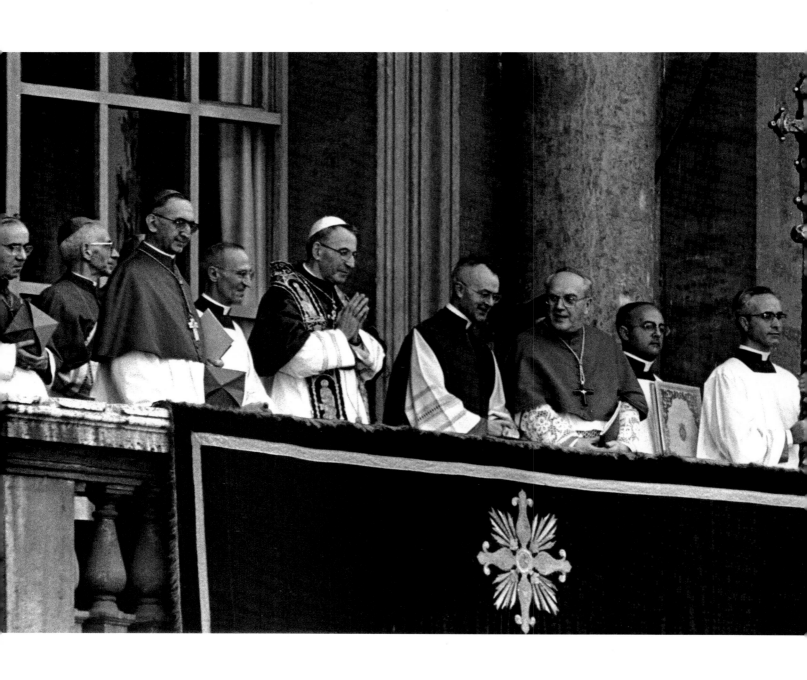

VATICAN CITY, 1978
John Paul I makes his first appearance as pope.

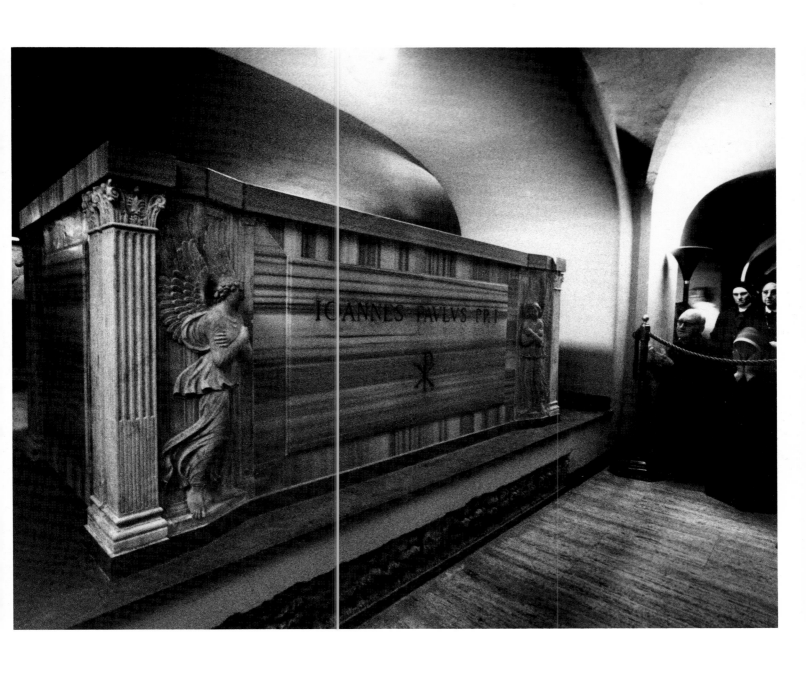

VATICAN CITY, 1978
The tomb of Pope John Paul I, in the lower level of St. Peter's Basilica. He died 33 days after his election.

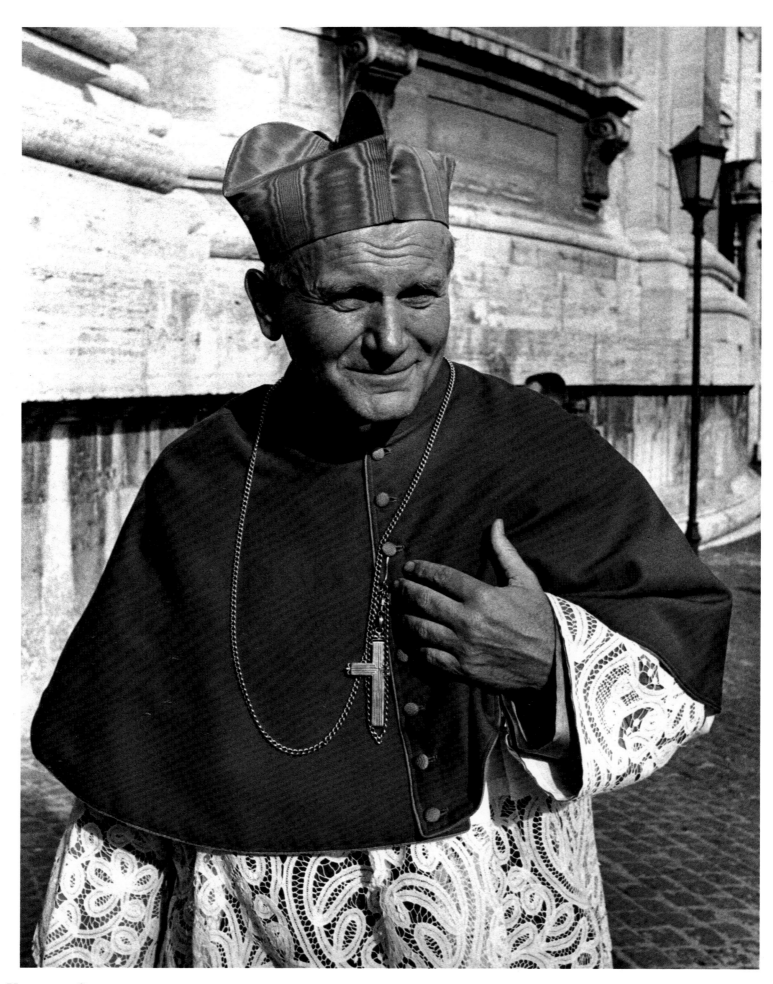

VATICAN CITY, 1978
Cardinal Karol Wojtyla from Poland.

S lightly more than a month after John Paul I was elected pope in 1978, the world's cardinals were back in Rome to bury him and select his successor. I had not expected to be back at the Vatican so soon either.

At the St. Martha entrance of St. Peter's, I asked one cardinal, as he entered the basilica, who the next pope would be. He said, "It's up to the holy spirit."

When I asked him for his name, he said, "I'm Cardinal Wojtyla, from Poland." He then disappeared through the Vatican doors into conclave.

In the next photograph anyone would take of him, he was Pope John Paul II.

In electing the first Polish pope and first non-Italian one in 456 years, the cardinals chose a remarkable man — at once an intellectual and an evangelist.

The world is his mission. Dozens of times he has ventured from the Vatican to visit the faithful in countries from Argentina to Zaire, logging millions of miles in a white- and red-striped plane dubbed Shepherd One.

Even a 1981 assassination attempt that put him in the hospital and another close call in 1982 did not diminish his appetite for moving into throngs of the faithful to touch hands and kiss children.

I covered John Paul II on two trips to the United States and three visits to Poland. These assignments were real endurance tests. I traveled with one camera around my neck and one over my left shoulder, and, over my right

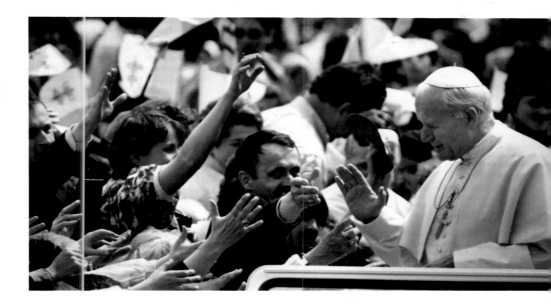

shoulder, a camera bag with everything I needed for the entire trip. It became part of me. Papal visits are tightly scheduled and keep him rolling from place to place. To get the best vantage point, I often would arrive hours ahead — at 4 a.m., say, for a 9 a.m. appearance. Afterward, if I was sending photos back to the Free Press, the challenge was to get my film to the wire service and prints transmitted as fast as possible before rushing to the next place I needed to be.

The crowds that turn out to see and hear a pope are pretty much the same anywhere, I suppose. In Poland I was particularly struck by the quiet expressions of faith in people whose religious and political freedom is restricted. I tried to capture that in some of my pictures.

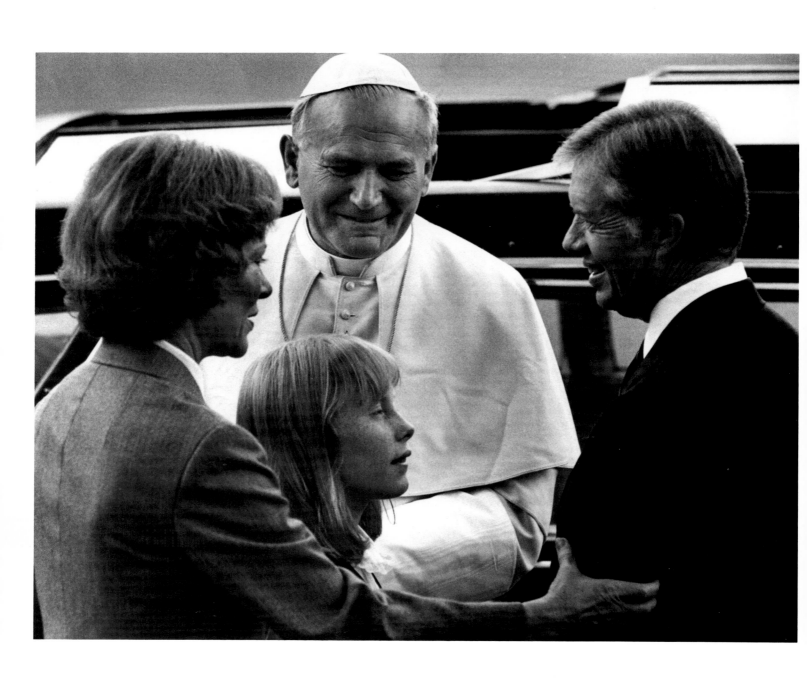

WASHINGTON, D.C., 1979
The first family meets John Paul on his first papal visit to the U.S. I was one of four photographers allowed to be at the steps of the White House when Rosalynn, Amy and President Carter greeted him.

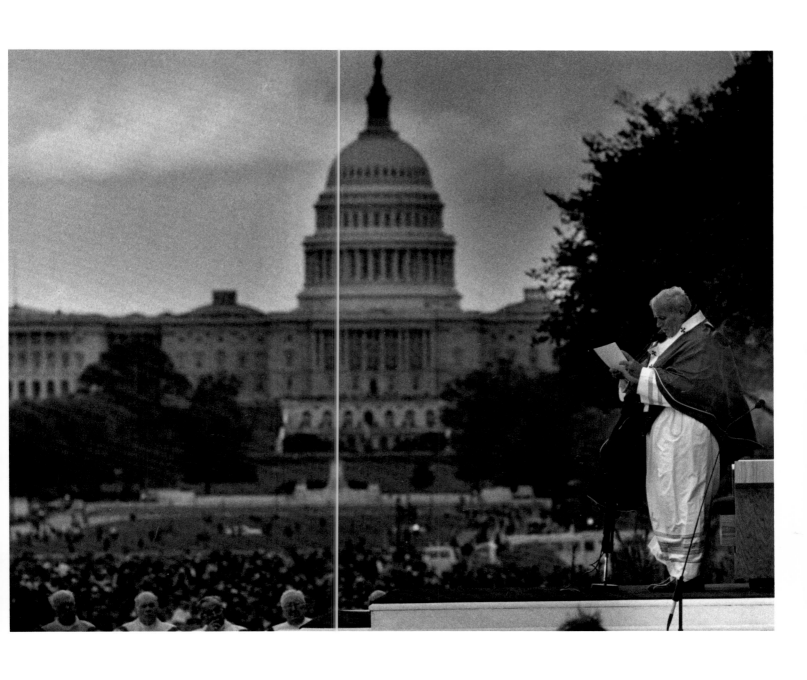

WASHINGTON, D.C., 1979
**Pope John Paul II speaks on the National Mall in front of the
U.S. Capitol.**

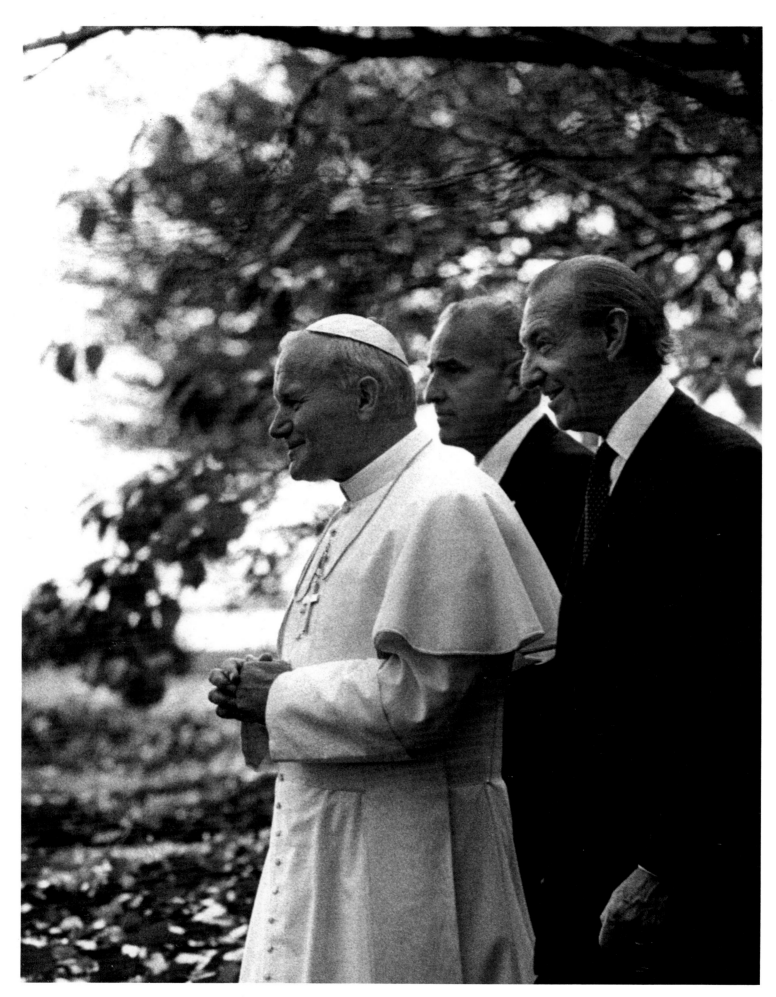

NEW YORK, 1979

**John Paul II enjoys a stroll through the United Nations
gardens with UN Secretary General Kurt Waldheim.**

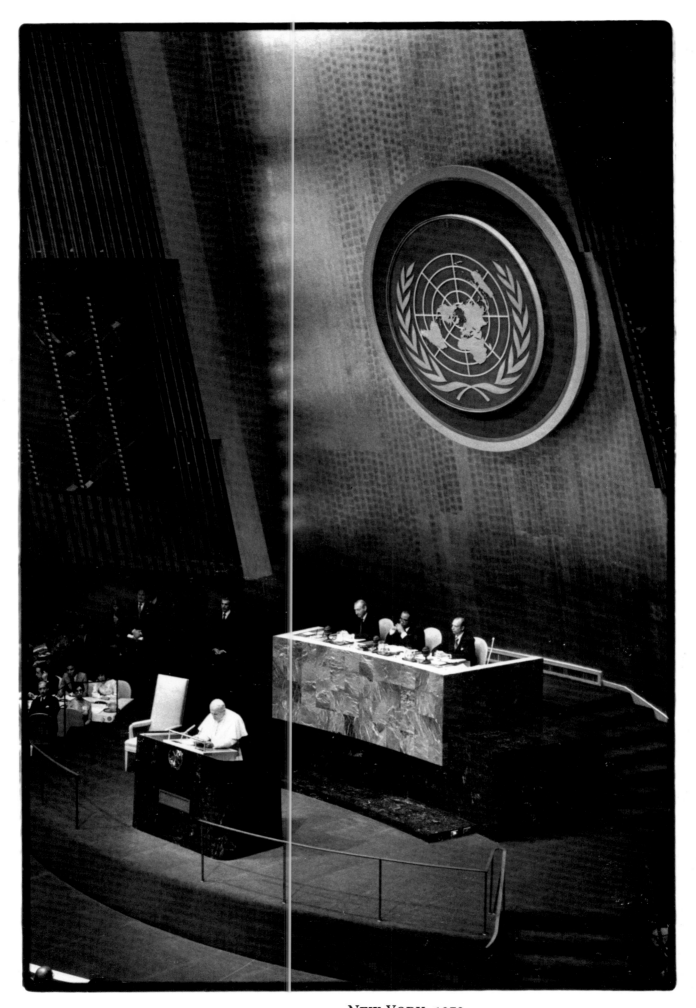

NEW YORK, 1979
John Paul addressed the United Nations. I took close-ups,
too, but the overall shot told more about this impressive hall.

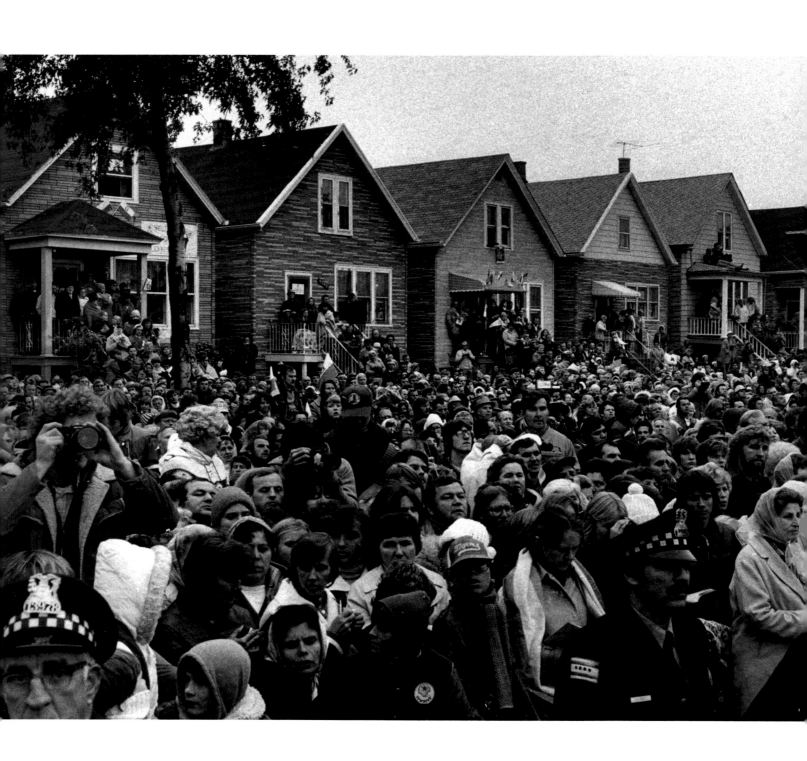

CHICAGO, 1979

In Chicago, John Paul II held mass for the Polish community in the Five Holy Martyrs Church. The overflow crowd jammed all the side streets to hear the pope through loudspeakers.

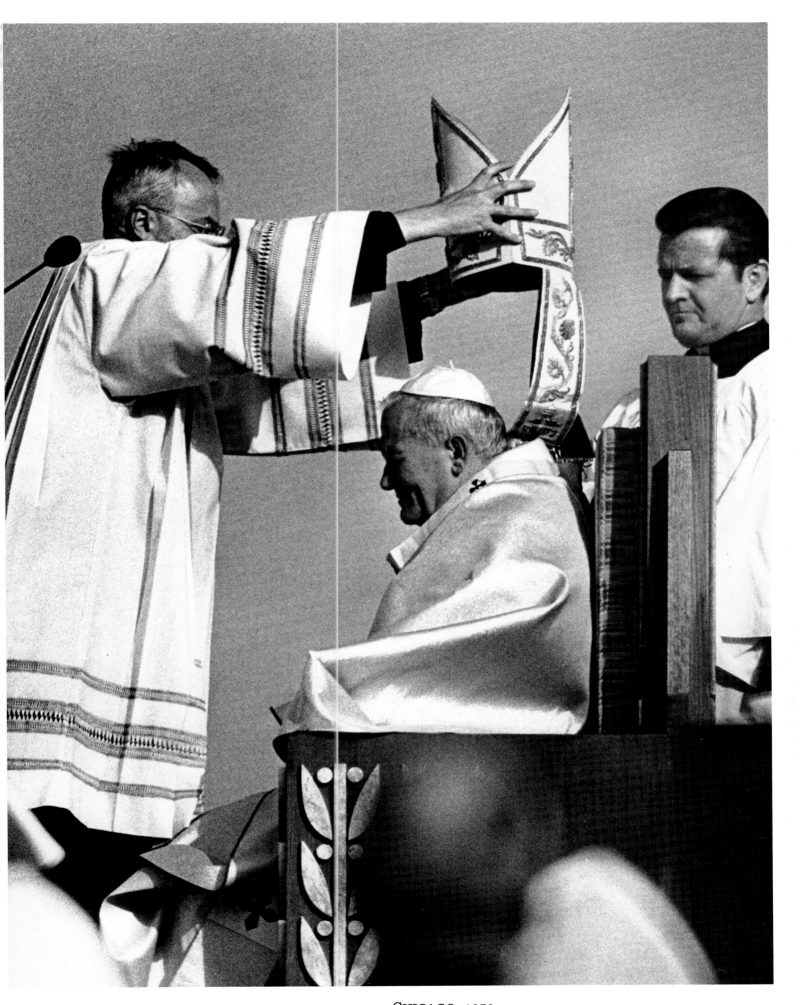

CHICAGO, 1979
**In Chicago, Father Noe places the mitre on Pope John Paul II
while Father Roche of Chicago looks on.**

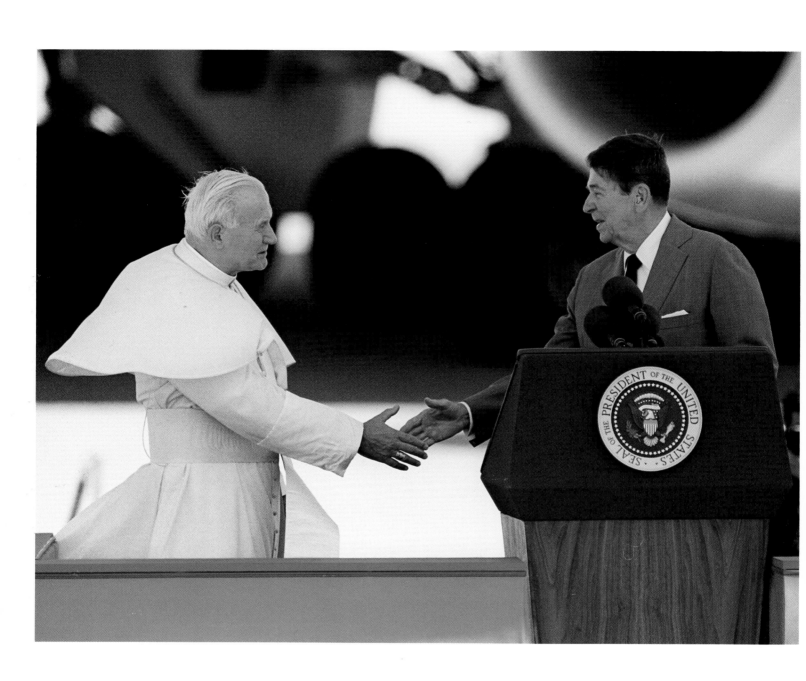

MIAMI, 1987

On Sept. 10, Pope John Paul II made his second trip to the U.S., and President Reagan was on hand to greet him at the Miami airport. That also was my birthday.

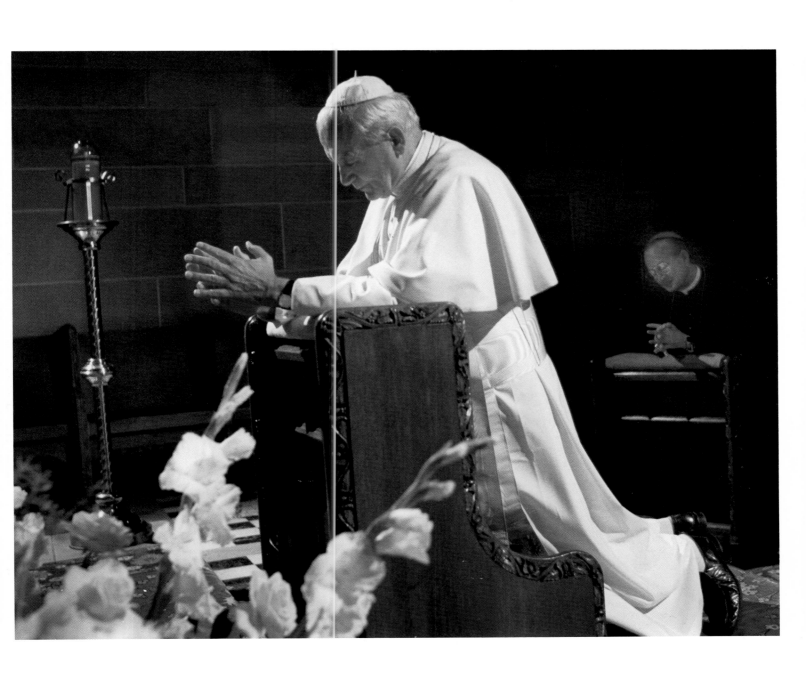

DETROIT, 1987

The pope prays in the chapel of the Cathedral of the Blessed
Sacrament. Behind him is Archbishop Edmund C. Szoka.
They paused there for only a couple minutes before going
into the cathedral to say prayers. I was the only photographer
there. This was his first Detroit appearance on this trip. He
had been to Detroit before, as a cardinal.

233 □ POPES

POLAND, 1979

People walk to Wadowice, the hometown of John Paul II. No cars were allowed within 20 miles, just official buses, so the average person who wanted to see the pope had to walk 20 miles in 95-degree June heat. It was his first visit to Poland as pope.

POLAND, 1979

Despite the pouring rain, the throng kneels in prayer during mass at Katowice, a village in Poland. Many in the one million-plus congregation had stood, waiting for the beginning of the mass, for up to six hours during the rainstorm. I always carry a rubbish bag to cover my equipment in case of rain. It fits in your camera bag, and it keeps you from getting caught unprepared.

As more than one million Poles cheer his entrance (next page), John Paul II rides on a flower-bordered route into Warsaw's Tenth Anniversary Stadium, where he celebrated high mass.

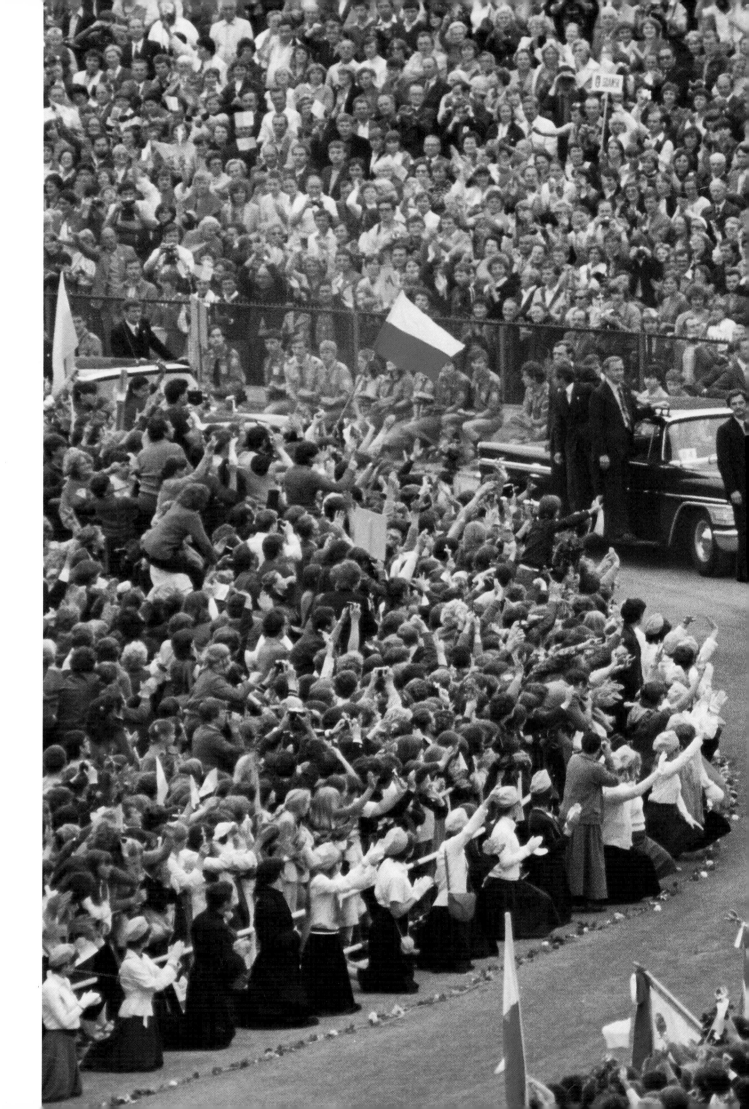

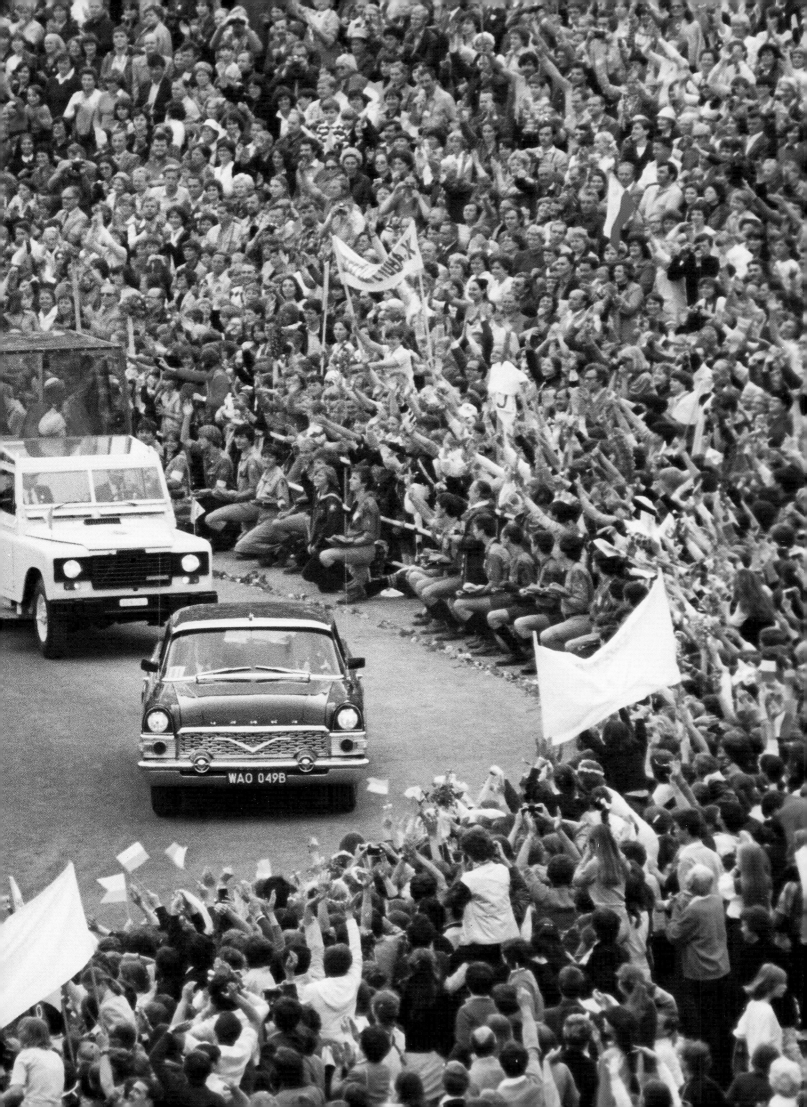

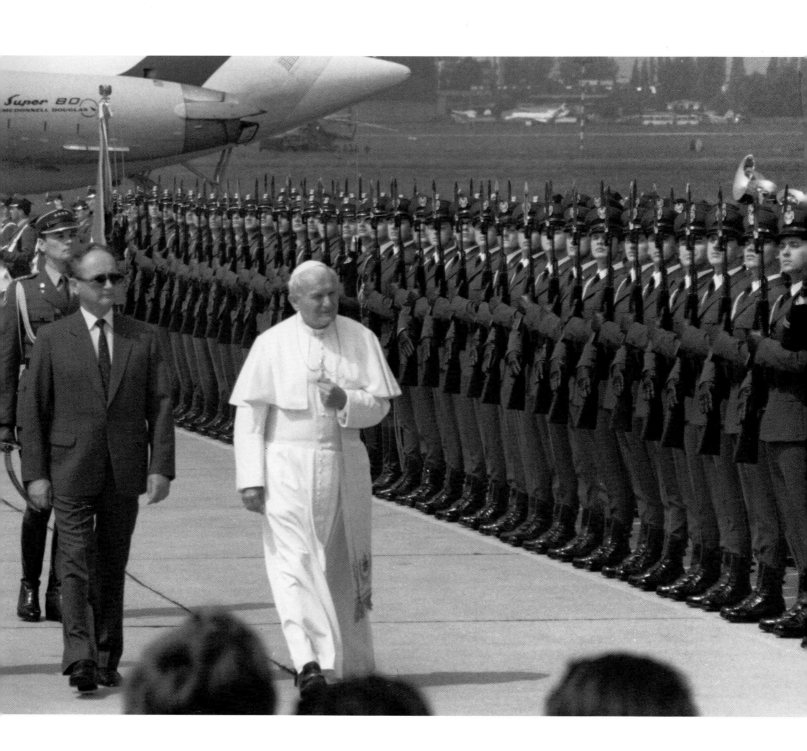

WARSAW, 1987

Pope John Paul II made his third visit to Poland June 8-14.
Upon his arrival in Warsaw, he was greeted by the Polish
leader, Gen. Wojciech Jaruzelski, at the Okecie military
airport. After the band played the national anthem, they
reviewed an honor guard of 300 army and navy troops.

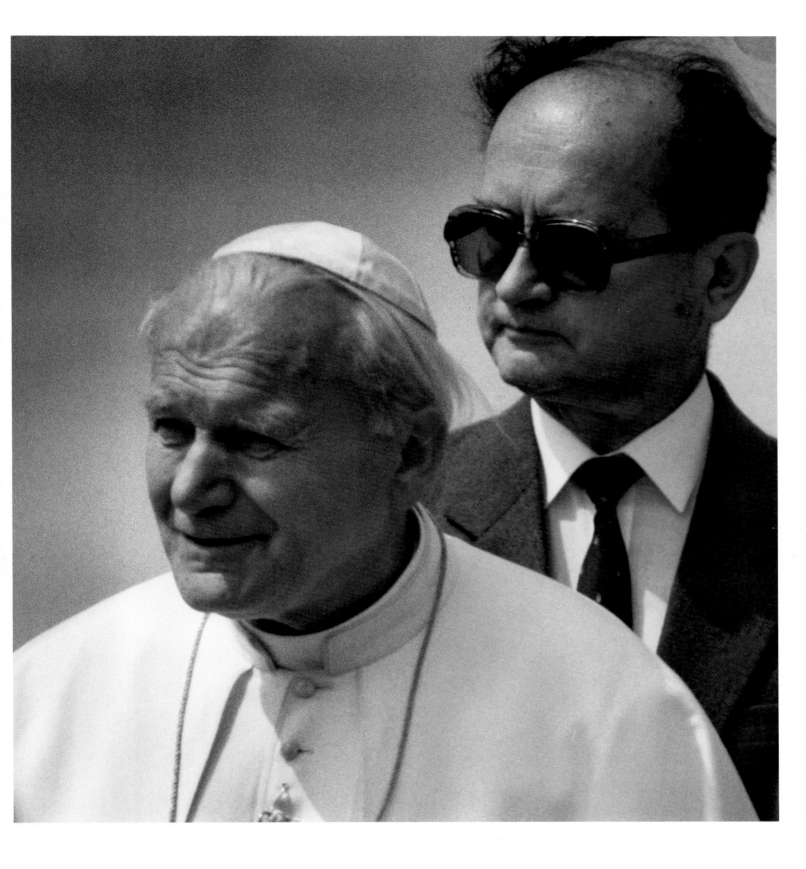

WARSAW, 1987
To me, this says church and state. These two men — the
Polish pope and Gen. Wojciech Jaruzelski — are shaping the
future of Poland. The clash of ideals of Roman Catholicism
and communism is an undercurrent of daily life here.

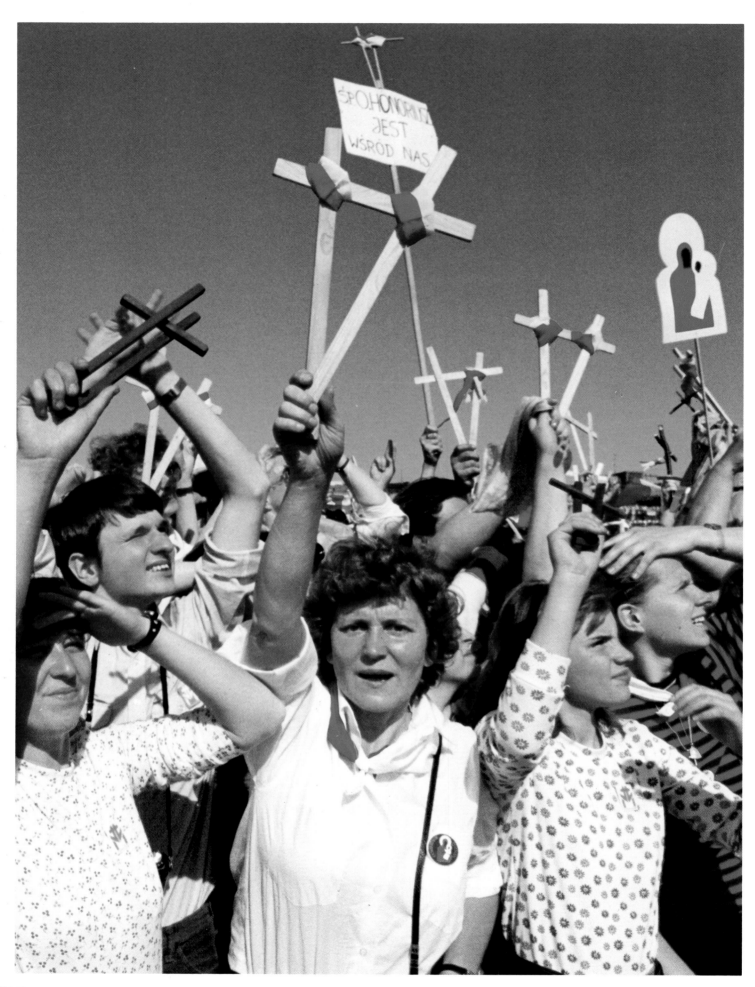

Poznan, 1983
**This was the pope's second visit to his homeland. The faithful
wave wooden crosses and say, "We trust in you." On the
same trip (opposite), the pope greets a crowd in Warsaw.**

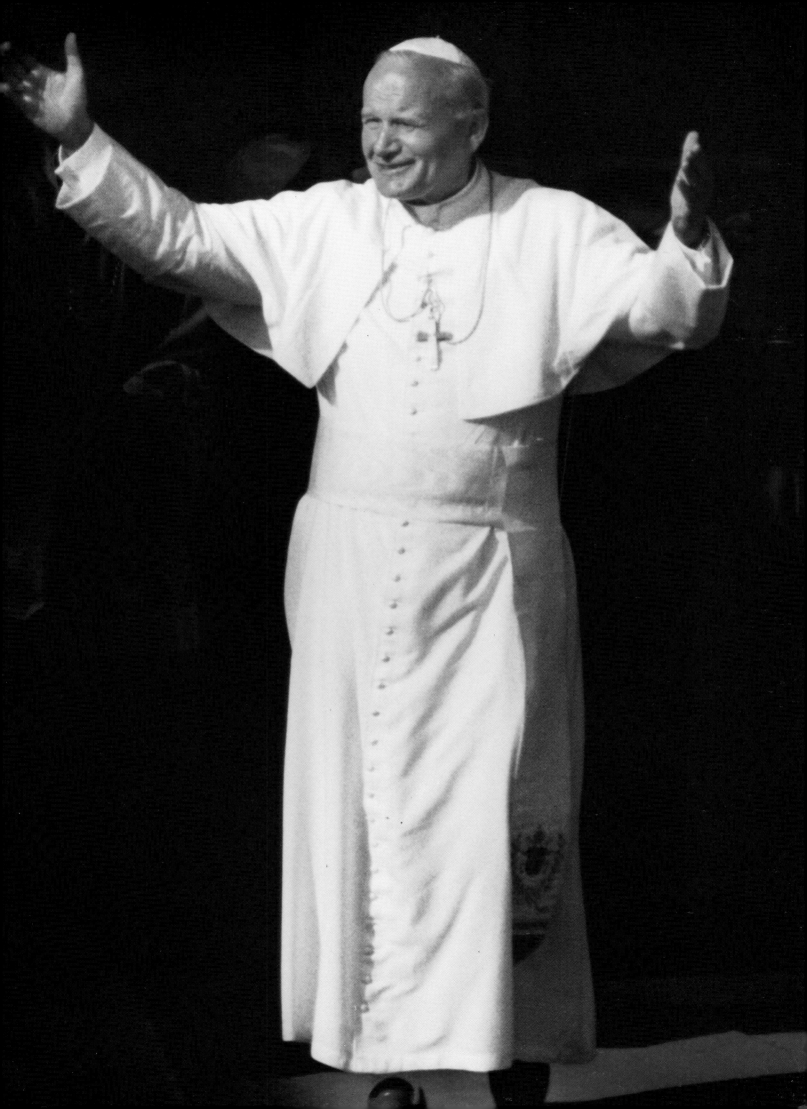

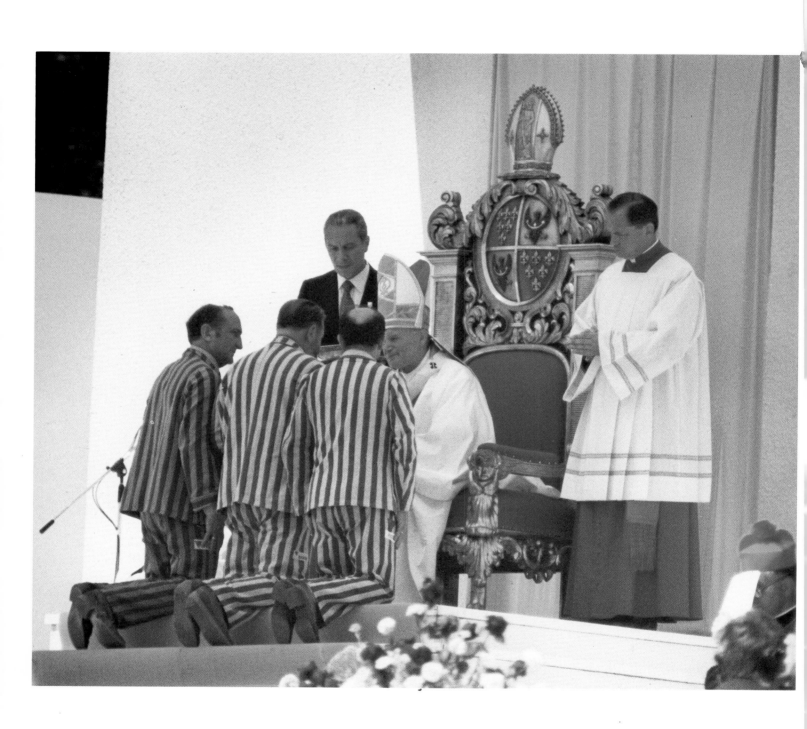

WROCLAW, POLAND, 1983
**Three survivors of Auschwitz, wearing the uniforms of Nazi
concentration camp prisoners, are blessed by the pope during
an audience at Wroclaw.**

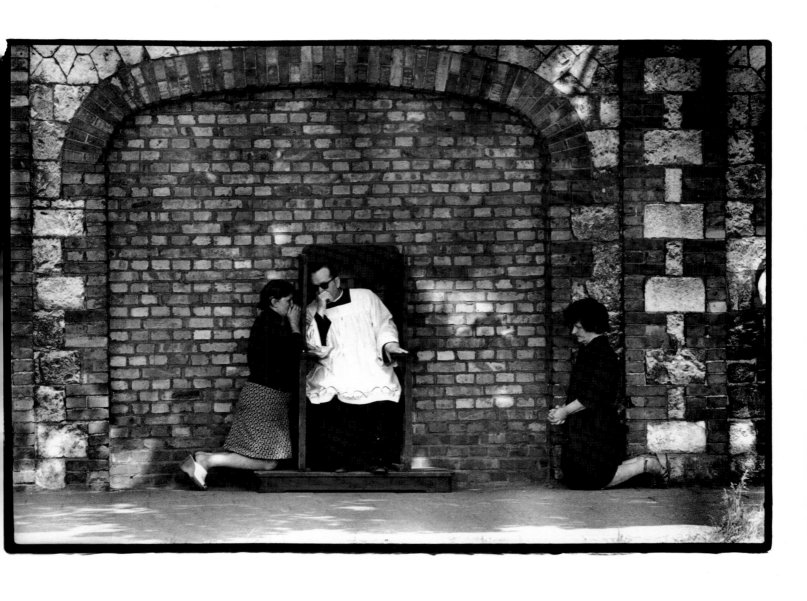

POLAND, 1983
**One of four confession stations along the walls of the
Monastery of Josna Gora in Czestochowa.**

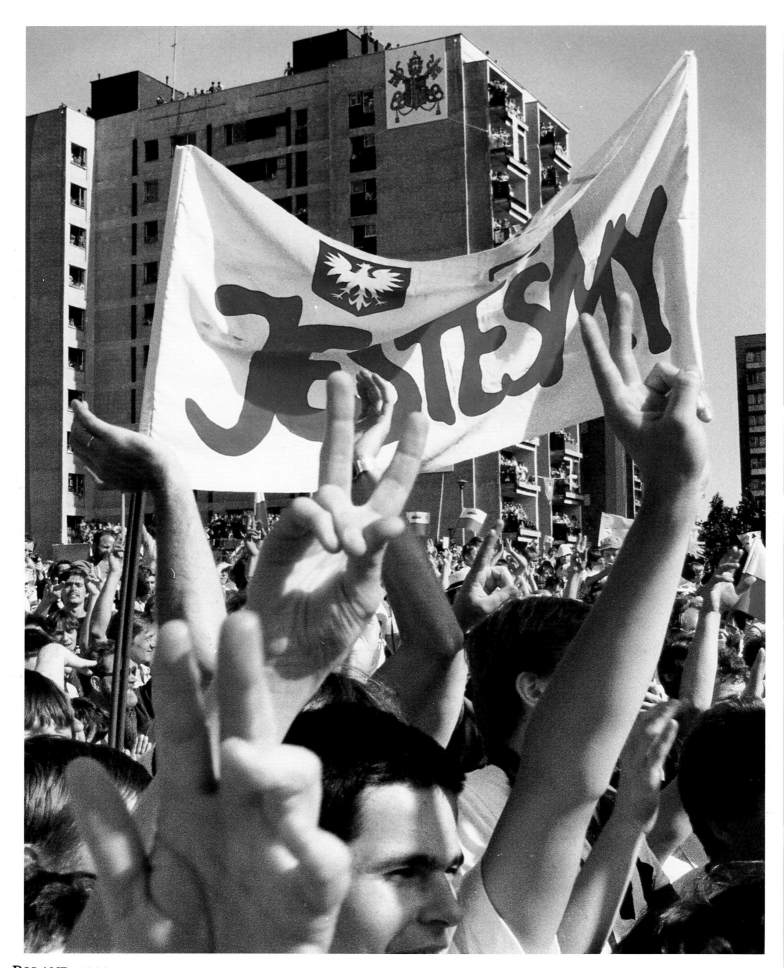

POLAND, 1983
With the name Solidarity banned by the government, union supporters defiantly display a banner proclaiming Jestesmy — "We are!" — as they march into a crowd gathered before the Church of St. Maximilian Kolbe at Nowa Huta, near Krakow, where the pope was going to say mass.

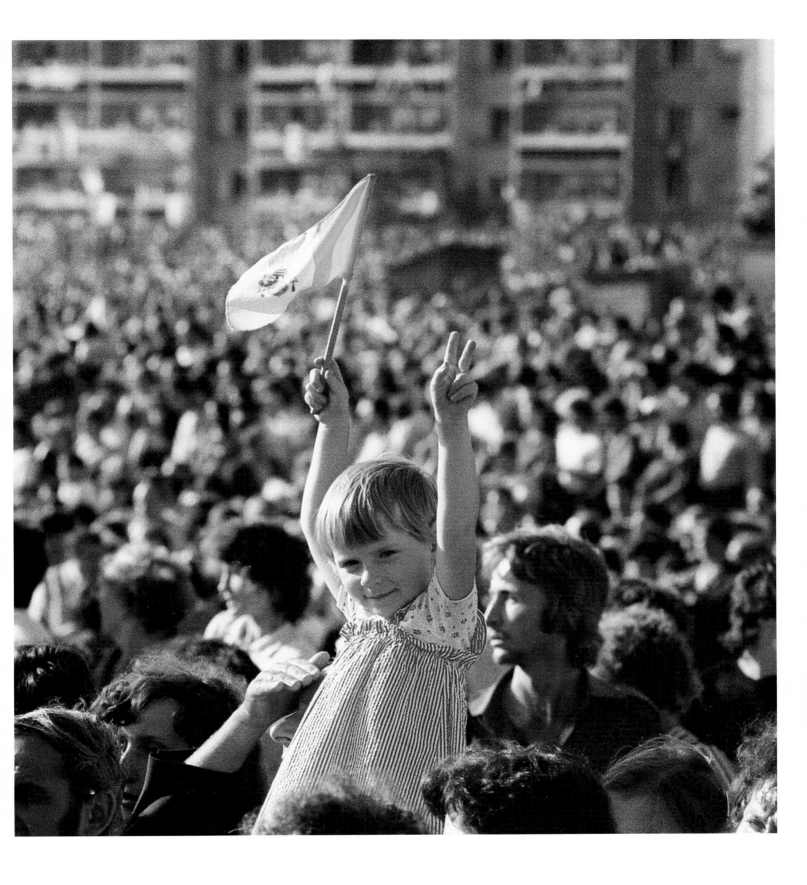

POLAND, 1983
Elsewhere in the crowd, a child is held high, waving the
Vatican flag and a victory sign.

245 □ POPES

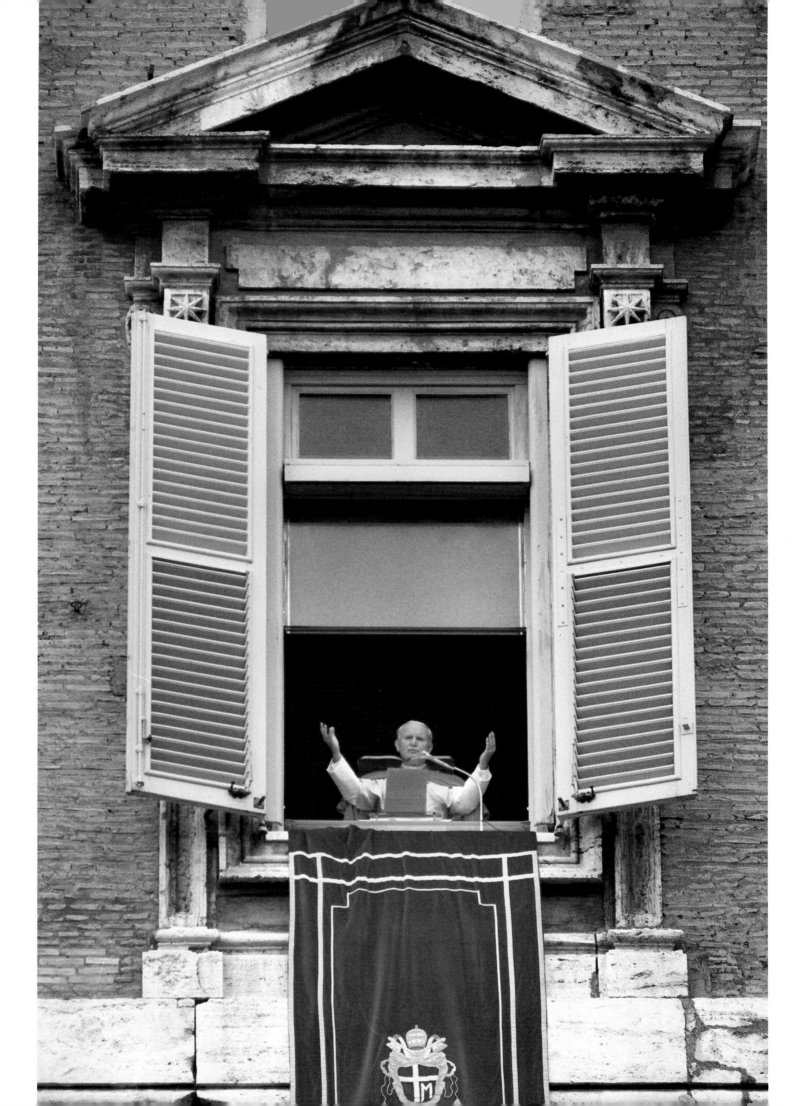

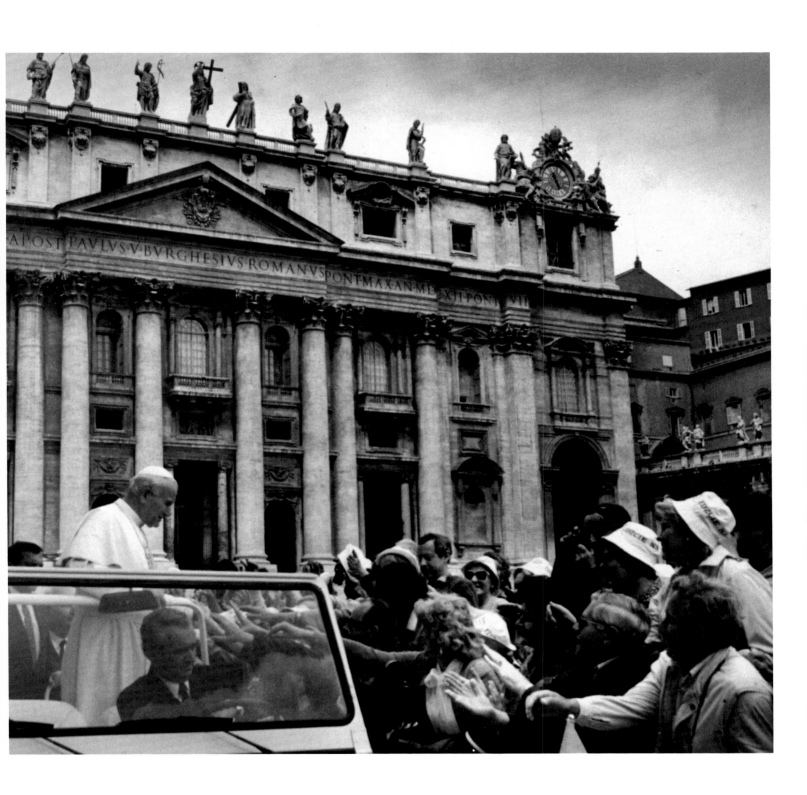

VATICAN CITY, 1987

**Every Sunday at midday, Pope John Paul II appears high in
the window of his study in St. Peter's Square (opposite). He
addresses a few words to the crowd below, referring to things
of relevance to the city and the world. This leads to the
recitation of the Angelus, the traditional prayer of the people,
which is said at midday and in the evening. Above, he arrives
in the Popemobile at St. Peter's Square for a public audience.**

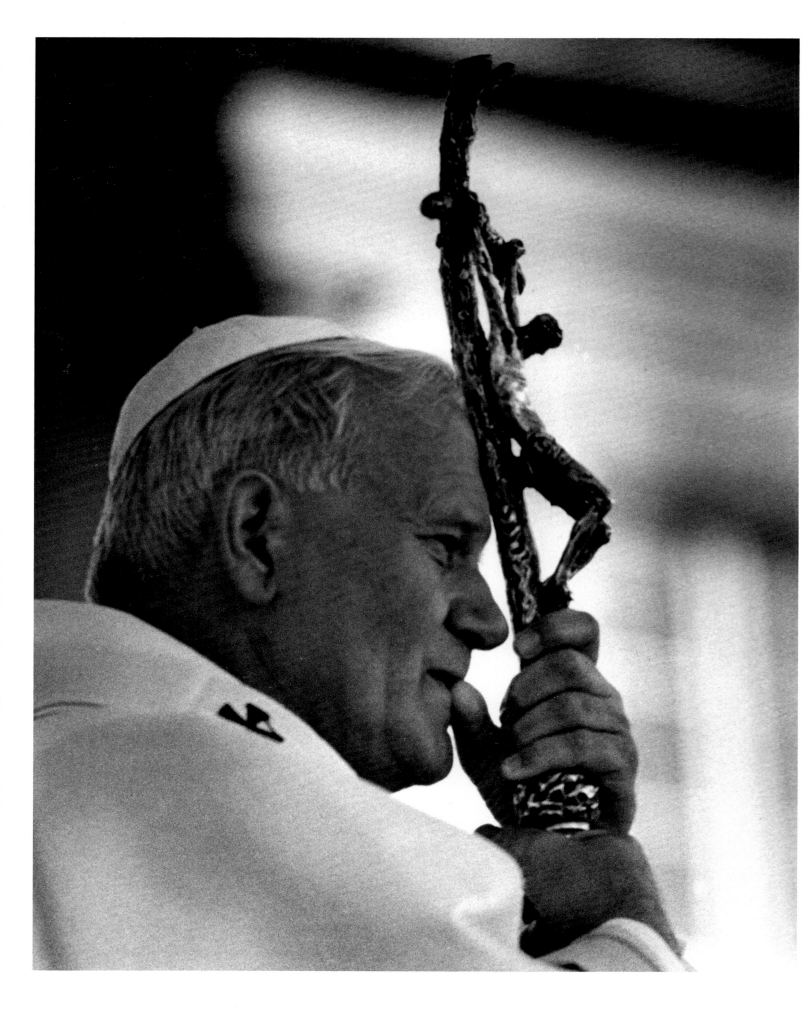

KRAKOW, 1983
**John Paul II listens to the crowd in Krakow sing "Sto Lat"
(May you live 100 years).**

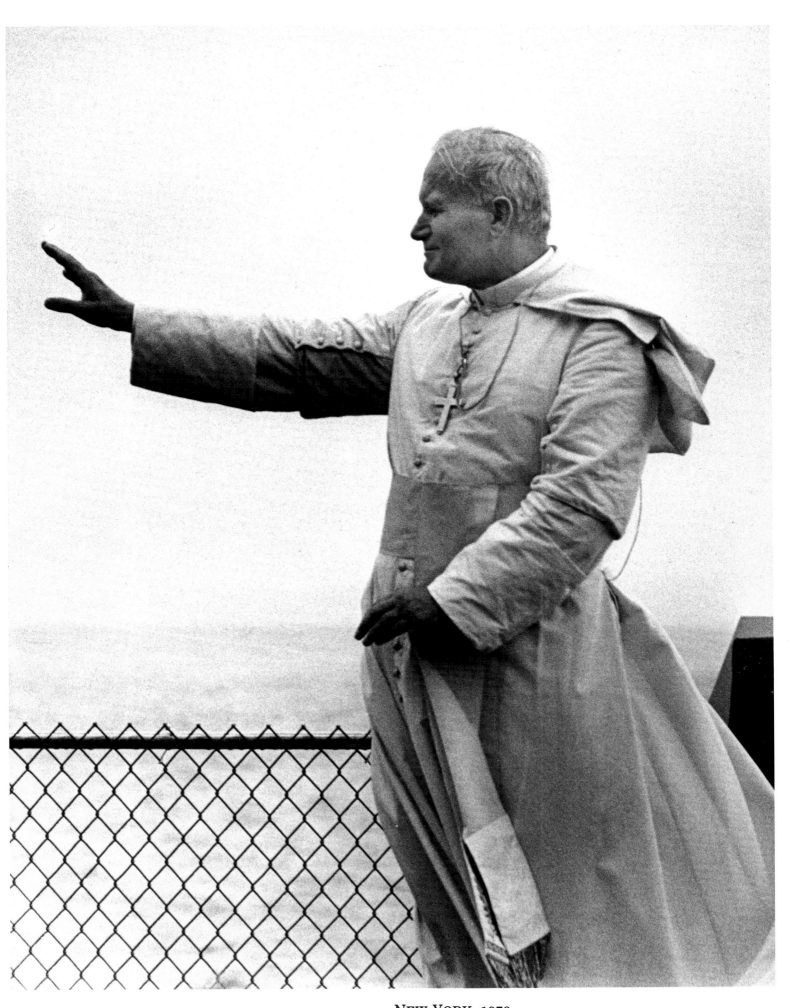

NEW YORK, 1979
In Battery Park, during a pouring rain, John Paul II said, "The pope is not all sunshine."

PORTFOLIO

One of the great things about my profession is never knowing what the day is going to bring.

You may photograph a princess, a pony, a protest or a professional baseball player.

Getting the right angle on a picture may take you up in a cherrypicker or leave you knee-deep in mud.

Being ready for any possibility is the challenge of an entire career.

In between the obviously special assignments — such as, for me, covering presidents and popes — are what some people call "routine" assignments. I have tried to avoid that word. Pictures only become routine when the photographer settles for a routine approach.

On these last pages are some favorite pictures of mine.

ANN ARBOR, 1956

A dowser is said to be able to locate underground water using a forked hazel twig that twitches at a place where a well could be drilled. A dowser's ability lies beneath the level of conscious perception. Because of the mystery, he is also known as a "water witch." This dowser was on a farm in Ann Arbor. He didn't say much. To give it the mysterious look, I laid a light on the ground to cast the shadows upward. (He did find water.)

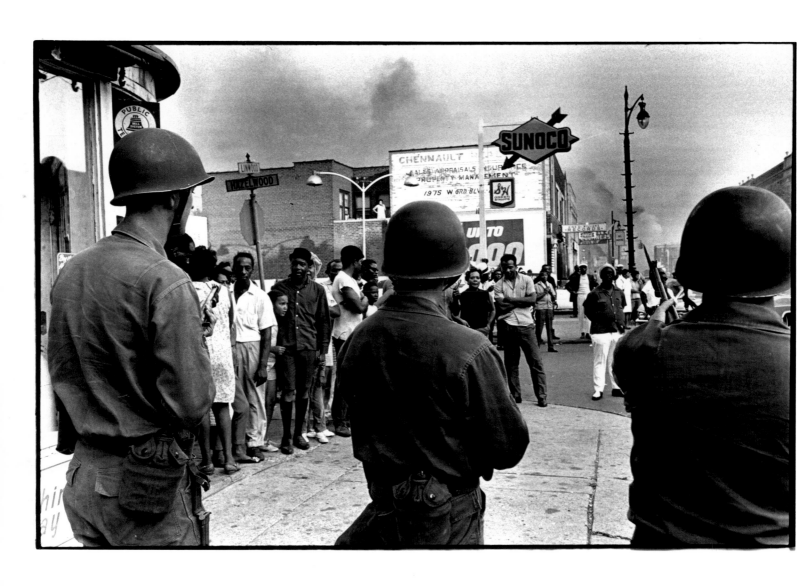

DETROIT, 1967

**The 1967 Detroit riot. National Guardsmen patrolled
Linwood Avenue at Hazelwood on the first day of one of the
worst weeks in Detroit history. Forty-three people died,
hundreds were injured, more than 3,000 people were
arrested. Fires destroyed entire city blocks.**

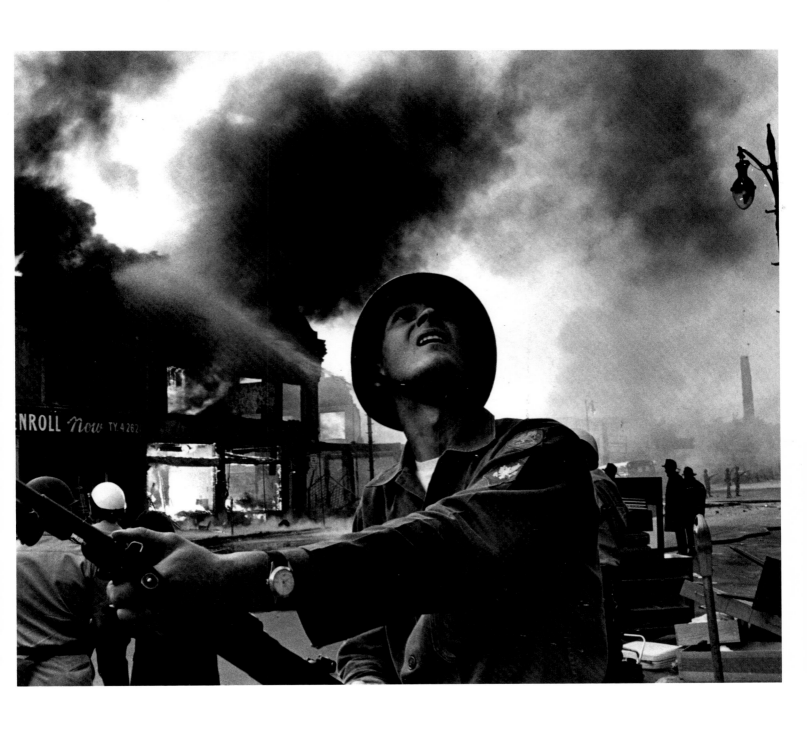

DETROIT, 1967

Shots were banging all around. I was walking alongside this National Guardsman, who was looking for snipers. There was tremendous tension at the time. The 8,000 National Guardsmen called up to help patrol the riot-ravaged west side were ill-trained to deal with anything like what was happening on Detroit streets. This photo was used all over the world, and was part of the entry that won the Pulitzer Prize for the Free Press.

PONTIAC, 1971

**In Pontiac, busing of students was a major issue. The courts
ordered schools to transport students from one school to
another to integrate them. This mother and child stopped the
bus as it tried to leave the school parking lot.**

PONTIAC, 1971

This woman carried the American flag as she ran in front of the bus. The bus driver zigged and zagged to get around her, but finally had to stop to avoid running into her.

PALMER PARK, 1950

Mom was the caddy for junior golf day as Tommy Taylor went swinging. This was a routine assignment. As soon as I spotted the mother walking behind, I knew I had my picture. I shot it from a sand trap, using a Speed Graphic. They walked on, unaware of me.

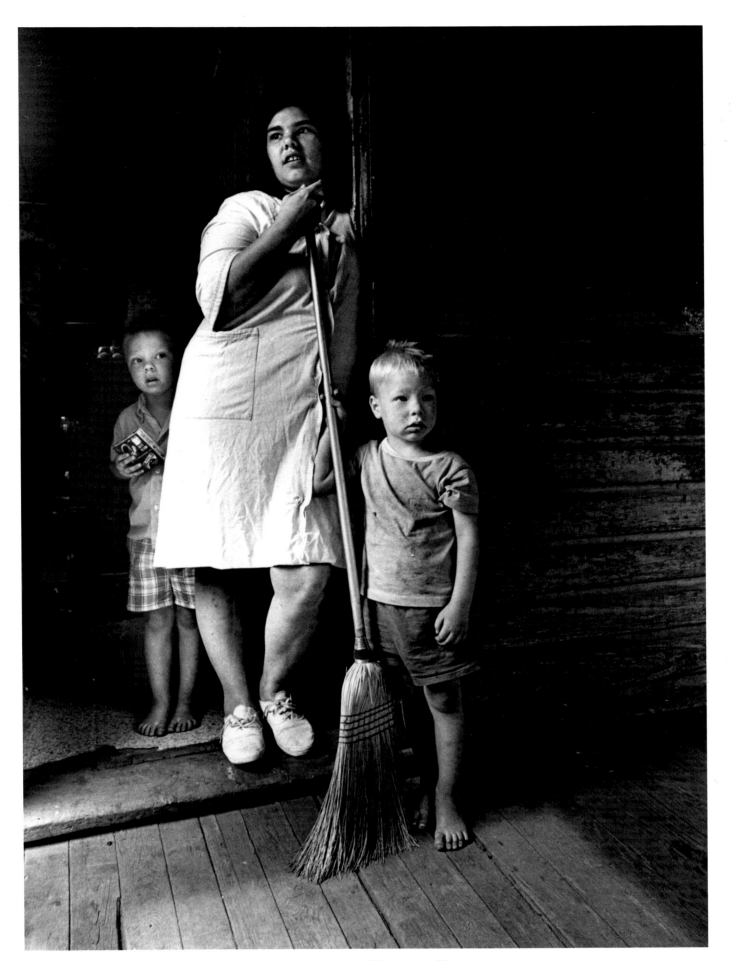

HAZARD, KY., 1972

A lot of people were moving to Michigan because coal mines in Appalachia were going out of business. A reporter and I went down there to interview some of the people left behind. There was a lot of poverty. This lady was very nice, but she wouldn't give her name.

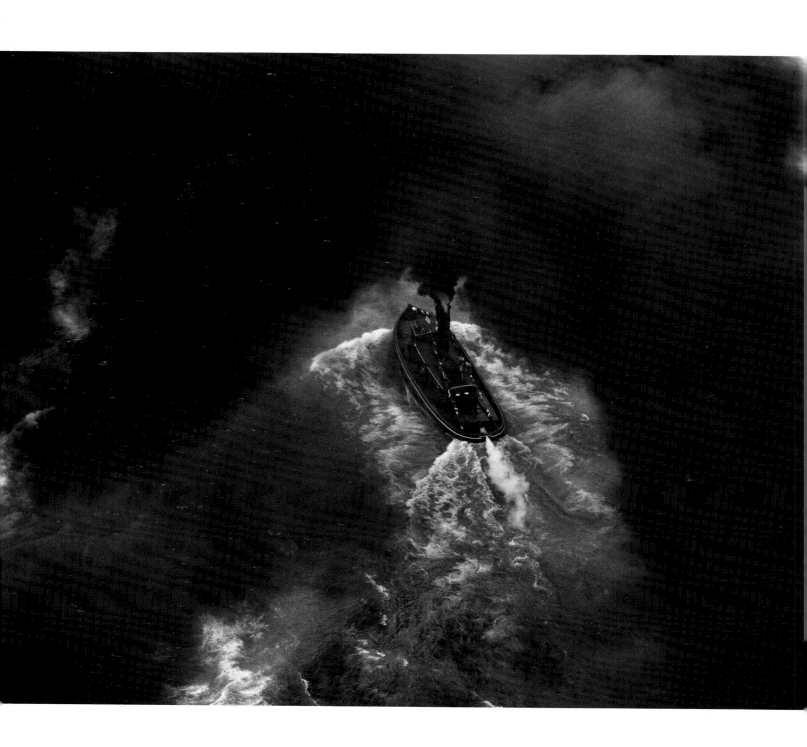

Detroit, Undated

Smoke rings a tugboat churning down the river. I was crouched near the open door of a helicopter, taking a picture to go along with a story on air pollution. I kept telling the pilot to go lower. Finally, he told me if we went any lower, we might choke on the smoke.

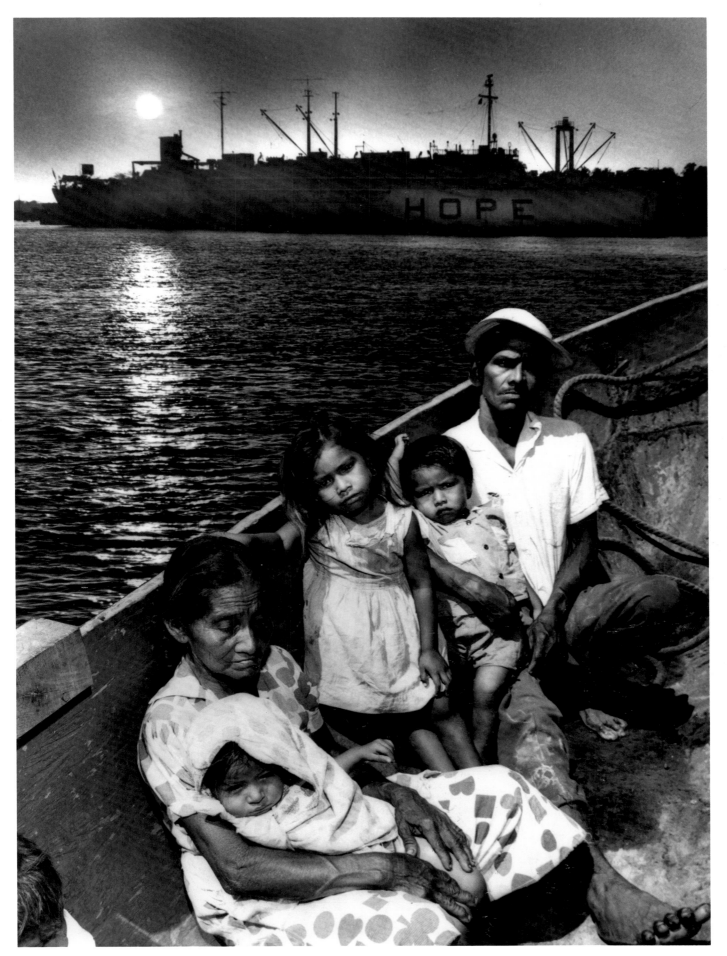

NICARAGUA, 1966

Nicaraguan family waits at sunset in Corinto to be taken aboard the hospital ship S.S. Hope. Project Hope now has shore clinics, and no longer uses the hospital ship, but they used this picture as a poster for several years. I went there and spent a week on the ship.

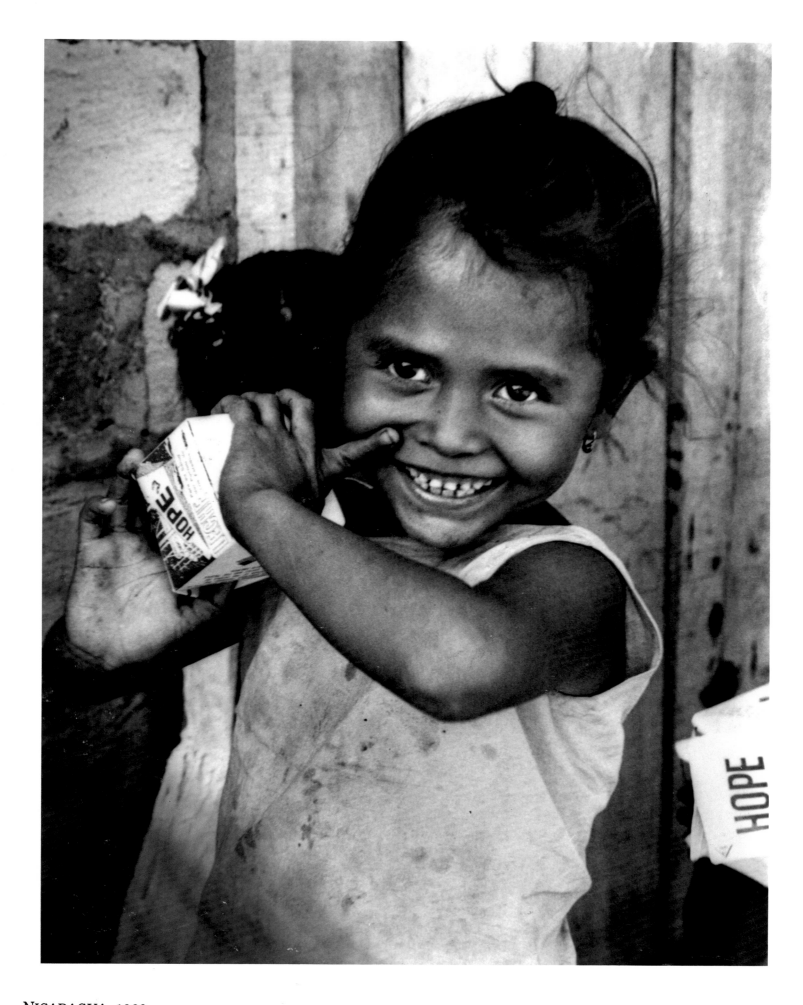

NICARAGUA, 1966
Young child is happy over the half-pint of milk given to her by
Project Hope. Three times a week the ship would deliver milk
to kids in the town. Some didn't even know what it was.

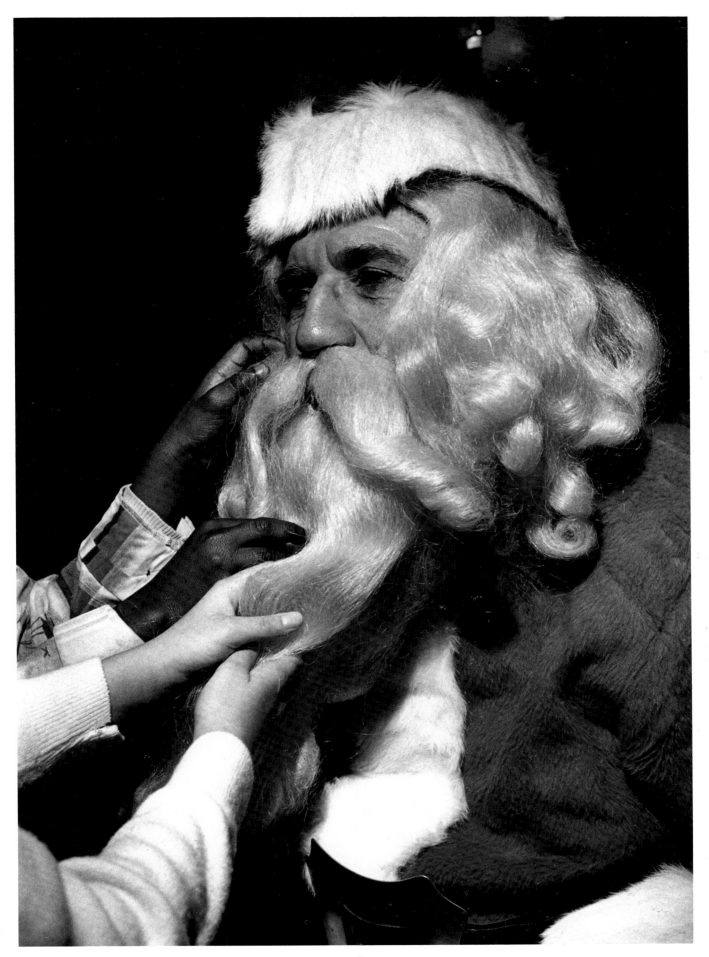

DETROIT, UNDATED

They feel to see. Little hands of blind children find a way to tell if it's really Santa by his whiskers. This has been an annual party at the Masonic Temple, put on by the Lions Club. Retired Common Pleas Judge Ben Stanczyk has played Santa for 20 years.

MOROCCO, 1946

Senegalese soldiers form an honor guard for the sultan, Mohammed V. A mosque is in the background. I was discharged from active duty in December 1945 but was still in the Naval Reserve and I got back to fly to Morocco with the reserve. Every Friday, the Moslem Sabbath, it is the custom for the sultan of Morocco to enter the mosque in Rabat in a carriage and leave on a white horse (opposite).

MOROCCO, 1946
French military and diplomatic officials were coming to
dinner, and I got permission to photograph this dining room in
the sultan's palace. They don't call themselves sultans now;
the official title was changed to "His Majesty the King."

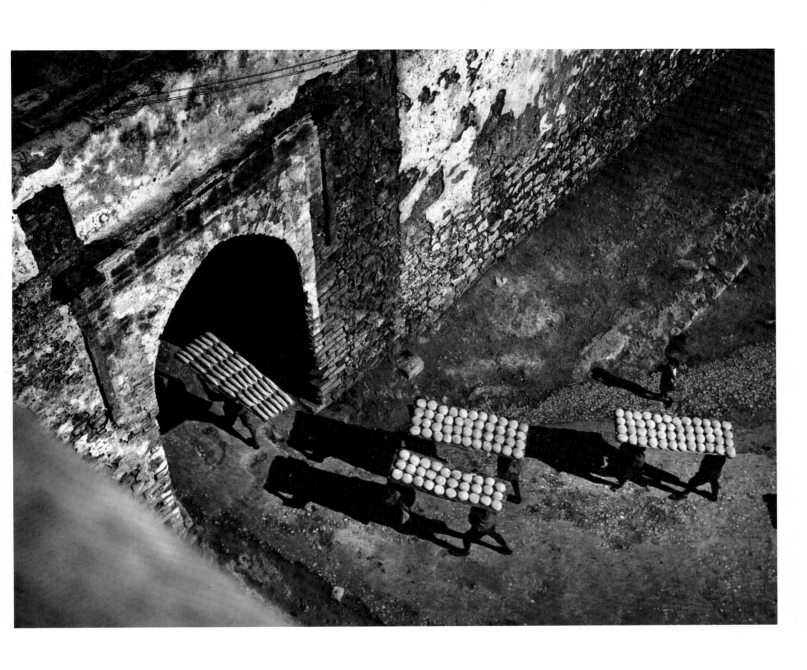

MOROCCO, 1946
Workers in Rabat carry bread into the walled city where roads are too narrow for vehicles.

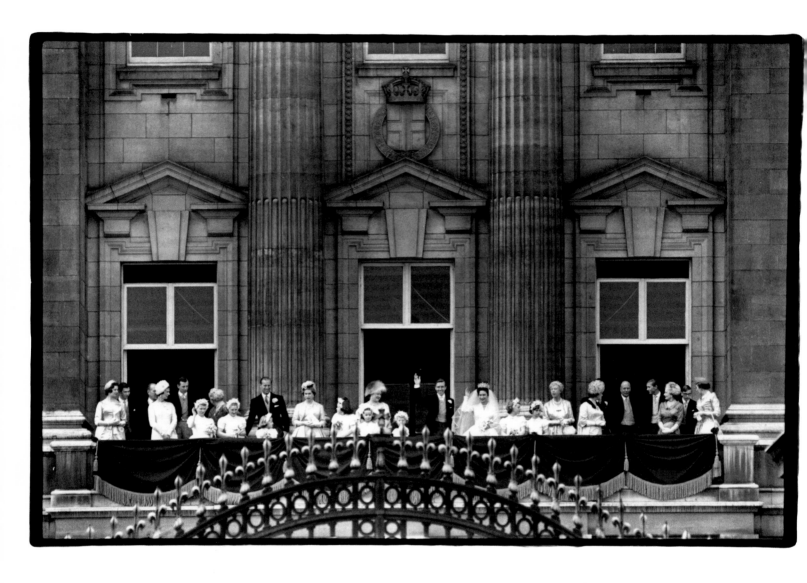

LONDON, 1960

The wedding of Princess Margaret to Anthony Armstrong-Jones on May 6. They wave to the crowd from a balcony at Buckingham Palace, after the ceremony in Westminster Abbey. The queen and the rest of the royal family joined the newlyweds on the balcony.

No pictures were allowed during the preparations inside Westminster Abbey. I just walked in with the TV technicians who were checking the lighting. I took a photo of a woman putting the carpeting together, and others from different angles. As I was leaving, the canon asked me what I was doing, and I simply told him. "Oh say, you can't be here," he said. I apologized and left. We ran this picture in Detroit, and AP transmitted it worldwide. No one else had it.

Michelangelo was commissioned by Pope Julius II to paint the vault of the Sistine Chapel, and he began to paint the ceiling on May 10, 1508. For four years, he lay on his back high above the floor on a scaffolding with wet plaster dripping in his eyes, creating one of the world's greatest treasures.

In 1987, I stood on a similar scaffolding seven feet below the ceiling of the Sistine Chapel to photograph one stage of the restoration of Michelangelo's masterpiece.

In the restoration, which started in 1984 and was to last almost a decade, no color was added to the original frescoes and no color brightener used. What emerged after the cleaning were the true and original colors of Michelangelo. And they are bright and vibrant colors indeed.

In undertaking the restoration, the Vatican Museum's conservation experts had determined that animal glues and gums applied to the frescoes by restorers of the past were deteriorating and, in the process, detaching color pigments from the plaster in many places. Further, the years of dust and smoke from candles, oil lamps and open braziers once used to heat the chapel had left a residue on everything.

Michelangelo painted the Sistine's ceiling and the wall depicting "The Last Judgment" by using the "buon fresco" technique. That means the artist paints with thin, watery pigments over a layer of still-wet plaster. A natural chemical process permanently suspends the colors in the plaster. This is why such frescoes last so long.

Other parts of the painting were done "a secco," in which colors are applied on dry plaster. The colors are prepared by mixing pigments with lime or organic substances such as glues, egg yolks and so forth. These portions of the painting are more fragile and more subject to change over time.

High on the modern scaffolding, only a few people actually touch the frescoes in the cleaning process. Each section of fresco, about a square foot at a time, is dusted and washed with distilled water. Then, a cleaning mixture is applied with a brush or daubed on with cotton.

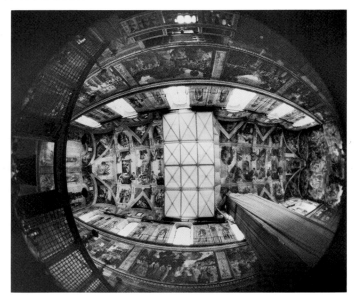

Enclosed scaffolding obscures the center of the ceiling of the Sistine Chapel. The draped elevator is at lower right.

After a carefully measured period of time (usually three minutes), the mixture and the dissolved foreign substances are removed with distilled water and sponges. After a 24-hour rest, the procedure is repeated.

The "a secco" areas are carefully analyzed and cleaned with procedures specially determined for each instance.

The level of cleaning is carefully controlled to reveal the colors as Michelangelo painted them so people for generations to come can look up and marvel at the beauty of his work.

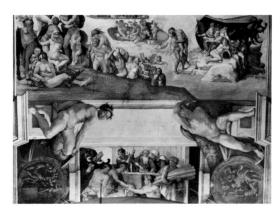

Restored: "The Flood"

Unrestored: "The Creation of Man"

VATICAN, 1987

Maurizio Rossi, a Vatican restorer, and his associate Luigi Bonetti stand on the scaffolding seven feet below the ceiling, about 60 feet above the floor of the Sistine Chapel. On the scaffold is a laboratory for analyzing every aspect of each section of the paintings before anyone touches it.

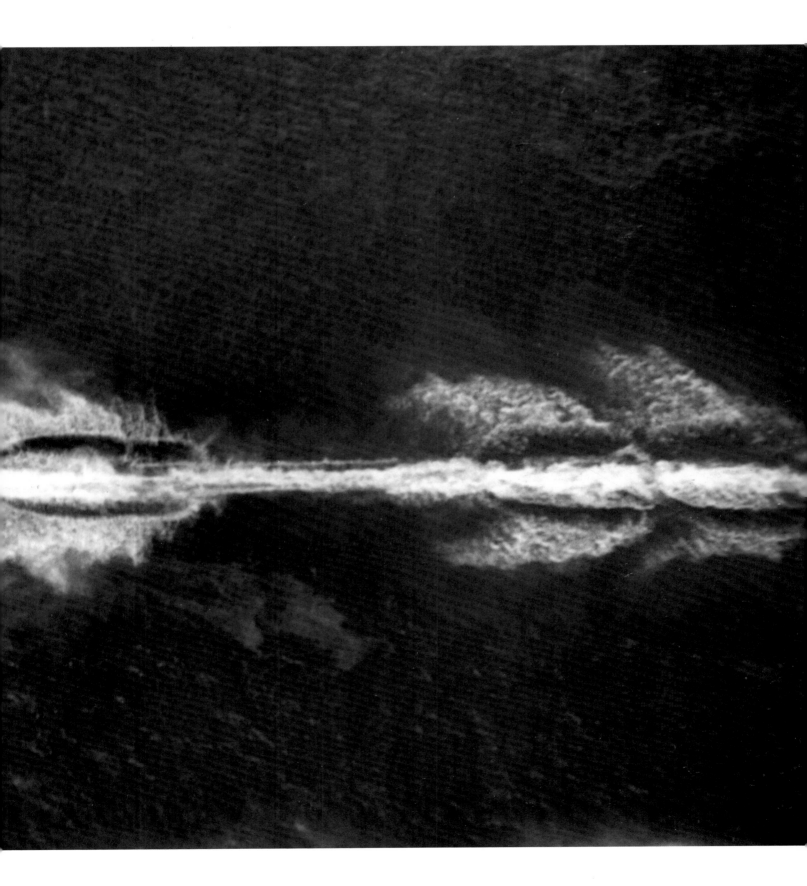

DETROIT, 1950
An aerial photo of My Sweetie skipping along to victory in the Detroit Memorial, a power boat race on the Detroit River.

DETROIT, 1985
**The Detroit Grand Prix. Formula One cars whiz by the first
turn after the start, with the Renaissance Center as a
backdrop.**

DETROIT, 1984
The fourth game of the World Series with the San Diego Padres. Next evening, when the Tigers clinched the World Championship four games to one, there was pandemonium.

Home to mama.

I had heard about a rare palomino pony on a farm in Oakland County. This was in 1956.

I was getting set up to take a picture when the owner told me, "You'd better hurry. That pony is hungry. When he gets out, he's going to want to eat."

Sure enough, only minutes later, following some inner time clock, Baby Palomino caught up to its mother and hurried into the barn for feeding. I followed them into the barn. Taking no notice of me, she ate, then lay down and curled up for a nap.

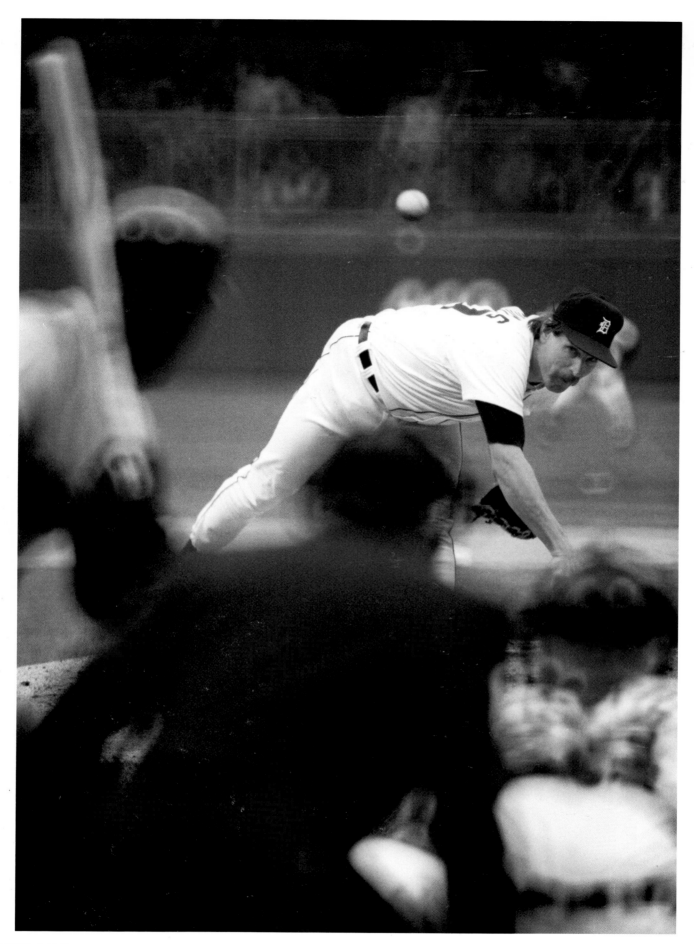

DETROIT, 1987

Tiger Jack Morris sends the ball toward the plate on Opening Day. Morris became baseball's highest-paid player in 1987 on the strength of his 141 wins in the 1980s, more than any other major league pitcher. In arbitration, he was awarded a salary of $1.85 million for 1987, and at year's end the Tigers signed him for two more years at $4 million.

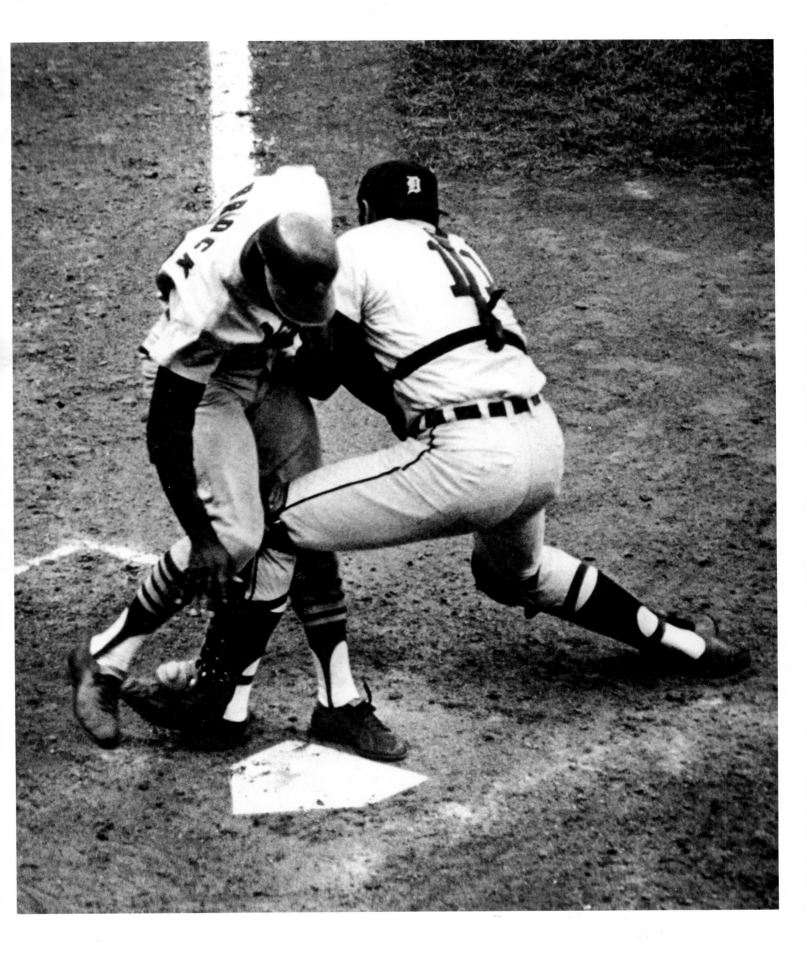

DETROIT, 1968

He shoulda slid. It was the 1968 World Series. The Detroit
Tigers were behind the St. Louis Cardinals three games to
one. They won the fifth game after Lou Brock was called out
at the plate by one inch, in the fifth inning in Tiger Stadium.
Bill Freehan made the out after catching a perfect long throw
from outfielder Willie Horton.

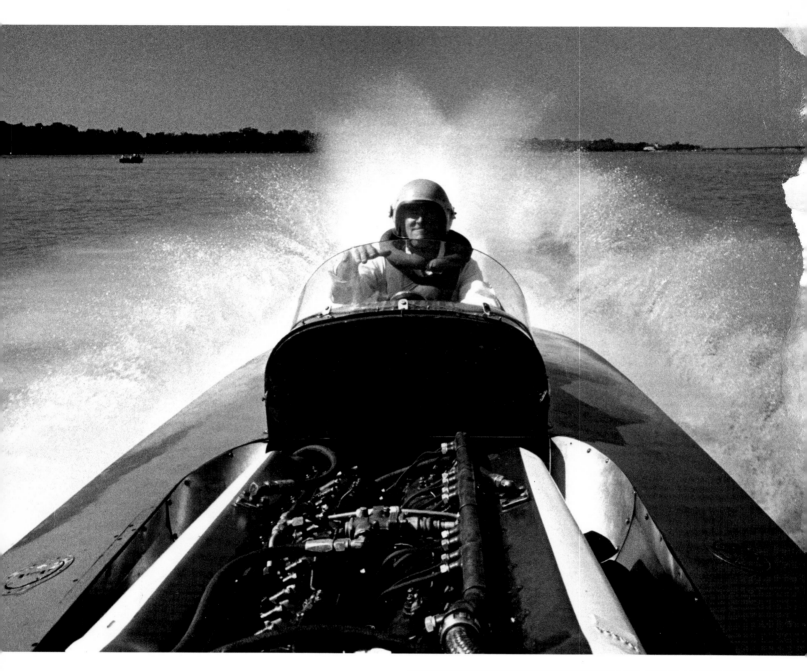

DETROIT, 1970

During a trial run for the Gold Cup power boat race, I rode backwards standing in the pit at the bow of the boat while Miss U.S. raced at speeds of up to 147 m.p.h. We started out slower, but there was no spray, so I kept giving the signal for "faster" to Roy Duby, the driver of the boat. I couldn't even be strapped in, but I did have a life jacket on. The photographer on the shore was probably waiting for me to get flipped off. Duby said, "You're crazy, you're crazy." George Simon, the owner of the boat, proclaimed me "a distinguished member of the 100 Mile Per Hour Club — Backwards."